# The Book of American Windsor Furniture

# The Book of American Windsor Furniture

*Styles and Technologies*  JOHN KASSAY

*With measured drawings by the author*

University of Massachusetts Press   Amherst

To my wife, Mary, for her affection, patience, and dedication and

for the hours she spent processing my writing and rewriting

Copyright © 1998 by
The University of Massachusetts Press
All rights reserved
Printed in Hong Kong
LC 97-39207
ISBN 1-55849-137-6
Designed by Dennis Anderson
Set in ITC New Baskerville

Library of Congress Cataloging-in-Publication Data
Kassay, John 1919–
    The book of American Windsor furniture : styles and technolgies /
John Kassay ; with measured drawings by the author.
        p.   cm.
    Includes bibliographical references.
    ISBN 1-55849-137-6 (cloth : alk. paper)
    1. Furniture—United States—History—18th century.   2. Decoration
and ornament—Windsor style.   I. Title.
NK2406.K35   1998
749.214—dc21                                              97-39207
                                                              CIP

British Library Cataloguing in Publication data are available.

Unless noted, all photographs are by the author. The measured drawings in this book are
by John Kassay and may not be reproduced without his explicit permission. Please direct
inquiries to the University of Massachusetts Press, Box 429, Amherst MA 01004.

# Contents

# Preface and Acknowledgments

Windsor chairs are distinctive in many ways. They are *unique* in structure—light, strong, and portable. English and American Windsor chairmakers were knowledgeable about the physical characteristics of wood species and employed them to best advantage. Windsors are expressions of *utility*. They were made in forms conducive to both work and relaxation. Windsors are *universal*. They were bought by rich and poor. The affluent patronized chairmakers whose products were made from select grades of wood, who employed high levels of craftsmanship, and whose forms were the most elaborate and desirable. Simpler Windsors were readily available to people with less money to spend. Windsors are *ubiquitous*. They were used on the veranda, in the hall, the parlor, dining and drawing room, library, bedroom, kitchen, servants' quarters, garden, schoolroom, church and meetinghouse, farmhouse, countinghouse, office, statehouse, theater, tavern, and on ships. Probably no other style of seating has found such wide use or made a more lasting impression on the English and American populace.

Windsors are fabricated principally from sticks. They have been known by different names, such as stick, rustic, rural, and country. The family consists mainly of chairs and benches, but also includes short and tall stools, round-top candlestands, tables with different shaped tops, cradles, and children's furniture. Chairs have three main components: a thick plank seat, four legs, and spindles socketed to the upper surface to form a back. The legs, stretchers, and spindles are assembled with round socket joints and in the main are the work of wood turners rather than joiners.

It seems likely that the Windsor name comes from the ancient town of Windsor, in Berkshire, England, where beech trees provided a plentiful supply of wood for legs and other turnings.

This study has been an ambitious enterprise, one that has taken more than a dozen years to complete and would not have been possible without the help of many, many people and institutions. First, I wish to acknowledge posthumously the contributions of those early English and American Windsor chairmakers who while developing the Windsor style achieved high levels of woodworking skills and honest workmanship. With fond memories I extend a warm thank you to the legion of students whom I had the privilege of teaching in my classes on technical drawing and furniture making for four decades.

I am especially indebted to the following persons, who from the earliest days of the project gave generously of their time and knowledge to see the book completed:

To Robert Treanor, teacher, author, draftsman, and Shaker and Windsor furniture maker. Bob spent many hours checking the drawings and reading the manuscript. His corrections and suggestions have greatly improved the work.

To Nancy Goyne Evans, Registrar and Research Fellow, Henry Francis du Pont Winterthur Museum, for her scholarly research and writings on the subject of Windsor furniture, much of which I found most useful to this study.

To Dave Sowa, friend and fellow worker in wood, for his generous long-term loan of a word processor and printer, which made my wife's task of processing my writing somewhat easier.

I also extend grateful thanks to the many collector/dealers who allowed me to measure, photograph, and include for publication many choice Windsors in their possession, some of which I borrowed for drawing:

Blue Candlestick Antiques; Jerome Blum Antiques; Dr. Donald Bond, Dealer; Butterfield and Butterfield Auctioneers; Corbett's Antiques; Thomas Crispin, Author/Dealer; Donald Flynn; Kinnaman and Ramaekers, Inc.; Bernard & S. Dean Levy, Inc.; Oveda Maurer Antiques; Montgomery Antiques; Dennis and Louise Paustenbach; Pilgrim-Roy Antiques; Thos B. Rentschler Antiques; Marguerite Riordan; John Keith Russell; David Schorsch, Inc.; David Stockwell; Robert and Mary Lou Sutter, Antiques; Jeffery C. Tillou Gallery; Van Dusen Schuman Antiques; C. K. Wallace Antiques; I. M. Wiese.

Sincere appreciation goes to the many private collectors who kindly welcomed me into their homes and proudly showed me their Windsors. I am grateful to them for granting me permission to examine, measure, photograph, and include some of these Windsors in the book: Lynn and Frank Barrett; Kenneth and Caroline Brody; George W. Dodge; Mr. and Mrs. Jim Dougherty; Gary and Dianna Espinosa; Ron Galloway; Alan and Laurie Harris; Thomas and Kay Harrison; Ruby Sadler Inglish; Sandra MacKenzie; Mardie M. Miller; David Pool; Mahlon and Isabel Pool; Greg and Bonnie Randall; Richard B. Roy; Benjamin and Toby Rose; Charles Santore; Charles and Katharine Schultz; Karen Wasser; Mr. and Mrs. Leo van de Water; Mr. and Mrs. Matthew Young; and those who wish to remain anonymous.

I am indebted to the many museum directors, curators, librarians, and staff members for making their Windsor collections available for hands-on study and photography, for responding to my requests for additional photographs, and especially for sharing their insightful knowledge about their collections.

In England and Europe: American Museum, Bath (Shelagh Ford, Secretary / Publicity); Design Council, London (Anthony Land, Head of Policy and Planning); Jesus College, Oxford (Dr. A. E. Pilkington, Acting Principal, and Henry Crabb, staff); Museo delle Antichità Egizie, Torino, Italy (Dr. Elisabetta Valtz, Director); The National Gallery, London (Dr. Allan Braham, Keeper); National Museum of Wales, Cardiff (L. Joy Bowen, Archivist); Niedersächsische Landesmuseum, Hannover, Germany (Photo Archives); Rijksmuseum, Amsterdam, Netherlands (Dr. J. W. Niemeijer); Victoria and Albert Museum, London (Albert Neher, Furniture Conservator).

In the United States: Art Institute of Chicago (Milo M. Naeve, Curator of American Arts); Brooklyn Museum, New York (Christopher Wilk, Assistant Curator); Chester County Historical Society, West Chester, Pennsylvania (Margaret Bleecke Blades); Colonial Williamsburg Foundation, Williamsburg, Virginia (Ronald L. Hurst, Curator of Furniture); Custom House, Salem, Massachusetts (David Kyser, Curator); Fine Arts Gallery, San Diego, California (William S. Chandler, Associate Curator, Decorative Arts); The Henry Ford Museum and Greenfield Village, Dearborn, Michigan (Michael J. Ettema, Curator, Collections Division); Henry Francis du Pont Winterthur Museum, Winterthur, Delaware (Nancy Goyne Evans, Karol Schmiegee, Registrars); Historic Deerfield, Deerfield, Massachusetts (Donald E. Friary, Director); House of Seven Gables, Salem, Massachusetts (David Goss, Museum Director); Independence National Historical Park, Philadelphia, Pennsylvania (John C. Milley, Chief of Museum Operations); M. H. deYoung Museum, San Francisco, California (Donald Stover, Curator of American Decorative Arts, and Lee Hunt Miller, Curator of European Decorative Arts); The Metropolitan Museum of Art, New York,

New York (Mary Doherty, Photography and Slide Library); Milwaukee Art Museum, Milwaukee, Wisconsin (Claire F. Fox, Assistant Registrar); Munson-Williams-Proctor Institute, Utica, New York (Paul Schweizer, Director); Museum of Early Southern Decorative Arts, Winston-Salem, North Carolina (Brad Rauschenberg, Director of Research); Museum of Fine Arts, Boston, Massachusetts (Jonathan Fairbanks, Curator of American Decorative Arts); National Society of Colonial Dames, Octagon House, San Francisco, California (M. S. Manwaring, President); Pocumtuck Valley Memorial Association, Memorial Hall Museum, Deerfield, Massachusetts (Jeannette Blohm, Curatorial Assistant); Slater Memorial Museum, Deerfield, Massachusetts (Joseph P. Gualtieri, Director); Sleepy Hollow Restoration, Tarrytown, New York (Joseph T. Butler, Curator and Director of Collections); Society for the Preservation of New England Antiquities, Boston, Massachusetts (Brock W. Jobe, Chief Curator); Yale University Art Gallery, New Haven, Connecticut (David Barquist, Assistant Curator).

I take full responsibility, and apologize in advance, for any errors that may be in this book.

The Book of American Windsor Furniture

# Introduction: Origin and Evolution of Windsors

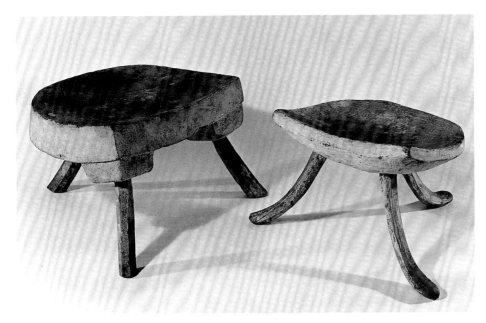

Figure i. Low stools, Thebes, Egypt (tomb of Kha), Eighteenth Dynasty (c. 1400 B.C.). Painted wood. *Left,* H 14 in., *right,* H 12½ in. Museo delle Antichità Egizie, Torino.

Some of the features now associated with Windsor furniture can be seen in rustic hand-hewn low stools of Egypt from as long ago as the eighteenth dynasty (c. 1567–1320 B.C.). These antecedents are documented in Egyptian tomb wall paintings depicting craftsmen at work sitting on low stools. Fortunately, examples of these ancient seats have been found, so it has been possible to study their materials, tool-marks, and construction features.[1]

The typical low stool had three or four hand-hewn straight or naturally curved stumpy splayed legs socketed (in what is now thought of as the Windsor manner) to a thick flat or dished plank seat (fig. i). The shaved or adzed legs on the stool on the left are socketed to intermediate blocks of wood attached (by an undetermined method) to a slightly saddled seat. Obviously, the blocks add strength to the legs. The legs on the other stool appear to have been sawn and sculpted. Both stools have D-shaped seats with the straight edge at the front.

From the beginning of the Roman Empire (27 B.C.–A.D. 395) numerous paintings depict craftsmen sitting on low benches assembled with socketed stick legs and working at tables assembled with mortise-and-tenon joints. There are few illustrations or artifacts that document the existence or allow us to trace the development of socketed stick-constructed furniture during the early years of the Middle Ages (which began around A.D. 476); however, from the thirteenth century

Figure ii. Choir stall, monastery chapel of Pohlde, District Osterrode, Harz, Germany (1284). H 57½ in., W 23⅝ in. Niedersächsisches Landesmuseum, Hannover, Germany.

onward, there are many illustrations of stools, benches, and tables assembled with socketed parts. A thirteenth-century carving of a choir stall panel (fig. ii) shows in considerable detail a wood carver sitting on a stool working at a low bench. The man is carving an architectural element for a church with a mallet and chisel. His stool and bench are patterned after typical shop furniture forms of the period. The legs on both pieces simulate hand adzing and socketing to a plank seat and bench top. Carved into the back panel are the tools of his trade: a compass and small square, a rack holding assorted chisels, and a pot of glue or possibly lamp black, for marking out details to be carved.

By the early sixteenth century, stools were fitted with backs of a few short sticks socketed to the back edge of the seat and capped with a horizontal board. They were a logical and comfortable addition to the low stool. Backs also were included in the

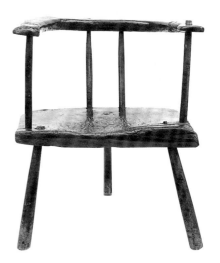

Figure iii. Back stool, Museum of Welsh Life, St. Fagans, Cardiff, Wales.

design of plank-style chairs and benches and greatly advanced the evolution of the Windsor chair. An early Welsh example (fig. iii), called a "back stool," is typical of many found in that country and throughout Britain.[2] The stool has a thick, almost flat, D-shaped plank seat, a heavy three-piece arm rail, cylindrical arm spindles, and three tapered and wedged rough-hewn legs.

Stools were used in humble households and in workshops. In the mid-seventeenth century, stretchers were incorporated in stick furniture, as can be seen in a painting of a Netherlands alchemist with the tools of his trade (fig. iv). The alchemist sits on an upholstered round stool that has shaved

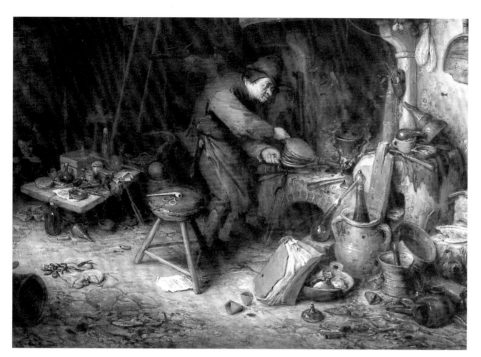

Figure iv. Detail of painting *An Alchemist,* by Adriaen van Ostade, Netherlands (1661). H 13⅜ in., W 17¹⁵⁄₁₆ in. Reproduced by courtesy of the Trustees, The National Gallery, London.

legs; its stretchers are socketed to the legs with round tenons. Stretchers contributed strength and allowed for the use of thinner boards for seats.

The wood-turning lathe played a vital role in the development of Windsor furniture. It is likely that the Egyptians of the eighteenth dynasty were unfamiliar with the lathe although the bow drill was common and was most likely used in making rounds for low stools.[3] Ancient mechanics drilled holes in hard substances by rotating, by hand or a bow strap, a shaft that had been dipped in an abrasive. This is identical to the principle used in the rotation in primitive lathes.[4] Turning progressed from bow drill, to bow lathe, to the spring pole lathe (fig. v). The spring-pole lathe has been used since the eighth century B.C.[5] This lathe was introduced to England by way of France at the time of the Norman Conquest (1066) and accounts for the accelerated development and commercialization of Windsor-style seating. By the fourteenth century, wood turning was an organized trade, practiced by a growing number of skilled craftsmen who produced a large variety of turnery. These turners made parts for spinning and wagon wheels, walking sticks, household utensils, architectural elements, and high-style furniture.

## English Windsors

English Windsor chairs may have been made as early as the seventeenth century but this has yet to be established. Except

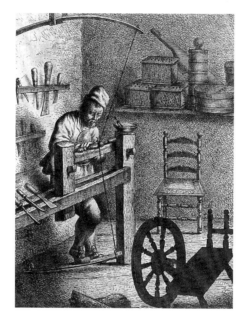

Figure v. *The Turner.* Engraving on paper by Jan Joris van Vlet. Netherlands c. 1635. H 8¼ in., W 6¾ in. Rijksmuseum-Stichting, Amsterdam.

for a few references describing Windsors on wheeled platforms used for transporting the wealthy around their formal estate gardens, little has been written about them as a distinct furniture form, probably because they were plain in style with rural origins. Not much is known about their provincial makers.

Writings about landscape gardening appeared around the years of 1710-40. The earliest written reference to Windsor furniture was made by Stephen Switzer in a treatise on landscaping formal gardens,

dated 1718. Switzer describes a garden walk to a promontory that contained a Windsor seat.[6] Another early reference is found in a document written in 1724 by John Percival, earl of Egmont. Percival describes a visit to the garden at Hall Barn, near Beaconsfield, Buckinghamshire, and states, "my wife was carried in a Windsor chair." Further reference to Windsors in gardens appeared in a newspaper advertisement dated 1730 placed by one John Brown who advertised for sale "all sorts of Windsor Garden Chairs of all sizes, painted green or in the wood."[7] Within the decades of the 1720s and 1730s, English Windsor chairs became extremely fashionable for both indoor and outdoor use.[8] Most chairs were painted green, probably because that color concealed the different woods and was less obvious in the landscape.

The first illustration of a Windsor chair is found in a painting by Jacques Rigaud, dated about 1733 and published in 1739. It depicts a scene in Stowe Garden at Buckinghamshire near the town of Windsor (fig. vi). A detail of the painting shows a patrician man and woman sitting in comb-back armchairs. The chairs are mounted on platforms with two large wheels at their back and a small tiller guiding wheel at the front.

Features on a large, entirely hand-crafted high- (comb-) back armchair (fig. vii) resemble, from the seat down, a Welsh back stool. The addition of long back spindles, as well as the supporting bent arm and crest rail, transforms what is essentially a large four-legged stool into a full-blown, relatively plain Windsor armchair. The added comfort that came from including fully developed curved spindle backs and arms on stools was soon recognized. A variety of patterned backs and seats were designed and the newer forms were readily accepted.

At this time, chairs were made by carpenter-joiners, who were general woodworkers with limited chairmaking skills. These craftsmen were replaced by "bodgers" (an appellation for skilled itinerant wood turners) who set up their portable pole lathes among the beech trees and produced turned objects such as components for spinning and wagon wheels, household items, and legs, stretchers, and arm supports for Windsor chairs. Bodgers were familiar with socketed construction, the joinery used in Windsor furniture, but few bodgers or craftsmen made an entire chair. As it emerged, the Windsor chair lent itself to a division of labor and mass production, even in the smallest operations. Several parts could be made in volume, binned, pulled as needed, and assembled and finished on a factorylike assembly line. A

complement of craftsmen-specialists consisted of a benchman who sawed out parts, a bottomer who dished seats, a bender who bent curved parts, a framer who bored holes and assembled parts, and a finisher who stained and polished the completed chairs.[9]

The needs and demands of a growing population helped change the nature of Windsor production from small rural operations to large city factories employing apprentices, journeymen, and specialists, all directed by the owner-entrepreneur. High Wycombe near London became the center of the chairmaking industry.

English Windsor settees of the mid-eighteenth century are not numerous and those made were usually of the high- (or comb-) back style. A furniture inventory of a gallery dated 1738 lists double- and triple-sized settees, indicating they were first made for use in public buildings.[10]

In one example (fig. viii), the woods used include ash, for the crest rail, spindles, arm rail, and arm supports; elm, for the seat; and beech for the legs. The back consists of sixteen long one-piece spindles. The unbent crest rail has an elaborately scrolled upper edge and a single beaded lower one. A matching bead is carried around the perimeter of the seat, and the plank seat is dished into two well-defined comfortable seating areas. The arm supports have tenons wedged through the arm rail and seat and are side pinned for added security. The arm rail is one piece, bent at the juncture of the back and arm spindles. The legs are lathe-turned and have hock-shaped feet—a carving detail found on some early high-style English furniture.

By the middle of the eighteenth century, two grades of Windsors were being mass produced. The first were plain, strong, hard-wearing inexpensive utility chairs turned out and marketed to the lesser middle classes for use in cottages and farm houses.[11] These chairs also saw service in taverns, schoolrooms, servant quarters, and public buildings. Although many different woods were selected for their physical properties, ash (or willow) was commonly used for the bent parts, beech for the turnings, and elm for the seats. The second category was classic high-style Windsors made of selected woods such as yew and elaborated with carvings, fret-work, abundant curves, upholstery, and attractively finished with paint and gilding.

A few well-established design details found on classic English furniture were incorporated in high-style Windsors and were so labeled—but with little justification. Thus there are cabriole-style front legs on Queen Anne and Chippendale

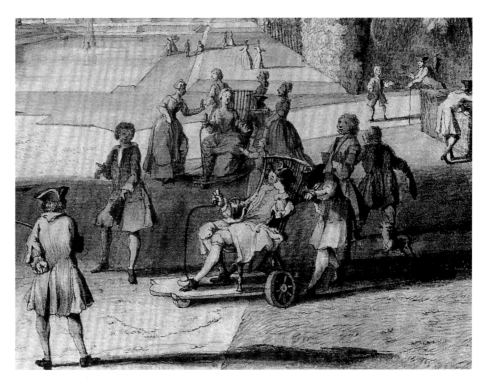

Figure vi. Enlarged detail of the Queens Theatre, Stowe Garden, Buckinghamshire, 1739. Pen-and-ink and wash drawing on paper by Jacques Rigaud. The Metropolitan Museum of Art, New York, Harris Brisbane Dick Fund, 1942. [42.79(7)].

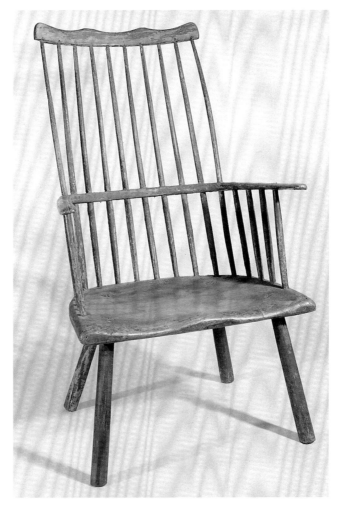

Figure vii. English Windsor high-back armchair, c. 1730–50. Crest rail, unidentified fruit wood; spindles and legs, oak; seat, elm. H 51¼ in., W 24 in., D 26¾ in. Colonial Williamsburg Foundation.

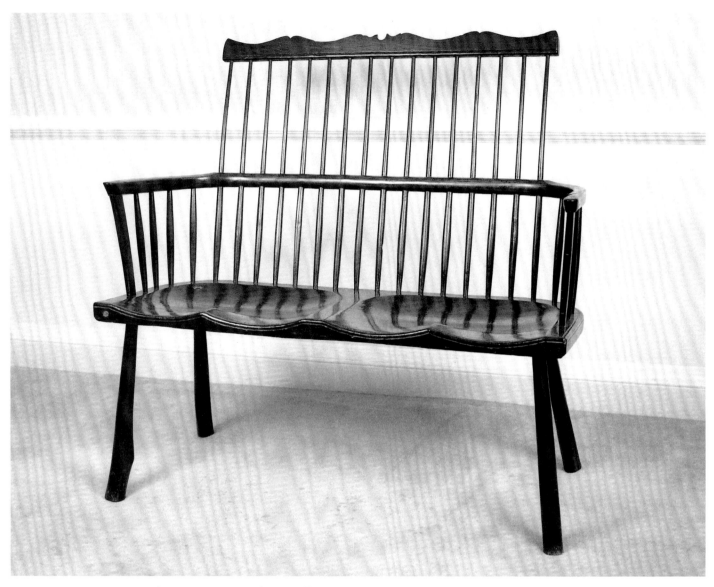

Figure viii. High-back settee, c. 1740–55. H 43 in., W 46¼ in., D 17¼ in.
The Principal and Fellows, Jesus College, Oxford, England.

Windsors, pointed back bows and splats with open cathedral tracery on Gothic Windsors, and vase and ring turnings on Hepplewhite and Sheraton Windsors. Sometimes distinguishing features led to naming Windsors by their place of origin, thereby giving us Buckinghamshire, Suffolk, Lancashire, and Yorkshire Windsors, among others.

One of the earliest labeled Windsor is a c. 1750 comb-back (or fan-back) armchair (fig. ix). It is the only known Windsor made by Richard Hewett, whose trade label is fixed to the underside of the seat. On the label, Hewett identifies himself as a carriage and chairmaker working in the district of Slough in Berkshire County. Carriage makers had tools, skills, and knowledge similar to those employed in making Windsor chairs; it was, therefore, natural for many carriage makers to add Windsor chairmaking to their business.

Hewett's chair is made of ash and beech and has an elm seat. It is a classic example of Windsor chairmaking, exhibiting both beauty and craftsmanship. Noteworthy details are the wavelike, bent crest rail, the double heart-shaped back splat, the extra broad D-shaped saddled seat (designed for male use), and the well-designed cabriole-style front legs. Other features include flanking stiles, tenoned and pinned to the crest rail and seat, a splat that is let into the crest and arm rail and tenoned to the seat, and legs that penetrate the seat and are wedged. The back legs are plain cylinders with a ball turning. A plain-turned, bulbous centered H-pattern stretcher strengthens the legs.

The Irish poet and novelist Oliver Goldsmith owned a handsome braced comb-back armchair (fig. x). It features design details that were newly incorporated in urban-made Windsors produced during

the mid-eighteenth century. They are the upturned ears on the crest rail, the two back stays (or bracing spindles), a bob-tail (or tail-piece) projection of the seat, and a three-piece lap-jointed arm rail. The rams'-horn arm supports are tenoned to the arms and pinned to a dished circular seat. The leg turnings have colts' feet. (Rams'-horn arm supports were infrequently used in early Philadelphia comb backs [see figs. 7 and 8]. Colts'-foot leg turnings were never adopted by American Windsor chairmakers.)

Bow-back Windsors with wheel motif splats were first introduced in 1783. One fine example (fig. xi) is a composition of turned, bent, shaved, sawn, and sculptured parts. The chair has five solid wood bent members which required four different bending forms. The legs, a typical English turning pattern, are supported by a crino-line stretcher and the arm rail joins swept-

back arm supports, another English design. On common Windsor chairs, splats were made of elm, beech, or yew, while on high-style varieties, fruit woods—apple, cherry, pear, and plum—were used for both their strength and attractive color.

Over time, the height of bows was increased and another variety, high bow-backs, was introduced. The Windsor style shown in figure xii was introduced in the latter part of the eighteenth century. These chairs were called interlaced bow backs. They were available in other latticelike patterns and with arms. The bow on this chair is tenon-wedged to a slightly saddled shield-shaped seat. The leg turnings are typical English patterns supported with an H-pattern stretcher. The four lattice pieces were bent rather than sawn and half-lapped and tenoned to the bow and seat.

An elegant labor-intensive Windsor made of yew wood has a mahogany seat (fig. xiii). The padfoot cabriole-style legs at the front and the taper-turned legs at the rear are tenon-wedged through the seat. The front legs have fretted triangular brackets glued to the legs and seat. A crinoline stretcher with spurs supports the legs and stabilizes a typical English-pattern seat. A bent two-piece Gothic pointed back bow is finger jointed at the center and tenoned to the one-piece, bent arm rail. The bent arm supports are tenoned to the arm rail and seat. Elaborate fretwork arm splats are tenoned at their top to the armrail and seat at the bottom. The medial splat is recessed and dove-tailed into the front of the arm rail; the one-piece flanking splats pass through the arm rail and are tenoned at their ends. Most joints are pinned for security and the carvings are undercut for greater emphasis. The back legs convey strength and stability and the front corners of the shield-shaped seat curve outward and further contribute to the chair, which is a harmony of curves.

## American Windsors

The first Windsor furniture in America was imported from England. From the beginning of colonial settlement, a lively maritime trade was carried on with England and many fine examples of English-made Windsor chairs were included in this early commerce.

The style may have been introduced in Philadelphia by patrician Patrick Gordon. Gordon left London in 1726 to assume the lieutenant governorship of Pennsylvania. He brought with him five Windsor chairs. Upon his death in 1736 five Windsor chairs, presumably the same chairs, were listed in his probate records.[12]

Emigrant and local chairmakers copied features of these gentleman high back't (comb-back) English imports, particularly the crest rail, D-shaped seat, bent semi-circle arm rail, and board-shaped arm supports (see figs. ix and 4). Baluster-style turnings and H-pattern stretchers were borrowed from Delaware River Valley slat-back framed rush-bottom armchairs.[13] The back splat and cabriole-style leg, popular with English customers, were not adopted by American consumers.

American-made comb backs were popular because their canted back and plank, form-fitting saddled seat were considerably more comfortable than the perpendicular backs of rush-bottom chairs that were in vogue. Furthermore, Windsors were light, strong, and inexpensive, their seats never needed replacing, and they were readily enhanced with a fresh coat of paint.

To be economically successful, colonial woodworkers had to diversify and become jacks-of-all-trades. Depending on their tools, skills, interest, and opportunities, they bought and sold lumber, built and repaired houses and barns, repaired and made furniture, and some made Windsor chairs, all the while farming their land.[14]

The financial potential of this relatively easily produced new form of seating was soon realized. Chairmaking became a specialized trade and many craftsmen concentrated exclusively on this industry.

Figure ix. Comb-back armchair made by Richard Hewett, c. 1750–60. H 45 in, W 23 in., D 18 in. Thomas Crispin Collection. Reproduced from Thomas Crispin, *The English Windsor Chair*.

Figure x. Braced comb-back armchair, 1755-65. Owned by Oliver Goldsmith, England. H 37¾ in., W 25 in. Courtesy of the Board of Trustees of the Victoria and Albert Museum, London.

Figure xi. Round-top Windsor with wheel splat, c. 1800, London. The wheel-pattern splat became very popular and made these chairs nationally famous. Thomas Crispin Collection. Reproduced from Thomas Crispin, *The English Windsor Chair* (Dover, N.H.: Alan Sutton, 1992).

The craft of Windsor chairmaking spread rapidly from Philadelphia, where it had developed into something of a monopoly, to southern and northern coastal cities and into the many river valley towns where chairmakers located and advertised their Windsors "as good and cheap as those made in Philadelphia."[15]

Responding to competition, customers' taste, and reaction to English fashions in Windsors, colonial chairmakers adopted, refined, embellished, and developed many variants of the Windsor form.

Within a hundred years of their introduction to America, seven styles of chairs, classified by the pattern of the backs, were being marketed. Five seat shapes, five leg styles, and four stretcher patterns were also designed to accommodate the different backs. Stools, cradles, stands, and tables of Windsor design were also produced.

Windsors were readily accepted by prosperous members of society: Thomas Jefferson, Benjamin Franklin, and George Washington owned Windsors. People of modest means bought inexpensive patterns, such as bow backs.

During the early days of the republic, the scarcity of coin and paper money promoted a system of bartering goods and services and chairmakers engaged in this practice for a number of years. While these transactions typically were on an individual basis, by the first quarter of the nineteenth century, furniture warerooms, the forerunner of today's furniture stores, stocked and sold a selection of finished Windsors on a cash and carry basis.

There were also some tradespeople who worked on commission. Auctions, peddling, and word of mouth were other, limited methods of selling chairs.

Chairmakers promoted their merchandise by advertising in newspapers, listing in city directories, marking the chair bottoms with burned or stamped brands or with impermanent paper labels. In addition to the maker's name and place of manufacture, many paper labels had pictures of the Windsor chairs.

It was cheaper to transport Windsors by water than overland. Depending on the size of the shipment, the boats ranged from small rowboats to large steam-powered ocean-going vessels. Shipping Windsors safely and quickly required special care in packing and transporting.

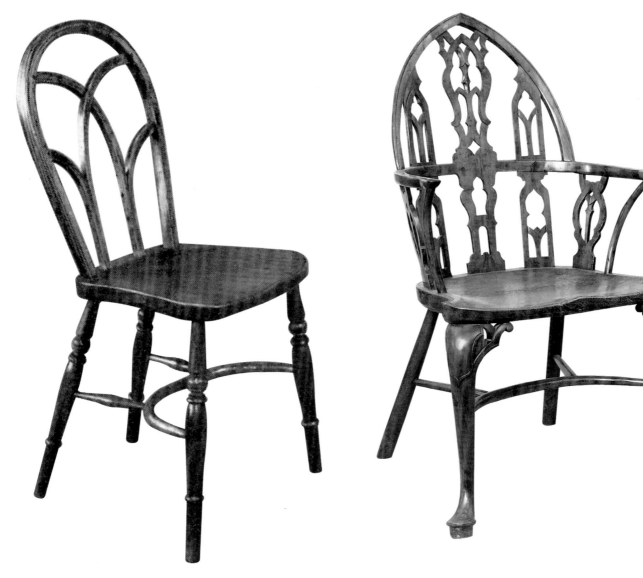

Figure xii. The neo-Gothic influence in English Windsors is obvious in the pointed arches within the bow of this bow-back single chair (side chair), c. 1800. These chairs were called interlaced bow backs. J. Gordon Roe, *Windsor Chairs* (New York: Pitman, 1953), with permission of The Design Council, London.

Figure xiii. This superior (c. 1770) example of Windsor craftsmanship shows the extent to which Queen Anne, Chippendale, and Gothic patterns influenced English Windsor chairmakers and their clientele. The chair is a semi-rare style of Windsor; nevertheless, several examples are extant. Courtesy of the Board of Trustees of the Victoria and Albert Museum, London.

Chairs in pairs were padded with mats, and to conserve space and offer protection, one seat was inverted in the other. Chairs shipped overseas or in large quantities were often packed unassembled in boxes and barrels and protected with straw. Referred to as "knock downs," they were assembled and finished at their destination. For local deliveries and where water routes were nonexistent, flat-bed horse-drawn wagons fitted with high stakes transported Windsors. The chairs were stacked high on these wagons and protected with straw. The wagons, referred to as "chair racks," were a familiar sight in New England. Some hotels built large barns to accommodate these chair racks.[16] Although English Windsors influenced the American product, the American Windsor chair was one of the most exciting native expressions in colonial furniture. They are the most American of furniture in form and feeling and they fit harmoniously with most other furniture styles. Probably no style of furniture has had a greater or more lasting influence than the Windsor.

The best of American Windsors are quaint, light, strong, portable, and remarkably comfortable. They are attractive from any angle, even from the back (which cannot be said of most other furniture styles). Their history is currently being augmented because of a resumption of interest and a renewed appreciation of the style. Many amateur and professional furniture artisans have challenged the basic Windsor chair of sticks and plank seat and have come up with remarkably successful beautiful interpretations. Three interpreters who come to mind are Henry Hobson Richardson (1836–1886), architect and designer of furniture and furnishings for public buildings; George Nakashima (1905–1990), furniture designer; and Sam Maloof (1916– ), a contemporary furniture designer and producer.

# COMB-BACK SIDE CHAIR

MIXED WOODS

CIRCA 1790

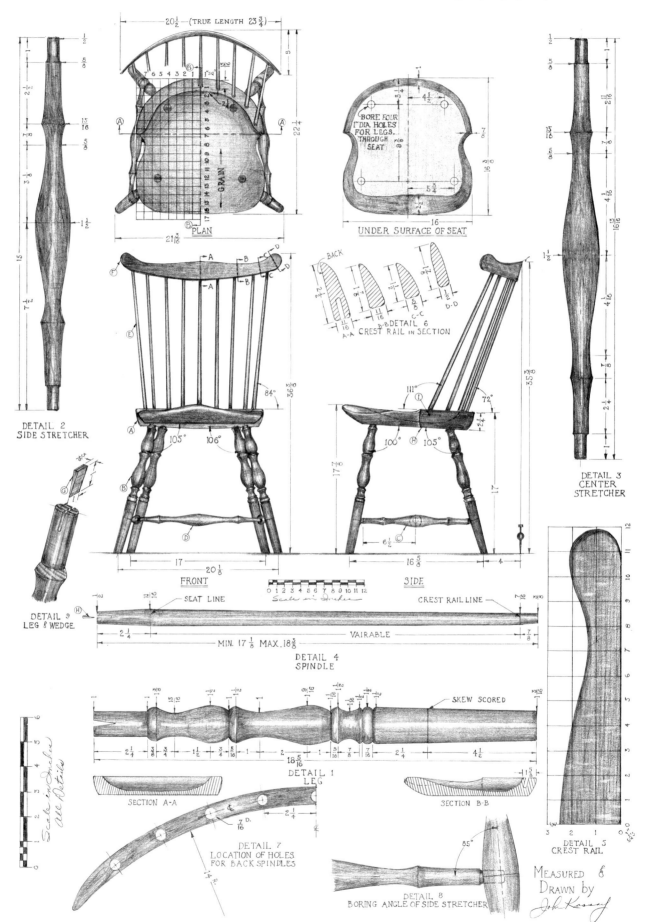

PLAN

UNDER SURFACE OF SEAT
BORE FOUR 1" DIA HOLES FOR LEGS THROUGH SEAT

DETAIL 2
SIDE STRETCHER

DETAIL 3
CENTER STRETCHER

BACK

A-A DETAIL 6
B-B CREST RAIL IN SECTION
C-C
D-D

FRONT

SIDE

DETAIL 9
LEG & WEDGE

SEAT LINE
CREST RAIL LINE
Scale in Inches
VAIRABLE
MIN. 17 1/8 MAX. 18 3/8
DETAIL 4
SPINDLE

SKEW SCORED

DETAIL 1
LEG

SECTION A-A

SECTION B-B

Scale in Inches all Details

DETAIL 7
LOCATION OF HOLES
FOR BACK SPINDLES

DETAIL 8
BORING ANGLE OF SIDE STRETCHER

DETAIL 5
CREST RAIL

MEASURED &
DRAWN by
John Kassay

# 1   Comb-Back Chairs

All the spindles in the backs of comb-back chairs are similar in size and shape and are capped with a horizontal crest rail (or crest board) which gives the back a comblike form and accounts for their name. The spindled backs on comb-back chairs also lack the flanking stiles that are found on fan-back chairs. Comb-back chairs are also called "high" or "low" backs.

The first American-made Windsor chairs were comb-back armchairs produced in Philadelphia around 1725.[1] Referred to throughout the colonies as "Philadelphia Chairs," they quickly became popular and a great number were turned out in several different shops.[2] Many splendid comb backs were also produced in neighboring Berks, Bucks, Chester, and Lancaster counties and shipped to other colonies.[3]

The large well-saddled seat, tall wrap-around back-supporting spindles, and arm-supporting arm rail, along with good seat height and well-splayed legs, contributed to the comfort of the Philadelphia comb-back armchairs. Indeed, of the different Windsor chair forms, these were probably the most comfortable. Comb backs are light yet strong, relatively easy to make, and inexpensive. They largely replaced the market for the more expensive slat-back rush-bottom chair.

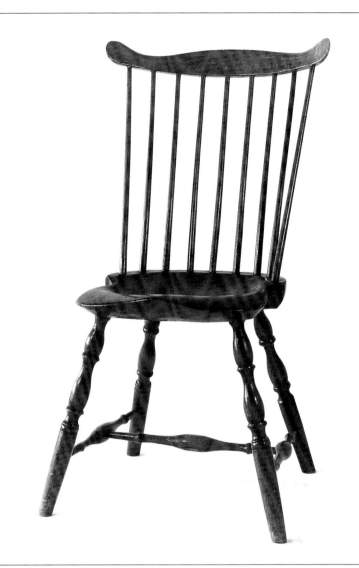

## 1. Comb-Back Side Chair

Eastern Connecticut, about 1790

Maker unidentified

Seat—pine; legs, side stretchers—maple; center stretcher—chestnut; spindles—hickory; crest rail—red oak. Red maple varnish stain covers traces of original green paint.

Author's

H 36⅛, W 21³⁄₁₆, D 22¼

| Letter | No. | Name | Material | T. | W. | L. |
|--------|-----|------|----------|-----|-----|-----|
| A | 1 | seat | pine | 2¼ | 16 | 16⅜ |
| B | 4 | legs | maple | 1⁹⁄₁₆ dia. | | 18³⁄₁₆ |
| C | 2 | side stretchers | maple | 1½ dia. | | 15 |
| D | 1 | center stretcher | chestnut | 1½ dia. | | 16¹³⁄₁₆ |
| E | 9 | spindles | hickory | ¹¹⁄₁₆ dia. | | 18⅜ |
| F | 1 | crest rail | red oak | ¹¹⁄₁₆ | 2½ | 23¾ |
| G | 4 | leg wedges | maple? | ³⁄₁₆ | 1 | 1 |
| H | 3 | spindle wedges | maple? | ⅛ | ½ | ½ |
| I | 3 | seat pins | maple? | ⅛ dia. | | 1½ |

The features of this comb-back side chair are extremely rare. Only two chairs of its kind are known to exist and they probably came from the same shop.[4] The large uncarved upturned ears on the crest rail and the leg turning pattern are Connecticut forms. Interesting features and construction details include the evenly tapered back spindles, which all go through the seat. On this chair, all the spindles are pinned. (Typically only the outer spindles penetrate the seat and are pinned from the back.)

The shield-shaped seat is exceptionally handsome with a deeply carved center that emphasizes the high pommel and contributes to its comfort. The edges are sharp with heavy underbeveling. The leg turnings, although somewhat heavy, are crisp and skillfully executed. They have great splay, are tenoned-wedged to the seat, and hold three rather plain stretchers, notable only for their so-called arrow-end turning.

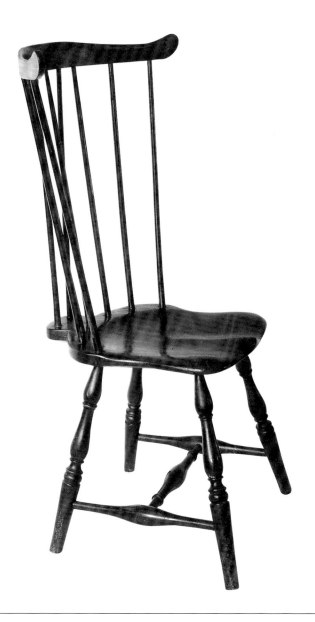

## 2. Braced Comb-Back Side Chair

Probably New Jersey or Pennsylvania, about 1800

Maker unidentified

Seat—tulip poplar; legs, stretchers—maple; spindles, crest rail—white oak. Black paint covers original brown maple stain.

Mahlon and Isabel Pool

H 42, W 23½, D 20¾

| Letter | No. | Name | Material | T. | W. | L. |
|--------|-----|------|----------|-----|-----|-----|
| A | 1 | seat | tulip poplar | 1⅜ | 16⅛ | 20 |
| B | 4 | legs | maple | 1⅝ dia. | | 17¹¹⁄₁₆ |
| C | 2 | side stretchers | maple | 1¹¹⁄₁₆ dia. | | 14⅞ |
| D | 1 | center stretcher | maple | 1¾ dia. | | 16⅜ |
| E | 7 | back spindles | white oak | ⅝ dia. | | 24 |
| F | 2 | bracing spindles | white oak | ⅝ dia. | | 24½ |
| G | 1 | crest rail | white oak | ⅝ | 2⅝ | 29½ |
| H | 2 | wedges | maple | ⅛ | ⅝ | ½ |

Braced comb-back side chairs are another rare Windsor chair form. Only five examples similar to this chair have been identified to date. Three have been published.[5] They are unusual variants and were made in two different shops during the latter part of the eighteenth-century, possibly on special order or as experiments to be added to the establishments' inventory. This chair is atypical in that it has a long crest rail, seven exceptionally long back spindles, which give the chair a very tall back, a shovel-shaped seat, and an unnecessarily wide, unattractive tail piece.

The tail piece is an extension of the seat and holds two bracing spindles. The bracing spindles contribute less strength to the back than if they had they been angled outward. Also noteworthy are the substantial baluster-style legs that are socketed to the very thin seat. The hollowed-out area is especially thin and to have produced it without breaking the seat must have challenged its maker.

# BRACED COMB-BACK SIDE CHAIR CIRCA 1800

MIXED WOODS

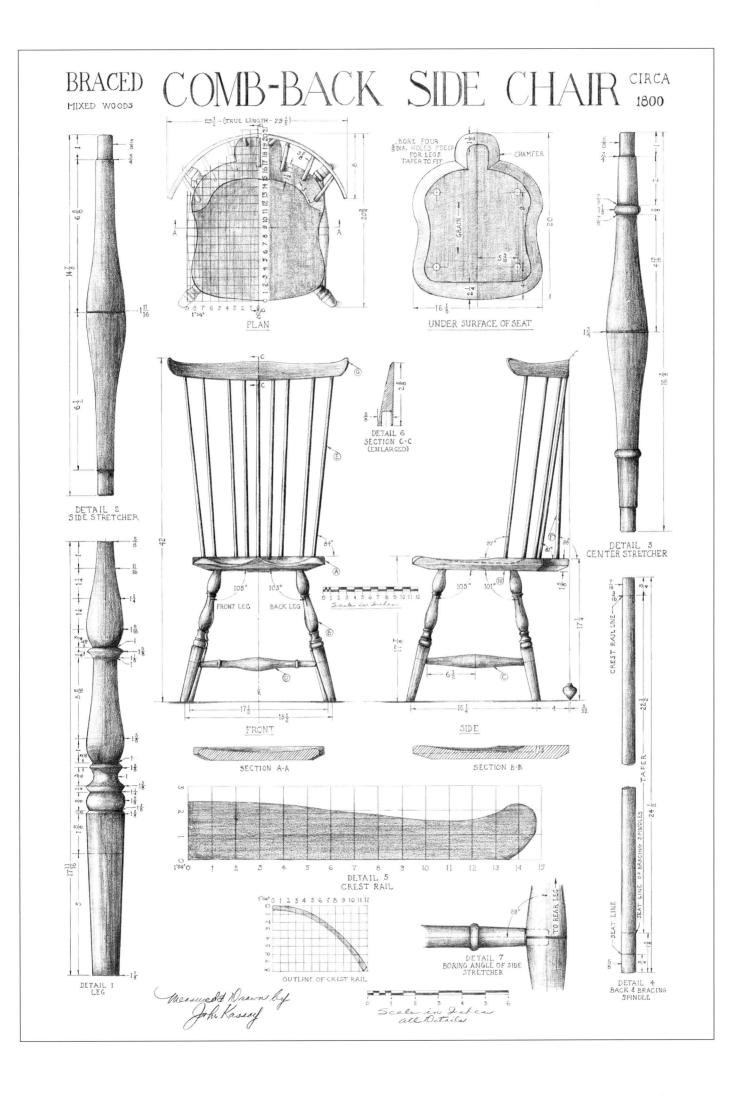

PLAN

UNDER SURFACE OF SEAT

BORE FOUR ¾ DIA. HOLES 1"DEEP FOR LEGS TAPER TO FIT

CHAMFER

GRAIN

DETAIL 2
SIDE STRETCHER

DETAIL 1
LEG

DETAIL 6
SECTION C-C
(ENLARGED)

FRONT

SIDE

SECTION A-A

SECTION B-B

FRONT LEG    BACK LEG

DETAIL 5
CREST RAIL

OUTLINE OF CREST RAIL

DETAIL 7
BORING ANGLE OF SIDE STRETCHER

TO REAR LEG

DETAIL 3
CENTER STRETCHER

DETAIL 4
BACK & BRACING SPINDLE

CREST RAIL LINE
TAPER
SEAT LINE OF BRACING SPINDLES
SEAT LINE

Scale in Inches

Scale in Inches
all Details

Measured & Drawn by
John Kassay

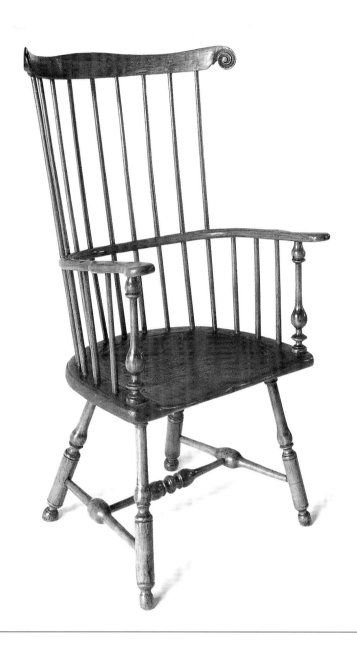

## 3. Comb-Back Armchair

Philadelphia, about 1760

Maker unidentified

Seat—pine; legs, stretchers, arm supports—maple; spindles, arm rail, crest rail—hickory. Varnish over unidentified paint particles.

Dr. Donald Bond

H 43¾, W 25, D 24¼

Features that make this a classic early Philadelphia comb-back chair are the tall wraparound supporting back, large, D-shaped, deeply saddled seat, and the well-splayed legs, carved voluted ears, side-scrolled hand holds, and the beautifully designed, well-integrated, skillfully executed turnings. Two minor design flaws are the unnecessarily wide crest rail and the thick arm rail.

| Letter | No. | Name | Material | T. | W. | L. |
|--------|-----|------|----------|-----|-----|-----|
| A | 1 | seat | pine | 2 | 23¾ | 17 |
| B | 4 | legs | maple | 1¹¹⁄₁₆ dia. | | 18 |
| C | 2 | side stretchers | maple | 1⅞ dia. | | 15 |
| D | 1 | center stretcher | maple | 1¹¹⁄₁₆ dia. | | 17¾ |
| E | 9 | back spindles | hickory | ⁹⁄₁₆ dia. | | 27¾ |
| F | 6 | arm spindles | hickory | ⁹⁄₁₆ dia. | | 12⅛ |
| G | 2 | arm supports | maple | 1¹¹⁄₁₆ dia. | | 13⅜ |
| H | 1 | arm rail | hickory | 1 | 1⅜ | 51⅛ |
| I | 2 | applied scrolled hand hold | hickory | 1 | 1⅜ | 7¾ |
| J | 1 | crest rail | hickory | ¹¹⁄₁₆ | 2¹¹⁄₁₆ | 32 |
| K | 4 | seat wedges | maple | ⅛ | 1 | ¾ |
| L | 2 | arm support wedges | maple | ⅛ | ½ | ⅝ |
| M | 6 | arm spindle wedges | maple | ⅛ | ½ | ½ |
| N | 3 | crest rail pins | maple | ⅛ dia | | ⁹⁄₁₆ |

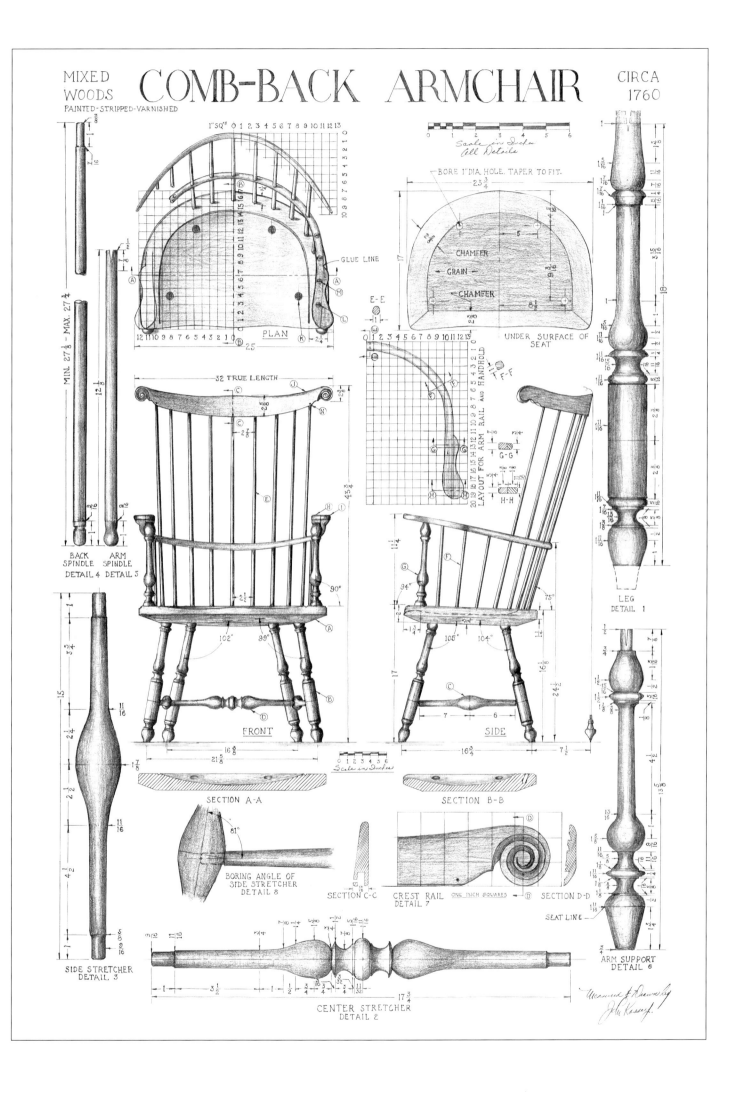

# COMB-BACK ARMCHAIR

MIXED WOODS
PAINTED-STRIPPED-VARNISHED

CIRCA 1760

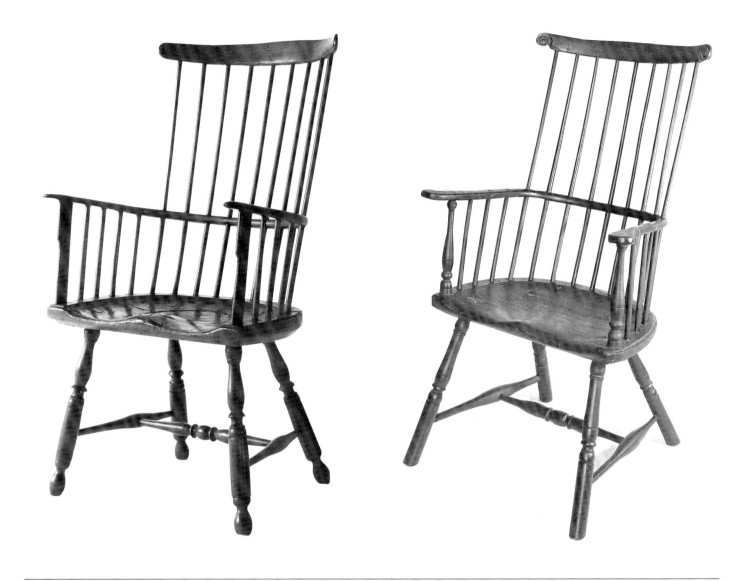

## 4. Comb-Back Armchair

Philadelphia or New Jersey, about 1745

Maker unidentified

Seat—pine; legs, stretchers—ash; spindles, arm rail, crest rail—hickory; arm supports—maple. Clear varnish over stripped green over red paint.

Blue Candlestick Antiques

H 43, W 24⅜, D 24

The English influence is very evident in this American-made comb-back armchair. The straight, earless crest rail, the tapered unscrolled arm rail, the flat board arm supports, the parallel paired cove cuts in the seat, and the turning pattern on the center stretcher are forms derived from early English Windsors. The chair is a historically important piece.[6] Unfortunately, long ago it was converted into a commode but, interestingly, the cut-out part was retained and has been reinstalled.

## 5. Comb-Back Armchair

Philadelphia, about 1750

Possibly Thomas Gilpin

Seat—poplar; legs, stretchers, arm supports—maple; spindles, arm rail, crest rail—hickory. Black over green paint.

Bernard and S. Dean Levy, Inc., New York

H 43¼, W 26¼, D 15¾

Photo: Helga Photo Studios

The earliest documented American Windsor chairs are a few branded examples made in Philadelphia by Thomas Gilpin (1700–1766).[7] Although it lacks Gilpin's brand, this comb back has many features similar to those found on Gilpin chairs: nonelevated ears on a thin-to-thick crest rail, slightly tapered spindles, urn-shaped turnings, large straight foot turnings, flat sausage-shaped turnings on the center stretcher, paired gouge-cut coves on the D-shaped seat, and off-center side stretchers. The straight foot turning was briefly used as a leg pattern.[8]

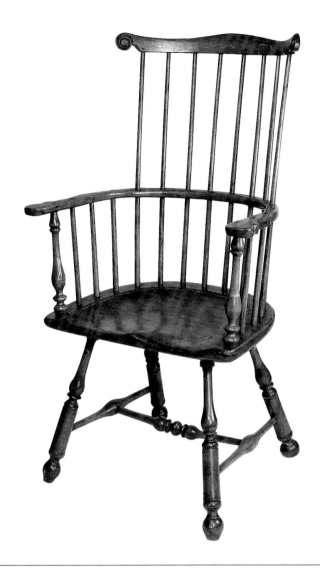

## 6. Comb-Back Armchair

Philadelphia, about 1770

Maker unidentified

Seat—pine; legs, stretchers, arm supports—maple; Crest rail, arm rail—hickory. Natural wood finish—never painted.

Private collection

H 45, W 23 at seat

Photo: Helga Photo Studios

Early Philadelphia comb-back chairs, those with cylinder and ball feet, had nine back spindles. This graceful chair, however, has eight. The chair may have been made on special order or as a prototype. If that were the case, it proved to be a not well-accepted variant and is quite possibly the only one of its kind. This is unfortunate because it is an exceptionally beautiful chair—a classic example of the chairmakers' art.

The overall proportions of the chair are excellent and its features are beautifully integrated. The narrow serpentine pattern crest rail ends in two complete carved spirals. The constant tapered spindles continue through the arm rail and into the D-shaped seat. The curves of the crest and arm rail are the same as its D-shaped seat. The six short arm spindles, also tapered, are the traditional number. All the spindles are attractively, uniformly spaced. The seat has a heavy undercut chamfer, a cove-cut upper edge that continues on the inside and isolates the flat spindle area from the carved seat part. The turnings are the work of a skilled artisan; their complex details are crisp and well matched. The arm-support pattern is mirrored in the upper portion of the legs and the cylindrical section of the legs are slightly concave, making them more interesting.

The pattern for the "stepped-back" off-center medial stretcher was adopted from Queen Anne and rush-bottom chairs.

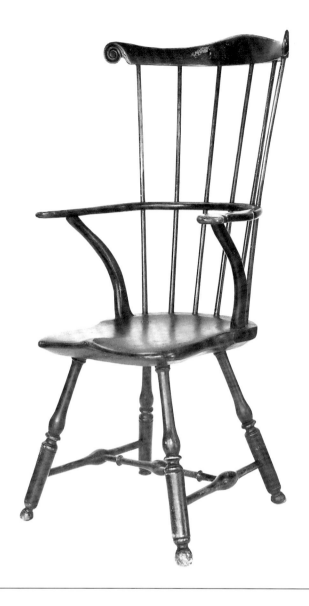

## 7. Comb-Back Armchair

Philadelphia, about 1760

Maker unidentified

Seat—poplar; legs, stretchers—maple; spindles—hickory; arm supports, arm rail, crest rail—oak. Late nineteenth-century dark green paint, over light green, over red undercoat

Sandra MacKenzie

H 43½, W 22, D 24

This chair is a charming example of a provincial comb-back Windsor variant.

The sawn rams'-horn arm supports and shovel-shaped seat are features found on early English Windsors.[9]

The crest rail has an inviting wraparound bend with a high peaked center, chamfered ears, and multispiral, skillfully carved volutes.

The six back spindles and each of the arm supports create a large void that gives the chair an unattractive open-airiness. Assembling the back spindles required holes of three different diameter in the seat, arm rail, and crest rail. Those in the arm rail had to be taper-reamed from the underside. The arm supports seem to leap forward and the heavy, boldly angled legs contribute strength and stability to the chair.

Both ends of the arm supports have shouldered tenons, the upper one is through-wedged to the bent scrolled arm while the lower one is stopped in the seat and pinned from the side. The seat is saddled with a slight pommel and was probably designed to hold a cushion.

The Philadelphia-style legs have attenuated balusters and are through-tenon-wedged to the seat. The baluster and ringed center stretcher is assembled to asymmetric bulbous side stretchers.

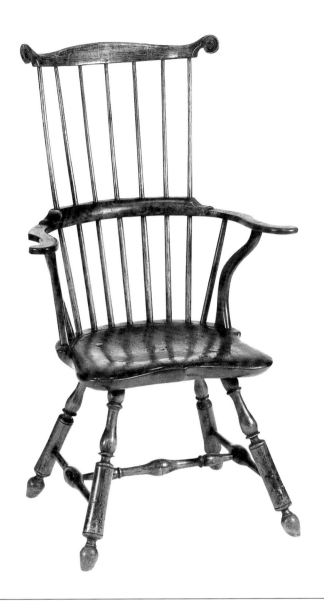

### 8. Comb-Back Armchair

Philadelphia, about 1765

Maker unidentified

Seat—tulip poplar; legs, stretchers, arm supports, arm crest—maple; arms, spindles, crest rail—hickory. Unidentified finish.

Milwaukee Art Museum, Gift of Miss Paula Uihlein

H 40¼, W 24¾, D 21

Photo: P. Richard Eells

On this chair the crest rail, rams'-horn arm supports, scrolled arms, and leg turnings are in the style of figure 7. In form, however, the chair is more urban and represents a new comb-back pattern.[10] It differs in the number of spindles (seven), a bolder shield-shaped seat, and a heavy sculptured three-piece arm rail. This sawn and carved arm rail is a style that came into its own with the development of low-back Windsors and was also used on sack backs, writing-arm chairs, and settees. On Philadelphia sawn-arm Windsors, the ends of the arms butt against a shoulder cut on the underside of the crest rail. On the Rhode Island style (see fig. 11), the ends of the arms butt and the crest rail caps the arms, making it an easy joint to fabricate.

Holes of three different diameters were required to assemble the back spindles on this chair; holes in the arm crest also had to be tapered to produce a good fit. The seat is nicely saddled and has a moderate pommel accentuated by an unusual projection that continues down the large chamfered edge. In plan, the outline of the front edge forms a cupid's bow. The side stretchers are plain with off-center swellings and the center stretcher, also swelled, has flanking rings and small baluster ends. The chair legs have a compressed baluster and a concave cylinder; forms that complement the other turning details are the narrow neck above the foot and the slender reel above the cylinder.

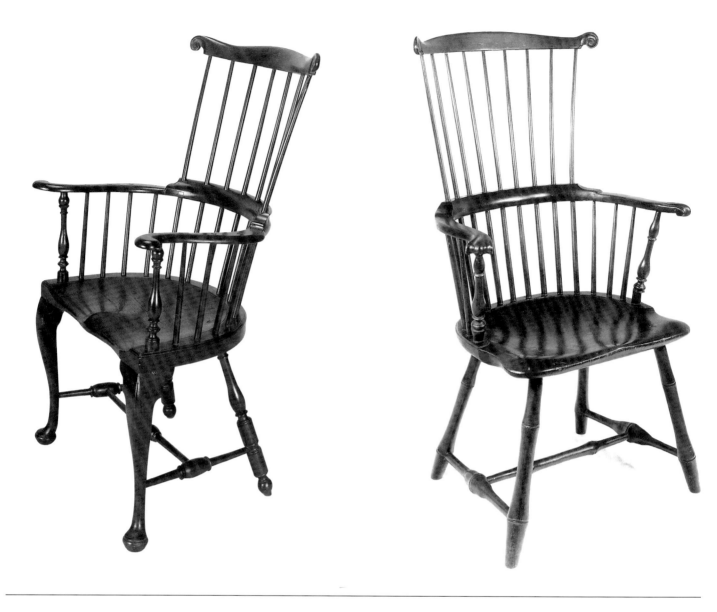

## 9. Comb-Back Armchair

Philadelphia, about 1765

Maker unidentified

Walnut. Natural patina

The Art Institute of Chicago, Gift of Mrs. Christopher Brown, Marshall Field, Mrs. Harold T. Martin, Mrs. Alex Vance, and Mary Weller Langhorne Fund, 1979.22

H 43, W 23⅞, D 17

Photo: Courtesy, The Art Institute of Chicago © 1989

English chairmakers occasionally made Windsors entirely of mahogany, probably on special order for wealthy patrons;[11] those chairs, however, may never have been sent to the colonies. This Philadelphia-made comb-back armchair is unique because it is made totally of walnut and has features similar to those found on English high-style and Windsor furniture. The cabriole legs and ornate turnings on the stretcher are patterns that were used on

English Windsors. An advertisement placed in the Charleston (South Carolina) *Gazette* (June 23, 1766) by local merchants Sheed and White is believed to be the first reference to the manufacture of American (Philadelphia) Windsors made of walnut.[12] The chairs were marketed locally and shipped in coastal trade but failed as an attempt to bring the Windsor style into a higher economic market.[13] This chair, possibly the sole representative of that advertisement, is a fine example of the chairmakers' art and demonstrates the collective efforts of three master craftsmen: a skilled turner, an accomplished carver, and a careful joiner/assembler. The chair features lathe-turned spindles and a crest rail sawn and carved from a solid block of walnut.[14] The three-piece sawn and shaped arms and arm crest, the turned arm supports, the D-shaped and saddled seat, the turned baluster and cylinder back legs are all in the Philadelphia Windsor style.

## 10. Comb-Back Armchair

Philadelphia, about 1786

John Lambert (1760?–1793)

Seat—poplar; legs, stretchers—maple; crest rail, spindles—ash; arms, arm crest—mahogany. Painted black—excluding arm rail.

Bernard and S. Dean Levy, Inc., New York

H 42½, W 26, D 17½

Photo: Bernard and S. Dean Levy

The name John Lambert is labeled and stamped on the underside of the seat of this comb-back chair. Lambert, a Quaker, was only thirty-three when he died, but in his brief lifetime he established himself as an important manufacturer of Windsor chairs and settees. He advertised his Windsors were available in nine different patterns and that his shop was equipped with "3 machines for letting in feet with propriety and dispatch."[15] Obviously these machines were used to bore leg holes in seats and other chair parts. This chair is an

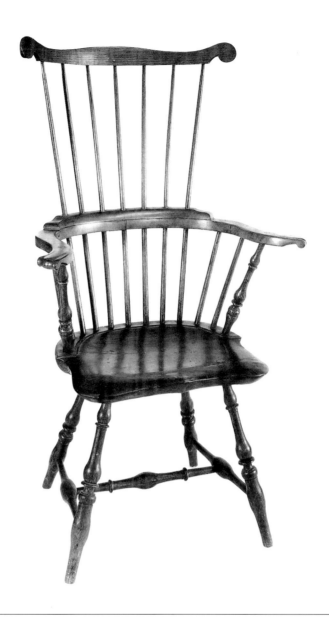

example of the comb-back style in transition, and all the parts above the seat are examples of traditional forms. The shield-shaped seat gained favor over the earlier D pattern and the quicker and easier to produce double-bobbin bamboo-style turnings on the undercarriage replaced the cylinder and baluster designs. Bamboo-style turnings were introduced in the 1780s in response to the public's growing interest in the Orient. Eventually they were used on every form of Windsor seating. The mahogany arms are another interesting example of a fine cabinet wood used as a functional decorative accent.

## 11. Comb-Back Armchair

Rhode Island, about 1780

Maker unidentified

Seat—pine; legs, stretchers, arm supports—maple; arms, arm crest—maple. Varnish over traces of red and green paint

Pocumtuck Valley Memorial Association, Memorial Hall Museum, Deerfield, Massachusetts

H 43¼, W 26, D 24

This chair is a Rhode Island interpretation of a sawn-arm comb back. Two pronounced features establish the origin of the chair: the turning pattern of the legs and the structural manner in which the arms and arm crest are assembled. The leg style was a new one at this time and was a modification of the baluster form. It was used extensively on bow-back armchairs, less on sack backs, and rarely on comb backs and continuous-bow armchairs. The turning details from the small shoulder

upward are typical double baluster, while from the shoulder downward a large bead surmounts a dual concave tapered leg, a turning favored by Rhode Island artisans. As previously mentioned, the arms on Rhode Island chairs meet at the center and are capped with a crest rail (see fig. 8). The arms on this chair were sawn from boards at least eight inches wide and the arm crest was shaped from a very wide, thick board. The knuckle hand holds on the scrolled arms were carved completely out of the arms, without applied pieces that would have given them much needed fullness. However, to accentuate them, the carvings are preceded with undercuts. Undercutting was common, done more to save time than material. Leaving the ears on the crest rail uncarved also saved time.

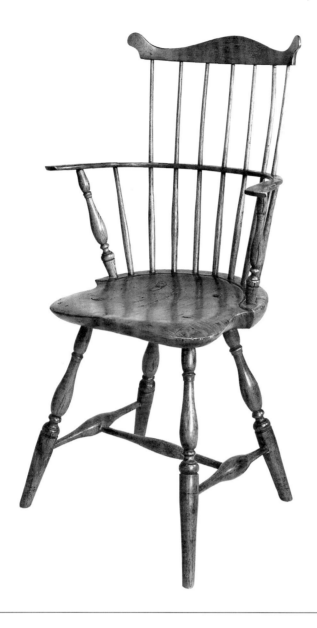

## 12. Comb-Back Armchair

Connecticut, about 1780

Maker unidentified

Seat, legs, stretchers, crest rail—maple;
arm supports, spindles, arm rail—hickory.
Unidentified finish.

Bernard and S. Dean Levy, Inc., New York

H 38, W 16, D 15½

Photo: Helga Photo Studios

In the later decades of the eighteenth
century, a significant number of distinc-
tively different Windsor comb-back arm-
chairs were produced, especially in New
England. This chair is a typical Connecti-
cut example. In contrast to Philadelphia
comb backs, the components above the
seat are more delicate. It is narrower; it is
shorter by as much as six inches; and the
shield-shaped seat is higher. The Connecti-
cut-style, wavy upper edge of the crest rail

ends in uncarved, upturned ears, the
slender spindles have a distinct swelling
below the arm rail, and the arm supports
and leg turnings have attenuated balusters.
The typical flaring, round-ended hand
holds have been squared off. The long leg
taper permitted the stretchers to be placed
higher.

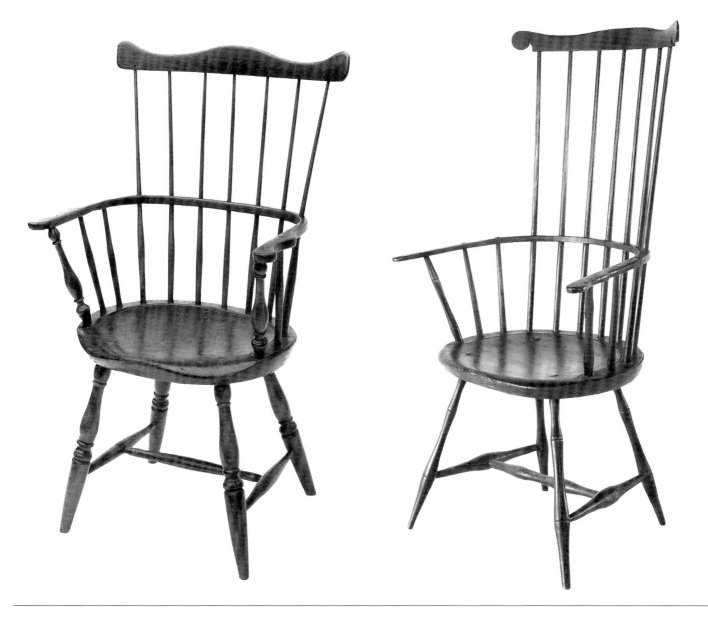

## 13. Comb-Back Armchair

New England, probably Connecticut, about 1790

Maker unidentified

Seat—pine; legs, stretchers, arm supports— maple; arms, crest rail, spindles—red oak. Red maple varnish stain over remnants of green paint

Donald Flynn

H 40, W 23½, D 18

The decline in the comb-back style is evident in this late period chair of moderate merit. Its positive features are its swelled tapered spindles, its crisp turning details on the well-matched arm supports, its adequately scooped seat, and its reduced, then increased, diameters near the ends of the medial stretcher. Less attractive features are the poorly shaped ears, the broad, weakly defined seat pommel, the abrupt side ramps, and the bulky leg turnings.

All the back spindles are pinned to the crest rail. The arm spindles and arm supports penetrate the arm rail and seat and are wedged. The legs do not penetrate the seat.

## 14. Comb-Back Armchair

Probably Pennsylvania, about 1800

Maker unidentified

Seat—pine; legs, stretchers, arm supports— maple; spindles, arm rail, crest rail—hickory. Recent black paint over original red.

Van Dusen Schuman Antiques

H 45½, W 26, D 21½

The simple lines of this well-proportioned late chair give it an open airy feeling while the well-splayed legs impart a sense of stability. The arm supports, legs, and center stretcher turnings are nicely matched. The legs penetrate the elliptical seat and are wedged. Decorative elements include turned-down ears on the mildly scalloped crest rail, scrolled hand holds in a thin narrow arm rail, and attractive double-bobbin bamboo turnings.

# BRACED COMB-BACK ARMCHAIR c 1790

LAYOUT of CREST-RAIL

GRAIN

PLAN

SEAT LAYOUT

ARM LAYOUT

SEAT BOTTOM

BEVELS

BORE FOUR HOLES, TAPER LEGS TO FIT.

DETAIL 1
TAIL PIECE
NOT TO SCALE

CREST RAIL IN SECTION

C-C

FRONT

B-B

A-A

DETAIL 4
ARM SUPPORT

GRADUAL CURVE

DETAIL 2
ARM SPINDLES

DETAIL 3
BACK & BRACING SPINDLES

22 11/16 TRUE LENGTH

25 5/8

45 1/2

72°

101°    105°

1 7/8

14

18 3/4

FRONT

Scale in Inches

26 1/4

78°

99°    106°

81°    78°

14 1/4    13 1/2

83°    89°

15 5/16    6 1/16

11 7/8

SIDE

SECTION D-D

SECTION E-E

DETAIL 7
BORING ANGLE
OF SIDE STRETCHER

97°

CREST RAIL LAYOUT

DETAIL 5
LEG

17

DETAIL 6
SIDE STRETCHER

13 7/8

11/16

DETAIL 8
CENTER STRETCHER

14 7/8

Scale in Inches all details

MEASURED & DRAWN by
John Kassay

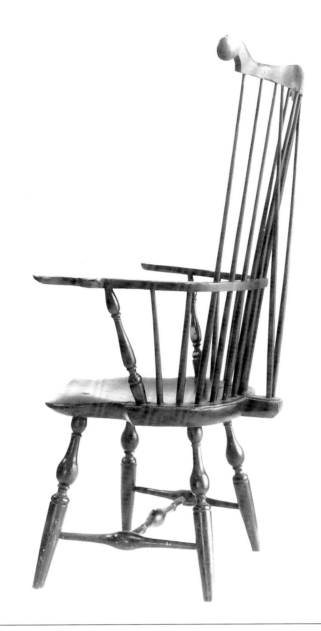

## 15. Braced Comb-Back Armchair

Probably Massachusetts, about 1790

Maker unidentified

Seat—pine; legs, stretchers, arm supports—maple; spindles, arm rail, crest rail—hickory. Recent touch-up black paint over early black over red.

Munson-Williams-Proctor Institute

H 43½, W 25⅝, D 21¾

Photo: Munson-Williams-Proctor Institute

| Letter | No. | Name | Material | T. | W. | L. |
|---|---|---|---|---|---|---|
| A | 4 | legs | maple | 1¹⁵⁄₁₆ dia. | | 17 |
| B | 1 | seat | pine | 1¾ | 17 | 20¾ |
| C | 2 | arm supports | maple | 1³⁄₁₆ dia. | | 11⅞ |
| D | 2 | side stretchers | maple | 1¹¹⁄₁₆ dia. | | 13⅞ |
| E | 1 | center stretcher | maple | 1¹¹⁄₁₆ dia. | | 14⅞ |
| F | 4 | arm spindles | hickory | ⅜ dia. | | 11¼ |
| G | 9 | back spindles | hickory | ⅜ dia. | | 27¾ |
| H | 2 | bracing spindles | hickory | ⅜ dia. | | 27⁷⁄₁₆ |
| I | 1 | arm rail | hickory | ¾ | 2³⁄₁₆ | 45³⁄₁₆ |
| J | 1 | crest rail | hickory | ½ | 2½ | 22¹¹⁄₁₆ |

This beautifully proportioned braced comb-back armchair is relatively rare because of its bracing spindles. Bracing spindles were not considered structurally necessary and they were not usually incorporated in comb-back armchairs. It was generally thought that the circular steam-bent arm rail with forward-thrusting locked-in arm supports and arm spindles gave the backs enough support, although a few comb backs with bracing spindles do exist.

Bracing spindles aside, the chair merits high marks for these features: a wavelike scrolled crest rail with perked up ears; slightly bulbous tapered spindles; beveled side-scrolled hand holds; a well-saddled shield-shaped seat with a pronounced pommel; tapered stretchers with abrupt, enlarged centers (the center one is ringed); long, tapered, and exceptionally large bulbous turnings on the baluster legs; and the less-accomplished arm supports. The sum of its parts makes this chair a Windsor masterpiece.

# LOW-BACK

MIXED WOODS

CIRCA 1750

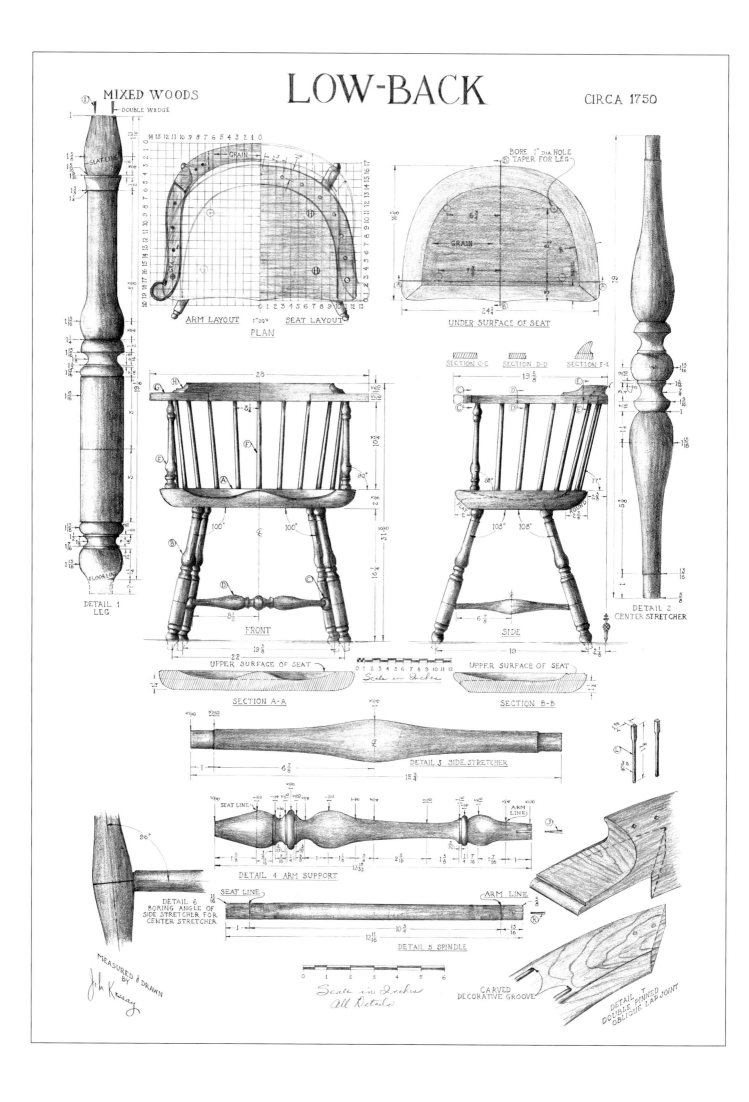

ARM LAYOUT    SEAT LAYOUT

PLAN

UNDER SURFACE OF SEAT

DETAIL 1
LEG

DETAIL 2
CENTER STRETCHER

SECTION C-C    SECTION D-D    SECTION E-E

FRONT

SIDE

UPPER SURFACE OF SEAT    UPPER SURFACE OF SEAT

Scale in Inches

SECTION A-A    SECTION B-B

DETAIL 3  SIDE STRETCHER

DETAIL 4 ARM SUPPORT

DETAIL 6
BORING ANGLE OF
SIDE STRETCHER FOR
CENTER STRETCHER

SEAT LINE    ARM LINE

DETAIL 5 SPINDLE

MEASURED & DRAWN
BY
John Kassay

Scale in Inches
All Details

CARVED
DECORATIVE GROOVE

DETAIL 7
DOUBLE PINNED
OBLIQUE LAP JOINT

# 2  Low-Back Chairs

## Introduction

Not too long ago furniture scholars writing about Windsors suggested that the low back was the first American Windsor style made. Recent research has established that the low back was introduced in Philadelphia after the comb back,[1] although both chair styles were soon produced simultaneously and in the same shops.

All low backs are armchairs and they are the only Windsor chairs without bent parts. They were patterned after the roundabout or corner chairs that were made first in England and then later in the colonies. In England, because they were formal chairs, the roundabouts were made in walnut or mahogany in the Queen Anne style. Those with deep aprons had slip seats, which served as commodes in bedrooms, and were called "close stools." Comb- and fan-back Windsors were also modified into "potty chairs" by cutting a hole in the plank seat (see fig. 4). The distinguishing feature of low-back chairs is the heavy three-piece U or horseshoe-shaped sawn arm rail and the numerous short spindles that support the rail. The same pattern arm rail was also used on comb-back Windsors (see figs. 8-11) and on earlier English and American roundabout and corner chairs. English influence can be seen in decoratively turned Queen Anne medial stretchers and D-shaped seats. As with comb backs, the medial stretchers on early low backs were also assembled off center, that is, closer to the rear of the chair. On later chairs they were installed on center.

Most low backs were made with D-shaped seats, although a few later examples have elliptical seats. Attractive variants were made in Rhode Island with pipestem-turned spindles and elaborately detailed turned legs. Equally decorative are the turned side stretchers, a pattern derived from period New England roundabouts and corner chairs.[2] By progressively increasing the length of the seats and backs they became double chairs and, later, with more legs and stretchers, settees.

Low backs are heavy, strong chairs that lend themselves for use in and about private residences and public buildings. With the advent of mass-produced machine-made Windsors, the low back degenerated into the so-called firehouse and captain style chairs, and they have remained popular to the present day.[3]

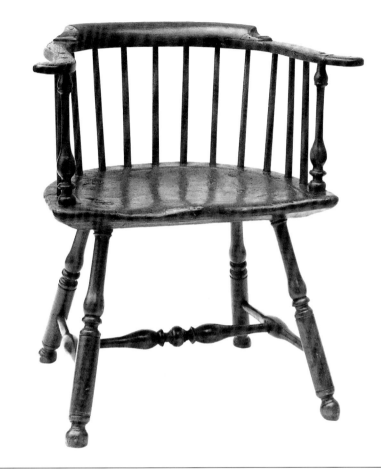

| Letter | No. | Name | Material | T. | W. | L. |
|---|---|---|---|---|---|---|
| A | 1 | seat | walnut | 2⅜ | 16⅝ | 24¾ |
| B | 4 | legs | maple | 1¹³⁄₁₆ dia. | | 19⅛ |
| C | 2 | side stretchers | maple | 1¾ dia. | | 15¾ |
| D | 1 | center stretcher | maple | 1¹³⁄₁₆ dia. | | 19 |
| E | 2 | arm supports | maple | 1⅝ dia. | | 13¼ |
| F | 13 | spindles | hickory | ¹¹⁄₁₆ dia. | | 12¹¹⁄₁₆ |
| G | 2 | arms | red oak | ¹⁵⁄₁₆ | 4⅝ | 19¹¹⁄₁₆ |
| H | 1 | crest rail | maple | 2¼ | 6³⁄₁₆ | 22 |
| I | 8 | leg wedges | maple | ⅛ | 1 | 1 |
| J | 2 | arm support wedges | maple | ⅛ | ⅜ | 1 |
| K | 4 | 2 outer spindle wedges each side | maple | ⅛ | ⅜ | 1 |
| L | 4 | pins | maple | ¼ | ¼ | 1⅞ |

## 16. Philadelphia Low-Back Chair

Philadelphia, 1750

Maker unidentified

Seat—walnut; spindles—hickory; arms—red oak; all other parts—maple. Originally painted green, traces of black, light green, and white remain. Recently refinished with brown stain, waxed.

Mr. and Mrs. Matthew Young

H 31⅜, W 28, D 22

A thick, very wide piece of wood was needed for the crest rail on this low back. Making it involved considerable hand work and, due to its intricate shape, it became more difficult to hold the piece properly as more wood was removed to arrive at the final form. A special holding device was no doubt designed when several of these chairs were ordered.

The size of the parts on the chair convey a sense of strength, sturdiness, and durability. After more than two centuries, the chair is still sound and steady. The ball feet, half of which have been worn away, show signs of considerable use.

The elegantly light arm-support turnings contrast dramatically with the heavy legs and the elaborate details on the center

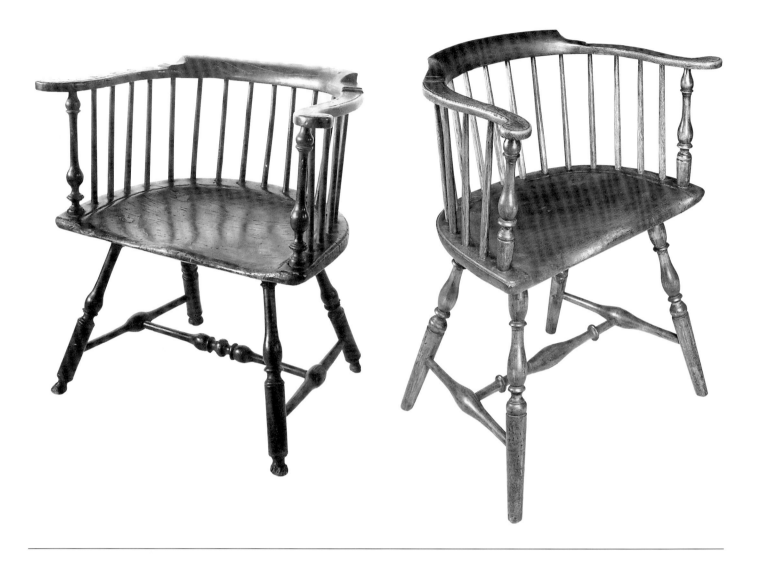

stretcher are pleasingly dissimilar to the plain side stretchers.

The seat is exceptionally thick. It is made of walnut burl, a wood species and grain pattern rarely used for Windsor seats.

The chair is assembled with both socketed and through tenons. All the through tenons are single wedged, while the large leg tenons are double wedged. The wide leg stance is an additional asset for a very handsome low back.

## 17. Philadelphia Low-Back Chair

Philadelphia, 1760

Maker unidentified

Seat—pine; legs, stretchers, crest rail, arm support—maple; arms, spindles—oak. Old dark green paint over original lighter green.

Dr. Donald Bond

H 27⅜, W 27¾, D 21¼

This Philadelphia low back was made slightly later than figure 16, but is equally attractive. The turnings are not as heavy as

the earlier chair, but they are well executed. The long thin tapered columns below the ring turnings on the arm supports and legs are especially pleasing. The leg cylinders are slightly concave, a feature found on some Philadelphia comb backs (see fig. 8) and possibly unintentional. The side stretchers are a poor match; the right one is thicker and may be a replacement. The seat is heavily beveled and has seat grooves and single-wedged leg tenons. The arms and arm crest are sawn, shaped, and assembled in the manner of other Philadelphia-made low backs.

## 18. Philadelphia Low-Back Chair

Probably Pennsylvania, about 1764

Maker Unidentified

Seat—pine; legs, stretchers, arm supports, arm crest—maple; arms, spindles—ash. Unidentified finish.

Bernard and S. Dean Levy, Inc., New York

H 29, W 26½, D 14¾

Photo: Helga Photo Studio

This low back is similar to but much lighter than the two earlier Philadelphia examples.

The side-scrolled arms, plain spindles, and D-shaped seat are Philadelphia patterns, whereas the baluster-style arm supports, legs, and ringed medial stretcher are forms adopted from the emerging fan-back style.

The arm crest barely laps the end of the arms near a spindle hole, and although the chair has survived many years of use, this construction feature must be considered a design flaw. It would have been more

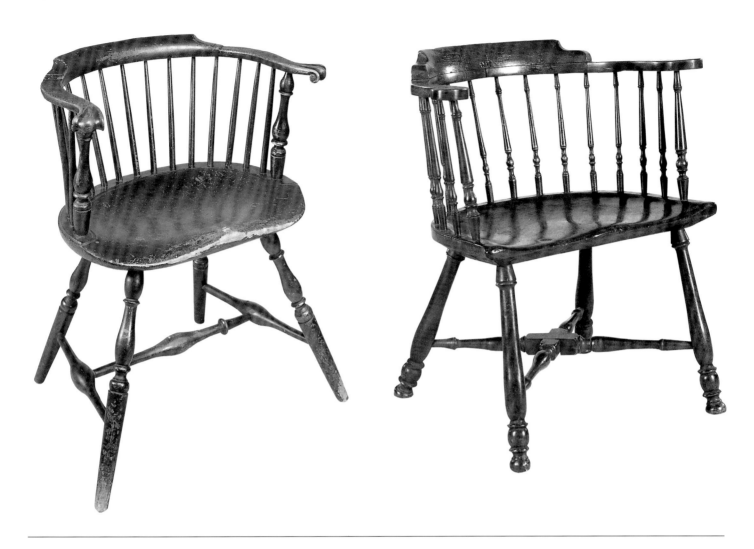

reliable to have used a wider board for the arms, which would have allowed for a longer lap and made it possible to locate the ends farther away from the spindle hole.

## 19. Philadelphia Low-Back Chair

Pennsylvania, about 1765

Maker unidentified

Seat, arm crest—poplar; legs, stretchers, arm supports—maple; arms, spindles—ash. Brown paint covers early green.

Bernard and S. Dean Levy, Inc., New York

H 28½, W 25½, D 16¾

Photo: Helga Photo Studio

Except for the carved knuckle hand holds and the oval seat, this chair closely matches the previous example. It probably was made in the same shop and within the same period. Neither chair is marked, however their points of similarity include their turning patterns, number of spindles, through-tenon-wedged legs, seat grooves,

and the potentially weak arm-to-crest-rail joint. This joint alone is evidence enough to assign the same origin to the two chairs.

The knuckle hand holds on the chair are undercut and have applied pieces on their underside which give greater fullness to the knuckles—an attractive detail to a nice chair.

## 20. Rhode Island Low-Back Chair

Rhode Island—probably Newport, 1770

Maker unidentified

Probably maple. Painted, probably black.

The Metropolitan Museum of Art, Gift of Mr. and Mrs. Henry Sherman, 1967 (67.260.3)

H 26⅞, W 25½, D 18⅜

Photo: The Metropolitan Museum of Art

When it came to designing low backs, Rhode Island craftsmen marched to a different drummer. Very little Pennsylvania influence shows in this Rhode Island product, although it has many English details. The side-scrolled arms, ornate

turnings, hardwood seat, lack of cove cuts on the seat, and arrow-ended cross stretchers are patterns found on both English and American roundabout chairs. Stylistically, this handsome chair is less formal than roundabouts.

On Rhode Island low-back Windsors a hardwood (usually maple) was used throughout. Shaping and saddling a seat out of maple was not easy. Interesting features of the chair are the unmolded ends on the arm crest rail, pipestem-turned spindles with matched leg turnings, socketed tenons on the arm supports and legs, and the X stretcher (in place of the typical H stretcher). The arms and crest rail are assembled in typical Rhode Island fashion, that is, the arms butt at the center and are capped by the crest rail.

# 3 Fan-Back Chairs

## Introduction

Fan-back chairs represent a distinctive style change in American Windsor chair forms. The first American fan backs were made in Philadelphia just before the outbreak of the Revolutionary War (1775). They are, however, largely a postwar product, one that developed out of the tall comb-back style, but with antecedents in English fan backs. American chairmakers omitted the English splat, board stiles, and cabriole legs, using instead round stiles, Pennsylvania cylinder blunt-arrow style legs, which phased into baluster-tapered legs, and, later, New England bamboo patterns. The English shield-shaped and round seats were retained, but in oval form; the rare D-shapes were also used.

The principal design element that separates fan-back chairs from other Windsors is the two decoratively turned stiles. These stiles (also called posts) flank a number of tapered back spindles, which can be as few as five and as many as eleven on braced backs. All are surmounted by a bent crest rail, which is the only bent part on a fan-back chair. Additionally, on fan backs with arms, the arms terminate at the stiles, where they are securely joined, usually with wood screws and pins. This arm-to-stile construction method was also used on other later Windsor seating forms, for example, fan-back rocking chairs and fan-back settees.

Four styles of fan-back chairs were manufactured: unbraced and braced side chairs and unbraced and braced armchairs, with the latter the most desired, probably because they were the most durable and comfortable of the line.

Fan backs were popular for about sixty years and were produced in great numbers, as were comb backs, in Pennsylvania and throughout New England (but not in New York). Their popularity may be because they were less provincial than comb backs, and thus appealed to an increasingly affluent population.

## 21. Fan-Back Side Chair

Lisbon, Connecticut, about 1807

Marked S. Tracy (1782–1866)

Seat—pine; legs, stretchers, stiles—maple; crest rail, spindles—white oak. Traces of brown, over red, over original green paint; all stripped clear, varnished, and waxed.

Donald Flynn

H 35, W 20½, D 21³⁄₁₆

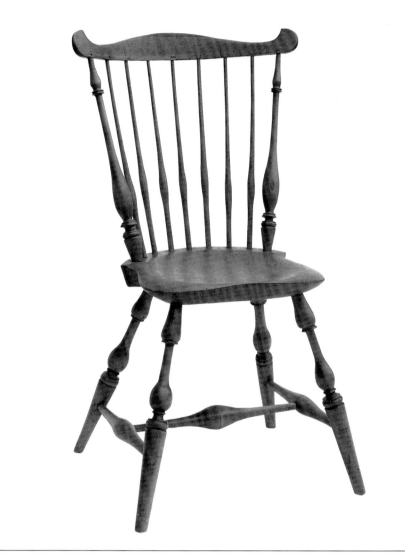

| Letter | No. | Name | Material | T. | W. | L. |
|--------|-----|------|----------|-----|-----|-----|
| A | 1 | seat | pine | 1⅞ | 15 | 16⅜ |
| B | 4 | legs | maple | 1¾ dia. | | 17⅞ |
| C | 2 | side stretchers | maple | 1⁹⁄₁₆ dia. | | 14 |
| D | 1 | center stretcher | maple | 2 dia. | | 16 |
| E | 2 | stiles | maple | 1½ dia. | | 19⅝ |
| F | 7 | spindles | white oak | ¾ dia. | | 18⅛ |
| G | 1 | crest rail | white oak? | ⁹⁄₁₆ | 2½ | 22¾ |
| H | 2 | wedges | maple | ⅛ | ½ | ¾ |
| I | 3 | pins | maple | ⅛ sq. | | ¹¹⁄₁₆ |

The letters S. Tracy are marked (not branded) on the underside of the seat of this fan-back side chair; however, in design and construction, the details are so similar to branded S. Tracy chairs that it is most likely the work of Steven Tracy, of Lisbon, Connecticut. Records are sketchy, but Steven probably served an apprenticeship under his uncle, Ebenezer Tracy, the patriarch of a Connecticut chairmaking family. For a number of years Steven was a member of the large Tracy household and engaged in the family's industry.

Ebenezer died in 1803 and Steven married Rebecca Tracy, his first cousin, in 1804. By the time he was twenty-one Steven was directing the family enterprises. For the benefit of the relatives, the first order of business after Ebenezer's death was the sale of a sizable stock of chairs and chair parts. "One hundred and three chairs of different sorts," were sold. "6400 chair rounds [stretchers and legs], and 277 chair bottoms [seats]" were readied for sale.[1]

When figured on the basis that seven rounds (four legs and three stretchers)

# MIXED WOODS CIRCA 1807 FAN-BACK SIDE CHAIR

BRANDED S. TRACY

(TRUE LENGTH 22⅝)—20½

SLIGHT OUTWARD CURVE

21¼

PLAN

UNDER SURFACE OF SEAT

4⅝
7" R
BEVEL
GRAIN
16⅜
8¼
3⅜
BORE 8 HOLE FOR 4 LEGS 1⅛ DEEP
7 DIA.
15
4⅞

DETAIL 1
LEG

1 DIA.

LAYOUT FOR CREST RAIL

81°
2⅜

105°    106°

107°
73°

106°  103°

74    77°

35

17⅜    15 1/16

18½

16¼    4 7/16

FRONT          SIDE

0 1 2 3 4 5 6 7 8 9 10 11 12
Scale in Inches

DETAIL 5
STILE

DETAIL 4
SPINDLE

TAPER — 5

1    5½    18⅛    11

SECTION B-B

SECTION A-A
¼ X 45° CHAMFER

SECTION C-C   SECTION D-D   SECTION E-E
DETAIL 6
CREST RAIL

MEASURED & DRAWN BY
John Kassay

0 1 2 3 4 5 6
Scale in Inches
all Details

DETAIL 7
WEDGE IN BOTTOM OF STILE

91°

DETAIL 8
BORING ANGLE OF SIDE STRETCHER

DETAIL 3
CENTER STRETCHER

DETAIL 2
SIDE STRETCHER

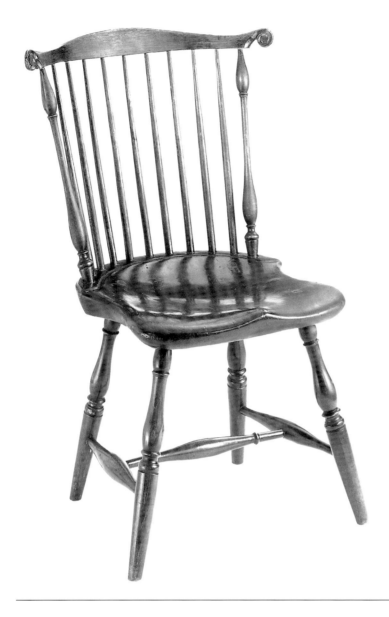

were needed for a single side chair, Tracy's stock of rounds was enough to make more than 900 chairs (less bottoms). How much of this inventory was used in producing assembled chairs is not known, but most likely this fan back is one of those made from this stock. Attractive features of this chair are the upturned pointed ears on the crest rail, which are different from the typical rounded-over Connecticut pattern; the complex, well-executed turning details on the stiles, and the nicely sculptured shield-shaped seat. Less attractive are the upper baluster turnings on the legs and the thin portion immediately below.

## 22. Fan-Back Side Chair

Philadelphia, about 1783

Branded F. [Francis] Trumble (1716–1798; worked 1741–1798)

Seat—yellow poplar; legs, stretchers, stiles—maple; crest rail—oak; spindles—hickory. Finish unidentified

The Henry Francis du Pont Winterthur Museum, Gift of Mr. and Mrs. David H. Stockwell

H 35¹³⁄₁₆, W(seat) 18½, D(seat) 19⁵⁄₁₆

Photo: Courtesy, Winterthur Museum

Through early newspaper advertisements and business records we learn something of Francis Trumble's versatility and entrepreneurial activities. Starting in the early 1740s and continuing for more than fifty years, Trumble was responsible for an extensive line of fine furniture in the Queen Anne, Chippendale, and Federal styles.[2]

He produced a variety of upholstered pieces as well as hardwood furniture, much of which he sold in domestic and foreign markets. He conducted a customer service designing furniture and repairing used furniture. He also retailed lumber and furniture hardware to other furniture makers.[3]

Trumble was not the first to produce

Windsors in Philadelphia, but he was one of a small number of craftsmen who helped establish the industry. He trained a great number of apprentices and maintained a large labor force. Two very early orders for Windsor chairs are dated 1759; one was for "6 Windsor chairs" and the other for 12, plus a child's chair. Though not identified, their early date suggest they were comb backs. One can get some idea of the size of his Windsor production from an advertisement he placed in the *Pennsylvania Gazette* dated December 27, 1775, which read "having for sale, twelve hundred Windsor chairs" and "wanted to buy 40,000 hickory sticks for Windsors."[4] A good portion of this Windsor inventory was sold in local, coastal, and West Indian markets. The "hickory sticks" were for spindles and bent parts. Trumble produced seven types of Windsor chairs, one of which was fan backs, which he first made in 1780. He gave up manufacturing other furniture and specialized in Windsor chairs

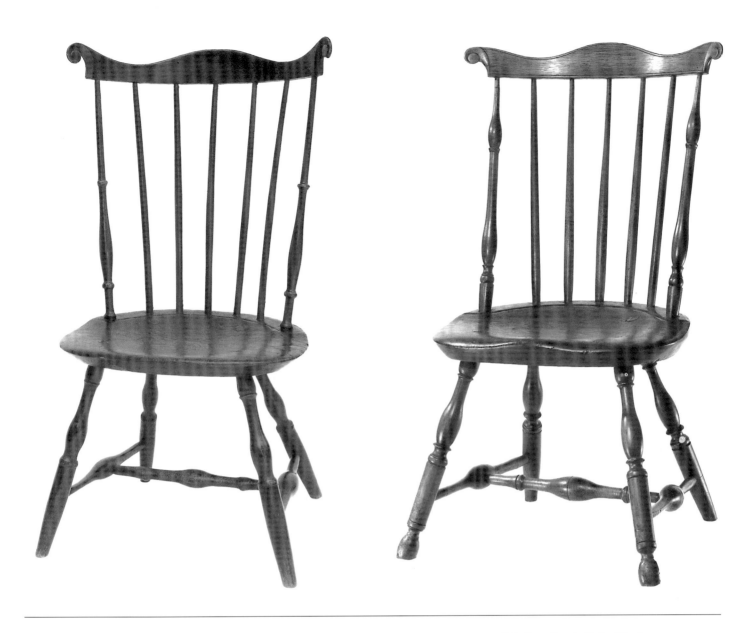

until his death at the age of eighty-two.[5]

This handsome fan-back chair by Trumble has a narrow, long-neck crest rail, well-carved voluted ears, stretched-out thin stiles, a deeply carved seat with a pronounced pommel, and stout, well-socketed tenoned legs. All these fine features are evidence of why Trumble was so successful in the Windsor chairmaking industry.

## 23. Fan-Back Side Chair

Lancaster County, Pennsylvania, about 1770

Maker unidentified

Seat—pine; legs, stretchers—maple; crest rail, stiles, spindles—red oak. Late twentieth-century brown paint, over yellow paint, over original red primer.

Blue Candlestick Antiques

Size unidentified

This fan-back side chair has features typical of Windsors made in Lancaster County— an area in Pennsylvania that was settled by German emigrants. The crest rail, with its dynamic flowing upper edge that ends in high-relief, deeply carved volutes, is in severe contrast to the straight lower edge. This is a classic Lancaster County form. The uniformly spaced, slightly fanned-out, five-spindle back (seven or nine spindles are more usual) gives the chair an open airy feeling. The mildly decorated turnings throughout impart a somewhat rural look to the chair.

The spindles are tapered at both ends and show some variation in shape, an indication of hasty hand scraping. It is interesting that the slender stiles have three turned rings, with the lowest one serving as a locking stop for the under-the-seat wedged tenon. Also noteworthy is the semi-round, deeply hollowed, heavy beveled seat and the typical Lancaster County leg turnings.

## 24. Fan-Back Side Chair

Philadelphia, about 1770

Stamped F. T. [Francis Trumbull]

Seat—pine; legs, stretchers, stiles—maple; crest rail—hickory. Originally painted dark green

Henry Ford Museum and Greenfield Village, Dearborn, Michigan

H 35, W 21½, D 19¾

Photo: Courtesy, Henry Ford Museum and Greenfield Village

The letters F. T. are branded twice on the seat bottom of the chair and are evidence that this fan-back side chair was also made by Francis Trumble. Other styles of Trumble's Windsor chairs also have the initials F. T. or F. TRUMBLE.

Trumble's familiarity with features of Lancaster County Windsors is evident in this chair, which is his interpretation of the Pennsylvania German style. The beaded high-arching crest rail, parallel five-spindle back, round dished seat, and dual style legs

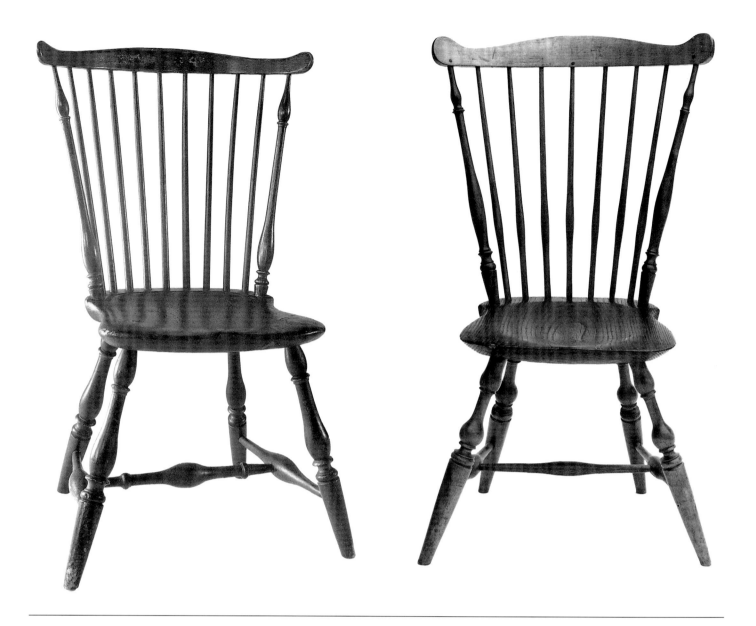

(cylinder blunt arrow in front and tapered in the back) are all Germanic patterns. However, Trumble included double-baluster turned stiles, which is a Philadelphia turning form.

Lancaster County chairmakers used the dual leg style on other Windsor chair forms. (See the sack backs in figs. 46 and 47.)

## 25. Fan-Back Side Chair

Probably Philadelphia, about 1780

Maker unidentified

Seat—pine; legs, stretchers—maple; crest rail, spindles, stiles—hickory. Original pea-green paint covered with early black, recently touched up.

Dr. Donald Bond

H 36½, W 23¾, D 19¼

The long crest rail and broad shield-shaped seat on this fan-back side chair nicely accommodate the attractively fanned-out stiles and spindles. The turnings, although not exceptional, are attractive enough to do credit to the chair. The spindles have constant tapers and the stiles have attenuated balusters. The splayed legs are socketed and wedged to the seat and hold plain side stretchers and an arrow-ended center stretcher.

## 26. Fan-Back Side Chair

Connecticut, about 1790

Maker unidentified

Seat—chestnut; legs, stiles—maple; crest rail, spindles, stretchers—oak. Clear varnish over traces of green paint.

Donald Flynn

H 37¼, W 22¼, D 19⅞

Although attractive, this fan-back side chair has a few design faults. The seat is too narrow, the bulbous portion of the center stretcher is too small, and the turning pattern on the stiles is not unified. In its favor are the nicely spaced spindles, the exceptionally deep-dished seat, and the well-splayed legs with their crisp, matched details. Bulbous spindles, chestnut seat, bold turnings, socketed legs, and no seat groove are trademarks of E. B. Tracy of Connecticut. (See fig. 51.)

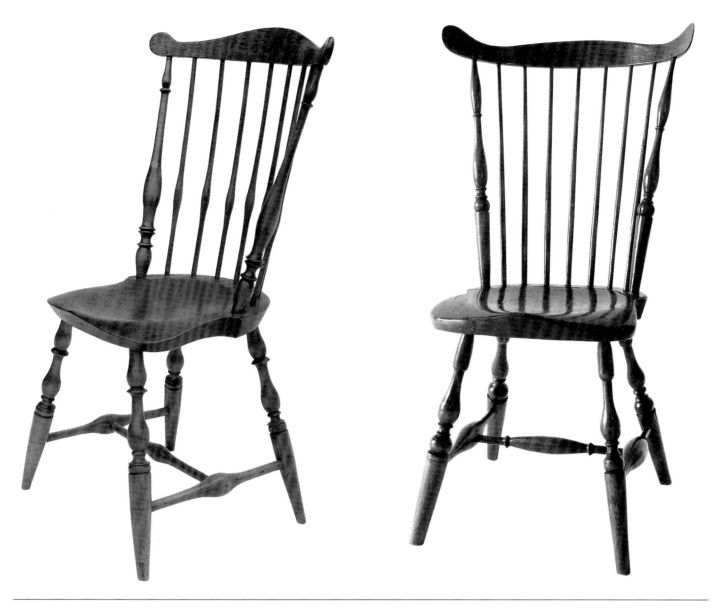

## 27. Fan-Back Side Chair

Connecticut, about 1800

Probably Amos Denison Allen

Seat—pine; legs, stretchers, stiles—maple; crest rail, spindles—red oak. Green paint stripped, clear varnish.

Donald Flynn

H 36⅞, W 21¾, D 20

This fan-back side chair is identical to a set of six advertised for sale and attributed to Amos Denison Allen. Allen served an apprenticeship under Ebenezer Tracy (his future father-in-law) and though the chair shows Tracy influences it probably was made long after 1796 when Allen left the master's shop to set up his own establishment. The chair has negative and positive features: its chief faults are the indecisive transitional turning on the stiles between the bottom of the large bulbous part and the upper ring; the small diameter on the center stretcher; and the somewhat overly large taper on the legs. The other turned details are well done, as are the shaved spindles and the sculptured seat, which is exceptionally beautiful. This is an interesting but not especial chair.

## 28. Fan-Back Side Chair

Probably Connecticut, about 1800

Maker unidentified

Seat—pine; legs, stiles, stretchers—maple (the left stretcher is oak and may be a replacement); crest rail, spindles—hickory. Original green paint stripped; now clear varnish.

Lynn Barrett

H 35½, W 19½, D 20¾

The stiles and spindles on this chair are set off from the slightly saddled seat with an incised cove cut. The legs do not penetrate the seat, a trait popular in Connecticut chairs. The long crest rail with its large upturned ears, the long taper on the stiles, the squared-off edges of the seat, and the absence of a transitional turning between the two baluster turnings on the legs make this chair markedly different from other fan backs. These differences do not necessarily detract from its appearance, and overall it is an interesting and attractive chair.

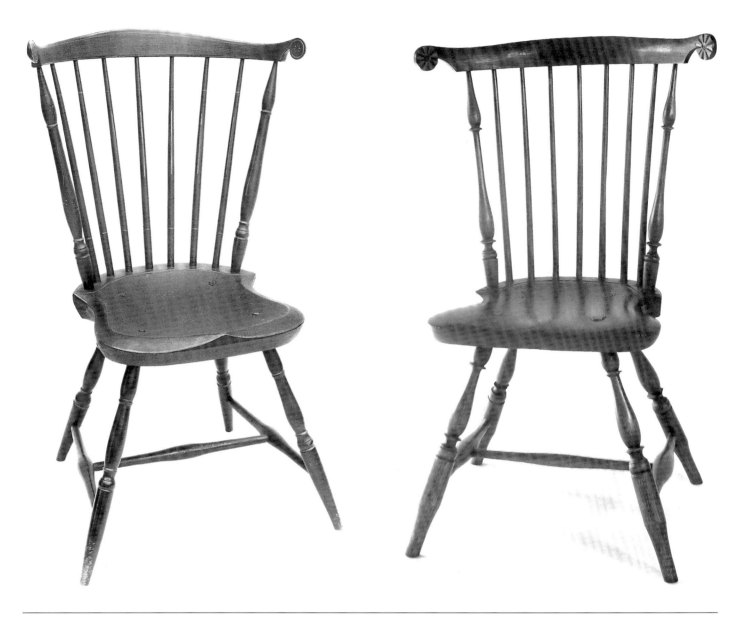

## 29. Fan-Back Side Chair

Connecticut or Massachusetts, about 1800

Maker unidentified

Seat—pine; legs, stretchers, stiles—maple; crest rail, spindles—hickory. Original dark green paint, gold striping.

Mr and Mrs Jerome W. Blum

H 36½, W 23¼, D 22

This fan-back chair is from either Connecticut or Massachusetts. The crest-rail ears are carved in a rosette motif, rather than in the traditional volute pattern.

Rhode Island, Massachusetts, and, most commonly, Connecticut chairmakers embellished crest-rail ears with leaves, wheel spokes, gouge punchmarks, and other individual expressions. On this chair, various elements of the turnings are poorly defined and are possibly the work of an apprentice or a moderately skilled turner. The spindles fan out attractively and the legs are generously splayed. The thin center leg stretcher is not compatible with the side stretchers and the shield-shaped seat is probably a personal interpretation. The legs penetrate the seat and are wedged; the seat groove which isolates the stiles and spindles is matched by a sharp ridge that defines the seat saddle. The sides and front have heavy chamfers that terminate in a high pommel and the edges of the seat are simply squared off.

## 30. Fan-Back Side Chair

Connecticut or Rhode Island, about 1800

Maker unidentified

Seat—pine; legs—maple; stretchers, stiles, spindles—ash; crest rail—red oak. Traces of blue paint, stripped and stained brown maple.

Pilgrim/Roy

H 36¾, W 23⅝, D 18¾

This is another example of a chair with interesting carved ears, in this case a radiating spoke pattern. The long crest rail is beautifully sculptured and contains equally spaced tapered spindles. The exceptionally well-designed stile and leg turnings are well executed. The cusp turnings (rings) were a challenge to produce and are the mark of a master turner. The seat is moderately saddled and has deep concave cut outs at the sides which exaggerate the shield shape. The thin center stretcher is the only negative feature on this otherwise handsome chair.

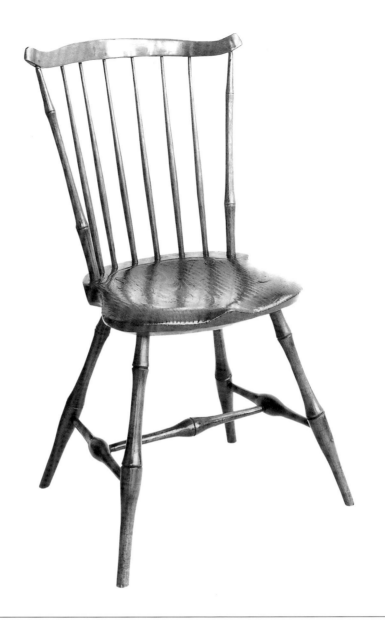

## 31. Fan-Back Side Chair

Connecticut or Rhode Island, about 1810

Maker unidentified

Seat—pine; legs, stiles, stretchers, crest rail—maple; spindles—hickory. Clear varnish over stripped green paint.

Ron Galloway

H 36³⁄₁₆, W 21, D 19¹⁵⁄₁₆

This fan-back side chair is notable for the plain but attractively different pattern of the crest rail and the bamboo-style turnings.

The lower edges on crest rails were almost always straight, but on this chair the lower edge echoes the upper, that is, it was cut to the same profile, making it unique. The ears, which were usually scrolled, were squared off and left uncarved. Were these forms the chairmaker's personal statement? The six back spindles are plain turned with double tapers and the bamboo-style turnings on the stiles and legs have long graceful undercuts between deep double-scored nodes. The beautiful sculptured seat holds adequately splayed legs that are strengthened with wedged tenons and H-pattern bulbous centered stretchers. Altogether this is a charming chair.

# BRACED FAN-BACK SIDECHAIR

## C 1780

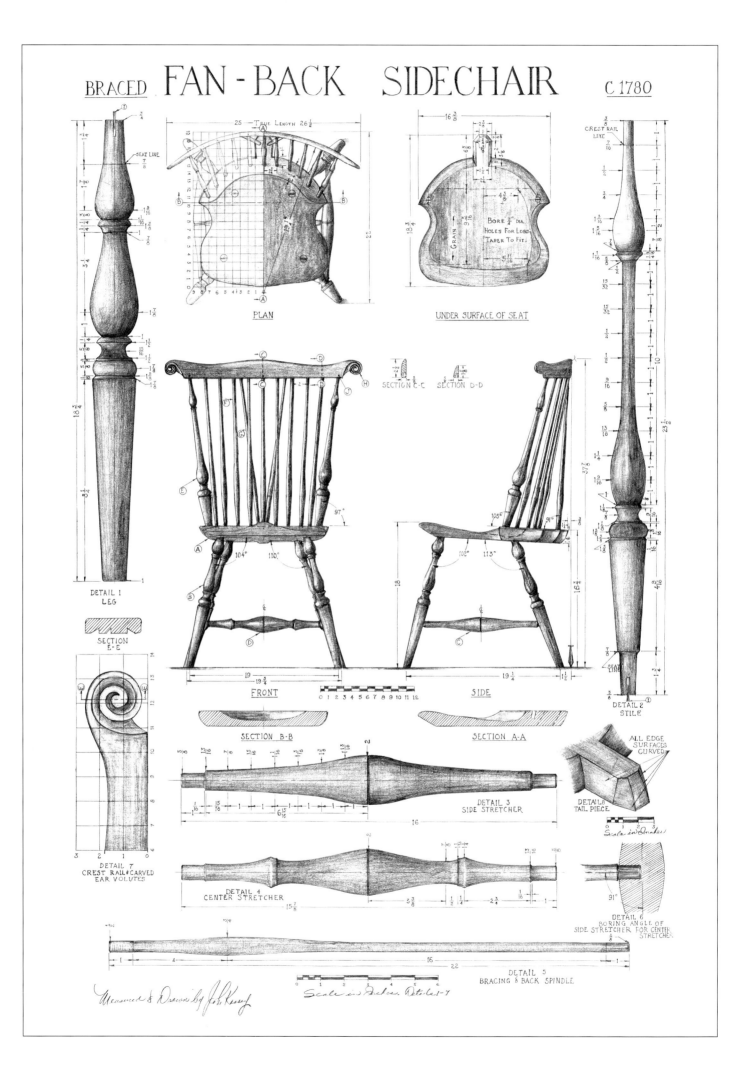

PLAN

UNDER SURFACE OF SEAT

Bore ⅝" dia. Holes For Legs, Taper To Fit.

DETAIL 1
LEG

SECTION E-E

DETAIL 7
CREST RAIL & CARVED EAR VOLUTES

SECTION C-C    SECTION D-D

FRONT

0 1 2 3 4 5 6 7 8 9 10 11 12

SIDE

SECTION B-B

SECTION A-A

DETAIL 2
STILE

ALL EDGE SURFACES CURVED

DETAIL 8
TAIL PIECE

Scale in Inches

DETAIL 3
SIDE STRETCHER

DETAIL 4
CENTER STRETCHER

DETAIL 6
BORING ANGLE OF SIDE STRETCHER FOR CENTER STRETCHER

DETAIL 5
BRACING & BACK SPINDLE

Measured & Drawn by John Kassay

Scale in Inches. Details 1-7

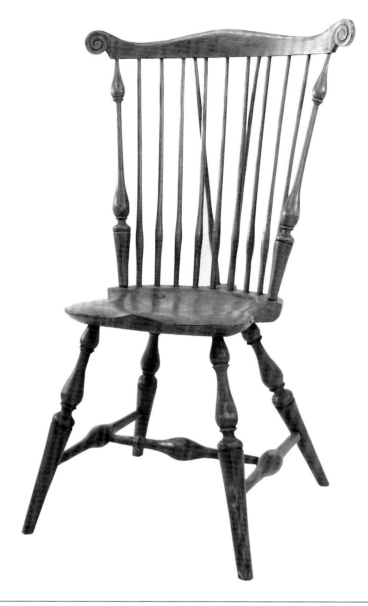

## 32. Braced Fan-Back Side Chair

New England, about 1780

Maker unidentified

Seat—pine; legs, stretchers, stiles—maple; spindles, crest rail—hickory. Green paint over original red ground.

I. M. Wiese, Antiquarian

H 37⅞, W 25, D 22

This style of braced fan-back side chairs is one of the most beautiful Windsor chair patterns. These chairs added a wonderful addition to the Windsor chair family and are a credit to their early makers. Most everything on the chair is of the finest design. Its noteworthy features are the long thin crest rail with flaring ears, the full carved volutes, the tapered spindles with abrupt swellings near their lower ends, and the dramatic thick and thin turnings on the stiles and legs.

| Letter | No. | Name | Material | T. | W. | L. |
|---|---|---|---|---|---|---|
| A | 1 | seat | pine | 1¾ | 16⅜ | 18¾ |
| B | 4 | legs | maple | 1⅞ dia. | | 18¾ |
| C | 2 | side stretchers | maple | 2 dia. | | 16 |
| D | 1 | center stretcher | maple | 2 dia. | | 15⅞ |
| E | 2 | stiles | maple | 1⅝ dia. | | 23½ |
| F | 9 | back spindles | hickory | ¾ dia. | | 22 |
| G | 2 | bracing spindles | hickory | ¾ dia. | | 22 |
| H | 1 | crest rail | hickory | ⅝ | 2½ | 26½ |
| I | 6 | wedges | maple | ⅛ | ¾ | 1 |
| J | 3 | pins | maple | ⅛ dia. | | ⅜ |

The seat is attractively shaped with good saddling and a high pommel, sharp edges, and deep chamfering. The well-splayed legs are tenoned-wedged to the seat and hold plain bulbous side stretchers and an arrow-ended center stretcher.

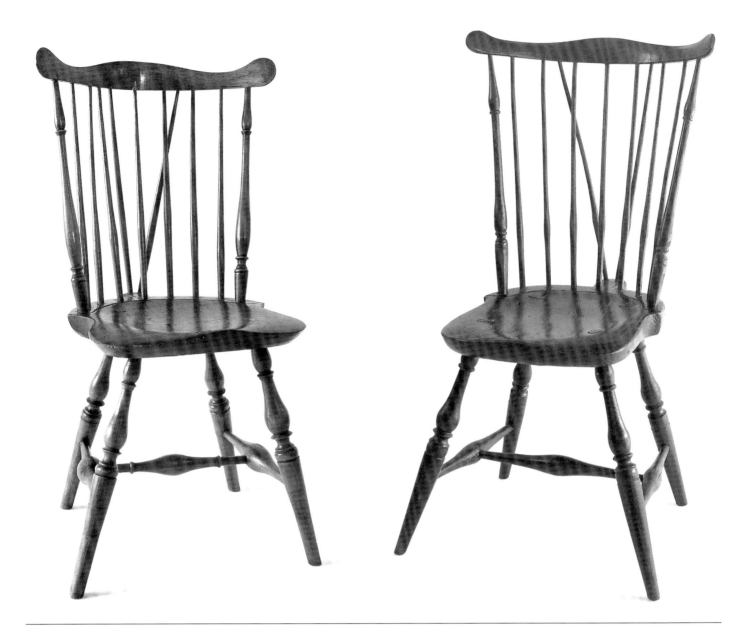

### 33. Braced Fan-Back Side Chair

Probably Connecticut, about 1800

Maker unidentified

Seat—pine; legs, stiles, stretchers—maple; crest rail, spindles—hickory. Orange shellac over stripped green paint.

Private collection

H 36⅛, W 20⁵⁄₁₆, D 22⁵⁄₁₆

This braced fan-back side chair is an attractive well-designed piece with an appealing provincial feel. The large upturned uncarved ears on the crest rail is a Connecticut feature, as are the tapered, slightly swelled spindles. The nicely saddled seat has a distinct pommel, sharp edges, and heavy chamfering. The round-ended tail piece that anchors the two bracing spindles is a continuation of the seat. The mark of an expert wood turner shows in the well-matched stiles and leg turnings. Unfortunately, the legs were shortened, probably to accommodate a small person, but they have since been ended out.

### 34. Braced Fan-Back Side Chair

Connecticut or Rhode Island, about 1800

Maker unidentified

Seat—pine; legs, stretchers, stiles—maple; crest rail, spindles—hickory. Black paint over early green, over red undercoat.

Corbett's Antiques

H 38¹¹⁄₁₆, W 21⅞, D 20⅝

Although this chair has the same features as the previous chair, it has a more countrified look. The back of this chair is taller, the center stretcher is unringed, and the seat is not particularly well designed, especially with its homely, almost square, edges. The turning details on the stiles and legs were originally fine and crisp but were destroyed through too aggressive sanding, done during refinishing.

### 35. Braced Fan-Back Side Chair

Probably eastern Connecticut, about 1800

Maker unidentified

Seat—pine; legs, stiles, stretchers—maple; spindles, crest rail—hickory. Original green paint.

Courtesy, Historic Deerfield, Inc., Deerfield, Massachusetts

H 38¼, W 16, D 18¼

Photo: Helga Photo Studio

On this braced fan-back side chair the crest rail has a high arched center and small upturned ears carved in an unusual stylized leaf pattern. Also different is the wide spacing of the bracing spindles, possibly done to introduce added strength to the back. The seat, which appears to be exceptionally narrow, is moderately dished, has a

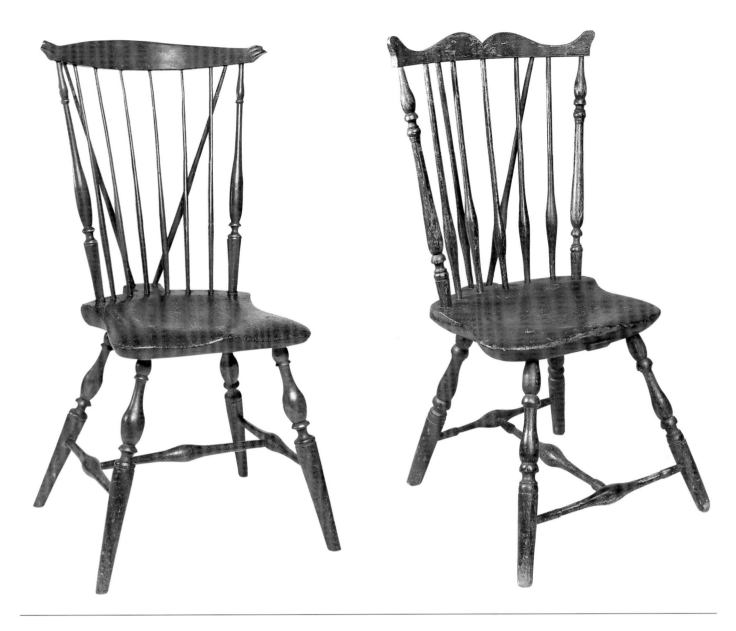

pronounced pommel, sharp edges, and lacks the usual groove separating the spindle area. The baluster turnings are well matched, bold, and crisp, and for greater effect the two legs with the largest balusters were installed in the front.

## 36. Braced Fan-Back Side Chair

Connecticut, about 1800

Maker unidentified

Seat—pine; legs, stretchers—maple; crest rail, spindles—hickory. Painted black.

Bernard and S. Dean Levy, Inc., New York

H 37½, W 17, D ?

Photo: Helga Photo Studio

The cupid's-bow crest rail on this braced fan-back side chair is a Connecticut form, and although rare, is found on two other published examples of fan backs, one braced and the other unbraced.[6] It is possible there are others, but they are as yet undiscovered.

The turnings on the stiles and legs are too heavy to be aesthetically pleasing, as is also true for the swellings on the spindles. The cusp turnings (the detail immediately below the balusters) are rolled over rather than thin and crisp.

Typically, the grain on shield-shaped seats runs from front to back; this was done for strength. On this chair, however, the grain is oriented from side to side, which is an obvious structural error, because it makes the seat more likely to split. Having realized this, the chairmaker had three choices: to discard the seat; to recut it to fit a child-sized chair; or to add a cleat across the grain. Simply adding a cleat would have called attention to the defect and so the maker innovatively designed the needed cleat with a tail piece and dadoed it into the seat (the front end is visible in the photograph).

The unusual rotated H-stretcher arrangement is also curious. Were the legs, with the stretchers in place, assembled incorrectly to the seat, or was this another experimental variant directed toward adding to the manufacturer's line? It must not have been very successful because only a few were made.[7]

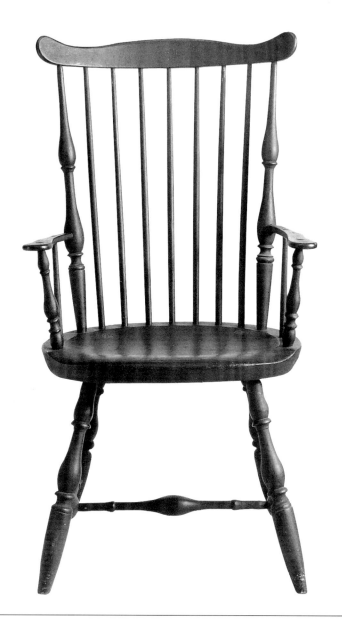

## 37. Fan-Back Armchair

Probably Rhode Island, about 1810

Maker unidentified

Seat—pine; other parts—probably maple. Traces of original red and mustard paint covered with later brown.

Pocumtuck Valley Memorial Association, Memorial Hall Museum, Deerfield, Massachusetts

H 38, W 21¾, D 18

Although Nutting shows three unbraced fan-back armchairs,[8] the style is somewhat uncommon. This unbraced fan-back armchair conveys a feeling of reserved strength and stability. Quite possibly it was a style designed to be used in public buildings. The chair features a typical New England crest rail, a nicely scooped oval seat, excellent turnings, arrow-ended stretchers, and a handsome stance. Unattractive details are the thin arms, the undefined seat pommel, and the bulging curve on the tapered portion of the legs.

| Letter | No. | Name | Material | T. | W. | L. |
|--------|-----|------|----------|-----|-----|-----|
| A | 1 | seat | pine | 1¾ | 14½ | 20 |
| B | 4 | legs | maple? | 1⅝ dia. | | 16⅜ |
| C | 2 | side stretchers | maple? | 1¹³⁄₁₆ dia. | | 13½ |
| D | 1 | center stretcher | maple? | 1½ dia. | | 16¼ |
| E | 7 | back spindles | maple? | ⅜ dia. | | 22 |
| F | 2 | stiles | maple? | 1⁹⁄₁₆ dia. | | 23⁵⁄₁₆ |
| G | 2 | arm spindles | maple? | ⅝ dia. | | 8⅝ |
| H | 2 | arm supports | maple? | 1⅛ dia. | | 9⅞ |
| I | 2 | arms | maple? | ½ | 2⅛ | 9¼ |
| J | 1 | crest rail | maple? | ⅝ | 2½ | 24 |
| K | 4 | leg wedges | maple? | ⅛ | size to suit | |
| L | | arm support wedges | maple? | ⅛ | size to suit | |
| M | | arm spindle wedges | maple? | ⅛ | size to suit | |
| N | | crest rail pins | maple? | ⅛ dia. | | ⅜ |

# CIRCA 1810 FAN-BACK ARMCHAIR

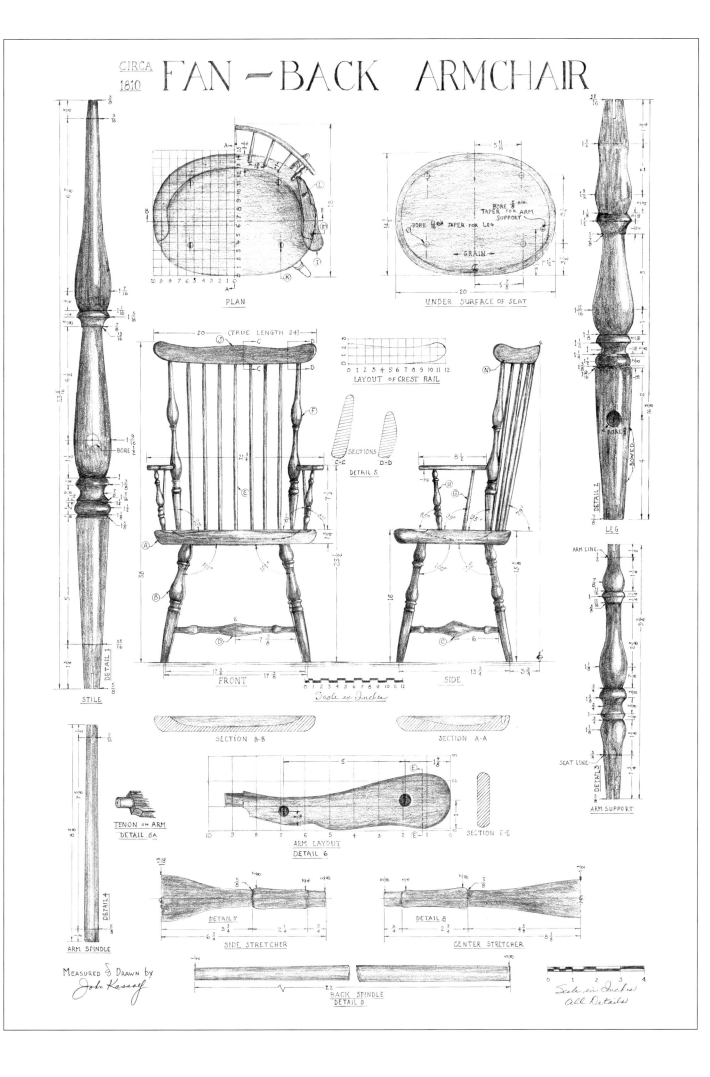

PLAN

UNDER SURFACE OF SEAT

STILE

DETAIL 1

LAYOUT of CREST RAIL

SECTIONS
C-C    D-D
DETAIL 5

FRONT

SIDE

Scale in Inches

LEG
DETAIL 2

ARM SUPPORT
DETAIL 3

SECTION B-B

SECTION A-A

ARM SPINDLE

DETAIL 4

TENON ON ARM
DETAIL 6A

ARM LAYOUT
DETAIL 6

SECTION E-E

SIDE STRETCHER
DETAIL 7

CENTER STRETCHER
DETAIL 8

BACK SPINDLE
DETAIL 9

Measured & Drawn by
John Kassay

Scale in Inches
All Details

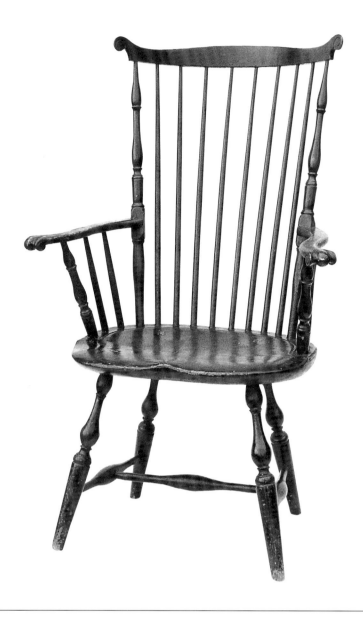

## 38. Fan-Back Armchair

Massachusetts, about 1790

Maker unidentified

Wood and finish unidentified

The American Museum in Britain

Size unidentified

Photo: The American Museum in Britain

Although unbraced fan-back armchairs were not as popular as the braced variety, all the components of this example harmonize nicely to make it an exceptionally attractive and comfortable chair. The long thin crest rail has high-profile voluted ears, the tapered back and arm spindles convey a sense of strength and permanency, and the complex turned details on the stiles change from one form to another without pause. This is the only Windsor chair style that has a square section retained within a turning as shown here on the stile turnings. Achieving this transition required careful layout and skillful execution. The side-scrolled arms were fastened to the stiles with a countersunk woodscrew driven through the back of the stile. The carved knuckle hand holds have a piece applied on their underside to give them greater fullness. The comfortable looking oval seat is well saddled and has a high pommel and rounded underedges, which create a feeling of thinness. Stiles, arm supports, and legs penetrate the seat and are wedged. For additional security, wooden pins were sometimes driven from the seat edge through the stiles and arm supports, but it is not possible to determine if that was done on this example. This chair is a masterpiece of the craft of Windsor chairmaking.

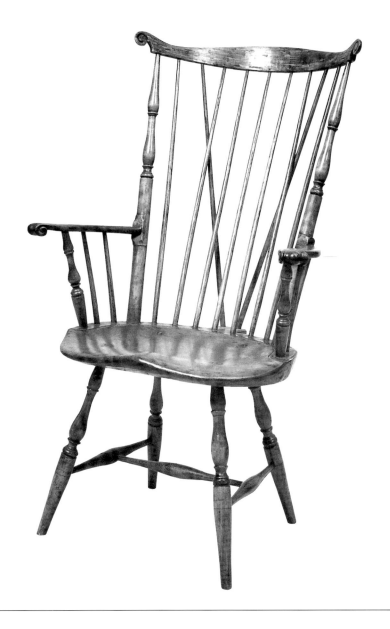

## 39. Braced Fan-Back Armchair

Massachusetts, about 1780

Maker unidentified

Seat—pine; legs, stretchers, arms, arm supports, stiles—maple; spindles—hickory; crest rail—red oak. Unidentified paint, stripped, and unidentified clear finish.

Butterfield and Butterfield Auctioneers

H 46, W 27¼, D 26¾

Photo: Butterfield

Braced fan-back armchairs are the most formal of all Windsor chair styles and this example is about as nice as any made.

Unfortunately, all these chairs seem to have a problem in spacing the back and bracing spindles along the crest rail in an aesthetically pleasing way. The spindles, including the bracing spindles, are evenly spaced, which means that the inner back spindles are unattractively vertical. On other braced-back Windsor chair styles this problem was prevented by locating the bracing spindles within the equally spaced back spindles. By doing this, all the back spindles could be attractively fanned.

In this chair, the details on the baluster-pattern turnings are crisp and nicely matched, although those on the stiles could have been improved by stretching out the lower baluster and adding a baluster turning below the arms, which would have added to the chair's beauty. The scrolled ears are carved in a single volute and the front end of the S-carved arms are undercut and have an applied piece to allow more fullness to the carved knuckles. The arms are cut to a V, which fits the outer corner of the square section of the stiles and are held in place with a single woodscrew and supported by arm supports and spindles. The stiles, arm supports, and legs are through-tenoned to the elaborately saddled seat. As is typical with braced backs on oval seats, the tail piece is a separate tenoned addition, double pinned through the joint.

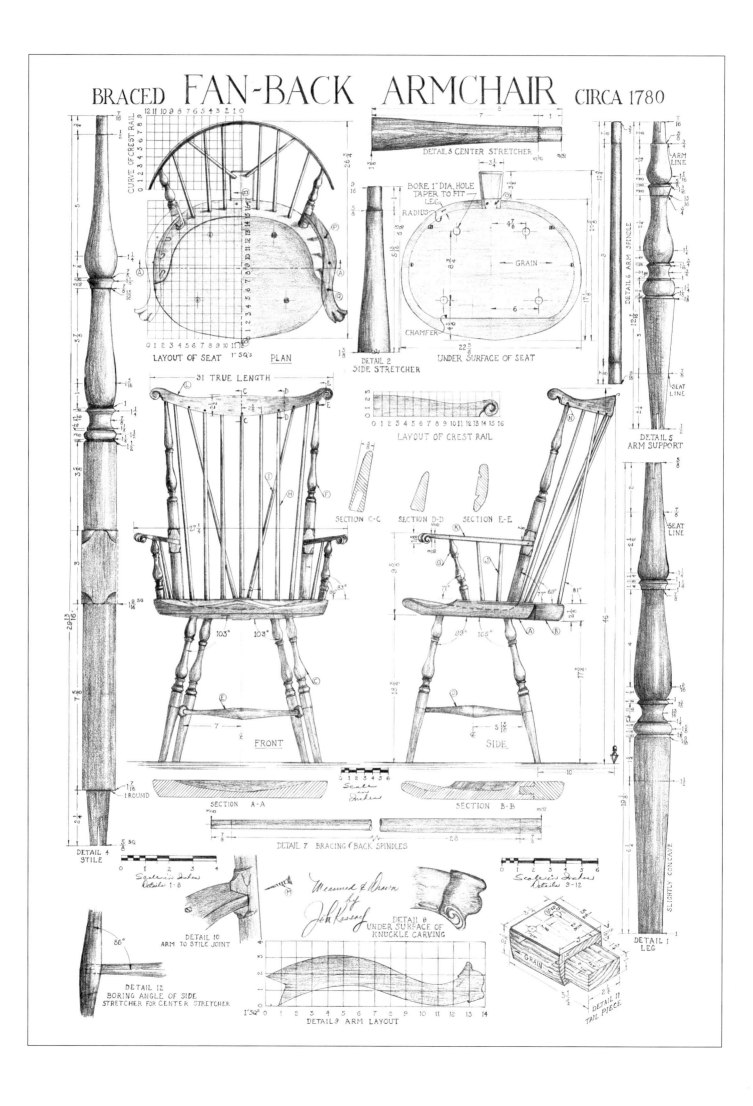

# BRACED FAN-BACK ARMCHAIR CIRCA 1780

Braced Fan-Back Armchair

| Letter | No. | Name | Material | T. | W. | L. |
|---|---|---|---|---|---|---|
| A | 1 | seat | pine | 2⅛ | 17⅛ | 22⅝ |
| B | 1 | tail piece | pine | 2⅛ | 3¼ | 5¼ |
| C | 4 | legs | maple | 1⅝ dia. | | 19⅛ |
| D | 2 | side stretchers | maple | 1⅜ dia. | | 13⅝ |
| E | 1 | center stretcher | maple | 1⅜ dia. | | 16 |
| F | 2 | stiles | maple | 1⁹⁄₁₆ sq. | | 29¹³⁄₁₆ |
| G | 2 | arm supports | maple | 1¾ dia. | | 12⁷⁄₁₆ |
| H | 7 | back spindles | hickory | ⁹⁄₁₆ dia. | | 29¾ |
| I | 2 | bracing spindles | hickory | ⁹⁄₁₆ dia. | | 29¾ |
| J | 4 | arm spindles | hickory | ⁹⁄₁₆ dia. | | 10¾ |
| K | 2 | arms | maple | 1³⁄₁₆ | 3³⁄₁₆ | 14 |
| L | 1 | crest rail | red oak | ⅝ | 2¾ | 31 |
| M | 2 | F.H. woodscrews | steel | No. 8 | | 2 |
| N | 5 | crest rail pins | maple | ⅛ dia. | | ⅝ |
| O | 2 | tail piece pins | maple | ³⁄₁₆ dia. | | 2⅛ |
| P | 2 | arm pins | maple | ⅛ dia. | | 2 |
| Q | 14 | wedges | maple | | size to suit | |

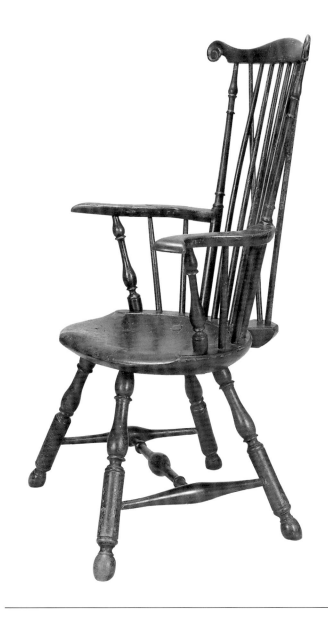

## 40. Braced Fan-Back Armchair

Philadelphia, about 1770

Maker unidentified

Seat—tulip poplar; legs, arm supports, stretchers, stiles—maple; arms, crest rail—oak; spindles—hickory. Dark green covers original light green.

The Art Institute of Chicago, Bequest of Elizabeth R. Vaughan

H 20, W 26, D 22⅜

Photo: The Art Institute of Chicago

Here is a splendid example of a very early Philadelphia braced fan-back armchair. Philadelphia features are the deeply curved, scrolled crest rail, carved volutes, ring turnings on the stiles, flat cyma-curved arms, rounded-over, dubbed-off hand holds, and cylinder and blunt arrow feet.

Although not easily seen in the photograph, the back spindles have typical unattractive gaps between the stiles and spindles. Also not obvious is the diagonal direction of the grain in the round seat, a seldom-seen orientation that was probably used to avoid making a separate mortise-and-tenon tail piece. It is doubtful that the angled grain increased the strength of the seat, but certainly, the angled grain on the tail piece jeopardizes its strength. What appear to be unfinished hand holds may have an English antecedent because hand holds on English Windsors were simply rounded over and left uncarved. Additional noteworthy features are the robust legs and their great splay, the dynamic forward-thrusting arm supports, the very thick, deeply scooped seat, and the coffin-shaped tail piece.

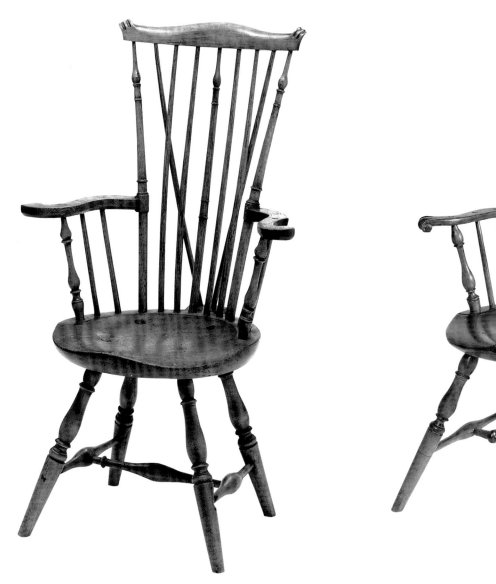
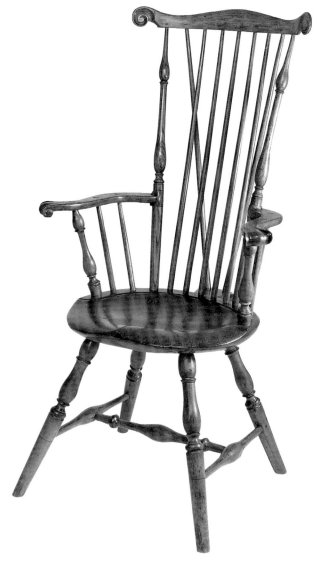

## 41. Fan-Back Armchair

New England, about 1760

Maker unidentified

Seat—poplar; legs, stretchers, stiles, arm supports, crest rail—maple; spindles—hickory. Painted black.

Museum of Fine Arts, Boston, Anonymous gift

H 42¼, W 18⅜, D 21

Photo: © Museum of Fine Arts

Although this braced fan-back armchair carries a New England attribution, it has features found on Philadelphia comb backs. The similarities include the turning pattern of the stiles, the shape and location of the spindles, and the round seat with diagonal grain. If the attribution is correct, the chair is proof that Philadelphia-trained Windsor chairmakers moved about. The carved ears on the crest rail and the distinctive sharp elbows and round hand holds on the cyma-curved arms are differ-

ent and a departure from typical forms. The lathe-turned middle back spindle is nearly the same pattern as the stiles and is most unusual.

## 42. Braced Fan-Back Armchair

Philadelphia, about 1780

Maker unidentified

Seat—tulip poplar; legs, arm supports, stretchers—maple; arms, crest rail—oak; stiles, spindles—hickory. Finish unidentified.

Bernard and S. Dean Levy, Inc., New York

H 44, W 19, D 20

Photo: Helga Photo Studio

Criticism of this attractive braced fan-back armchair is limited to the spacing of the back spindles and the undecorated lower end of the stiles. Its many noteworthy features include the long neck and carved volutes on the crest rail, the wide, carved knuckle hand holds, the round, diagonal-grained, deeply saddled seat, the well-turned baluster legs, which became the preferred turning form, and the greatly splayed legs, which give the chair an air of importance.

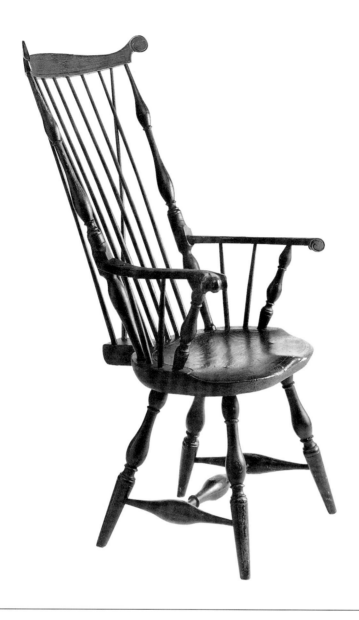

## 43. Braced Fan-Back Armchair

Massachusetts, about 1790

Maker unidentified

Seat—pine; legs, stiles, arm supports, stretchers—maple (based on a similar chair); crest rail—oak; spindles—hickory; arms—birch. Finish unidentified.

The Henry Francis du Pont Winterthur Museum

H 45⅝, W 27, D 28¾

Photo: Courtesy, Winterthur Museum

Even though the back spindles on this chair are vertical and parallel, the amount of open space inside the stiles is greatly reduced by the addition of two more spindles. The stiles are decoratively turned along their entire length. The vase-shaped turning below the arms is especially note-worthy; in fact all the turnings on the chair are well designed and of the highest quality. The crest rail is long and narrow, and has a beaded lower edge and shallowly carved volutes. The arms are not undercut at the carved knuckles but they do have an additional piece, applied for fullness. On the generously large oval seat, the direction of the grain is along the major axis, that is, side-to-side, as it should be. The direction of the grain on the tenoned tail piece is at right angles to the seat grain, as it should be for maximum strength.

# 4   Sack-Back Chairs

## Introduction

The first sack-back chairs were referred to in old inventories as "sack-backt" chairs and were developed in Philadelphia sometime during the 1760s. They were quickly accepted and were widely used during the 1770s and even more so after the Revolutionary War. Based on the number of surviving examples, it can be assumed that for approximately fifty years they were one of the favorite Windsor forms, far more popular than low backs. They were comfortable, durable, relatively inexpensive, very portable, and attractive and they lent themselves admirably for use in public buildings. Production moved quickly northward to hamlets, river towns, and large cities. Although considerably fewer were made in New York than in Philadelphia, New York chairmakers introduced a bold, markedly different turning pattern—one that exaggerated bulbous turning forms (see fig. 50). The chair was especially popular in New England where Connecticut (see fig. 51) and Rhode Island (see fig. 56) chairmakers also developed design characteristics different from their southern counterparts. Sack backs always have an arm rail and it is therefore redundant to refer to them as armchairs. In both form and construction they derived from Philadelphia comb-back armchairs, although on sack backs, from the arm rail upward, the back spindles (seven or nine) are contained within a bent bow. The ends of this bow are tenoned to the arm rail, thereby forming a sack; hence the name. In other words, the bow containing the spindles is tenoned to the arm rail rather than to a horizontal crest. Folklore has it that the bow was designed to accommodate the practice of pulling a sack over the back of a chair to protect the sitter from drafts.

The sack ends were assembled to the arm rail with wedged round tenons or shouldered-and-wedged tenons. The shouldered style was more durable but required additional time and care to make. A common design fault of sack backs is the unattractive open space at each end of the sack where it joins the arm rail. Some chairmakers, aware of this problem, solved it to some extent by arranging the spindles in a fanned-out pattern (see figs. 47–54). Extending the outer short spindles into the sack would have corrected this problem but that solution required boring a long mortise hole, which might seriously weaken the sack. Almost all seats were oval, although a few with D and shield shapes were also made. All the basic leg turning patterns, including regional variants, were used during the chair's popularity.

The baluster form with tapered legs was by far the most popular pattern. Bamboo-style turnings became the fashion toward the end of the eighteenth century and largely replaced the earlier styles. On a few sack backs three or more back spindles were extended through the sack and were crowned with a small horizontal rail that formed a head rest (see figs. 47, and 54). Braced-back sack backs (see fig. 61) are very rare, which is probably because chairmakers found that the bowed arm rail and sack gave the back adequate support.

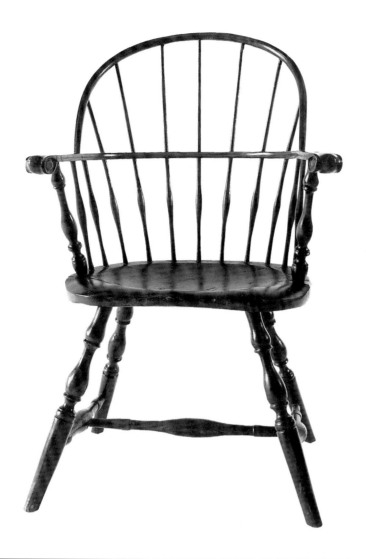

## 44. Sack-Back Chair

Connecticut, about 1820

Branded McCracken

Seat—pine; legs, arm supports—maple; stretchers—chestnut; arm rail, sack, arm spindles, back spindles—hickory. Walnut-colored varnish stain over original shellac.

Richard Roy

H 35¾, W 23¾, D 19⅞

This mid-size sack-back chair is branded with an unidentified name. Details of the chair are in the Tracy style and may have been made in his establishment or at least by someone familiar with his work. The chair is well proportioned, well constructed, and has classic lines.

The sack is tenoned-wedged to the arm rail and holds seven spindles. The three center spindles are through-tenoned-wedged to the sack, while the flanking pair are stop- or blind-tenoned. Interestingly, these tenon holes were bored part way

| Letter | No. | Name | Material | T. | W. | L. |
|--------|-----|------|----------|-----|-----|-----|
| A | 1 | seat | pine | 1¹¹⁄₁₆ | 15¼ | 19⅜ |
| B | 4 | legs | maple | 1⅜ dia. | | 16¹⁹⁄₃₂ |
| C | 2 | side stretchers | chestnut | 1⅜ dia. | | 13¾ |
| D | 1 | center stretcher | chestnut | 1½ dia. | | 18 |
| E | 2 | arm supports | maple | 1¼ dia. | | 12¾ |
| F | 4 | arm spindles | hickory | ¹¹⁄₁₆ dia. | | 11 |
| G | 7 | back spindles | hickory | ¹¹⁄₁₆ dia. | | 17 min. 21½ max. |
| H | 1 | arm rail | hickory | ¹¹⁄₁₆ | 2¾ | 43½ |
| I | 2 | knuckle hand holds | hickory | 1 | 2¾ | 2¼ |
| J | 1 | sack | hickory | ¾ dia. | | 41 |
| K | 13 | wedges | maple? | | size to suit | |
| L | 12 | pins | maple? | ⅛ dia. | | size to suit |

from the underside and the spindle lengths were carefully measured to seat properly in the holes. The spindles are fanned out beautifully within the sack and their abrupt swelling forms an attractive arc. The diameter of the spindles below the swelling is undercut, which emphasizes the swellings; their ends are also flared before they enter the seat. The arm rail terminates in bold, well-carved two-piece knuckle hand holds and the semi-oval,

deeply saddled seat holds well-made, nicely detailed leg turnings. The arm supports and arm spindles appear to leap forward. The well-matched legs are socketed to the seat and have more than adequate splay. The stretchers are arrow ended. Through natural wear or deliberate shortening, the legs, particularly those at the front, have lost some of their original length. Reducing the angle of backward lean made it a working chair rather than one for relaxing.

# SACK-BACK CHAIR

**MIXED WOODS**
Dark Walnut Varnish-Stain over Clear Varnished Natural Wood.

**BRANDED**
J.W. McCracken

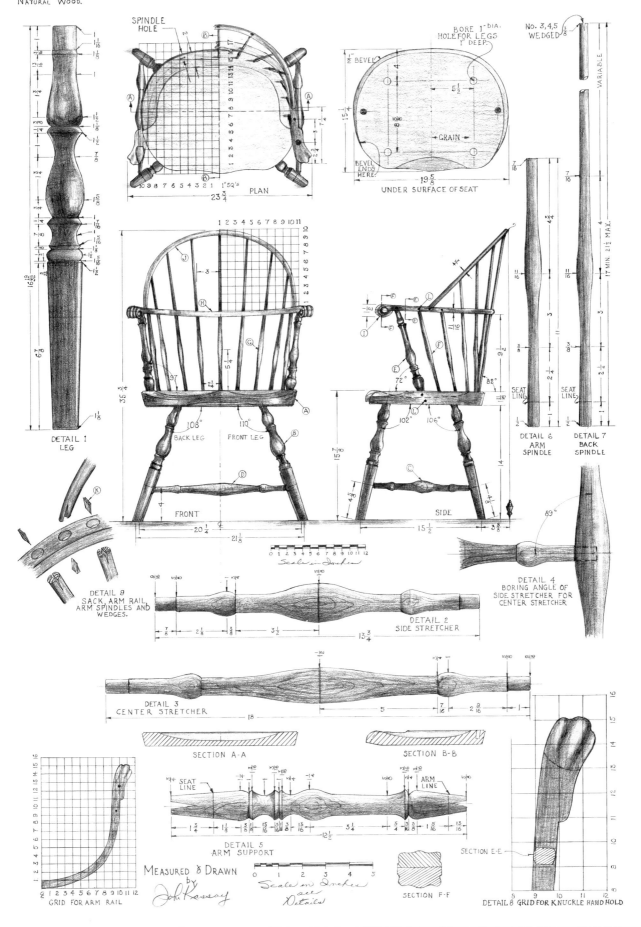

DETAIL 1
LEG

PLAN

UNDER SURFACE OF SEAT

SPINDLE HOLE

BORE 1" DIA. HOLE FOR LEGS 1" DEEP.

No. 3,4,5 WEDGED

GRAIN

BEVEL ENDS HERE

FRONT

BACK LEG    FRONT LEG

SIDE

DETAIL 6
ARM SPINDLE

DETAIL 7
BACK SPINDLE

DETAIL 9
SACK, ARM RAIL, ARM SPINDLES AND WEDGES.

Scale in Inches

DETAIL 2
SIDE STRETCHER

DETAIL 4
BORING ANGLE OF SIDE STRETCHER FOR CENTER STRETCHER

DETAIL 3
CENTER STRETCHER

SECTION A-A

SECTION B-B

SEAT LINE    ARM LINE

DETAIL 5
ARM SUPPORT

SECTION E-E

SECTION F-F

GRID FOR ARM RAIL

MEASURED & DRAWN
by
John Kassay

Scale in Inches
all Details

DETAIL 8 GRID FOR KNUCKLE HAND HOLD

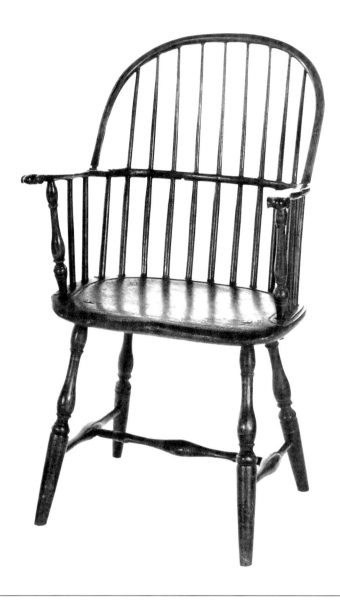

## 45. Sack-Back Chair

Philadelphia, about 1777

Branded F[rancis] Trumble

Seat—tulip poplar; legs, stretchers, arm supports—maple; sack, spindles, arm rail—hickory. Painted olive green.

Independence National Historical Park, Philadelphia

H 37⅛

Photo: Independence National Historical Park

This sack back is another Windsor style made by Francis Trumble and is typical of many he turned out in his very productive shop. Over a two-year period (1776–78) Trumble supplied the State House (now Independence Hall) with seventy-eight Windsors, some of which were branded sack backs in this style.[1]

The chair has nine back spindles and six arm spindles and carved knuckle hand holds. Trumble also made sack backs with seven back spindles and four arm spindles and ladle-shaped hand-holds.[2]

In both cases, his sack backs, although not dynamic, were strongly built and most suitable for use in public buildings. All the spindles are unattractive stout rods; the back spindles taper abruptly before entering the arm rail and then taper nicely into the sack. Their spacing is uniform, parallel, and vertical, an arrangement responsible for the unattractive open ends. The seat is oval and has an incised line separating the spindle area from the saddling. The saddling is uninspired with a mere suggestion of a pommel, a sign of minimal effort, to save labor (and money). For comfort, the chairs were probably fitted with loose cushions supplied by upholsters. The legs are through-tenon-wedged.

The arm supports and leg turnings are less stocky on this chair than on other Trumble sack backs. The chairs with larger diameters may be examples of his early work or perhaps the two styles were made simultaneously to meet various customers' preferences.

Finally and most noteworthy is the shaping on the arm rail. In cross section the curved back and knuckle hand holds are the same thickness, whereas the arms are flat and thinner, mostly from the under side. The arms were undercut to avoid the need to add additional material to form the hand hold.

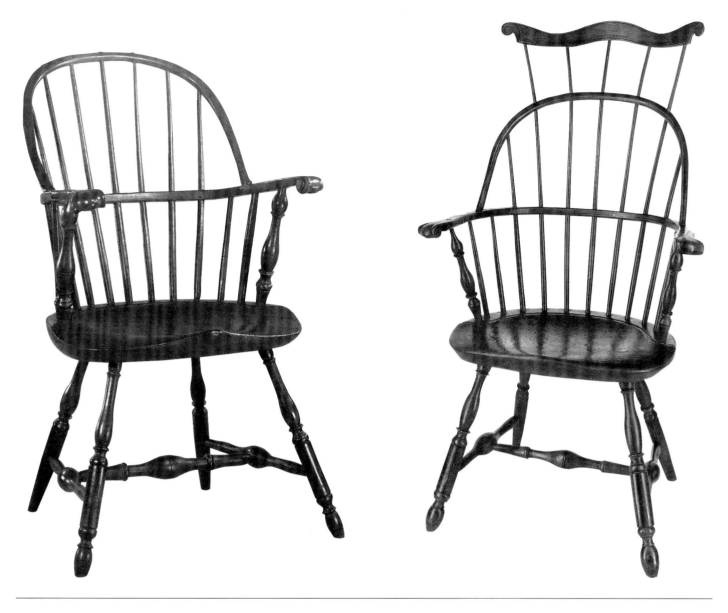

## 46. Sack-Back Chair

Lancaster County, Pennsylvania, about 1775

Maker unidentified

Seat—poplar; legs, stretchers, arm supports—
maple; sack, arm-rail, spindles—hickory. Finish
unidentified.

Eastern National Park and Monument

Size unidentified

Photo: Eastern National Park and Monument

On this sack-back chair, the turning
patterns of the front and back legs are
different. The front legs are Philadelphia-
style baluster straight-cylinders with blunt-
arrow feet. The back legs are baluster
tapered. Using two different leg patterns
on the same chair was common practice
among Lancaster County Windsor
chairmakers. Other interesting features of
the chair are a thick sack that gradually
reduces and then enlarges to form a
shouldered tenon, an equally thick arm
rail that ends in bold, outward-flaring

carved knuckles, a superbly saddled oval
seat, crisp turning details throughout, and
arrow-end turnings on the center stretcher.
These and the thrusting arm supports and
great leg splay make this chair the very best
of its kind.

## 47. Sack-Back Chair

Lancaster County, Pennsylvania, about 1785

Maker unidentified

Seat—poplar; legs, stretchers, arm supports—
maple; arm rail, sack, spindles—hickory; crest
rail—oak? Finish unidentified.

The Henry Francis du Pont Winterthur Museum

H 44⅞₁₆, W 25½, D 23¹⁄₁₆

Photo: Courtesy, Winterthur Museum

As with the previous chair (fig. 46), this
chair has the Lancaster County two-pattern
leg turning. In addition it has an interest-
ing comb-piece head rest. Chairs with this
feature were referred to as triple backs and

are a rare Windsor form. (For another
example see fig. 54.) The chairs were
probably innovative experiments made on
special order. The head rests offered extra
support to the sitter and must have been a
welcome feature.

In its construction, five of the seven back
spindles continue through the sack and
form the comb. These spindles required
four different diameter holes. Those in the
arm rail and sack also had to be slightly
tapered for a better fit.

The wavelike crest rail is different and
exceptionally attractive. Both edges are
beaded and have ears carved in a single
volute. For fullness, the carved knuckle
hand holes have additional wood applied
to their outer edges and to the
undersurface of the arm rail. The legs
penetrate a suitably nicely saddled oval
seat, all the turnings are crisp and well
matched, and the arrow-end turnings on
the center stretcher contribute additional
interest to a masterpiece.

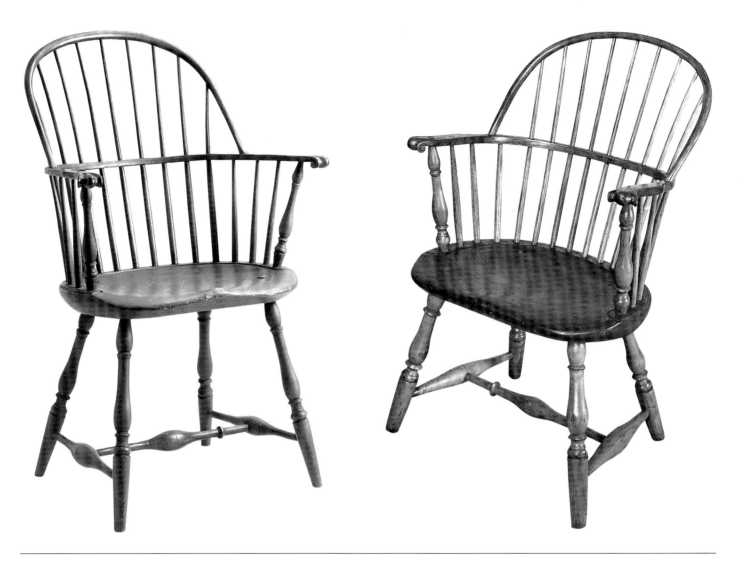

## 48. Sack-Back Chair

Wilmington, Delaware, about 1790

Branded Sampson Barnet

Wood and finish unidentified

The Henry Francis du Pont Winterthur Museum

H 38⅞, W 25⅝, D 16⅛

Photo: Courtesy, Winterthur Museum

Sampson Barnet was a skilled and prolific Windsor chairmaker who worked during the fourth quarter of the eighteenth-century. Branded examples of his fan-back, sack-back, and bow-back chairs are in public and private collections. This chair has several distinctive Barnet features: shouldered tenons on the sack ends, three arm spindles at the sides (instead of the customary two), slightly fanned out back spindles (a conscious effort to fill the sack), and long baluster leg turnings with short leg tapers, which necessitated the low stretcher placement.

The sack piece is carefully tapered for fullness, the knuckle carvings are of two pieces, and the legs penetrate the adequately saddled oval seat. Although the turnings are ordinary, they are suitable to this handsome chair.

## 49. Sack-Back Chair

Alexandria, Virginia, about 1786

Ephraim Evans

Seat—pine; legs, stretchers, arm supports—maple; arm rail, spindles, sack—ash.

Bernard and S. Dean Levy, Inc., New York

H 35¾, W 24½, D 16½

Photo: Helga Photo Studio

The name Ephraim Evans is stamped and labeled on the underside of the seat of this sack-back chair. The brand along with a paper label tends to certify that the chair is a genuine period piece made by Evans. The expense of having a brand made and labels printed suggests that there were other marked Evans Windsors but to my knowledge, none has as yet been pictured or discovered. Could this chair be the lone survivor of Evans's work?

In 1785, Evans moved from Philadelphia to Alexandria, Virginia, where he set up shop and advertised in an Alexandria newspaper that he was a Windsor chairmaker, "lately from Pennsylvania."[3] He may have relocated his business to get away from the competition in Philadelphia and out of the mainstream of Windsor chair production.

The origin of the chair has been ascribed to Virginia, although it could have been made in Philadelphia. It seems logical to assume that Evans transported chair parts and assembled chairs to Alexandria along with tools, patterns, and technical knowledge, including a familiarity with and preference for certain Windsor features.

The chair is strikingly similar to a branded Francis Trumble sack back in the

54

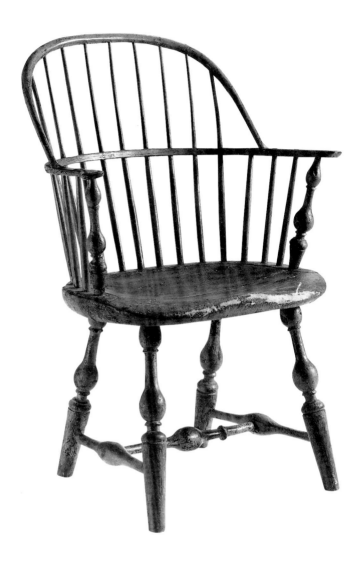

Independence National Historical Park Collection.[4] The two chairs are so much alike that one wonders if Evans served an apprenticeship under Trumble, possibly working in his establishment as a journeyman before moving on to Virginia.

This chair has nine back spindles, six arm spindles, carved knuckle hand holds, and very stocky turnings—all features Trumble used on many of his sack backs. The arm supports and legs are assembled with typical through-mortise-and-tenons with their exposed ends wedged. For added security the critical sack-to-arm-rail joints are pinned from the side, through the tenons.

Like so many Windsors, when the popularity of these chair declined, they were unappreciated and often mistreated, which is the case with this chair. The legs were shortened to remove some of their ends, which had rotted as the result of exposure to a damp dirt floor.

## 50. Sack-Back Chair

New York City, 1783–90

Probably Thomas and William Ash

Seat—poplar; legs, arm supports, stretchers—maple; arm rail, spindles, sack—oak. Finish unidentified.

Private collection

H 34, W 21⅜, D 16¼

Photo: Supplied by owner

Although unmarked, this sack back is probably the work of brothers Thomas and William Ash, who worked in New York City during the late 1780s.

There were not many New York sack backs produced, probably because the market was supplied by Philadelphia chairmakers who exported an enormous number of "Philadelphia chairs," which included sack backs.

Nevertheless, New York chairmakers produced some of the most handsome sack backs and although the chairs are imitative of Philadelphia work, they have their own distinctive characteristics. Generally the seats have a shallower cavity, a lower pommel, and rounder edges than their Philadelphia counterparts. Flat side-scrolled hand holds with undercut bevels were preferred over carved knuckles. The most prominent features, the ones that became the hallmark of New York Windsors, are the remarkably large bulbous turnings and deep reels set off by sharp cusps on the arm supports and legs. These were also used on New York bow-back and continuous-bow armchairs. Each of the stretcher pieces has a similar bulbous turning; the medial stretcher piece also has large flanking ring turnings.

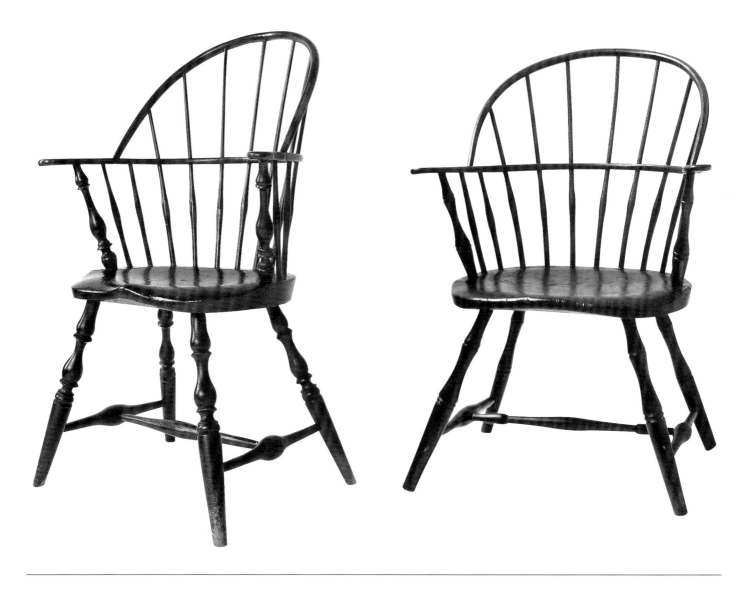

## 51. Sack-Back Chair

Lisbon, Connecticut, about 1795

Branded EB [Ebenezer]: Tracy (1744–1803)

Seat, stretchers—chestnut; legs, arm supports—maple; arm rails, spindles, sack—hickory. Late nineteenth-century black paint over white.

Private

H 36½, W 25¼, D 21

The initials and name "EB: Tracy" are branded under the seat of this classic sack-back chair. Ebenezer Tracy was the preeminent Windsor chairmaker in Connecticut and made this chair about 1795. Ebenezer had three wives (two of whom he outlived) and nine children, three sons and six daughters. He, along with his sons, nephew, and apprentices produced a great many fan backs, sack backs, bow backs, continuous-bow armchairs, writing-arm chairs, and settees. They also produced some other household furniture in addition to doing carpentry. The chair has the

usual features found on Tracy pieces: well-executed leg turnings and matching arm supports with large bulbous balusters, deep reels and sharp cusps, stop-tenoned legs assembled to well-saddled heavy edge-chamfered chestnut seats, no gouge-cut cove to isolate the spindle area, spindles with well-defined bulbous sections, double rings at the lower end of the arm supports, and side-scrolled hand holds.

The seven sack spindles are attractively spaced in a fanlike pattern and the arm supports and arm spindles thrust prominently forward. Sack-back Windsors of this quality are scarce, expensive, and greatly appreciated. (Tracy used six back spindles on his comb-back and writing-arm chairs; seven on fan backs and sack backs, and eight on unbraced bow and continuous-bow armchairs.)

## 52. Sack-Back Chair

Lisbon, Connecticut, about 1800

Branded E [lijah] Tracy (1766-1807)

Seat—chestnut; legs, arm supports, stretchers—maple; arm rail, spindles, sack—hickory. Late walnut-color varnish stain over red paint.

Oveda Maurer Antiques

H 34, W 24, D 20¼

The brand E. Tracy is found on the underside of the seat of this sack-back chair. The E. identifies Elijah Tracy, Ebenezer Tracy's first child. Elijah served an apprenticeship under his father, was in his employment for a time, and later established his own business on the family grounds. Upon his father's death he inherited property which he later sold. He moved to Paris, New York, where he may have continued the chairmaking trade. Known mainly for his chairs, he also engaged in a variety of wood-related occupations and produced a diversity of furniture forms. Some idea of

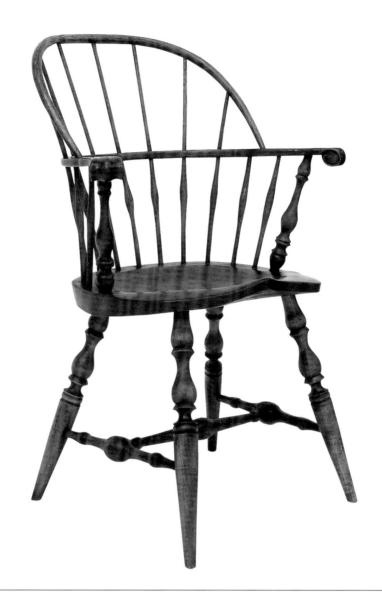

his chairmaking success can be gleaned from records that indicate that in 1799 he purchased four wood-turning lathes.[5]

On this chair the bamboo-style turnings have a bead on their lower node. This bead seems to be an exclusive Tracy characteristic and has become something of an identifying trade mark. The bead is also found on the arm supports and legs.

The two outer back spindles are stop-tenoned to the bent sack and the others penetrate and are wedged cross grain. The arm rail is attractively thin, has side-scrolled hand holds, and is supported by tenon-wedged arm spindles and arm supports. The generously splayed socketed legs are braced with plain turned nonbamboo-style side stretchers and a long arrow-tipped medial stretcher. The less attractive rear legs have smaller diameters.

## 53. Sack-Back Chair

Connecticut, 1800

Maker unidentified

Seat—unidentified hardwood, probably sycamore; legs, arm supports—maple; stretchers, spindles, arm rail, sack—red oak. Traces of red paint covered with mahogany stain.

Mahlon and Isabel Pool

H 36½, W 25½, D 23

Though unbranded, this sack back has many features similar to Tracy-made chairs and may have been built in his shop. The three center sack spindles penetrate the sack and are cross-wedged, while the outer sack spindles are stop-tenoned. As previously mentioned, through-tenoning these spindles would have required removing considerable wood, thereby seriously weakening the sack. For fullness, the prominent well-carved knuckle hand holds have an applied piece double-pinned to their underside. Shaping the comfortable-

looking seat of a hardwood must have been a difficult task for the chairmaker, but the crisp seat edges have lasted, due, no doubt, to the wearing qualities of the material. All the turning details are exceptionally crisp and nicely matched; the more impressive legs are placed in front. The arm supports have a V-groove below the main baluster, another feature found on Tracy chairs.

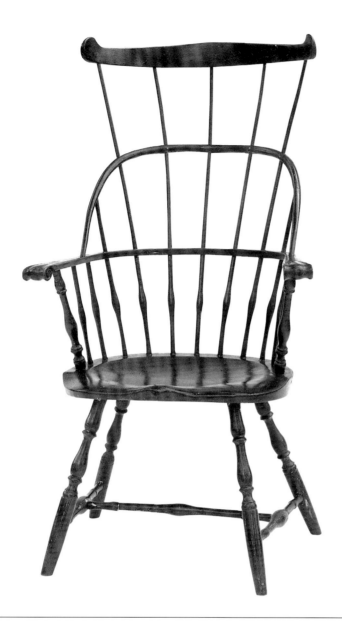

## 54. Sack-Back Chair with Comb

Connecticut, about 1790

Maker unidentified

Seat—pine; legs, arm supports, stretchers—maple; arm rail, spindles, sack, crest rail—oak. Green paint over old white, over green, over original red.

Mahlon and Isabel Pool

H 43⅜, W 24, D 24

Though unmarked, this sack-back chair also has Tracy-like features and surely was made by someone influenced by his work. The upturned ears, boldly carved knuckle hand holds, bulbous spindles, double-ring turnings on the arm supports, and arrow-ended stretchers are typical Tracy forms. However, the legs, which penetrate the seat, and the rather ordinary uninspired turnings are uncharacteristic of a Tracy chair. With the exception of comb backs and low backs, the innovative comb was used only occasionally on Windsor chair

forms. The ends of the sack are wedged to the arm rail and the center spindle is pinned (from the back) to the sack and arm rail. The hole in the sack for this pin is bored off-center, causing the pin to nick slightly the side of the spindle, which avoids weakening the sack. This is good construction technique and was commonly used.

## 55. Sack-Back Chair

Probably Connecticut, about 1790

Maker unidentified

Seat—pine; legs, arm supports, stretchers—maple; spindles, sack—hickory; arm rail—oak. Light green paint.

Kinnaman and Ramaekers Antiques

H 37⅛, W 20½, D 22

This stately sack back has many attractive features. The abruptly swelled spindles are a typical pattern found on Connecticut Windsors and, interestingly, they have an attractive form in that they taper, swell, then thin and flare before entering the seat. The flanking back spindles are stop-tenoned to the seat, as is customary on sack backs, and are pinned to a quite thin arm rail, which terminates in side-scrolled hand holds. The small oval seat is boldly saddled, has a pronounced pommel, and holds tenon-wedged arm supports and legs. Turning details on the supports and legs

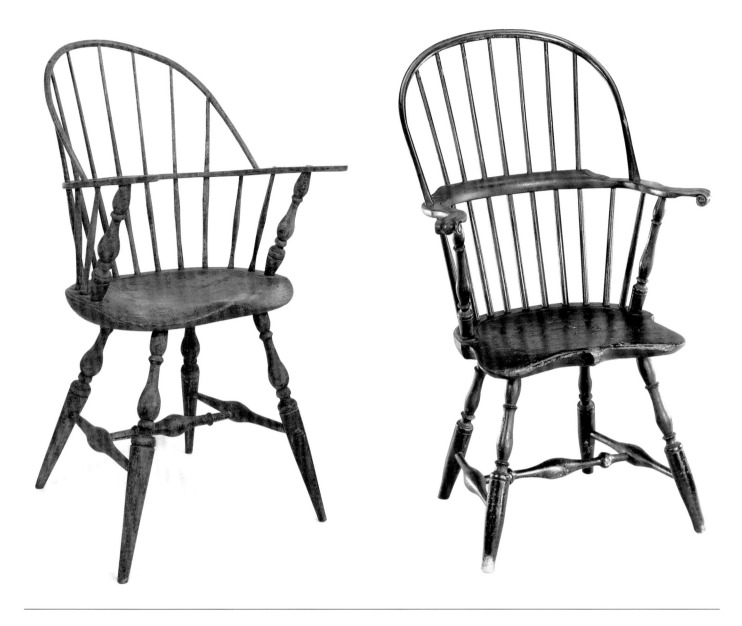

are crisp, skillfully matched, and wonderfully angled. However, the cusp form (located immediately below the baluster) seems somewhat suppressed.

## 56. Sack-Back Chair

Probably Rhode Island, about 1790

Maker unidentified

Seat—poplar; legs, arm supports, arm rail, arm crest, stretchers—maple; sack, spindles—ash. Black paint over remnants of green.

Colonial Williamsburg Foundation

H 40⅜, W 19⅛, D ?

Photo: Colonial Williamsburg

The sawn arm rail and arm crest on this sack back make the chair very collectable. This construction feature was used on other Windsor chair forms (see figs. 10 and 19). Actually, the chair could just as readily been a comb back or a low back. If the sack were eliminated and the spindles capped with a crest rail, this would be a comb back; socketing the back spindles into an arm rail would make it a low back. The through tenons at the ends of the sack are shouldered and wedged to the arms to add strength and longevity to a critical joint.

An additional piece of wood was applied to the underside of the hand holds to provide fullness to the beautiful carved knuckles, which are also emphasized by the undercut on the arms. The peaked scalloped front edge on the shield-shaped seat is distinctive and eye catching. The comfortable seat is adequately scooped with rounded and slanted ramps at each side of the pommel. The leg- and arm-support turnings are nicely matched and are tenon-wedged to the seat. The somewhat too heavy lower end of the legs is only slightly tapered and suggests a Rhode Island origin.

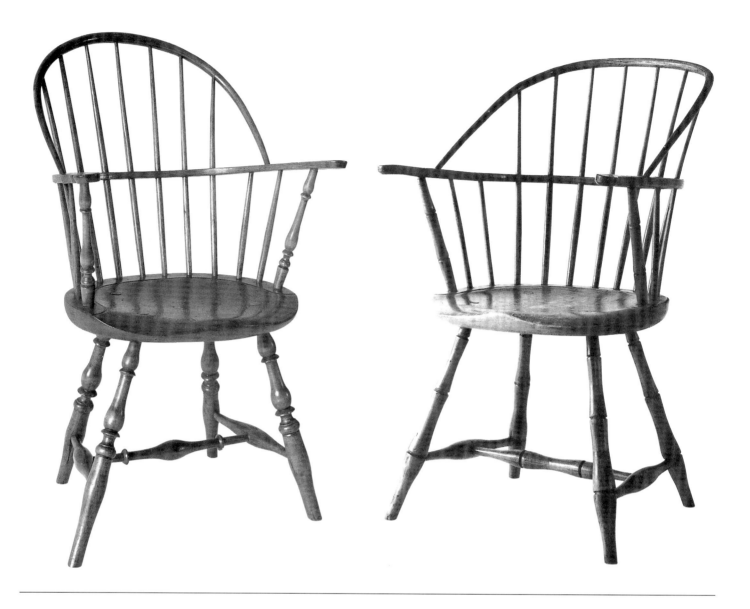

## 57. Sack-Back Chair

Rhode Island, about 1790

Maker unidentified

Seat—pine; legs, arm supports, stretchers—maple; spindles, sack—hickory; arm rail—red oak. Original green paint stripped, now clear varnish.

Dr. Donald Bond

H 37½, W 24½, D 21⅞

"Stately" and "elegant" best describe this Rhode Island sack-back chair. The leg turning was a new style at the time of its manufacture. From the small shoulder upward, the chair is in the typical double-baluster style, but from the shoulder to the floor there is a different foot design, one considered the most attractive of Windsor leg styles. This Rhode Island leg pattern was used extensively on bow backs (see fig. 70) and on continuous-bow armchairs (see fig. 97). A large bead surmounts a dual concave tapered leg with an enlarged center holding the side stretchers. Other

features of the chair are the slightly swelled tapered spindles that are angled rather than fanned, scrolled hand holds, slender arm supports, and a bulbous center stretcher with cusps, whose undercut sides turn inward.

## 58. Sack-Back Chair

Boylston, Massachusetts, 1799

Levi Prescott (1777–1823)

Seat—bass wood; legs, arm supports, stretchers—maple; arm rail, sack, spindles—hickory. Stripped and clear finish

Dennis and Louise Paustenbach

H 35⅞, W 21⅞, D 21½

A paper label on the undersurface of the seat of this sack-back chair reads: LEVI PRESCOTT CABINET & CHAIR MAKER, BOYLESTOWN, 1799.

The bamboo-type (double-bobbin) turnings on the arm supports and center stretcher and triple-bobbin turnings on the

legs are a distinctive feature of this chair, as are the long deep concave forms between the V-cut nodes. Also different is the place where the sack joins the arm rail. Nearly all sack backs have one, or more often two, arm spindles in front of this assembly point; this chair has none. This is likely to be a design preference, which can be verified by examining another identical Prescott sack back,[6] but was it imposed from structural necessity to avoid breaking the bow during assembly? Regardless of the cause, the location of the sack ends and the nearly vertical back spindles have created large openings.

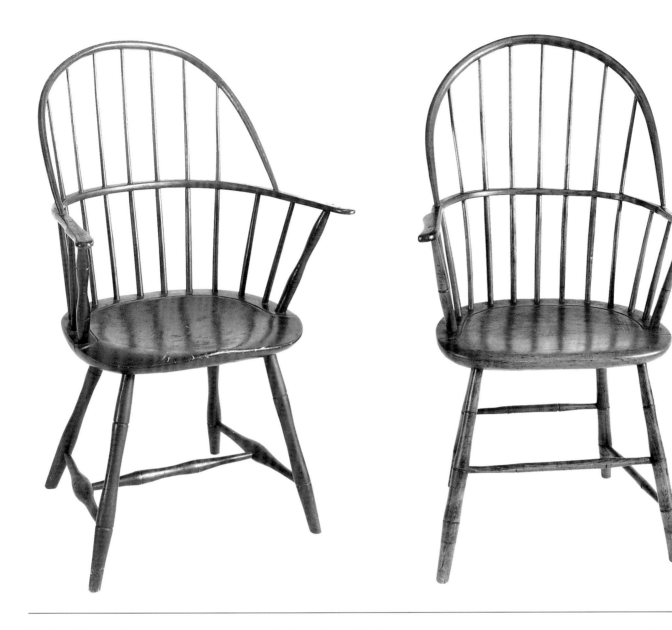

## 59. Sack-Back Chair

New England—probably Massachusetts,
about 1796

Maker unidentified

Seat—Pine; legs, arm supports, stretchers—
maple; arm rail, sack, spindles—hickory. Green
paint over original dark green paint.

Pocumtuck Valley Memorial Association,
Memorial Hall Museum, Deerfield,
Massachusetts

H 36, W 24⅜, D 20

The modest bamboo-turning pattern on
this sack-back chair is typical of a new
furniture style. Sack backs with baluster
turnings continued to be popular and were
produced along with the newer bamboo
style; in fact the seat and arm rail of this
chair could easily have been fitted with
baluster turnings. Generally speaking, the
two-node bamboo-style turning appeared
before the three-node turning and the H-
stretcher plan of the legs preceded the box
design.

## 60. Sack-Back Chair

New England—probably Massachusetts,
about 1800

Maker unidentified

Seat—pine; legs, arm supports—maple; arm rail,
sack, spindles—hickory; stretchers—oak.
Original finished stripped and clear varnish.

Pocumtuck Valley Memorial Association,
Memorial Hall Museum, Deerfield,
Massachusetts

H 39½, W 23½, D 20

Like the previous figure, this sack back also
has bamboo-style turnings but in this
example the legs are assembled in the box-
stretcher plan. The legs have three nodes,
the stretchers, two, and the arm supports,
one. The leg nodes indicated where holes
for the stretchers were to be bored. The
legs are socketed to the seat, the arm
supports are tenon-wedged to the seat, and
the arm rail and the five central back
spindles, as well as the four arm spindles,

are wedged to the sack and pinned to the
arm rail. The oval seat is slightly hollowed
with little if any pommel, has a single
incised groove, and holds nicely fanned
spindles.

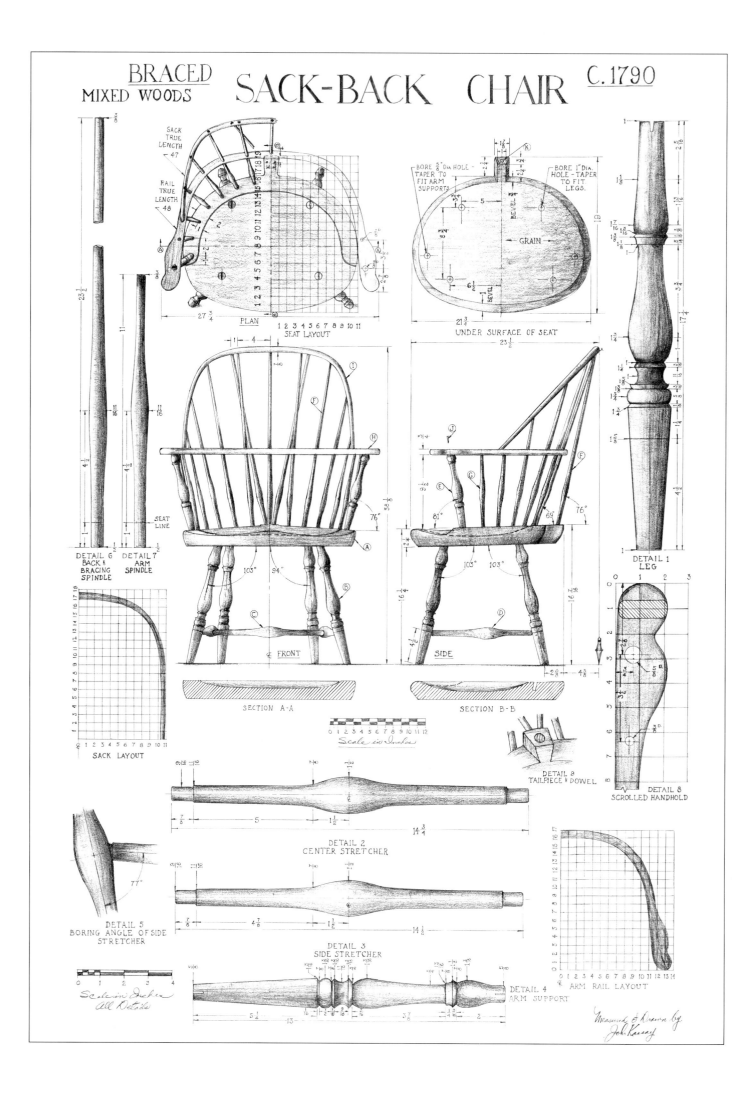

# BRACED SACK-BACK CHAIR C.1790
## MIXED WOODS

## 61. Braced Sack-Back Chair

Rural Connecticut or Massachusetts, 1780

Maker unidentified

Seat, stretchers—chestnut; legs, arm supports—maple; arm rail, sack, arm spindles, back spindles, bracing spindles—hickory; wedges—maple. Traces of black, green, and white paint, now stripped.

Author's collection

H 38⅛, W 27¾, D 23½

This braced sack-back chair was probably made in rural Connecticut by a country handyman with moderate woodworking skills and limited knowledge of Windsor styles and their structural complexities. Nevertheless, the chair is rare and unique. The bracing spindles put the chair in an exclusive category—only one other braced sack back, which is not a close likeness, is known.[7] An equally unconventional feature of this chair is that the tail piece, which supports the bracing spindles, is not a separate piece of wood but was fabricated out of the seat blank.

The short cross grain of this extension makes the piece vulnerable to breaking and thereby defeats its purpose. However, the chairmaker realized this potential and installed a large dowel through the tail piece into the seat. This is an easy and effective way of introducing strength to the tail piece but one wonders why the chairmaker chose to make the tail piece in this manner in the first place? Did he not know about the customarily used mortise-and-tenon joint? Did he lack the skill to lay out and produce such a joint? Or was he simply reluctant to reduce the width of a nice wide board?

The arm supports and arm spindles penetrate the arm rail and are wedged. The back and bracing spindles go through the arm rail and the sack and also are wedged. On most sack backs the two outer back spindles are stop-tenoned to the sack. As previously mentioned, boring a hole through the sack for these spindles introduces the risk of breaking the sack during assembling and also weakens the sack, increasing thereby the chance of joint failure. Fortunately the chair has survived in its original form with only minor repairs.

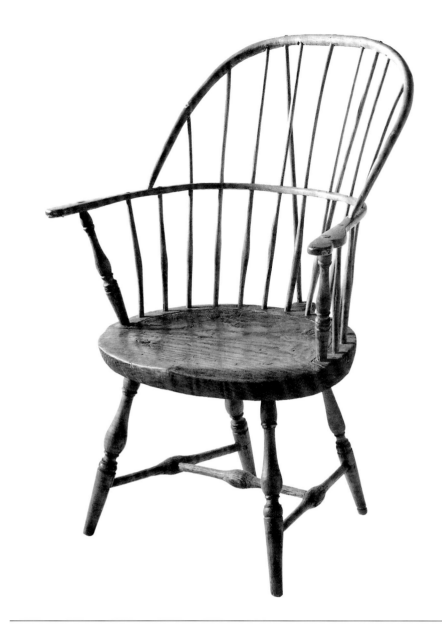

| Letter | No. | Name | Material | T. | W. | L. |
|---|---|---|---|---|---|---|
| A | 1 | seat | chestnut | 2¼ | 19 | 21¾ |
| B | 4 | legs | maple | 1¾ dia. | | 17¼ |
| C | 1 | center stretcher | chestnut | 1½ dia. | | 14¾ |
| D | 2 | side stretchers | chestnut | 1½ dia. | | 14½ |
| E | 2 | arm supports | maple | 1¹³⁄₁₆ dia. | | 13 |
| F | 11 | spindles | hickory | ¹¹⁄₁₆ dia. | | 23½ |
| G | 4 | arm spindles | hickory | ¹¹⁄₁₆ dia. | | 11 |
| H | 1 | arm rail | hickory | ¾ | 2³⁄₁₆ | 48 |
| I | 1 | sack | hickory | ⅞ dia. | | 47 |
| J | 26 | wedges | maple? | assorted sizes | | |
| K | 1 | tailpiece pin | maple | ¾ dia. | | 4 |

# 5 Bow-Back Chairs

## Introduction

The American bow-back Windsor chair is a descendant of the English pierced back-splat bow-back Windsor. First introduced and developed in Philadelphia in the 1780s during the Federal period, the style was readily accepted there and became popular as common inexpensive seating.[1] Originally these chairs were known and advertised as Philadelphia oval backs and later as loop, hoop, balloon, and kinked backs. Their popularity quickly spread throughout the states. They were the second Windsor side-chair pattern (fan backs were first) but they were the first style to be mass produced and, judging from the number of surviving examples, they were the most popular Windsor chair style, especially in the side-chair form.[2] Bow-back Windsors are identified by their one-piece curved bow, the ends of which are tenon-wedged into holes located near the rear of a shaped seat. The bow contains a number of vertical spindles that are socketed to the bow and the seat. Matching armchairs were also made and both styles were available with angled bracing spindles. The seats of armchairs are wider than those of side chairs and the chairs usually have clear-finish mahogany arms. Baluster-style leg turnings were shortly replaced by the simplified, quickly produced, bamboo patterns, an obvious response to the Oriental influence. To further simulate bamboo, many of these bow backs were painted a straw color.

Bow backs are the most popular and longest lasting Windsor style and are still being made and enjoyed today.

## 62. Bow-Back Side Chair

Lisbon, Connecticut, about 1810

Branded A. D. Allen (1774–1855)

Seat—pine; legs—maple; side stretchers—chestnut; center stretcher—ash; bow, spindles—red oak. Clear varnish over brown maple stain over green paint.

Blue Candlestick Antiques

H 37½, W 17⅞, D 18⅝

The name A. D. Allen is branded on the seat bottom of this bow-back side chair. Amos Denison Allen served an apprenticeship (1790–1795) under Ebenezer Tracy, his future father-in-law.

Allen used pine for the seat, which is a deviation from Tracy's preference of chestnut for his seats. The center stretcher is a replacement and the legs have lost

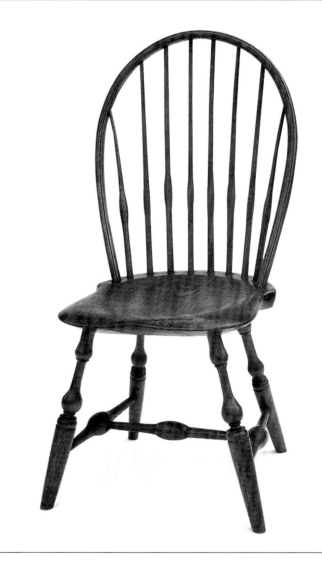

| Letter | No. | Name | Material | T. | W. | L. |
|---|---|---|---|---|---|---|
| A | 1 | seat | pine | 1¹¹⁄₁₆ | 16¼ | 16⅞ |
| B | 2 | front legs | maple | 1¾ dia. | | 17⅜ |
| C | 2 | back legs | maple | 1⁹⁄₁₆ dia. | | 17⅜ |
| D | 2 | side stretchers | chestnut | 1¾ dia. | | 14½ |
| E | 1 | center stretcher | ash | 1¾ dia. | | 14½ |
| F | 8 | spindles | red oak | ¾ dia. | | 21½ |
| G | 1 | bow | red oak | ⅞ | 1³⁄₁₆ | 57¼ |
| H | 4 | leg wedges | hardwood | ⅛ | ⅞ | ½ |
| I | 2 | bow wedges | hardwood | ⅛ | ¾ | ¾ |
| J | 4 | bow pins | red oak? | ⅛ dia. | | 1³⁄₁₆ |
| K | 2 | seat pins | red oak? | ³⁄₁₆ dia. | | 2⅛ |
| L | 4 | spindle wedges | red oak? | 1⁄₁₆ | ⅜ | ½ |
| M | 3 | spindle locking pins, bow | red oak? | ⁵⁄₃₂ dia. | | ⅞ |
| N | 8 | spindle locking pins, seat | hardwood | ⅛ dia. | | 1½ |

approximately an inch. The bulbous part of the back spindles forms an attractive arc that echoes the curve of the oval bow. The four inner spindles penetrate the bow and are wedged; the others are stop-tenoned to the bow. The length of these spindles and the depth of the holes had to be closely coordinated for proper assembly. Pins at the ends of the bow into the seat were

added later to strengthen the back. The bow face is beaded and the back is rounded over—the outer edge more than the front. There is an appreciable difference in the diameter of the legs. The more attractive legs were assembled in the front where they were most visible. This was a common practice among Windsor chairmakers.

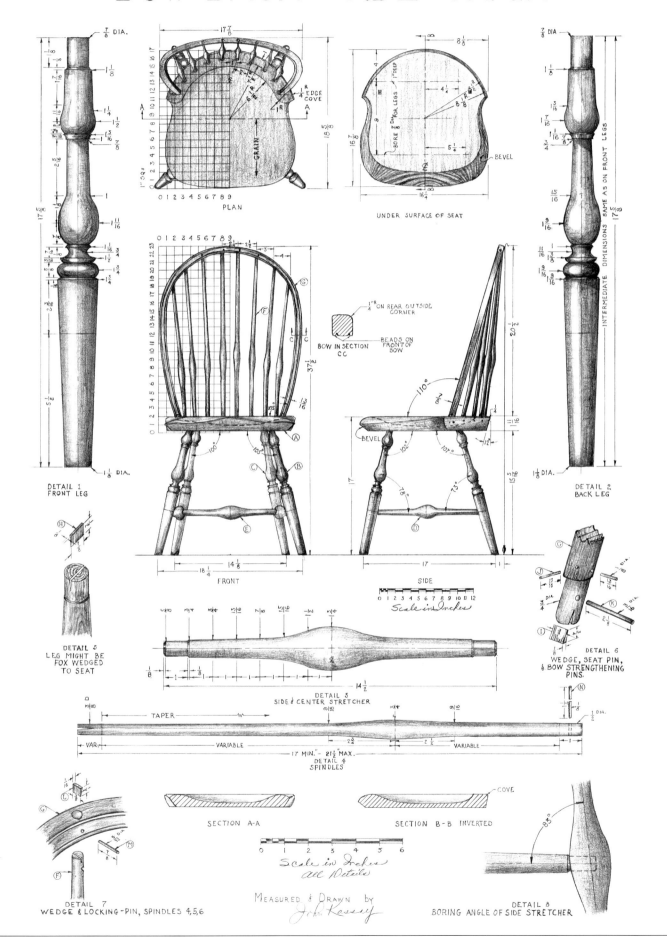

MIXED WOODS
CIRCA 1810

# BOW-BACK SIDE-CHAIR

BRANDED
A.D. ALLEN

DETAIL 1
FRONT LEG

DETAIL 2
BACK LEG

PLAN

UNDER SURFACE OF SEAT

GRAIN

EDGE
COVE

BORE 7 DIA. FOR LEGS

BEVEL

BOW IN SECTION
CC

1"R ON REAR OUTSIDE CORNER

BEADS ON FRONT OF BOW

FRONT

SIDE

BEVEL

Scale in Inches

DETAIL 6
WEDGE, SEAT PIN, & BOW STRENGTHENING PINS.

DETAIL 3
LEG MIGHT BE FOX WEDGED TO SEAT

DETAIL 5
SIDE & CENTER STRETCHER

TAPER

VAR.

VARIABLE

17 MIN." — 21½" MAX.

VARIABLE

DETAIL 4
SPINDLES

SECTION A-A

SECTION B-B INVERTED

COVE

Scale in Inches
All Details

Measured & Drawn by
John Kassay

DETAIL 7
WEDGE & LOCKING-PIN, SPINDLES 4,5,6

DETAIL 8
BORING ANGLE OF SIDE STRETCHER

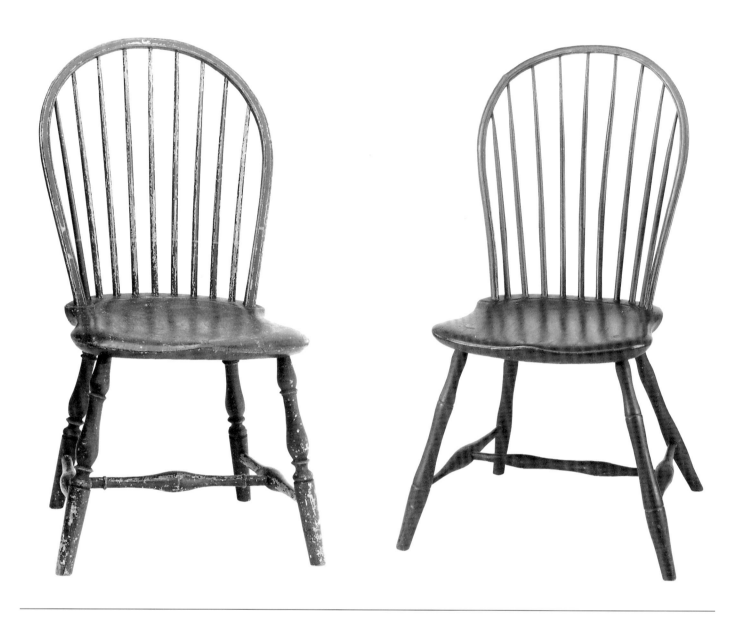

## 63. Bow-Back Side Chair

Probably Philadelphia, about 1780

Maker unidentified

Seat—pine; legs, stretchers—maple; bow, spindles—hickory. Dark green paint with seat highlighted in red over straw-color paint—all well chipped.

Mr. and Mrs. Jim Dougherty

H 35⅞, W 19¾, D 21

The thick neck on the main baluster of the legs suggests this bow-back chair was made in Pennsylvania—possibly Philadelphia or Pittsburgh. The low, wide back, the wide seat, and the placement of the short legs, which probably have been cut down, give the chair a low, boxy look. The close corner location of the front legs is reminiscent of English Windsors. The seat profile, the shape of the edge, and the dishing are all nicely realized. The long straight section on the bow is not unusual. Taken together, all parts of the chair make it more than a nondescript bow back.

## 64. Bow-Back Side Chair

Philadelphia or Delaware, about 1800

George Young

Woods and finish unidentified

The Henry Francis du Pont Winterthur Museum

36½, W 20¾, D 19¼

Photo: Courtesy, Winterthur Museum

This bow-back side chair was made by George Young, a cabinetmaker working in Philadelphia[3] and Delaware.[4] The chair features a tall, slightly pinched bow, tapered spindles slightly swelled below their center, a simplified shield-pattern seat with moderate saddling, bamboo two-node turnings, and awkward overly splayed legs.

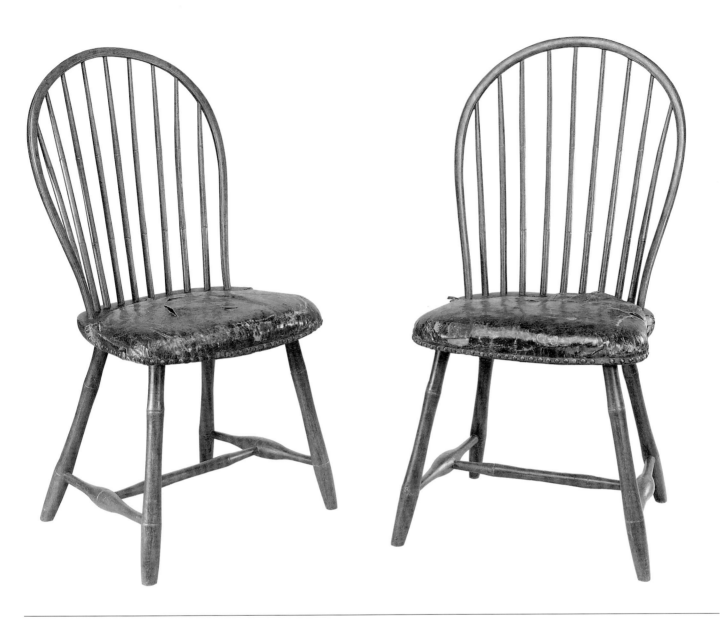

## 65. Bow-Back Side Chairs

Philadelphia or Delaware, about 1791

Attributed to John Letchworth (1759–1843)

Woods and finish unidentified. Leather upholstery.

Bernard and S. Dean Levy, Inc., New York

Size undetermined

Photo: Helga Photo Studio

Although unmarked, these upholstered bow-back side chairs have characteristics similar to those found on branded Windsors made by Philadelphia chairmaker John Letchworth, who was active from 1785 to 1805. Letchworth was one of Philadelphia's most prolific, creative, and successful Windsor chairmakers. He made no less than eight distinct Windsor chair patterns in addition to settees and at least one cradle.[5] These chairs may be two of a number he made for the New City Hall in Philadelphia, erected in 1791. On these chairs the bows are round in section and slightly pinched, the spindles, legs, and medial stretchers have two bamboo grooves, and the plain bulbous centered side stretchers are secured to well-raked legs. Upholstered chairs of this plain style were inexpensive, sturdy, reasonably comfortable, and useful in public buildings as well as private residences. They were advertised as having "stuffed seats" and were covered with fabric or colored leather.

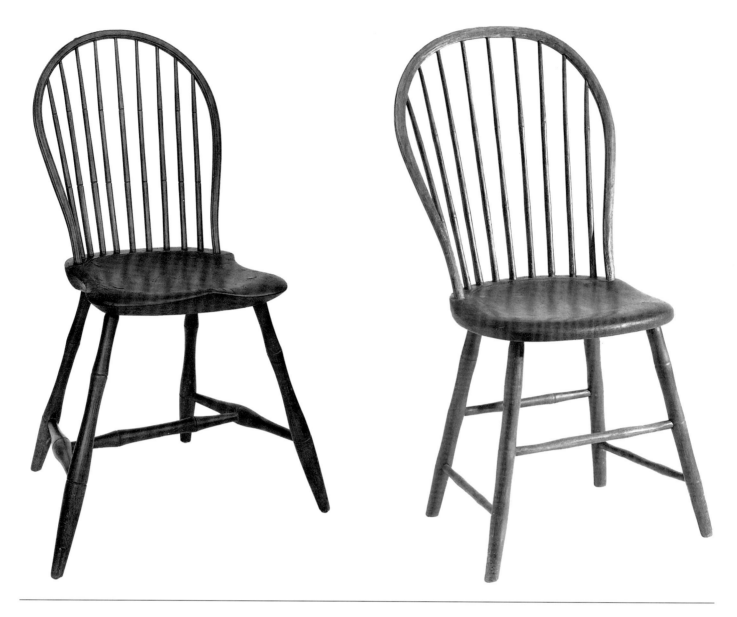

## 66. Bow-Back Side Chair

Philadelphia, 1799

Robert Taylor

Seat—pine; legs, stretchers—maple; bow, spindles—hickory. Yellow paint over gray green, over original salmon undercoat.

Blue Candlestick Antiques

H 44⁷⁄₁₆, W 25½, D 24¼

Remnants of a paper label dated 1799 are on the underside of this bow-back side chair. The label reads:

Windsor and Fancy chairs and Settees, wholesale and retail. ROBERT TAYLOR—Windsor and Fancy chair maker informs his friends and the public that he continues to carry on the Windsor and Fancy chair making business in all its various branches and upon the most reasonable terms —at No. 99 South Front Street (near Walnut Street), where he constantly [has] —on hand the most fashionable plain gilt and

[illegible] chairs. Orders from masters of vessels and others who may favor him with customs shall be attended to with accuracy and dispatch.

Except for the nine-spindle back, features of this Robert Taylor bow-back side chair are very similar to bow backs made by Philadelphia contemporaries Gilbert and Robert Gaw. Those brothers made twenty-seven seven-spindle bow backs for former President George Washington for use at Mount Vernon.[6] Due to competition, a considerable amount of copying took place among Windsor chairmakers and correct attribution is often impossible. That is not a problem in this case, as both Taylor and the Gaw brothers branded their works. The fine qualities of this chair are the cyma-curved bow, which is round in section with a double-beaded flat front, the attentively turned spindles, the legs and center stretchers with double bamboo grooves, and the side stretchers with their typical enlarged centers. The seat is exceptionally

well sculptured, with deep saddling, a high pommel, and sharp reverse-curved front edges. The only unattractive feature of the chair is its excessively raked legs.

## 67. Bow-Back Side Chair

Philadelphia, about 1805

[Samuel] Moon

Seat—poplar; legs, stretchers—maple; bow, spindles—hickory. Finish undetermined.

Chester County Historical Society, West Chester, Pennsylvania

H 37, W 15½, D 16

Photo: George J. Fistrovich

The name Moon is branded on the seat of this bow-back side chair and is attributed to Samuel Moon who, along with David Moon, worked in Philadelphia from 1803 to 1807.[7] The chair is an interesting variant of the Philadelphia bow-back form in that it was fabricated from two different

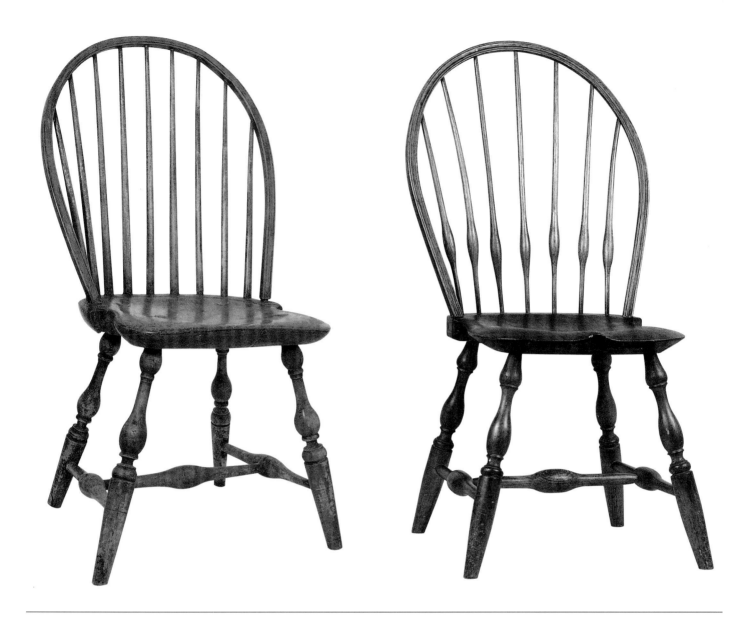

Windsor style subassemblies. The seat is oval and has a box stretcher; the back has a typical Philadelphia pinched bow with nine bamboo-turned spindles. Seats on bow backs of this period were generally shield-shaped with well-defined saddling and H stretchers, where as on rod backs (a Windsor style that was emerging at this time) the seats were oval or very slightly shield-shaped, with little if any saddling and box stretchers. Making chair parts that could be used in more than one style was both economical and common practice among chairmakers. Moon also used these components on his bow-back armchairs (see fig. 86). A matched set of four bow-back side chairs with the same seat and stretcher components, but branded J. Burden, Philadelphia, were advertised for sale, proof that interchanging parts was practiced not only by Moon.[8] (Burden was in partnership with Francis Trumble in 1796.)

## 68. Bow-Back Side Chair

New Brunswick, New Jersey, about 1797

Branded Ward [Joseph]

Seat—pine; legs, stretchers—maple; bow, spindles—hickory. Partially stripped of original pea-green paint.

Kinnaman and Ramaekers Antiques

H 34, W 19, D 19½

This chair is shorter and broader than bow backs made in other Windsor chairmaking centers and has very large bulbous leg turnings. These features, especially the robust leg turnings, are typical of bow backs made in New York City and indicate that Ward was familiar with and probably influenced by what was taking place on the Windsor scene across the Hudson River.

## 69. Bow-Back Side Chair

New England, about 1795

Unmarked but similar to a chair made by William Seaver of Boston

Seat—pine; legs—maple; bow—hickory; stretchers, spindles—chestnut. Finish unidentified.

John Keith Russell Antiques

Size undetermined

On this bow-back side chair, the abrupt swelling of the back spindles in the otherwise very thin tapered sections is most uncommon and represents what must have been a challenge for the chair's maker.

The double-beaded bow has shouldered tenons, which are wedged and pinned to a well-sculptured shield-shaped seat. The seat lacks an isolating groove cut and the legs are stop-tenoned. The leg turnings are accomplished but the legs may have lost a bit of their original length. The sausage-shaped turnings on the stretchers contribute to the chair's interest.

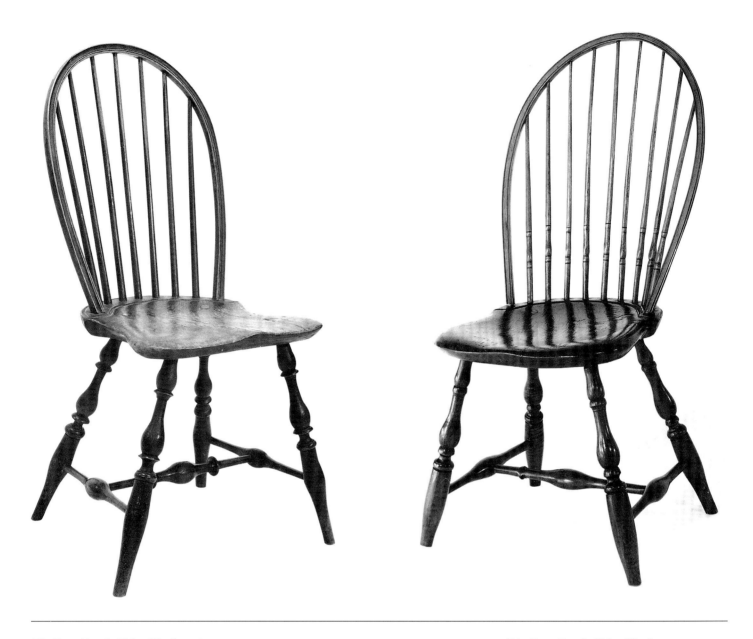

## 70. Bow-Back Side Chair

Duxbury, Massachusetts, about 1790

Maker unidentified

Seat—pine; legs, stretchers—maple; bow, spindles—hickory. Black paint.

Fine Arts Museum of San Francisco, Gift of the descendants of John T. Porter, son of Anne Thomas Porter (1991.53)

H 38, W 20¾, D 20⅛

The bend in the bow of this handsome chair is a constant curve and has attractively molded beaded edges with a concave center. It is shoulder-tenoned to an equally attractive sculptured seat and holds seven plain tapered spindles. The side stretchers are turned in the common bulbous center pattern, and the center stretcher has unusually large waferlike turnings. Although not particularly pleasing, they are the mark of an accomplished turner. The sharp edges on the large cusps on the legs are further evidence of the turner's extraordinary skill. The chair carries a Massachusetts provenance but the leg pattern is Rhode Island in style. The chair is a wonderful example of the chairmakers' craft.

## 71. Bow-Back Side Chair

Rhode Island, about 1795

Maker unidentified

Seat—pine; legs, stretchers—maple; bow, spindles—hickory. Clear varnish over original stripped paint.

Oveda Maurer Antiques

H 37½, W 18¼, D 20¾

On this Rhode Island chair the bow straightens out before it enters the seat. As is typical, it is tenoned to the seat, as are the lathe-turned pipestem spindles. This spindle pattern had to be lathe-turned rather than shaved. It is found on bow-back armchairs and, less often on low backs and continuous-bow armchairs. The seat is nicely saddled and has sharp edges and heavy beveling; the turnings on the undercarriage, however, lack distinction. Unfortunately the legs have lost some of their attractive Rhode Island concave foot.

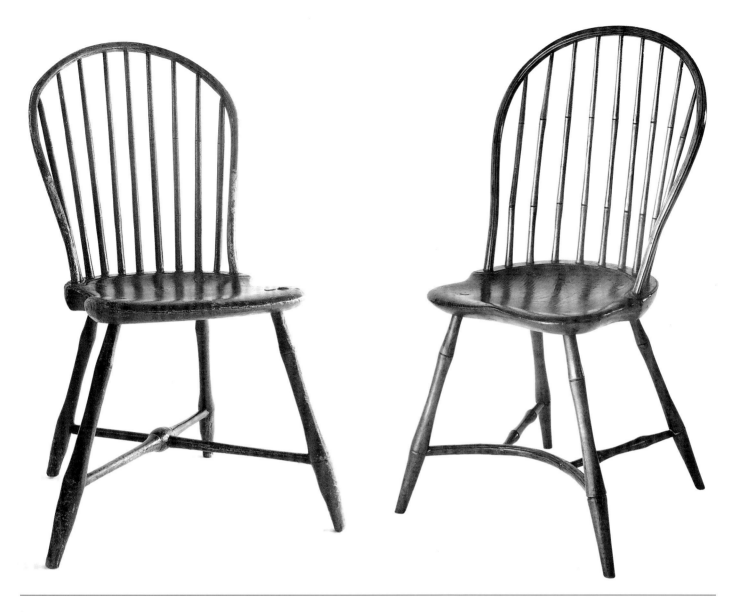

## 72. Bow-Back Side Chair

Massachusetts or Rhode Island, about 1790

Maker unidentified

Seat—pine; legs, stretchers, spindles—maple; Bow—maple? Brown over tan over original green paint.

Mr. and Mrs. Thomas M. Harrison

H 37, W 23½, D 21

One's attention is immediately drawn to the unusual X or cross-stretcher arrangement on this chair. Chairs with this stretcher pattern are very rare, never having been produced in great numbers and, probably, built in only one shop. This stretcher plan began with eighteenth-century English and American corner chairs and was added onto Rhode Island low-back Windsors whose joinery was much more complicated (see fig. 20). This stretcher style on Windsors was an innovative departure from the traditional H- or box-stretcher plan. The X-stretcher pattern is formed with two long stretchers, one passing through the enlarged center of the other and pinned in place. Stretcher ends are tenoned into the legs and pinned from the side. The bow, spindles, seat, and leg patterns are typical New England Windsor forms. The chair has survived two centuries due, no doubt, to respectful use.

## 73. Bow-Back Side Chair

Boston, about 1796

Branded S[amuel] J. TUCK[e]

Seat—pine; legs, spokes—maple; bow, spindles, curved stretcher—hickory. Late eighteenth-century varnish covers natural brown patina.

Blue Candlestick Antiques

Size undetermined

The stretcher style on this attractive bow back has many names. "Spoke" and "yoke" are currently used, but it is also called bent, bow, concave, curve, cowhorn, and crinoline. The latter two names were favored by English Windsor chairmakers. The seat is lightly branded twice with the maker's name and has an undecipherable letter at the end which may be an *e*. S. J. Tuck (or Tucke) made this chair on Battery March Street in Boston about 1795. The cross-sectional shape of the back bow and the curved stretcher are identical, that is, round on the back with beading on the front. The parts were probably fabricated from a single piece, then cut to length and bent in separate bending molds. The stretchers are tenoned to the legs and to the curved stretcher. All the bamboo-style turnings have two grooves, a pattern that preceded the more popular three-groove design.

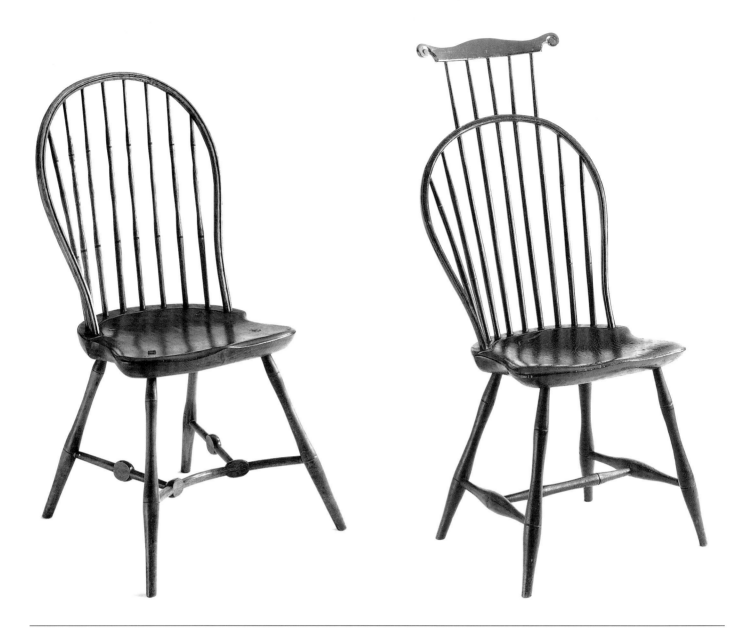

## 74. Bow-Back Side Chair

Probably Boston, about 1803

Attributed to Seaver and Frost

Seat—pine; legs, stretchers—maple; bow, spindles, curved stretcher—oak. Finish unidentified.

The Henry Francis du Pont Winterthur Museum

H 36⅞₆, W 20⅝, D 21½

Photo: Courtesy, Winterthur Museum

This eight-spindle bow back is attributed to partners William Seaver and James Frost, who worked in Boston from 1798 to 1807. It is structurally similar to figure 73. The medallionlike panels on the stretchers were a "new-fashioned" Windsor style, one planned to beat the competition, particularly that created by Philadelphia imports. To further promote sales, these panels were decoratively painted with leafage and flowers.[9] The medallions are an integral part of the stretchers and were turned out of wood the size of the medallions. Most of

the wood was turned away, leaving egg-shaped forms that were sawn flat on opposite sides. The curved stretcher was steam-bent and holes for the spoke stretchers were bored later. The bamboo grooves on the back spindles form a pleasing arc and echo somewhat the curve of the bow and front stretcher. The small swelling between the grooves is a nice addition.

## 75. Bow-Back Side Chair

Charlestown, Massachusetts, about 1800

T. C. Hayward (1750–1825)

Seat—pine [?]; legs, stretchers, crest rail—maple or birch [?]; bow, spindles—hickory or oak [?]. Finish unidentified.

The Henry Francis du Pont Winterthur Museum

H 43¼, W 19¼, D 18¾

Photo: Courtesy, Winterthur Museum

Thomas Cotten Hayward of Charlestown, Massachusetts, made this bow-back side chair. Hayward branded his chairs T. C. Hayward and two other examples of his work are known: a low-back writing-arm chair and a double-rod-back side chair, although neither of those examples has a comb. Including a comb in the design of this comely chair added to its beauty and increased its value. The spindles supporting the crest rail are a continuation of the back spindles. Three different diameter holes were required to install them. The

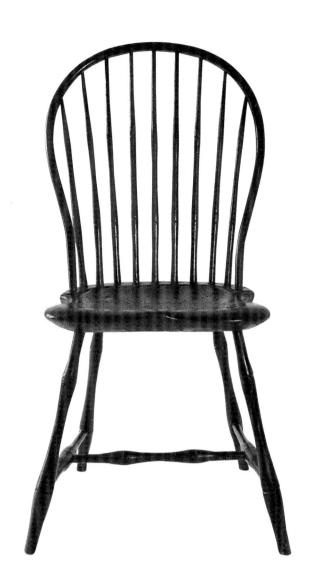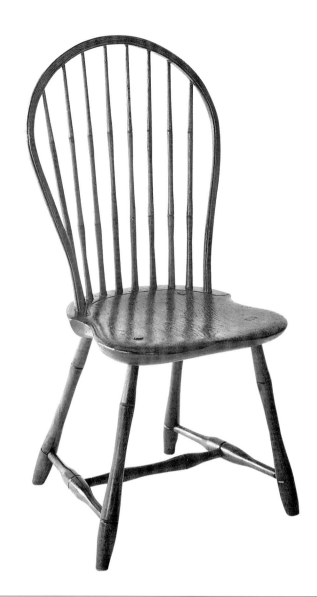

largest are at the seat and the smallest are at the crest rail; the holes in the bow are tapered. It seems incongruous to include a head rest comb piece on a side chair; it would have made more sense had this been a more comfortable armchair.

## 76. Bow-Back Side Chair

Boston, about 1789

Ruben Sanborn

Seat—pine; legs, stretchers—maple; bow, spindles—hickory. Original dark mahogany varnish stain, touched up.

Dr. Donald Bond

H 37⅜, W 20½, D 22

The exceptionally fine condition of this two-hundred-year-old Windsor is evidence of the respect and appreciation the owners had for the chair. The balloon pinched back, nicely shaped seat, and well-matched bamboo turnings blend together to form a very desirable chair. The seat is branded RUBEN-BOSTON. Ruben Sanborn is listed in a 1789 Boston directory as a chairmaker working on Doane Street. Seat height of this chair at the front is 17⅞ inches, which is probably close to or the original height.

## 77. Bow-Back Side Chair

Boston, about 1807

S[amuel] H.[?] HORTON

Seat—pine; legs, stretchers—maple; bow—oak; spindles—hickory. Clear varnish.

Alan and Laurie Harris

H 37, W 20, D 18½

This bamboo-style bow-back side chair is branded S. H. HORTON—BOSTON. Samuel Horton was a chairmaker working in Boston Neck in 1807 and this chair is a typical example of inexpensive, late eighteenth- and early nineteenth-century Windsors being produced in numerous chair factories along the Atlantic seaboard. The chair has the popular pinch waist bow, a not uncommon eight-spindle back, double-bobbin bamboo-style turnings, and less common block-shaped side stretchers. The seat height—16½ inches—indicates that the legs were shortened (or worn) at least one inch. The minimal saddling of the seat held down production cost.

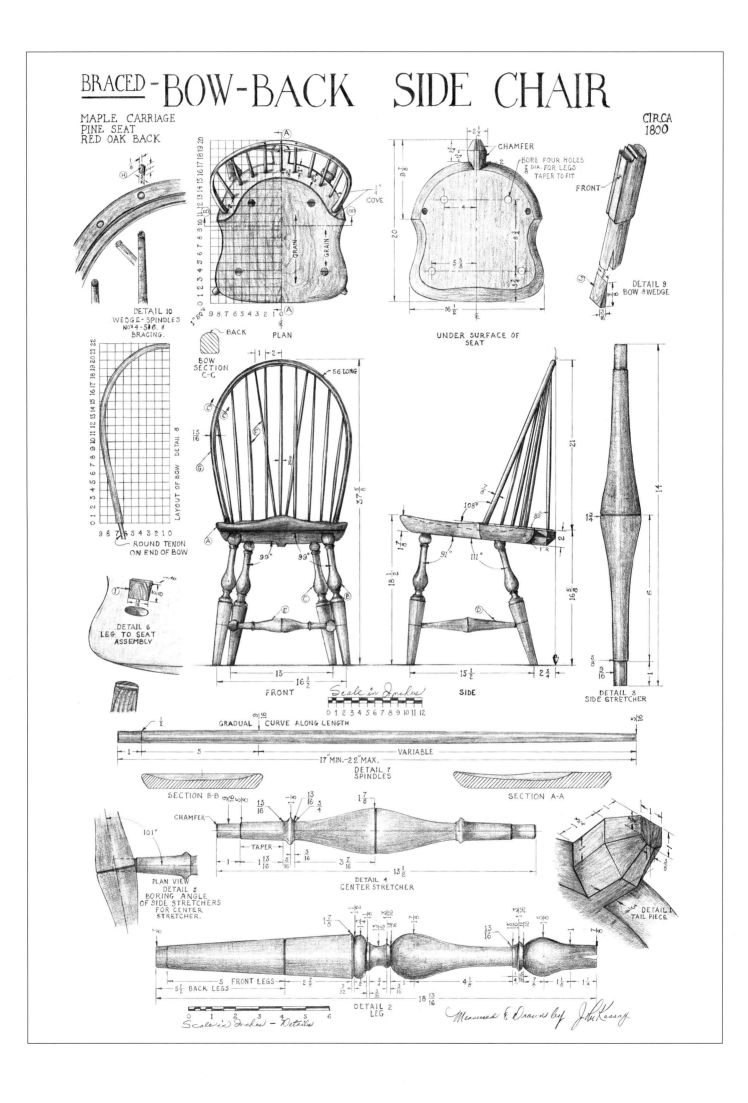

# BRACED-BOW-BACK SIDE CHAIR

MAPLE CARRIAGE
PINE SEAT
RED OAK BACK

CIRCA 1800

CHAMFER

BORE FOUR HOLES
$\frac{7}{8}$" DIA. FOR LEGS
TAPER TO FIT

FRONT

$\frac{1}{4}$" COVE

GRAIN

GRAIN

UNDER SURFACE OF SEAT

DETAIL 9
BOW & WEDGE

DETAIL 10
WEDGE-SPINDLES
Nos 4-5 & 6. &
BRACING.

BACK

BOW
SECTION
C-C

PLAN

56 LONG

LAYOUT OF BOW    DETAIL 8

ROUND TENON
ON END OF BOW

DETAIL 6
LEG TO SEAT
ASSEMBLY

FRONT

Scale in Inches

0 1 2 3 4 5 6 7 8 9 10 11 12

SIDE

DETAIL 3
SIDE STRETCHER

GRADUAL CURVE ALONG LENGTH

VARIABLE

17" MIN. - 22" MAX.

DETAIL 7
SPINDLES

SECTION B-B

SECTION A-A

CHAMFER

TAPER

DETAIL 5
PLAN VIEW
DETAIL 5
BORING ANGLE
OF SIDE STRETCHERS
FOR CENTER
STRETCHER.

DETAIL 4
CENTER STRETCHER

DETAIL 1
TAIL PIECE

5 FRONT LEGS
$5\frac{1}{2}$ BACK LEGS

$18\frac{13}{16}$

DETAIL 2
LEG

Scale in Inches - Details

Measured & Drawn by John Kassay

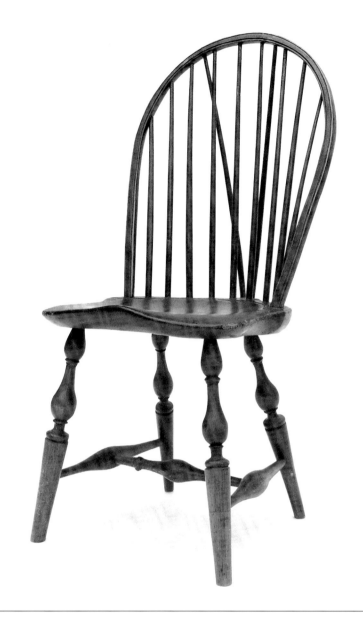

## 78. Braced Bow-Back Side Chair

New York City, about 1800

Maker unidentified

Seat—pine; legs, stretchers—maple; bow, spindles—oak. Mahogany varnish stain.

Donald Flynn

H 37⅜, W 18, D 20¼

Braced bow-back side chairs were produced as the same time as unbraced forms. The extra spindles contributed needed strength to a potentially weak back whose main strength came from the tenon-wedged bow. The grain on bow-back seats runs from front to back and the tail piece, holding the bracing spindles is not a separate piece, as it is in comb backs, but an integral part of the seat design. On this chair, the three inner back and two bracing spindles penetrate the bow and are wedged—all others are stop-tenoned. As with sack backs, in order to assemble the spindles properly, it was essential to mea-

sure carefully the distance between the depth of the hole in the bow and the seat. The lower half of the double-beaded bow straightens out before entering the fully sculpted seat. The leg turnings have wonderful thicks and thins and large bulbous sections, characteristic features of New York City Windsors.

| Letter | No. | Name | Material | T. | W. | L. |
|--------|-----|------|----------|-----|-----|-----|
| A | 1 | seat | pine | 2 | 16½ | 20 |
| B | 2 | front legs | maple | 1⅞ dia. | | 18³⁄₁₆ |
| C | 2 | back legs | maple | 1⅞ dia. | | 18¹³⁄₁₆ |
| D | 2 | side stretchers | maple | 1¾ dia. | | 14 |
| E | 1 | center stretcher | maple | 1⅞ dia. | | 13½ |
| F | 11 | spindles | red oak | ⅞ dia. | | 22 |
| G | 1 | bow | red oak | ⅞ | 1³⁄₁₆ | 56 |
| H | 3 | spindle wedges | maple? | ⅛ | ⁵⁄₁₆ | ½ |
| I | 4 | leg wedges | maple | ⅛ | 1³⁄₁₆ | ⅜ |
| J | 2 | bow wedges | maple? | ³⁄₁₆ | ⅜ | ⅞ |

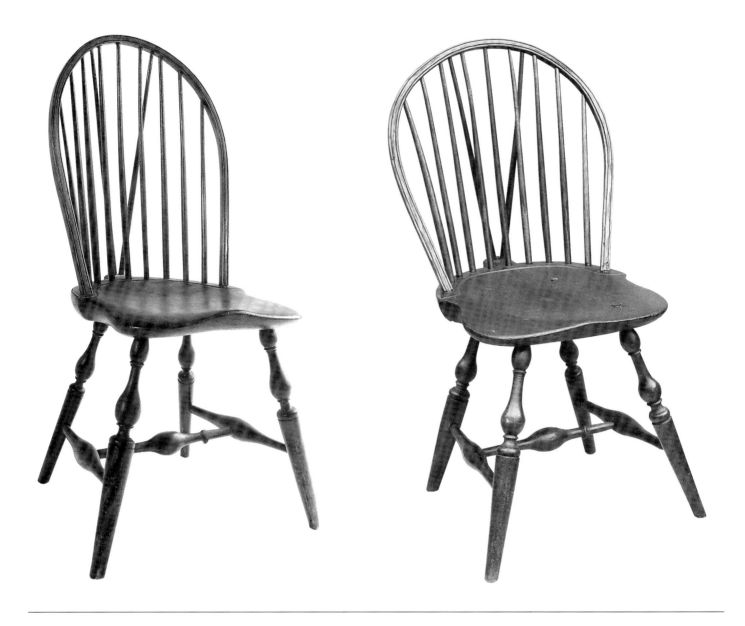

## 79. Braced Bow-Back Side Chair

New York City, about 1790

Maker unidentified

Seat—pine; legs, stretchers—maple; bow, spindles—white oak. Mahogany varnish stain over remnants of green paint.

Donald Flynn

H 37, W 19¾, D 19¾

The rather low back on this chair is another characteristic of New York City bow backs. The bow is beaded, has straight sides, and holds eleven stout spindles. All are stop-tenoned except the three center ones; those three pierce the bow and are wedged. The seat is beautifully sculpted with bold, well-defined chamfers, saddling, ramps, and a high pommel. The leg turnings are exceptionally handsome and have well-matched, crisply executed details. The main balusters are wonderfully large and the neck turnings are dangerously thin.

## 80. Braced Bow-Back Side Chair

New York City, about 1800

T[homas] TIMPSON (working 1785–1806)

Seat—poplar; legs, stretchers—maple; bow—hickory; spindles—ash. Finish unidentified.

The Metropolitan Museum of Art, Rogers Fund, 1934 (34.25)

Size undetermined

Photo: Courtesy, Metropolitan Museum of Art

The letters T TIMPSON, N. YORK are branded in the seat of this bow back. Thomas Timpson is entered in the 1801–05 New York City directory as a furniture and Windsor chairmaker. A few of his Windsors still exist. The bow on this chair is short and broad with straight sides and double beading and it holds eleven tapered, slightly bulbous spindles. The seat is a wide, shield-shaped with little saddling, and has almost no pommel. The turnings on the undercarriage are well executed.

Ring turnings on the center stretcher flank the bulbous center and the baluster leg turnings are in the New York City–style with good thicks and thins and long leg tapers.

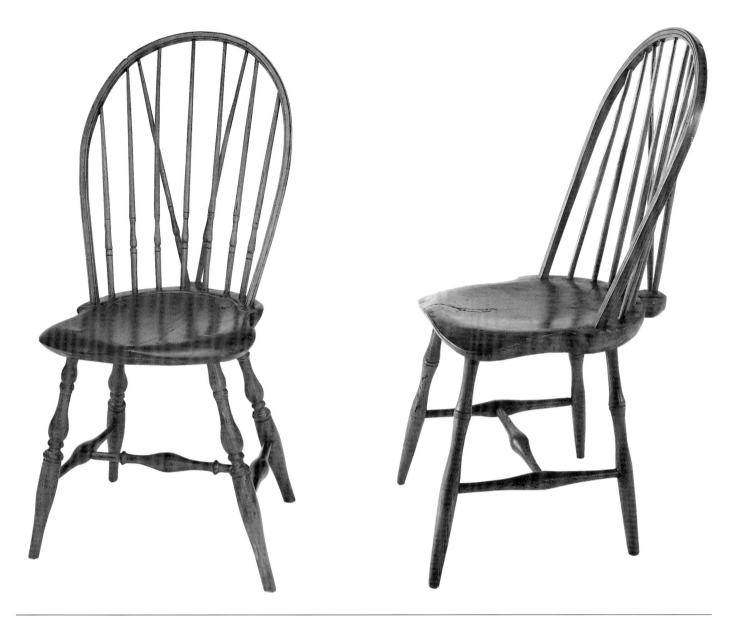

## 81. Braced Bow-Back Side Chair

Rhode Island, about 1800

Maker unidentified

Seat—pine; legs, stretchers—maple; bow, spindles—hickory. Original straw color paint stripped, clear varnish.

Richard Roy

H 38¼, W 19½, D 22⅝

The pipestem-turned spindles, sculptured shield-shaped seat, and Rhode Island–style concave feet all contribute to making this chair very pleasing. The flanking spindles are stop-tenoned to the bow, the well-splayed legs penetrate the seat, and the center stretcher is double ringed.

## 82. Braced Bow-Back Side Chair

Probably Connecticut, about 1800

Maker unidentified

Seat—pine; legs, stretchers—chestnut; bow, spindles—hickory. Finish unidentified.

Mr. and Mrs. Charles C. Schultz

Size undetermined

The line and form of this chair suggest it was made in rural Connecticut by someone not well versed in the art of Windsor furniture design and craftsmanship. The bow is unnecessarily heavy, the spindles are not carefully shaped, the character of the seat is somewhat rustic, and the turnings are rather ordinary. The close-to-the-edge location of the legs, however, is interesting and in the English manner. Like so many other Connecticut Yankees, the maker was influenced by the Tracy dynasty of Windsor chairmaking. For example the elimination of the gouge-cut coves on the seat and the double V cuts forming the bead on the upper part of the legs are Tracy features.

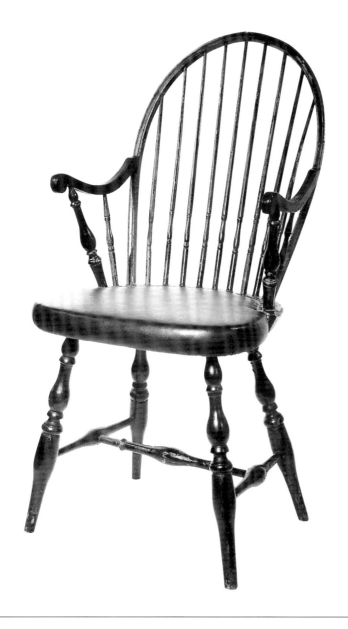

## 83. Upholstered Bow-Back Armchair

Rhode Island, about 1800

Maker unidentified

Seat—pine; arms—mahogany; legs, stretchers, arm supports—maple; bow, spindles—hickory; upholstery—new black leather. Gloss black paint covers original green.

Private collection

H 39⅜, W 19¾, D 23¼

The pipestem turnings, scrolled arms, upholstered seat, and adequately splayed and skillfully turned Rhode Island–pattern leg turnings are features that make this chair one of the finest examples of the bow-back style. They are commonly referred to as tenon-arm Windsors because their arms usually are tenoned through the bow and held in place with glue and wedges. On this chair, however, the arms butt to the bow and are secured with a single countersunk screw driven from the back, a common fastening method. The

| Letter | No. | Name | Material | T. | W. | L. |
|---|---|---|---|---|---|---|
| A | 1 | seat | pine | 1¾ | 19¼ | 18 |
| B | 4 | legs | maple | 1¾ dia. | | 18¹¹⁄₁₆ |
| C | 1 | center stretcher | maple | 1½ dia. | | 15½ |
| D | 2 | side stretchers | maple | 1½ dia. | | 12¼ |
| E | 2 | arm supports | maple | 1¼ dia. | | 11¹⁵⁄₃₂ |
| F | 9 | back spindles | hickory | ⁹⁄₁₆ dia. | | 23½ |
| G | 2 | arm spindles | hickory | ⁹⁄₁₆ dia. | | 9⅜ |
| H | 1 | bow | hickory | ¾ | ¾ | 60 |
| I | 2 | arms | mahogany | ¾ | 2⅝ | 12⅜ |
| J | 11 | wedges | maple? | | various sizes | |
| K | 4 | arm pins | maple? | ⅛ dia. | | ¹³⁄₁₆ |
| L | 2 | F.H. wood screws | steel | No. 8 | | 1½ |
| M | 1 | padding | ? | | | |
| N | 1 | black leather | | | | |
| O | 53 | furniture nails | gilt finish | | | ½ |

small shoulder on the arms at the point they meet the bow negates any attempt to create the illusion that the arms and the bow are the same piece of wood, as is suggested in figure 84.

The double beading on the face of the bow continues on the upper surface of the arms and around the hand holds. The beading stops where the arms are

assembled to the bow and continues underneath to the seat. The arm supports are tenon-wedged to the seat, blind-tenoned to the arms, and pinned from the side for security. The upholstered shield-shaped seat is hollowed only enough to hold padding, the edges are slightly rounded, and the leather cover is pulled over and tacked underneath.

# UPHOLSTERED BOW-BACK ARMCHAIR CIRCA 1800

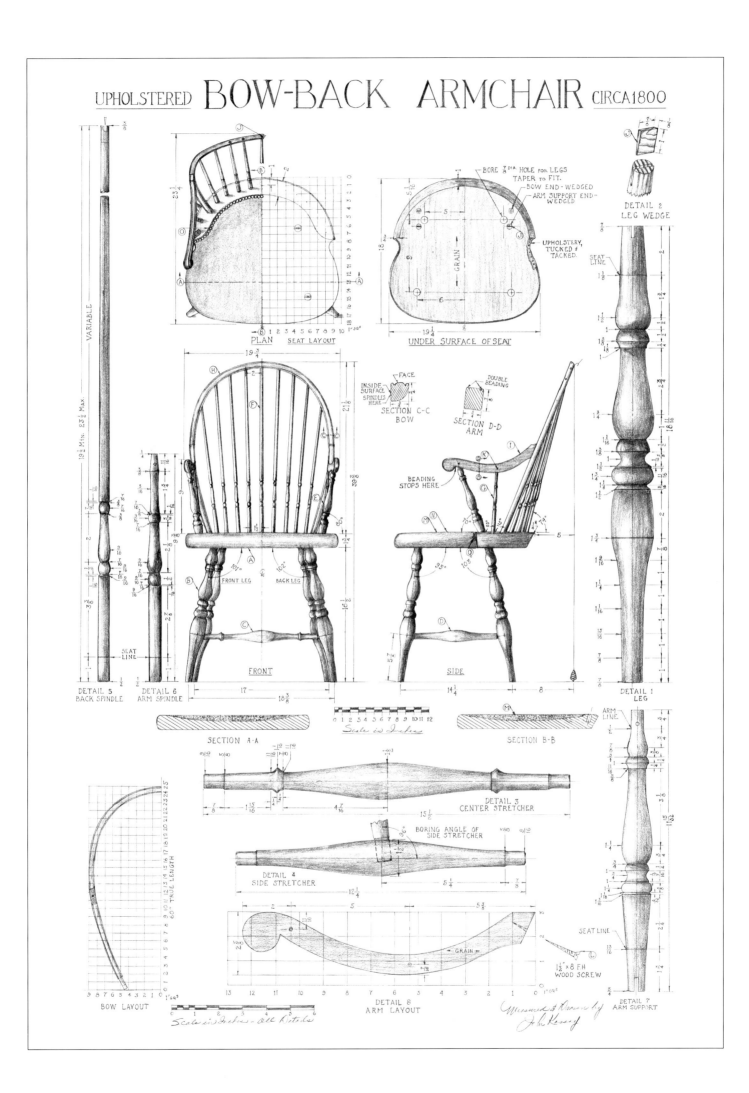

PLAN    SEAT LAYOUT

UNDER SURFACE OF SEAT

DETAIL 2 LEG WEDGE

SECTION C-C BOW

SECTION D-D ARM

DETAIL 5 BACK SPINDLE

DETAIL 6 ARM SPINDLE

FRONT

SIDE

DETAIL 1 LEG

SECTION A-A

Scale in Inches

SECTION B-B

DETAIL 3 CENTER STRETCHER

DETAIL 4 SIDE STRETCHER

BORING ANGLE OF SIDE STRETCHER

DETAIL 7 ARM SUPPORT

BOW LAYOUT

Scale in Inches - All Details

DETAIL 8 ARM LAYOUT

Measured & Drawn by John Kassay

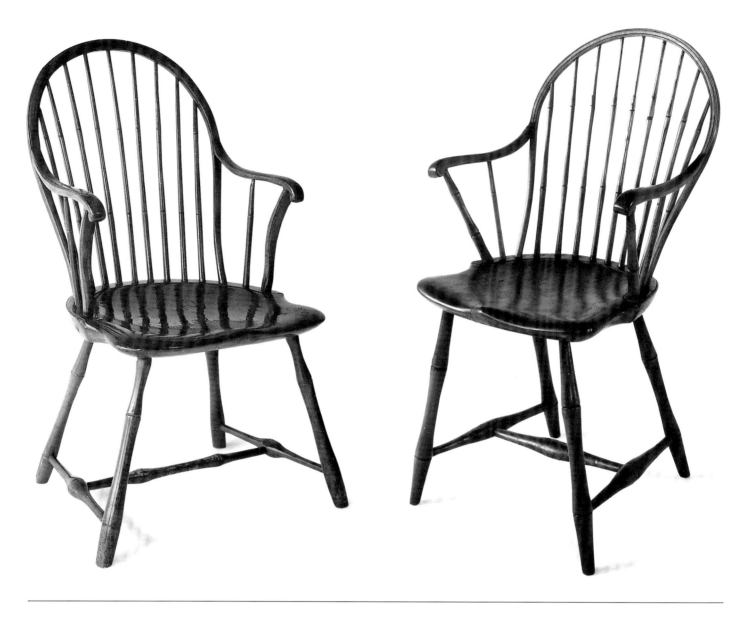

## 84. Bow-Back Armchair

Philadelphia, about 1800

W[illiam] Love

Seat—pine; legs, stretchers—maple; spindles—hickory; bow, arm supports, arms—oak. Clear varnish over stripped light green paint.

Alan and Laurie Harris

H 34¾, W 24, D 23¼

During the last decade of the eighteenth century this style of bow-back armchair was very popular and, with matching side chairs, was produced in great numbers in many Philadelphia shops. They were sold both locally and in surrounding rural areas and also as venture cargo in foreign ports.[10] The name W Love is branded in the seat. William Love was a chairmaker active in Philadelphia from 1793 to 1806.[11]

The chair conveys a feeling of strength and stability and the arms invite one to sit in a seat that is generously wide and adequately saddled. Scrolled arms with

rectangular tenons are wedged and pinned to the bow and flow into it as if they were the same piece. Beading on both the arms and bow further promotes this illusion. It has been suggested that the beading on the arms was done to imitate the lines of continuous-bow armchairs.[12] The beading is not carried below the arms where the bow is pinched and round in section. The arms are supported by single spindles and bulky English-pattern arm supports, which are through-tenoned to the arms and seat. Originally, the overly splayed legs would have presented an obstacle. They have been shortened to minimize this problem.

## 85. Bow-Back Armchair

Philadelphia, about 1805

Maker unidentified

Seat—pine; legs, stretchers, arms, arm supports—maple; bow, spindles—hickory. Original green paint now stripped. Clear varnish over maple stain.

Greg and Bonnie Randall

H 36¼, W 21, D 22⅜

This chair is similar to but less sedate than figure 84. It was made during the same time period and is another typical Philadelphia bow-back design but with a few slightly different details. The bow is round in section, thins out abruptly at the kinked ends, holds very slender but nicely formed bamboo spindles, and is angled back more than usual, which shows a conscious effort to make a more comfortable chair. The legs are properly splayed, have well-emphasized bamboo turnings, and are their original length. The medial stretcher matches the bulbous side stretchers. Like the previous chair, the seat has a sculptured quality, is attractively contoured and well saddled, and has a pronounced pommel. The somewhat long, conservatively shaped arms are tenoned to the bow without any attempt to create the illusion of their being a single piece. The arms are

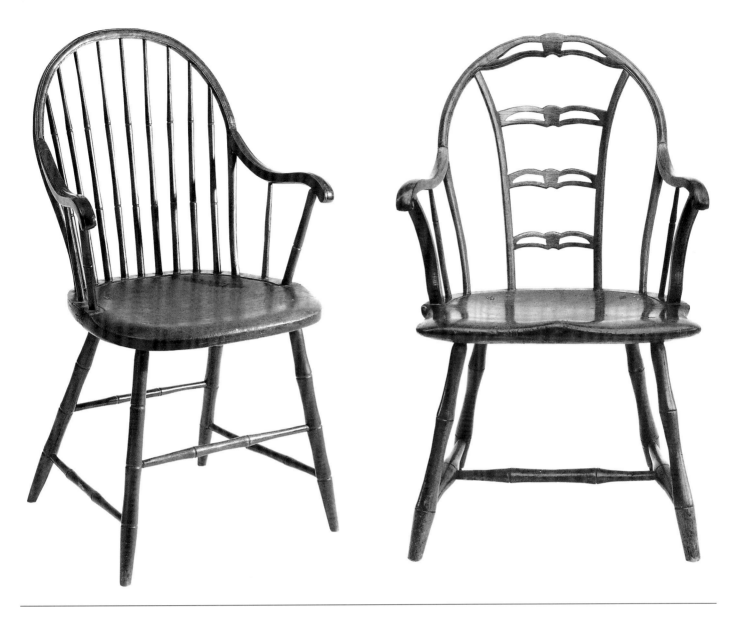

supported by bamboo-style turned arm supports which are tenoned to the seat at an acute angle and counter to the angle of the bow. The single arm spindle bisects these angles and creates a dynamic assembly.

## 86. Bow-Back Armchair

East Caln, Pennsylvania, about 1805

Branded Moon

Seat—poplar; bow—hickory; legs, arm supports, spindles—maple. Original green paint.

Chester County Historical Society, West Chester, Pennsylvania

H 37

Photo: George J. Fistrovich

This plain but handsome bow-back armchair is typical of many bow backs made in Pennsylvania at the turn of the eighteenth century. The seat is branded Moon and is attributed to Samuel Moon, a chairmaker

who worked in East Caln and Philadelphia. Except for the broader oval seat and back, this chair matches his side chairs, which were no doubt sold in sets.

## 87. Bow-Back Armchair

Philadelphia, about 1800

Probably John Letchworth (1759–1843)

Seat—bass wood; legs, stretchers, arm spindles—maple; bow, ladder—hickory; arms, arm supports—mahogany. Clear varnish.

Private collection

H 36½, W 23¼, D 21½

The pierced and curved ladder on this bow-back Windsor armchair is a design concept that evolved out of English Chippendale high-style chairs and American slat-back mahogany chairs. During the closing decade of the eighteenth century, Philadelphia furniture maker Daniel Trotter (1747–1800) and other producers

of high-style furniture made a limited number of these chairs. Called Chippendale Windsors, they were probably made on speculation to bridge the gap between formal seating styles and the plainer Windsor "stick" pattern. This chair has details similar to those found on branded John Letchworth chairs and may have been made by this eminent chairmaker. A matching side chair[13] and a child's side chair[14] also have similar characteristics and the same number of "birds-in-flight" slats. Except for their pierced slats and curved stiles, these chairs were fabricated from parts used in making typical Philadelphia bow-back chairs. The back is especially interesting in that the slats are assembled to the stiles with rectangular-shaped tenons and the top slat is assembled to the bow in the same manner. After the steam-bent bow dried, it was carved to the same pattern as the ladder and pinned in place from the top.

# BRACED BOW-BACK ARMCHAIR c.1795

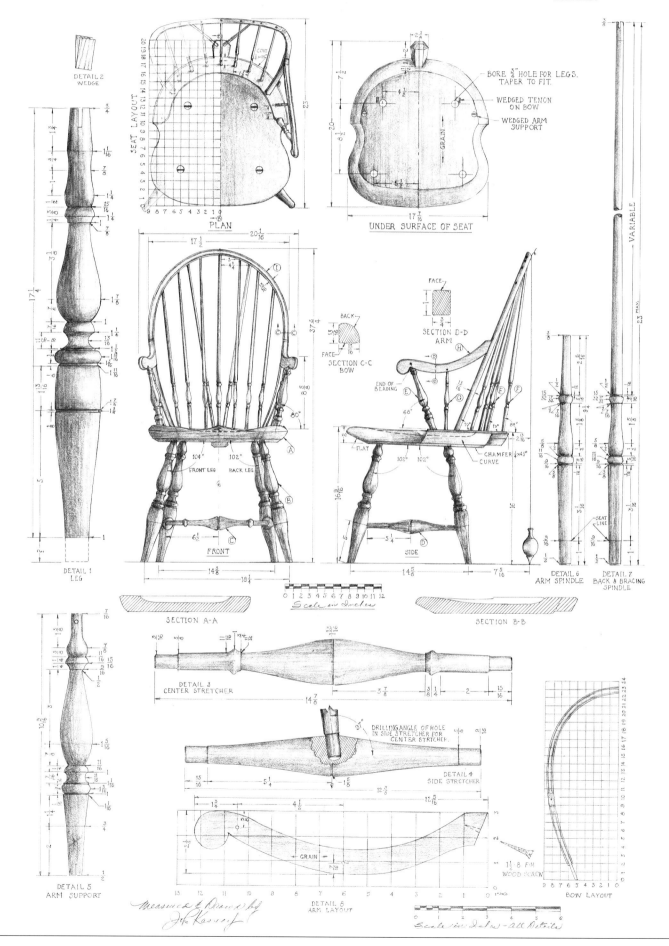

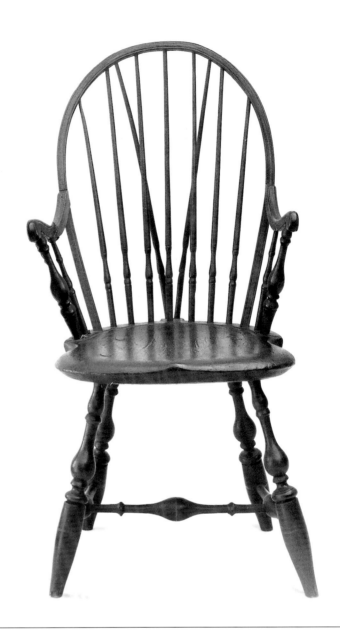

## 88. Braced Bow-Back Armchair

Rhode Island, 1795

Maker unidentified

Seat—probably pine; legs, stretchers, arm supports—maple; bow, spindles—hickory; arms—mahogany. Recent black paint over original red primer highlighted with gilt striping.

Jim Dougherty

H 37¾, W 20¹⁄₁₆, D 23

Fewer braced bow-back armchairs of the classic Rhode Island–style were made than unbraced forms. The chairmakers probably felt the arms gave the back adequate support and that bracing was unnecessary and an additional expense. On this chair, all the spindles within the bow are through-tenoned and wedged. As previously mentioned, the outer spindles were usually blind-tenoned on bow backs to avoid weakening the bow. The face and inner surface of the bow are square,

| Letter | No. | Name | Material | T. | W. | L. |
|--------|-----|------|----------|-----|-----|-----|
| A | 1 | seat | pine | 2 | 17⁷⁄₁₆ | 20 |
| B | 4 | legs | maple | 1¹⁵⁄₁₆ dia. | | 17¼ |
| C | 1 | center stretcher | maple | 1¹³⁄₁₆ dia. | | 14⅞ |
| D | 2 | side stretchers | maple | 1⅜ dia. | | 12⅜ |
| E | 2 | arm supports | maple | 1⁵⁄₁₆ dia. | | 10⁹⁄₁₆ |
| F | 9 | back & bracing spindles | hickory | ¹¹⁄₁₆ dia. | | 23 |
| G | 2 | arm spindles | hickory | ¹¹⁄₁₆ dia. | | 9¼ |
| H | 2 | arms | mahogany | ¾ | 2½ | 12⁵⁄₁₆ |
| I | 1 | bow | hickory | ¹³⁄₁₆ | 1³⁄₁₆ | 55½ |
| J | 4 | pins | | | size to suit | |
| K | 13 | wedges | | | size to suit | |

whereas the back is fully rounded. The double beading that runs around the entire length of the bow is interrupted at the point where the arms are joined but then continues on to the seat. This beading is also on the top of the arms and around the hand holds. The shield profile of the seat is emphasized with deep con-

cave cove cut outs at the sides and the tail piece is sawn and shaped with triangles and chamfers. The seat saddle, pommel, and chamfers are well achieved. The chair has lost about an inch of its legs.

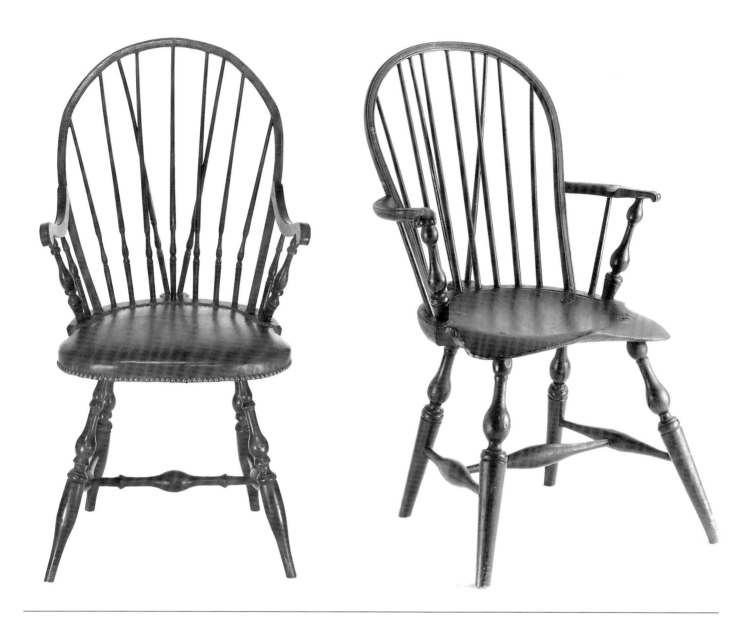

## 89. Upholstered Braced Bow-back Armchair

Rhode Island, about 1800

Maker unidentified

Seat—pine; legs, stretchers, arm supports—maple or birch; bow, spindles—hickory; arms—mahogany, unpainted; seat cover—reupholstered in brown leather, brass tacks. Dark green paint.

Henry Ford Museum and Greenfield Village, Dearborn, Michigan

H 38½, W 19¼, D 19⅞

Photo: Courtesy, Henry Ford Museum and Greenfield Village

The boxy-looking bow and outer left-hand back spindle are the only elements that detract from an otherwise very handsome chair. The chair features double beading on the bow, mahogany arms, pipestem turned spindles, a nicely upholstered broad seat, and beautiful Rhode Island–style, well-matched turnings. Additionally,

the edges of the seat were left square and can be seen impressed through the leather cover. The round-head brass tacks continue down the sides and across a carved depression at the rear of the seat. The seat's square edges and carved depression indicate the seat was designed to be upholstered.

## 90. Braced Bow-Back Armchair

Probably New York City, about 1790

Maker unidentified

Woods and finish unidentified

The Henry Francis du Pont Winterthur Museum

H 36¼, W 22¾, D 24⅜

Photo: Courtesy, Winterthur Museum

The carved knuckle hand holds, the flat S-curved arms, and the location of where the arms are attached to the bow make the chair unique. Flat sawn arms and carved hand holds are arm details that were used

extensively on earlier fan-back armchairs. They were, however, also used on a few New York City–made bow-backs.[15] Typically, the arms on bow backs were fastened to the face of the bow and not to the outer edge, as they are on this chair. Here the arms are held with wood screws driven through the arm and into the bow. The arm supports and leg turning details are well executed and nicely matched with good thicks and thins and large onion-shaped balusters favored by New York turners. Additional but not necessarily attractive features of the chair are the tall rectangular-bow and the large, flat knife-edge ramps at the front of the seat.

# 6 Continuous-Bow Armchair

## Introduction

The compound bent, single piece of wood that forms the back and arms on continuous-bow Windsor armchair attracts more attention than all other Windsor chair forms. This is true today and probably was when the chairs were first developed. In early documents they were called "round back" or "round top" chairs.[1] Currently they are being described as continuous-bow armchairs. The identity of the person who made this first "new-fashioned" chair will probably never be established. It is known, however, that they were first made in New York City and are truly an exclusively American design innovation and "represent a high point in the craft."[2]

Furniture historians and others look to what already exists when attempting to determine the ancestry of a newly developed furniture form, and they have done that with the continuous-bow armchair. The relationship between the curved back and arms on this new-style Windsor and the upholstered French Bergère chair is obvious. However, other similarities between the two styles are few. On the Bergère chair the curved back that continues into arms was actually several pieces of solid wood sawn, joined, and shaped into paired matching curved forms,[3] whereas the compound bends on the continuous-bow armchair were produced out of one long narrow piece of wood, steamed and bent to shape in a form. Thomas Burling (d. 1810), a New York City cabinetmaker, produced a limited number of the French-style chairs—Washington and Jefferson each ordered one of the swiveling type.

Several New York City Windsor chairmakers were producing continuous-bow armchairs.[4] Branded and labeled examples of New York City chairmaker brothers Thomas and William Ash (w. 1783–1794), John and James Always (w. 1786–1815), John DeWitt (w. 1794–1799), and William MacBride (w. 1785–1810) have fortunately survived. Whether the Bergère chair was their inspiration is a question that further research may answer. The technology of bending wood was not new with eighteenth-century Windsor chairmakers. For more than a hundred years—first in England and later in America—chairmakers had known of this process and were producing simple bends for Windsor chairs. Making the compound bends for a continuous-bow armchair, however, was more complicated. The problem of bending one piece of wood into a curved bow plus two arms on a different plane (90 degrees to the bow) in a single session was solved by adding extensions to the basic bow-back bending form. These extensions provided the necessary support and shape while the piece, which was installed upside down in the form, was being bent. Interest in and acceptance of this new-style Windsor moved rapidly to other areas beyond New York City. J. M. Hasbrouck in Kingston, New York, E. B. Tracy and his relatives in Connecticut, and James Tuttle in Salem, Massachusetts, were just a few of the many chairmakers producing braced and unbraced continuous-bow armchairs. It is interesting to note that this style was not produced in Philadelphia.

New England continuous-bow armchairs appear narrower and taller than their New York counterpart. Generally New England seats are narrower and lack seat grooves, their turnings are more attenuated, and the stretchers do not have ring turnings.

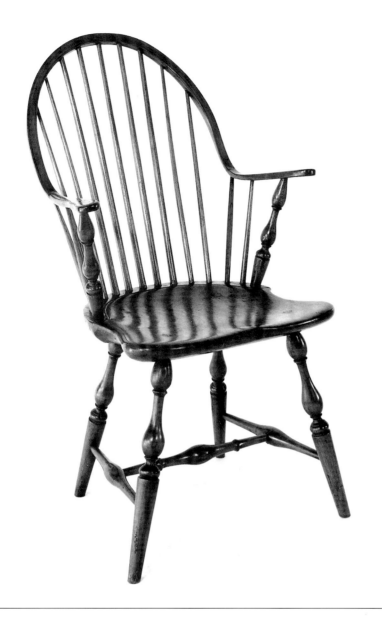

## 91. Continuous-Bow Armchair

New York, about 1790

Maker unidentified

Seat—pine; legs, arm supports, stretchers—maple; bow, spindles—hickory. Varnish.

Mr. and Mrs. Leo Van DeWater

H 36½, W 22¼, D 23

| Letter | No. | Name | Material | T. | W. | L. |
|---|---|---|---|---|---|---|
| A | 1 | seat | pine | 1⅞ | 18⅜ | 17 |
| B | 4 | legs | maple | 1¹¹⁄₁₆ dia. | | 17⁷⁄₁₆ |
| C | 2 | side stretchers | maple | 1½ dia. | | 13⅜ |
| D | 1 | center stretcher | maple | 1⁹⁄₁₆ dia. | | 15¼ |
| E | 2 | arm supports | maple | 1½ dia. | | 12³⁄₁₆ |
| F | 9 | back spindles | hickory | ⅜ dia. | | min. 19, max. 22¼ |
| G | 4 | arm spindles | hickory | ½ dia. | | min. 10, max. 10¾ |
| H | 1 | continuous bow-arm | hickory | ¹⁵⁄₁₆ | 1⅞ | 59½ |
| I | 17 | wedges | | | size to suit | |

The style of this continuous-bow armchair is influenced by three regions: Philadelphia, New York, and Connecticut. The fully rounded front edge on the seat is a treatment found on Philadelphia bow backs;[5] the slightly bulged tapered spindles, broad seat, and turned rings on the medial stretcher are New York features; and the tall back is a Connecticut characteristic. The turnings are well executed with good thicks and thins, although the upper balusters are too bulbous for good contrast with the main balusters. The legs are well splayed with arm supports dramatically thrust forward. The five inner back spindles, the arm spindles, and the arm supports are tenon-wedged to the bow and arms. The flanking back spindles are blind-tenoned. The double beading on the bow stops above the critical point where the bow thins out to form the arms. Although not evident in the photograph, the back spindles are slightly fanned. Interesting but typical are the uneven plane marks left on the bottom of the seat.

# CONTINUOUS-BOW ARMCHAIR

MIXED WOODS

CIRCA 1790

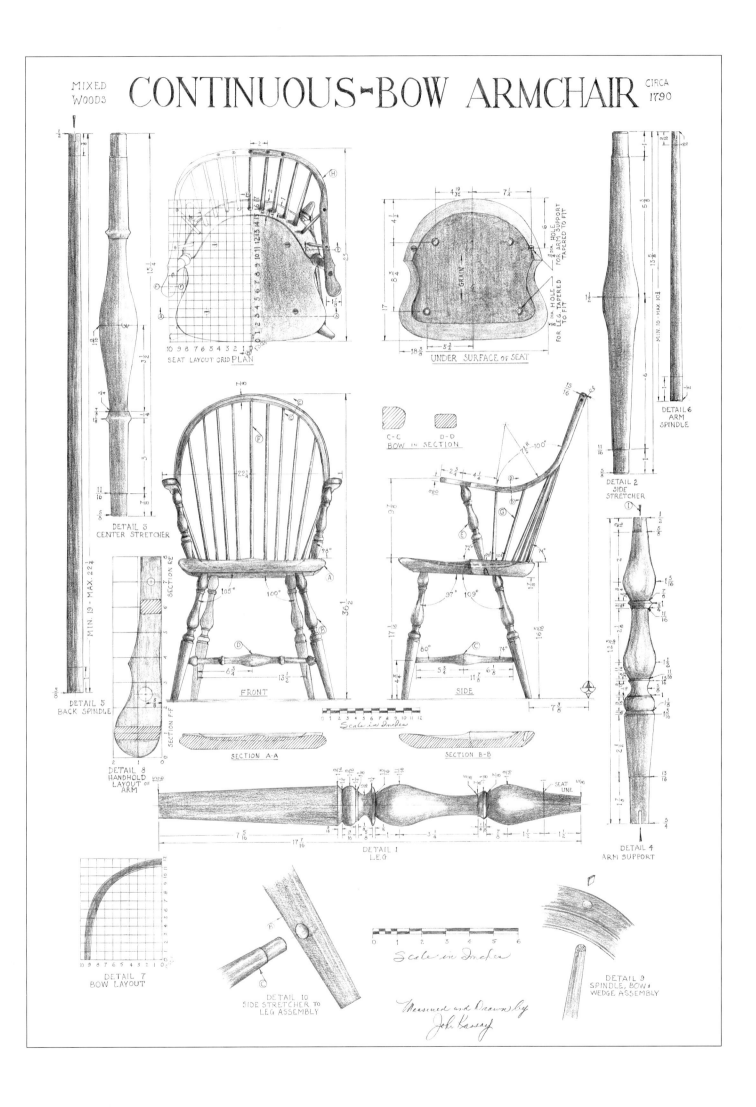

SEAT LAYOUT GRID PLAN

UNDER SURFACE of SEAT

DETAIL 3
CENTER STRETCHER

DETAIL 6
ARM SPINDLE

DETAIL 2
SIDE STRETCHER

C-C   D-D
BOW IN SECTION

DETAIL 5
BACK SPINDLE

FRONT

SIDE

DETAIL 8
HANDHOLD LAYOUT OF ARM

SECTION A-A

SECTION B-B

Scale in Inches

DETAIL 1
LEG

DETAIL 4
ARM SUPPORT

DETAIL 7
BOW LAYOUT

DETAIL 10
SIDE STRETCHER TO LEG ASSEMBLY

Scale in Inches

DETAIL 9
SPINDLE, BOW & WEDGE ASSEMBLY

Measured and Drawn by
John Kassay

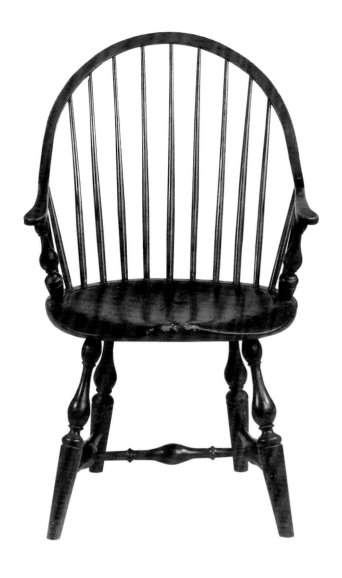

## 92. Continuous-Bow Armchair

New York City, about 1790

I. [John] Always (w. 1786–1815)

Seat—poplar; legs, arm, stretchers—maple; bow—hickory or ash.

Green paint over unidentified original finish.

Brooklyn Museum, Gift of Mr. and Mrs. Henry Sherman (67.128.10)

H 35, W 21, D 22¾

Photo: Courtesy, Brooklyn Museum

This chair is branded "I. Always" on the seat bottom. The initial I was a substitute for the name John. John Always, with his brother James, made Windsors some of which were continuous-bow armchairs.

The oval seat pattern can definitely be tied to earlier New York City sack backs.[6] Although oval seats were not used extensively on continuous-bow armchairs, the style preceded the shield shape which became the standard pattern for this style of Windsor. The low, wide bow, equally wide seat, vertical spindles, large bulbous turnings, and well-splayed legs are New York City characteristics. Unfortunately what would be a classic chair is somewhat flawed by replacement arms.

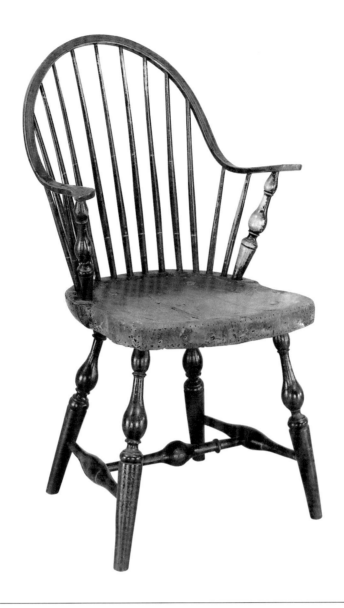

## 93. Continuous-Bow Armchair

New York City, 1797

John DeWitt (w. 1794–1799); upholstered by
William W. Galatian

Seat—tulip; legs, stretchers, arm supports—
maple; bow, spindles—hickory. Black paint with
striping over original green.

Colonial Williamsburg Foundation

H 35¼, W?, D?

Photo: Courtesy, Colonial Williamsburg
Foundation

Upholstered Windsor chairs are quite rare
but aside from the upholstery, the features
on this chair are similar to those found on
the best New York City–made continuous-
bow armchairs. The chair has a broad
shield-shaped seat, a wide graceful bow
that gradually thins and bends into arms
with paddlelike hand holds, tapered,
slightly bulged spindles, bold crisp well-
matched turnings, and long leg tapers with
well-splayed tenon-wedged legs. Physical

evidence and historical data pertaining to
the chair are interesting and informative.
The chairmaker's paper label is pasted
under the seat and reads: "JOHN DE WITT
/ Windsor chair maker / No. 47 Water-
street, near / Coenties Slip, New York."
One of a pair, this chair was made with
three matching bow-back side chairs.
Three of the group are labeled in this way,
and one also has the original upholster's
label, which reads: "WILLIAM W.
GALATIAN, UPHOLSTERER & PAPER-
HANGER / NO 10 WALL-STREET, NEW
YORK." The date May 1797 is printed at
the bottom of the label.[7] These rare labels
tell us the "who, where, and when" of a set
of important early Windsors. Bits of uphol-
stery remnants show the chair was uphol-
stered at least twice, first with green wool
and later in black leather. Tack marks
suggest the seat was decorated with a
double row of brass-headed upholstery
tacks. Painted wood, upholstery, and brass
tacks combine to make this an exception-

ally beautiful chair and a complement to
the surrounding formal furniture.

The thick plank seat was dished only
enough to provide a bowllike area for
padding, muslin, and the upholstery cover.
The usually present isolating cove cut is
omitted and a lower flat nailing area
extending to the side cut outs was made to
accommodate the upholstery. The arm
supports, arm spindles, and the five center
back spindles penetrate the bow and arms
and are wedged.

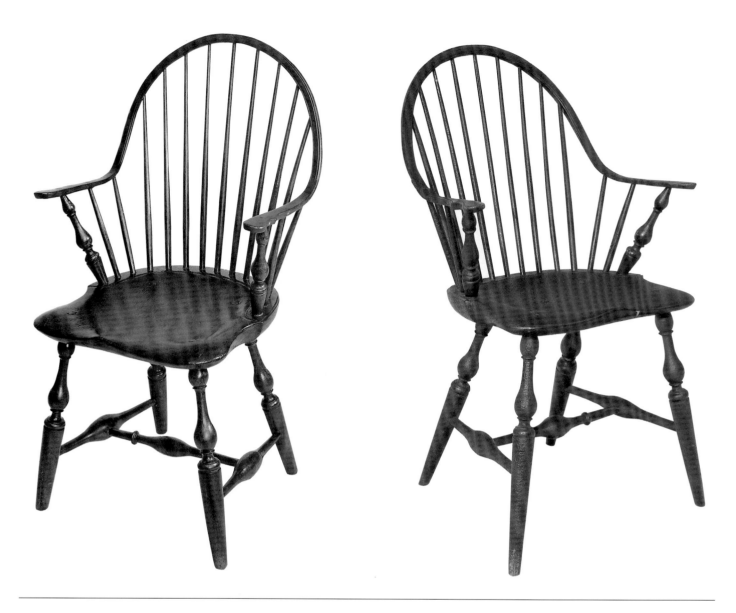

## 94. Continuous-Bow Armchair

New York City, about 1800

Maker unidentified

Seat—pine; legs, arm supports, stretchers—maple; bow, spindles—hickory. Original red paint.

Bernard and S. Dean Levy, Inc., New York

H 36, W 21½, D 17

Photo: Helga Photo Studio

This almost classic continuous-bow armchair is another good example of a New York product. Its attractive features include the graceful bends in the bow and uplifted arms, the slight bulge on the robust spindles, the beautifully sculptured seat, the well-defined details on the expertly matched turnings, and the firm stance of the legs.

## 95. Continuous-Bow Armchair

Kingston, New York, about 1790

J. M. Hasbrouck

Wood and finish unidentified

The Art Institute of Chicago, Gift of Emily Crane Chadbourne

H 36¼, W 22¼, D 22¼

Photo: Courtesy, Art Institute of Chicago © 1988

The name J. M. Hasbrouck is stamped on the underside of the seat of this chair. Josiah Hasbrouck made Windsors on the west side of the Hudson River in rural Kingston, New York. This chair conveys a feeling of rural conservatism, a not uncommon aspect of Windsors made away from the mainstream of urban production; nevertheless the back, seat, and undercarriage are attractively unified. The low back has a comfortable backward lean, which is counterbalanced by the forward thrusting arm supports and spindles. The exception-ally long legs have tapered feet that are longer than the elaborately turned section. Their extra length provides a higher than normal placement of the stretchers and seat.

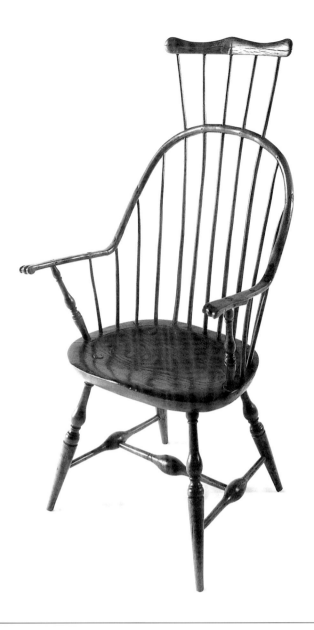

## 96. Continuous-Bow Armchair

Probably Connecticut, about 1800

Maker unidentified

Seat—chestnut; legs, stretchers—maple; arm supports, bow spindles, crest rail—red oak. Unidentified original finish, stripped.

Blue Candlestick Antiques

H 47¾, W 25¼, D 22

This attractive chair has several interesting and unusual parts. The comb piece, knuckle hand holds, and D-shaped seat were rarely used on continuous-bow armchairs, and even more rarely on the same chair. As previously mentioned, D-shaped seats were standard on early comb backs. The comb crest is supported by five very long, very thin one-piece back spindles. The high, delicate bow is sharply bent into long straight-sided scrolled arms and the knuckle hand holds are carved entirely out of the arms. The arms are supported by a single spindle plus arm supports that were turned to match the legs, each of which have nice long tapers. The turning details are restrained, the center stretcher is ringless, and the balusters are drawn out in typical Connecticut fashion.

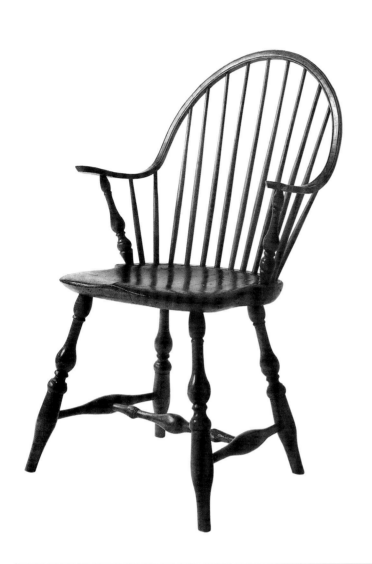
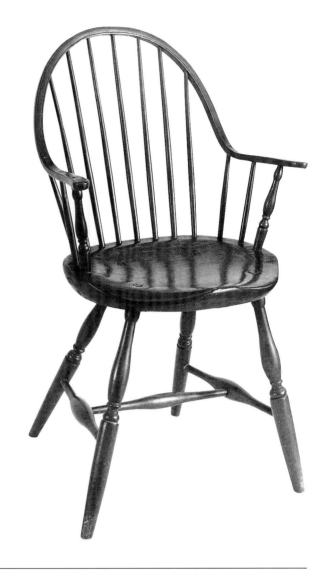

## 97. Continuous-Bow Armchair

Rhode Island, about 1800

Maker unidentified

Seat—pine; legs, arm supports, stretchers—maple; bow, spindles—hickory. Original green paint stripped; varnish.

Blue Candlestick Antiques

H 36⅛, W 21½, D 21¼

The bow, spindles, arm supports, and seat on this continuous-bow armchair are typical New York patterns, whereas the legs and center stretcher are Rhode Island forms. It is a handsome but not quite classic chair. The lower end of the legs are too heavy for the attractively composed turnings and the seat is weakly saddled. However, the well-angled back does contribute some comfort. It is interesting that the ends of the center stretcher are bulbous and somewhat imitative of arrowlike turnings found on earlier Windsor styles.

## 98. Continuous-Bow Armchair

Probably Connecticut Valley, about 1810

Maker unidentified

Seat—pine; legs, arm supports, stretchers—maple; bow, spindles—hickory. Red paint covers traces of light green paint.

Pocumtuck Valley Memorial Association, Memorial Hall Museum, Deerfield, Massachusetts

H 34½, W 22, D 20

The oval seat, arm supports, and leg turnings make this late continuous-bow armchair an appealing regional variant. Oval seats were, as previously mentioned (see fig. 92) the first and short-lived seat pattern used on this style of chair. The well-matched arm supports and leg turnings, although baluster in form, have stretched-out vase shapes rather than typical bulbous shapes. The cusp turning detail that almost always separated the main from the upper baluster has been omitted. All other parts

of the chair are standard patterns, assembled in the usual way; the unattractive open space between the back and arm spindles is also common. The well-slanted back required only a mild bend to the bow to form the arms. The arms lean outward and have uninspired ladle-shaped hand holds. Upon close examination the saddler's hand-tool marks can be seen on the seat under several coats of paint. The seat was further saddled at a later date, probably to make the chair more comfortable.

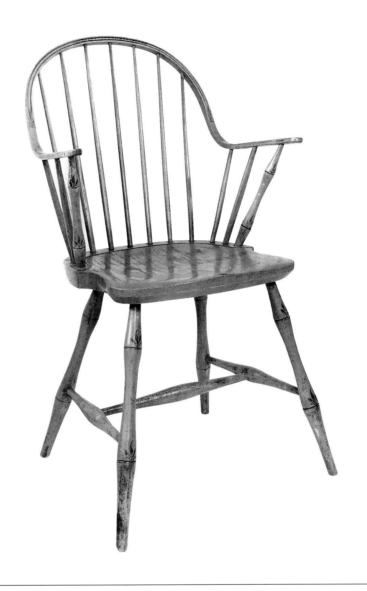

## 99. Continuous-Bow Armchair

Deerfield, Massachusetts, area, about 1815

Maker unidentified

Bow, arms, spindles—hickory; all other parts—maple. Original straw color paint with green decoration.

Blue Candlestick Antiques

H 34½, W 22, D 20

Variations in the shaved spindles and turnings on this late continuous-bow armchair indicate that the chair is a hand-crafted product. The seat is made of hard maple, a wood rarely used for this purpose. It is amazing that the chair was designed to be upholstered. The minimal saddling, slight pommel, wide nailing strip, elevated spindle area, and off-set edges support this assessment. However, the seat never was upholstered, probably because the chairmaker realized that maple was too hard for upholstery tacks. Except for the stretchers, the chair has bamboo-style turnings wedged to a double-beaded bow and arms that end in spoon-shaped hand holds. Perhaps the most attractive feature of the chair is the original painted decoration. Painted green nodes accentuate the bamboo turnings. Painted leafage at the ends of the beading and on the arm supports and front legs, and bell flowers across the top of the bow (not visible in the photograph) complete the decorations and make this chair very valuable.

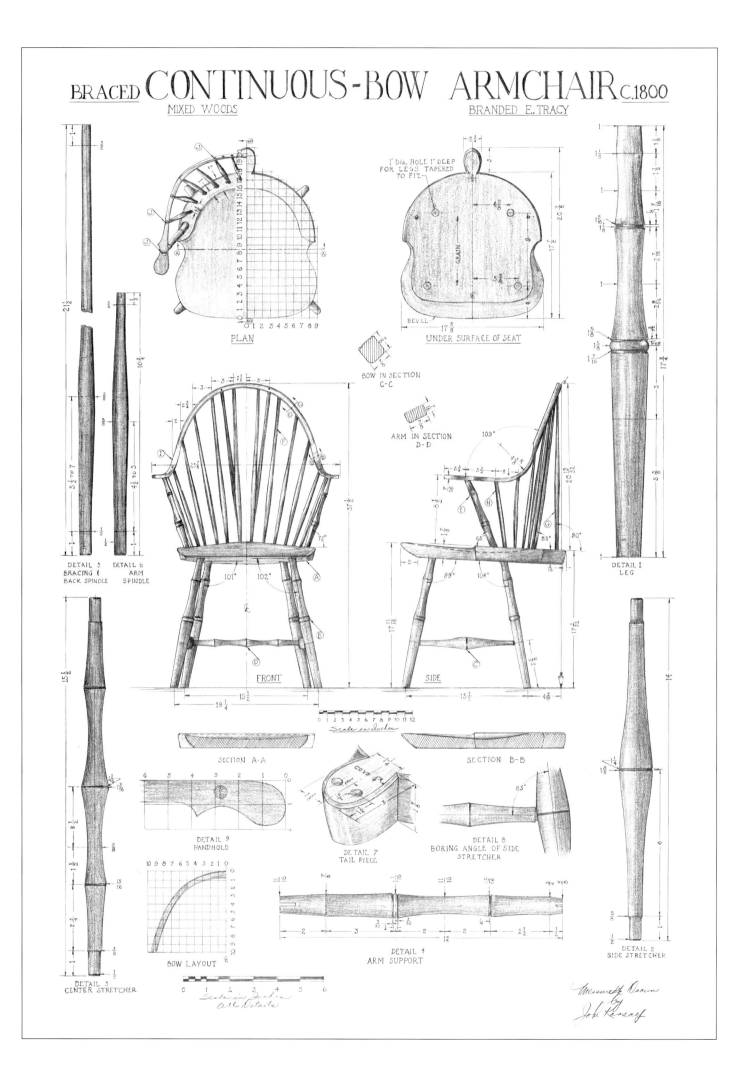

# BRACED CONTINUOUS-BOW ARMCHAIR c.1800

MIXED WOODS

BRANDED E. TRACY

PLAN

1" DIA. HOLE 1" DEEP FOR LEGS TAPERED TO FIT

BEVEL

UNDER SURFACE OF SEAT

BOW IN SECTION C-C

ARM IN SECTION D-D

DETAIL 5 BRACING & BACK SPINDLE

DETAIL 6 ARM SPINDLE

FRONT

SIDE

DETAIL 1 LEG

SECTION A-A

Scale in Inches

SECTION B-B

DETAIL 2 SIDE STRETCHER

DETAIL 9 HANDHOLD

DETAIL 7 TAIL PIECE

DETAIL 8 BORING ANGLE OF SIDE STRETCHER

DETAIL 3 CENTER STRETCHER

BOW LAYOUT

Scale in Inches All Details

DETAIL 4 ARM SUPPORT

Measured & Drawn by John Kassay

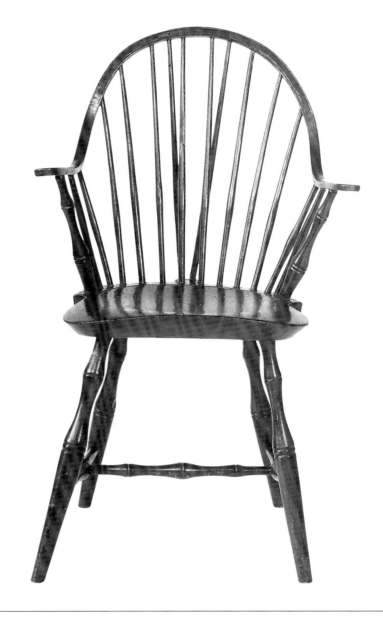

## 100. Braced Continuous-Bow Armchair

Lisbon, Connecticut, about 1800

Branded E[lijah] TRACY (1766–1807)

Seat—chestnut; legs, arm supports, stretchers—maple; bow, spindles—hickory. Mahogany varnish stain (probably original).

Slater Memorial Museum, Norwich, Connecticut

H 37½, W 23⅝, D 20⅞

| Letter | No. | Name | Material | T. | W. | L. |
|---|---|---|---|---|---|---|
| A | 1 | seat | chestnut | 1⅞ | 17⅝ | 20⅞ |
| B | 4 | legs | maple | 1⅝ dia. | | 17¾ |
| C | 2 | side stretchers | maple | 1⅜ dia. | | 14 |
| D | 1 | center stretcher | maple | 1³⁄₁₆ dia. | | 15¾ |
| E | 2 | arm supports | maple | 1¹⁄₁₆ dia. | | 12 |
| F | 8 | back spindles | hickory | ⅜ dia. | | 21½ max. |
| G | 2 | bracing spindles | hickory | ⅜ dia. | | 21½ |
| H | 4 | arm spindles | hickory | ⅜ dia. | | 10¾ |
| I | 1 | continuous bow-arm | hickory | ⅞ | 1⅞ | 57½ |
| J | 14 | wedges | maple | | various sizes | |

This handsome braced continuous-bow armchair was made by Elijah Tracy. His brand is on the seat. The spindles, arm supports, legs, and side stretchers are very similar to those on his sack-back chair (fig. 52) and, as is to be expected, show Ebenezer Tracy influence. Special features of the chair are the rather peaked double-beaded bow, the large bend flowing into flat arms, the side-scrolled hand holds, and the triple bamboo-groove center stretcher. The abrupt reduction in thickness on the bow preceding the bends that form the arms made it easier to execute these bends. The two bracing and four center spindles and the arm supports are tenon-wedged to the bow and arms. The seat is exceptionally attractive; the shield shape is nicely pro-filed, the saddling is comfortably deep, and the edges are crisp. The underbeveling is the entire thickness of the seat, the spindle area is isolated with an incised groove (which is uncharacteristic of a Tracy chair), and the tail piece is an interesting egg shape. Upholstered versions of this chair were available with seats designed with flat nailing edges.[8]

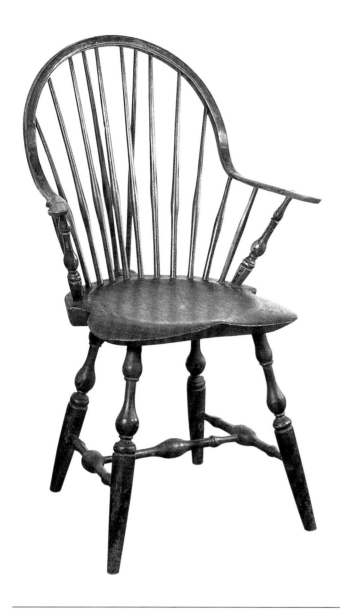

## 101. Braced Continuous-Bow Armchair

Lisbon, Connecticut, about 1790

Branded EB: Tracy

Seat—chestnut; legs, stretchers, arm supports—maple; bow—hickory; spindles—oak. Remnants of original black paint.

Historic Hudson Valley, Tarrytown, New York

H 36, W 23, D 21

Photo: Sleepy Hollow Restorations, Tarrytown, New York

Of the six different styles of Windsors made by the Tracy clan, probably none receives more attention than their continuous-bow armchairs, particularly their earlier pieces with baluster turnings. This chair is an example. We know it was made by Ebenezer Tracy Sr. or by an apprentice or journeyman working under his supervision in his chairmaking shop. The letters EB: Tracy are branded on the underside of the seat of the chair. The senior Tracy used a brand that had two dots like a colon after the letter *B*. The brand on this chair has those two dots. After Tracy died, his son Ebenezer Jr. removed the lower dot and used the brand on his chairs. Identical characteristics of the letters and the missing right arm of the letter *Y* on the brands of both father and son are proof that it is the same brand.[9] This chair has design details that Ebenezer Sr. preferred (see fig. 51). The chair is a classic piece, the work of a master at his best. It is beautifully proportioned and all its parts are skillfully executed in the Connecticut Windsor style which Tracy largely established. Little wonder that his chairs were copied by competitors!

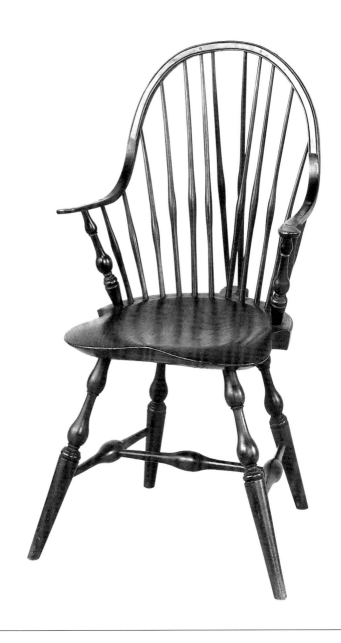

## 102. Braced Continuous-Bow Armchair

Lisbon, Connecticut, about 1785

Branded EB: TRACY

Seat—chestnut; legs, stretchers, arm supports—maple; bow—hickory; spindles—ash. Finish unidentified.

Yale University Art Gallery, Mabel Brady Garvan Collection

H 38⅜, W 20⅞, D 17½

Photo: Yale University Art Gallery

This is another branded continuous-bow armchair by Ebenezer Tracy and except for the plain stretchers, it is similar to figure 101. As previously mentioned, Tracy used eight back spindles in his continuous-bow armchairs. Some of these chairs have been described as having a "curious design quirk" in that they have a gap in the center of their backs, and that feature is apparent in this chair.[10] A simple assembly mistake is responsible for the gap: the two bracing spindles were inadvertently installed in holes intended for the two center back spindles. (Compare figures 100 and 101, which do not have this gap.) Considering the close proximity of the number of spindles and the many spindle holes in the bow and the short assembly time allowed for glue set-up, it was an easy enough mistake to make, although—surprisingly—not a frequent one. Perhaps, however, rather than an error, this "design quirk" was intended as a moderate restyling, done to offer the buyer another form.

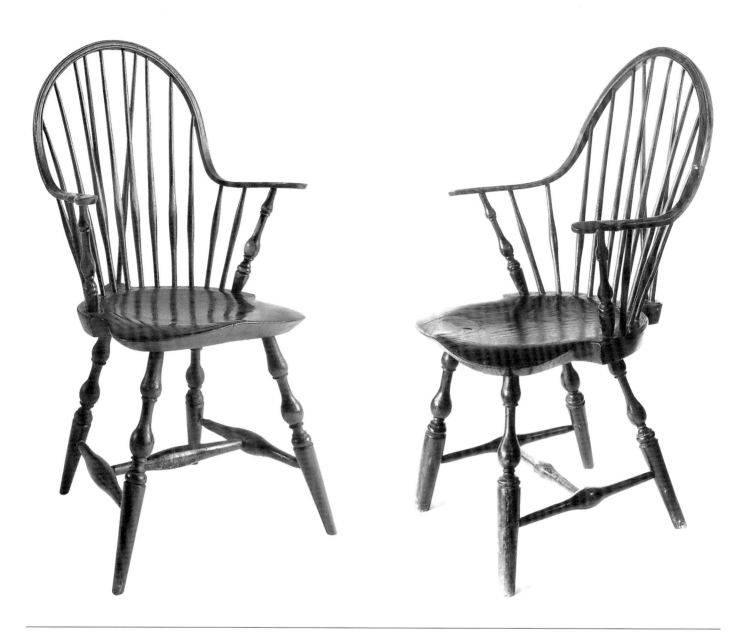

## 103. Braced Continuous-Bow Armchair

Connecticut, about 1800

Maker unidentified

Seat—unidentified (chestnut or pine?); legs, stretchers, arm supports—maple; bow, spindles—red oak. Old black paint over original light green.

Blue Candlestick Antiques

H 39, W 22, D 20¾

Although unmarked, this handsome chair has features of a Tracy-made Windsor and is possibly one of the many unmarked chairs that were assembled from the very large inventory of parts left after the elder Tracy's death. The Tracy characteristics are the eight back spindles, the absence of a spindle-isolating groove on the seat, the stop-tenoned legs, and the ringless center stretcher. Typical Connecticut features are the tall narrow bow, the swelled spindles, and narrow sharp-edged seat. The compact baluster turnings on the arm supports and legs are more New York than Connecticut patterns. Components of the chair are very attractive, particularly the seat, which is a medley of flowing forms.

## 104. Braced Continuous-Bow Armchair

Norwich, Connecticut, after 1803

Branded EB Tracy (1780–1822)

Seat—chestnut; legs, arm supports, stretchers—maple; bow, spindles—hickory. Restained dark oak varnish.

Dennis and Louise Paustenbach

H 37¼, W 22½, D 22⅜

On this chair the one dot on the EB Tracy brand identifies Ebenezer Tracy Jr. as the maker. Ebenezer Jr, the second of the elder Tracy's three sons, completed his chairmaking apprenticeship in 1801 in his father's shop and continued to work in the family "Cabinet and Chairmaking" business for some time after his father's death. It is a stately chair and, had it not been branded, could easily be misattributed as the work of the master. From its tall back to the long tapered foot, it manifests the best Connecticut Windsor chair characteristics.

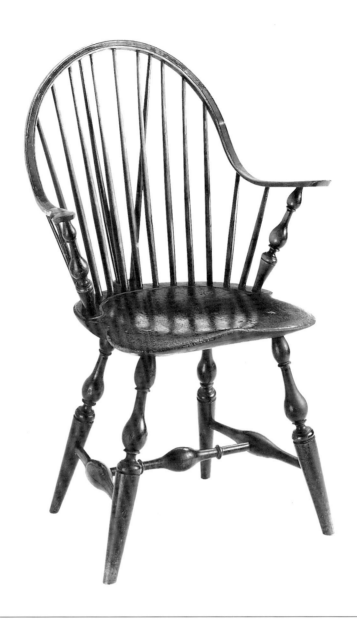

The baluster-style turnings are especially interesting because by 1800 bamboo-pattern turnings became more popular in Tracy work.[11] However, the chair could be part of the large stock of parts that were previously made, assembled, and sold after the elder's death. (See figs. 52 and 100.)

## 105. Braced Continuous-Bow Armchair

New York, about 1795

Branded W[alter] Macbride N-York
(w. 1785–1810)

Wood and finish unidentified

The Henry Francis du Pont Winterthur Museum

H 37¾, W 25½, D 21¾

Photo: Courtesy, Winterthur Museum

This classic chair carries the brand W MACBRIDE. Walter Macbride is listed in a New York City directory as a Windsor chairmaker working at locations in the city from 1792 to 1796. Continuous-bow armchairs made in New York City tend to have low, wide backs, wide shield-shaped seats, a spindle isolation groove, matching globe-shaped baluster turnings on their arm supports and legs, through-tenon-wedged legs, and paired ring turnings on the medial stretcher. Macbride's chair has all these features.

## Introduction

The last two decades of the eighteenth century were a period of innovation in Windsor chair design. Continuous-bow armchairs as well as fan backs and bow backs were still extremely popular and were manufactured in great numbers. However, a "new-fashion" Windsor chair form, one distinctively different from previous forms, was introduced in Philadelphia just before 1800 and gave the public another choice in Windsor seating.[1] In this style, a short, slightly bent lateral crest-rod joins the stiles at the corners, to form a square back. The style seems to have no direct English counterpart;[2] however, the square back in these chairs was a prominent feature on American Sheraton painted fancy chairs that were being produced in the same period (1785–1815). Within the Windsor family, rod backs were considered simplified versions of earlier classic Windsor chair styles and a general decline of the form. Nevertheless, many rod backs have handsome lines and attractive hand-painted decorations. Rod backs were quickly accepted by the public and production moved northward from Pennsylvania into neighboring states and New England. Originally called "square backs," the name was rapidly replaced with the more accurate designation of rod backs. The double rod-back pattern, called "double-bowed" Windsors followed the introduction of the single rod style and both forms were fitted with arms. The horizontal space between the rods on double rod backs was divided with the extension of selected back spindles. These spaces often had medallion-shaped hand-painted decorative pieces of wood which on some examples could be rotated. This multiple spacing caused the double rod-backs to be dubbed "bird-cage," "pigeon-hole" or "chicken-coop" Windsors. Rod-back chairs almost always have bamboo turnings throughout and box stretchers. Their simplified shield-shaped seats have minimal hollowing and lack a pommel or sharp edges. They were painted in a variety of colors but black highlighted with gilt painted nodes was the most popular. Use of unpainted mahogany for the arms was another attractive feature of some rod backs. In addition to chairs, settees, writing-arm chairs, and rockers, children's Windsors were also mass produced in the rod-back style.

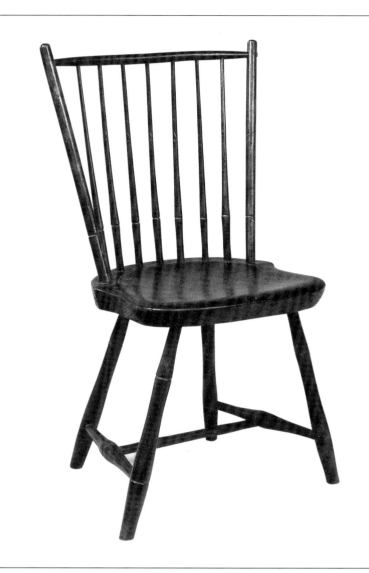

| Letter | No. | Name | Material | T. | W. | L. |
|---|---|---|---|---|---|---|
| A | 1 | seat | pine | 1¾ | 16 | 16 |
| B | 4 | legs | maple | 1⅜ dia. | | 16⅜ |
| C | 1 | center stretcher | maple | 15⁄16 dia. | | 15⅛ |
| D | 2 | side stretchers | maple | 1⁷⁄16 dia. | | 13⅜ |
| E | 2 | stiles | hickory | 1 dia. | | 20⅜ |
| F | 7 | spindles | hickory | 11⁄16 dia. | | 17½ |
| G | 1 | crest rail | hickory | ⅞ dia. | | 20 |
| H | 1 | wedge | maple? | | size to suit | |
| I | 2 | wedges | maple? | | size to suit | |
| J | 2 | wedges | maple? | | size to suit | |

### 106. Rod-Back Side Chair

Boston, 1815

T. H. Lewis

Seat—pine; legs, stretchers—maple; stiles, spindles, crest rod—hickory. Finish unidentified.

Butterfield and Butterfield Auctioneers

H 33½, W 20, D 20⅛

This rod-back side chair is typical of many that were made in New England during the first quarter of the nineteenth century.

Though quite plain, the chair does have several interesting features. They are the orderly alignment of the bamboo scoring on the stiles and spindles, the projecting ends on the stiles, the bent and tapered crest rod and the exceptionally thick seat with well-splayed legs. The crest rod is tenoned through the stiles, the center spindle is wedged to the crest rod and the H-stretcher plan, by this time a carry over that was soon to go out of favor to be replaced by the box-stretcher pattern.

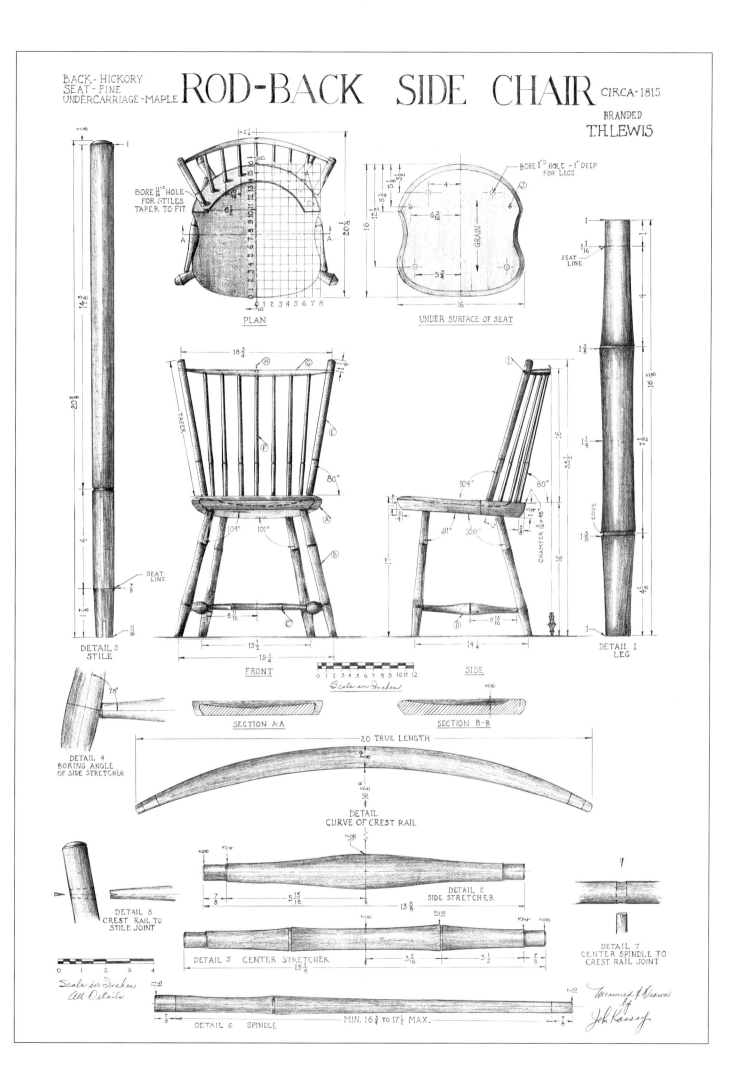

BACK - HICKORY
SEAT - PINE
UNDERCARRIAGE - MAPLE

# ROD-BACK SIDE CHAIR CIRCA·1815

BRANDED
T.H.LEWIS

BORE 11/16"D HOLE
FOR STILES
TAPER TO FIT

BORE 1"D HOLE - 1" DEEP
FOR LEGS

GRAIN

PLAN

UNDER SURFACE OF SEAT

SEAT
LINE

DETAIL 5
STILE

TAPER

SEAT
LINE

80°

104° 101°

FRONT

104°

80°

91° 109°

CHAMFER 1/8 × 45°

COVE

SIDE

DETAIL 1
LEG

Scale in Inches

78°

DETAIL 4
BORING ANGLE
OF SIDE STRETCHER

SECTION A·A

SECTION B-B

20 TRUE LENGTH

DETAIL
CURVE OF CREST RAIL

DETAIL 8
CREST RAIL TO
STILE JOINT

DETAIL 2
SIDE STRETCHER

DETAIL 7
CENTER SPINDLE TO
CREST RAIL JOINT

DETAIL 3    CENTER STRETCHER

Scale in Inches
All Details

DETAIL 6    SPINDLE

MIN. 16 3/4 TO 17 1/2 MAX.

Measured & Drawn
by
John Kassay

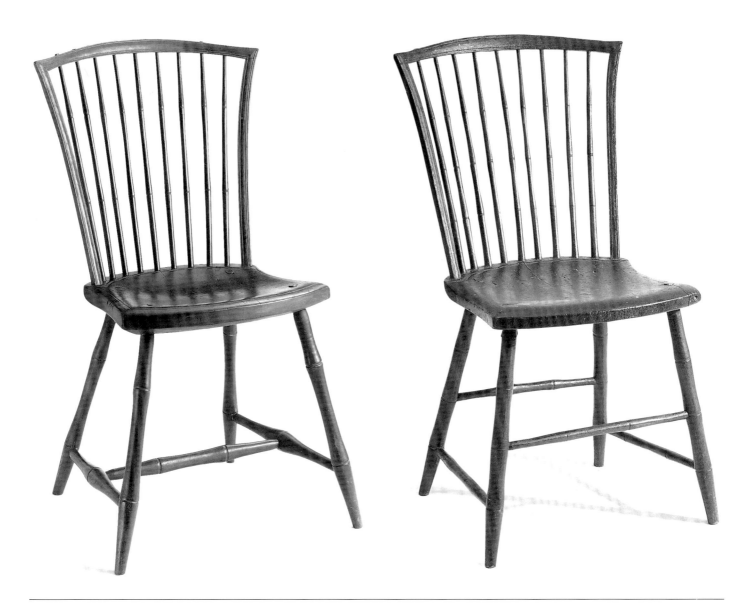

## 107. Rod-Back Side Chair

Probably Pennsylvania, about 1810

Maker unidentified

Wood and finish unidentified

The Henry Francis du Pont Winterthur Museum

H 34½, W 20½, D 20¾

Photo: Courtesy, Winterthur Museum

On this rod back, the arched crest rod, fanned-out stiles, and tapered spindles form a graceful back. Many technical processes were required to fabricate the parts and assemble the back: sawing, planing, shaving, scraping, steam bending, cutting mortise-and-tenon joints in the beaded stiles and crest rod, and boring holes in the seat. All spindles penetrate the crest rod and are wedged; all turnings, excluding the side stretchers, are bamboo

style. The shovel-shaped seat is a variant that seems limited to rod-back side chairs. The seat is hollowed out from front to back and is without a pommel. The square edges have a large radius contained within groove cuts.

## 108. Rod-Back Side Chair

Philadelphia, about 1805

Samuel Moon

Seat—poplar; crest rod, stiles—hickory. Finish unidentified.

Chester County Historical Society, West Chester, Pennsylvania

H 34

Photo: George J. Fistrovich

Except for three somewhat minor details, the features on this attractive rod-back chair are very similar to those in figure 107. The bamboo turnings have three grooves, the seat lacks paired groove cuts, and the stretchers are assembled in the newer box pattern. It is typical for chairs with box stretchers to have leg turnings with three grooves; those with H-stretchers have two grooves.

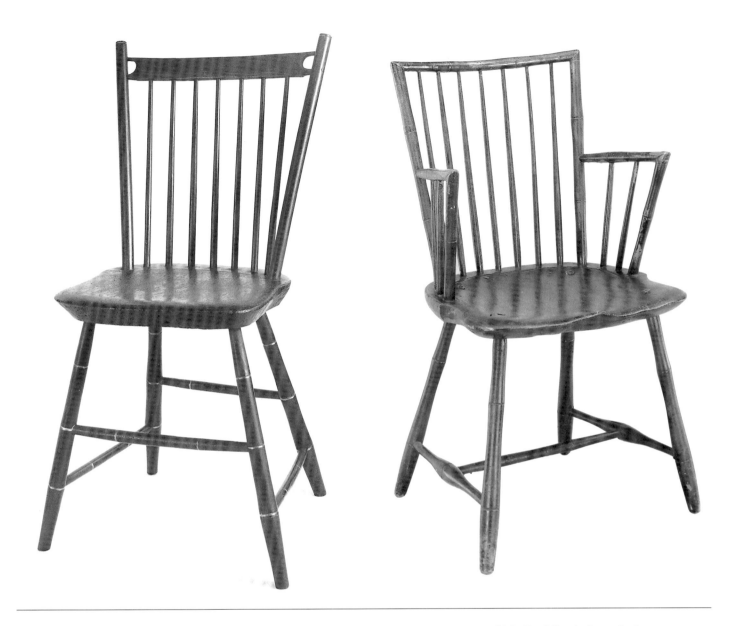

## 109. Bent-Board Side Chair

New England, probably Massachusetts,
about 1830

Maker unidentified

Woods unidentified. Late black paint and gold
striping covers remnants of white.

Pocumtuck Valley Memorial Association,
Memorial Hall Museum, Deerfield,
Massachusetts

H 34, W 18, D 17½

Except for the bent crest board with cut
outs at the ends, all components of this
chair are typical rod-back forms. The crest
board, called a fish tail, wishbone, or yoke
slat, is tenoned to the slightly tapered
stiles. The inward beveling of the seat
edges is attractive; however, the hollowing
and shield shape are little more than
suggested. The bamboo-style turnings on
the well-splayed legs and the box stretchers
are not too well articulated but the grooves
are decoratively highlighted with gold
paint, which adds interest to an otherwise
plain chair.

## 110. Rod-Back Armchair

Probably Philadelphia, about 1820

W. ZUTPHEN

Seat—tulip; legs—maple; other parts—hickory
or ash. Deep red paint covers original black.

Colonial Williamsburg Foundation

H 34, W 19¾, D 16¾

Photo: Courtesy, Colonial Williamsburg
Foundation

This rod-back armchair is similar to but
smaller than the Chapman chair (see fig.
111). It has false miter joints at the corners
of the back and arms. This miter effect is
achieved by cutting a bamboolike groove at
an angle on the ends of the joint. The
spindles are plain grooveless tapers.
Considerable attention was given to the
shaping and saddling of the seat, which was
rare with rod backs. The well-splayed legs
are through-tenoned to the seat and carry
bulbous side stretchers with a small diam-
eter center stretcher. The chair seems plain
but the integration of the parts has created
eye-catching angularity.

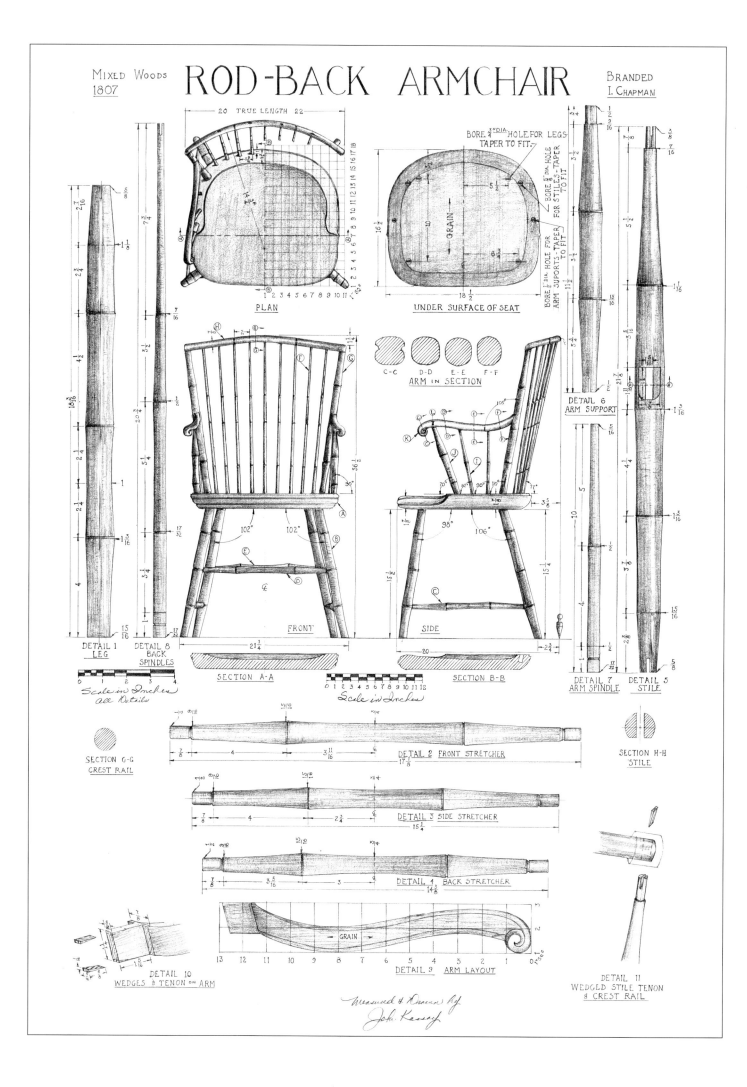

# ROD-BACK ARMCHAIR

MIXED WOODS
1807

BRANDED
I. CHAPMAN

PLAN

UNDER SURFACE OF SEAT

BORE ¾" DIA. HOLE FOR LEGS
TAPER TO FIT.

BORE ⅝" DIA. HOLE
FOR STILES - TAPER
TO FIT

BORE ½" DIA. HOLE FOR
ARM SUPORTS - TAPER
TO FIT

GRAIN

ARM IN SECTION

C-C   D-D   E-E   F-F

DETAIL 1
LEG

DETAIL 8
BACK
SPINDLES

Scale in Inches
all Details

FRONT

SECTION A-A

SIDE

SECTION B-B

DETAIL 6
ARM SUPPORT

DETAIL 7
ARM SPINDLE

DETAIL 5
STILE

Scale in Inches

SECTION G-G
CREST RAIL

DETAIL 2   FRONT STRETCHER

DETAIL 3   SIDE STRETCHER

DETAIL 4   BACK STRETCHER

SECTION H-H
STILE

DETAIL 10
WEDGES & TENON ON ARM

GRAIN

DETAIL 9   ARM LAYOUT

DETAIL 11
WEDGED STILE TENON
& CREST RAIL

Measured & Drawn by
John Kassay

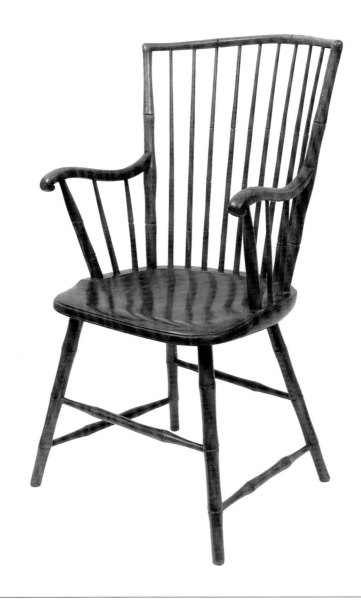

## 111. Rod-Back Armchair

Philadelphia, 1807

Branded I. [John] Chapman

Seat—pine; legs, side and back stretcher, arm supports—maple; crest rod, spindles, stiles, front stretcher—hickory; arms—mahogany. Remnants of green paint, stripped, clear varnish.

Independence National Historical Park, Philadelphia

H 36½, W 22¼, D 20

Photo: Courtesy, Independence National Historical Park

Rod-Back Armchair

| Letter | No. | Name | Material | T. | W. | L. |
|---|---|---|---|---|---|---|
| A | 1 | seat | pine | 1⅞ | 18½ | 16½ |
| B | 4 | legs | maple | 1³⁄₁₆ dia. | | 18³⁄₁₆ |
| C | 2 | side stretchers | maple | ¹⁵⁄₁₆ dia. | | 15¼ |
| D | 1 | front stretcher | hickory | ¹⁵⁄₁₆ dia. | | 17⅛ |
| E | 1 | back stretcher | maple | ¹⁵⁄₁₆ dia. | | 14⅜ |
| F | 9 | back spindles | hickory | ¹⁷⁄₃₂ dia. | | 20¾ |
| G | 2 | stiles | hickory | 1³⁄₁₆ dia. | | 21⅞ |
| H | 1 | crest rail | hickory | ⅞ dia. | | 22 |
| I | 4 | arm spindles | hickory | ½ dia. | | 10 |
| J | 2 | arm supports | maple | ¹⁵⁄₁₆ dia. | | 11½ |
| K | 2 | arms | mahogany | 1¼ | 2 | 12½ |
| L | 2 | pins | maple | | size to suit | |

(note: Width in drawing differs from ms. text. W 22¼)

Armchairs in the single rod-back style were also manufactured and advertised for sale. On this armchair, the large oval seat nicely accommodates the wide back. The back has grooving at the rear and decorative double grooving along the front and side edges.

A mortise-and-tenon joint joins the stiles to the compound curved crest rod. This interesting joint is made by first turning and leaving a collar at the ends of the rod, which is then steamed and bent to shape.

This step is followed by cutting mortise and tenons and temporarily assembling the pieces. After excess wood is removed, the rod is carved to its final shape.

All turnings are bamboo patterns with one, two, or three grooves, depending on their size and where they are used.

The vertical, curved mahogany arms taper in width from their double-wedged

tenon ends to beautifully carved scrolled hand holds. The even-numbered back spindles are through-tenon-wedged to the crest rod. The odd-numbered back spindles and arm spindles are stop-tenoned. The arm supports are stop-tenoned and in addition are pinned through the arm. Bamboo-turning details on the undercarriage are rather well defined.

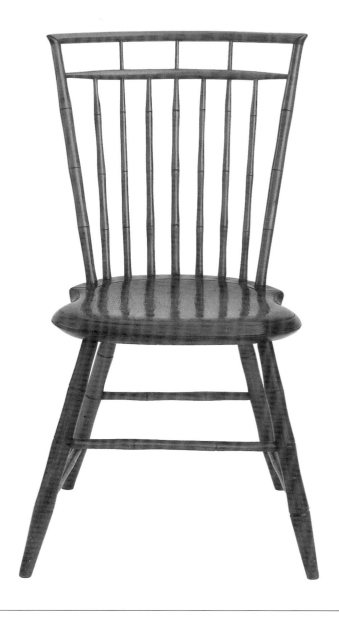

## 112. Double Rod-Back Side Chair

New England, 1810

Maker unidentified

Seat—pine; all other parts—maple. Clear varnish.

Gary and Diane Espinosa

H 34⅝, W 20½, D 19³⁄₁₆

Double rod-back side and armchairs were introduced after the single rod-back style. This light, airy, well-proportioned side chair is exceptionally attractive.

The beautiful sculptured seat is accentuated with carved grooves on the surface and edges, simulating upholstery. All the spindles pass through the lower rod, and the three long ones continue on through the upper rod. The false miters at the corners of the upper rod, called "duck bills," are very well realized. To make these false miters, a collar was first turned on the ends of the upper rod and a mortise hole for the tenoned end of the stile was bored

| Letter | No. | Name | Material | T. | W. | L. |
|--------|-----|------|----------|-----|-----|-----|
| A | 1 | seat | pine | 1¹¹⁄₁₆ | 17 | 15¾ |
| B | 4 | legs | maple | 1⅜ dia. | | 17⅜ |
| C | 2 | side stretchers | maple | ¾ dia. | | 14 |
| D | 1 | front stretcher | maple | ¾ dia. | | 15¾ |
| E | 1 | back stretcher | maple | ¾ dia. | | 13 |
| F | 2 | stiles | maple | ¹⁵⁄₁₆ dia. | | 20¼ |
| G | 4 | short spindles | maple | ⅝ dia. | | 16⁵⁄₁₆ |
| H | 2 | long spindles | maple | ⅝ dia. | | 19 |
| I | 1 | center spindle | maple | ¹¹⁄₁₆ dia. | | 19 |
| J | 1 | secondary crest rail | maple | ¾ dia. | | 18½ |
| K | 1 | crest rail | maple | ¾ dia. | | 19⅞ |
| L | 13 | wedges | maple | | size to suit | |

through the collar. The rod was then steam bent. When it dried, a portion of the collar was flattened off to provide a seat for the shouldered tenons. The illusion of the miter joint was carried out while the pieces were temporarily assembled. The excess wood on the collar was carefully removed and shaped to the stile. Then the diagonal groove was carved. The secondary crest rod on double rod-backs required that all

components of the back be assembled at one time and in a certain order. That order is: spindles and stiles to seat, secondary crest rod to spindles and stiles, then upper crest rod to spindles and stiles. When this is done, the eleven joints are wedged and any excess glue is removed. After the piece is dry, the projecting tenons and wedges are trimmed and sanded or scraped to profile.

# DOUBLE ROD-BACK SIDE CHAIR

### CIRCA 1810

### MAPLE WITH PINE SEAT

DETAIL 2
STILE

DETAIL 3
LEG

PLAN

UNDER SURFACE OF SEAT.

BORE 7/8 DIA. FOR LEGS 1 5/8 DEEP

FRONT

SIDE

Scale in Inches

DETAIL 4
LONG & SHORT
SPINDLES

DETAIL 5
CENTER
SPINDLE

DETAIL 6
REAR STRETCHER

SECTION A-A

SECTION B-B

DETAIL 7
SIDE STRETCHER

DETAIL 10
WEDGE AT BOTTOM
OF STILE

DETAIL 8
FRONT STRETCHER

DETAIL 9
TURNED COLLAR AT
ENDS, SHAPED AND
GROOVED TO SIMULATE
MITERED CORNER AND
BORED TO RECEIVE STILE

MEASURED & DRAWN BY
John Kassay

Scale in Inches
All Details

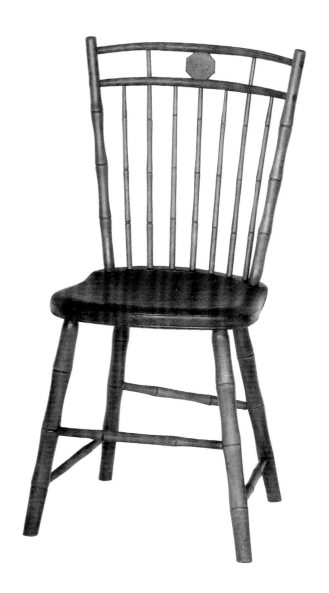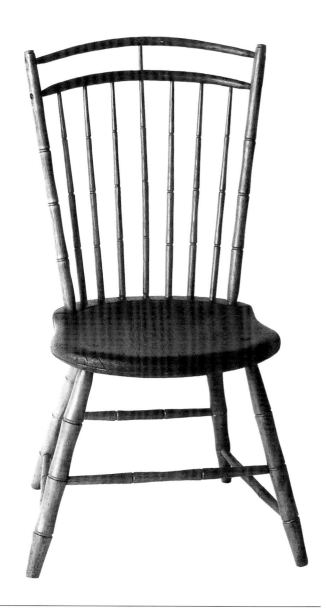

## 113. Double Rod-Back Side Chair

Philadelphia, 1810

[Anthony] Steel (worked 1791–1817)

Seat—pine; legs, stretchers, stiles—maple; spindles, crest rods—hickory. Clear varnish.

Thos. B. Rentschler—Blue Hills Farm Antiques

H 35⅛, W 18½, D 18

Photo: Rentschler

This chair was branded STEEL on the underside of the seat and was probably made by Anthony Steel who produced Windsors in a variety of styles (see fig. 114). The straight stiles and spindles fan out nicely and are assembled to the crest rods with exposed wedged tenons. The projecting ends on the stiles have an interesting caplike ring with a single score. Both rods have the same curvature and they were most likely bent in identical bending forms. The center back spindle terminates at the underedge of the medallion and a pin through the rod into the medallion locks both in place. The upper edge of the thick seat is generously rounded whereas the lower is square. Both edges are ornamented with an incised line of beading. The penetrating legs have rounded shoulder tenons and are double-wedged. All turnings are nicely achieved with pronounced double and triple bamboo separated by good concavity.

## 114. Double Rod-Back Side Chair

Probably Philadelphia, about 1817

Probably Anthony Steel

Seat—poplar; legs—maple; stretchers, stiles, spindles—hickory; crest rods—red oak. Maple-color stain, clear varnish.

Dennis and Louise Paustenbach

H 35, W 18, D 18⅝

This charming chair has features similar to figure 113. Although unmarked, this may be another Anthony Steel product. The chair has an attractive back, is well proportioned, and has a wonderful stance. The single back spindle dividing the rods was part of the initial design and contributes a far Eastern look to the chair.

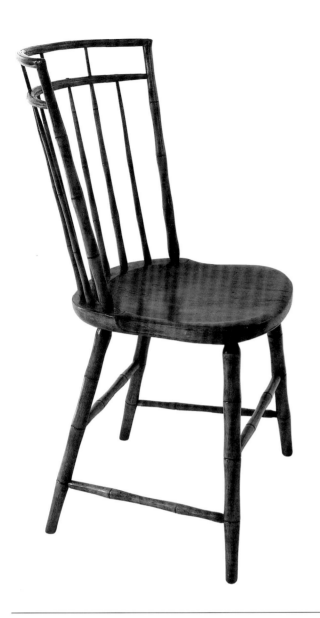
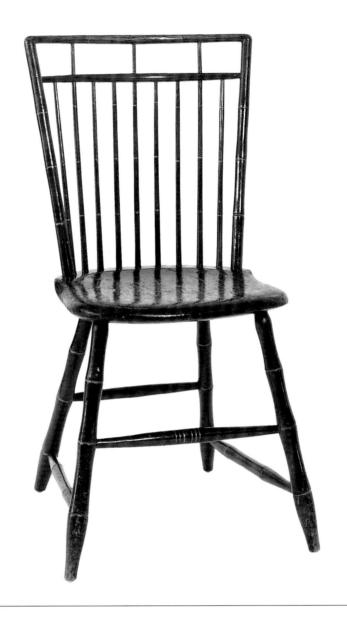

## 115. Double Rod-Back Side Chair

Probably Philadelphia, 1820

Maker unidentified

Seat—pine; legs, stretchers, stiles, spindles—maple; crest rod—hickory. Maple varnish stain covers remnants of original green paint.

Gary and Diane Espinosa

H 34⅜, W 20, D 18

Most rod-back chairs have slightly curved backs, but the back on this side chair is exceptional because it has a so-called barrel-shaped back. The overly stated curved back may be an attempt to increase the chair's comfort. The curve of the back edge of the seat is approximately the same as on most rod backs, although the curve of the crest rods are much greater than usual, nearly form a semi-circle. All other parts of the chair are standard rod-back forms.

## 116. Double Rod-Back Side Chair

Probably Philadelphia, about 1810

Maker unidentified

Seat—pine; legs, stretchers, stiles—maple; crest rods, spindles—hickory. Recent back paint over original black with gold striping.

Historical House, San Francisco

H 34, W 19, D 19¼

The backs of most rod-back chairs were assembled with seven uniformly spaced spindles; some, however, were made with nine, as in this example. The nine-spindle arrangement has created an interesting one, two, two, one spindle order in the secondary crest rod. Except for the six ornamental grooves on the front stretcher, all features of the chair are typical rod-back forms.

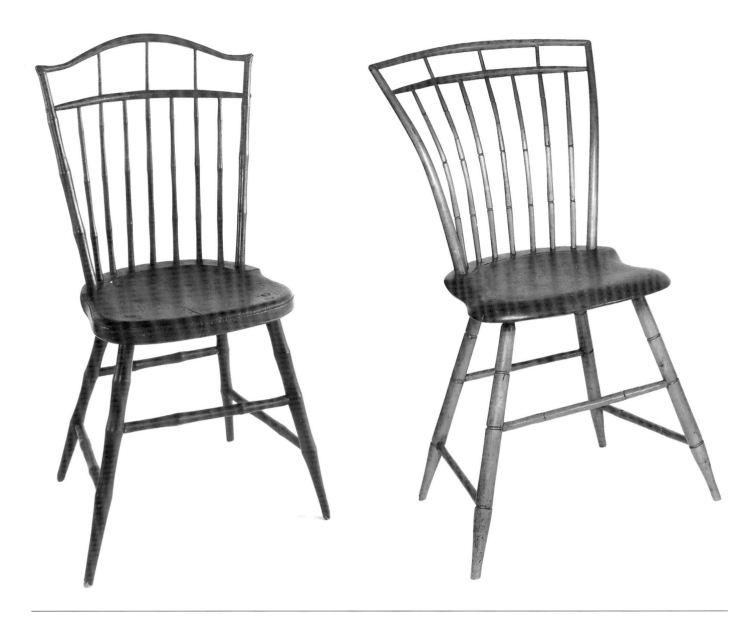

## 117. Double Rod-Back Side Chair

Probably Salem, Massachusetts, about 1810

Attributed to James Chapman Tuttle
(177?–1849)

Seat—pine; other parts unidentified. Original green paint covered with old red, alligatored paint.

Greg and Bonnie Randall

H 38, W 21, D 17½

The serpentine crest rod on this chair is a wonderful departure from the typical ubiquitous straight or curved rod forms. Its design is derived from the formal English Sheraton and Hepplewhite shield-back chair styles.[3] Though unmarked, the chair is very similar in size and form to chairs known to have been made by James

Chapman Tuttle, and it may be one of his. The deceptive miters on the corners of the crest-rod-to-stile joints are well accomplished, as are the beads on the front and sides of the seat edge, which are made to resemble upholstery.

## 118. Double Rod-Back Side Chair

Athol, Massachusetts, about 1815

[Alden] Spooner and [George] Fitts

Seat—pine; legs, stretchers, stiles—maple; crest rods, spindles—hickory. Traces of original stain, probably mahogany.

Courtesy, Historic Deerfield, Inc., Deerfield, Massachusetts

H 31½, W 15½, D 15

Photo: Helga Photo Studio

The most interesting features on this chair are the bent and flared components forming the back and the handsome carved simulated cushion seat. Both the back and the seat were designed to increase the chair's comfort. All the turnings have bamboo scoring except the crest rods and stiles, which are tapered and left plain.

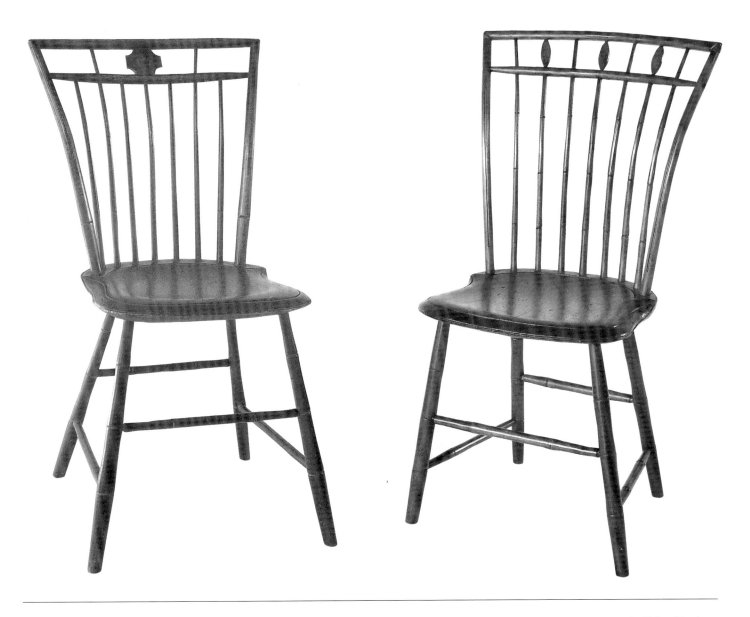

## 119. Double Rod-Back Side Chair

New England, about 1815

Maker unidentified

Seat—pine; all other parts—maple. Brown paint, gilt striping.

Dr. Donald B. Bond

H 34¾, W 19¾, D 18⅞

Among the distinctive features of this chair are the back-bent flaring stiles and spindles and the curved crest rods; all are designed for comfort. Three bending molds were necessary to bend these parts. The butterfly-shaped medallion has an attractive, barely perceptible hand-painted basket holding a spray of fernlike branches. A carved cove-and-bead accentuates the sharp contoured edge of the seat and a carved inner groove outlines the dished-out portion. A feeling of thinness is achieved through heavy chamfering. The

legs taper from small to large at the floor line and have lost little if any of their length. They have three bamboo rings, the stretchers have two, and the spindles, only one, and it is barely perceptible.

## 120. Double Rod-Back Side Chair

New England, about 1820

Maker unidentified

Seat—pine; all other parts—maple. Clear varnish.

Mardie M. Miller

H 35½, W 19¾, D 18⅜

The attractive features of this chair are the three oval medallions, the single vertical groove on the stiles, and the flared-out back. The somewhat circular dished seat, the bamboo-style legs, and the box stretcher are traditional rod-back patterns. See figure 123 for a matching armchair.

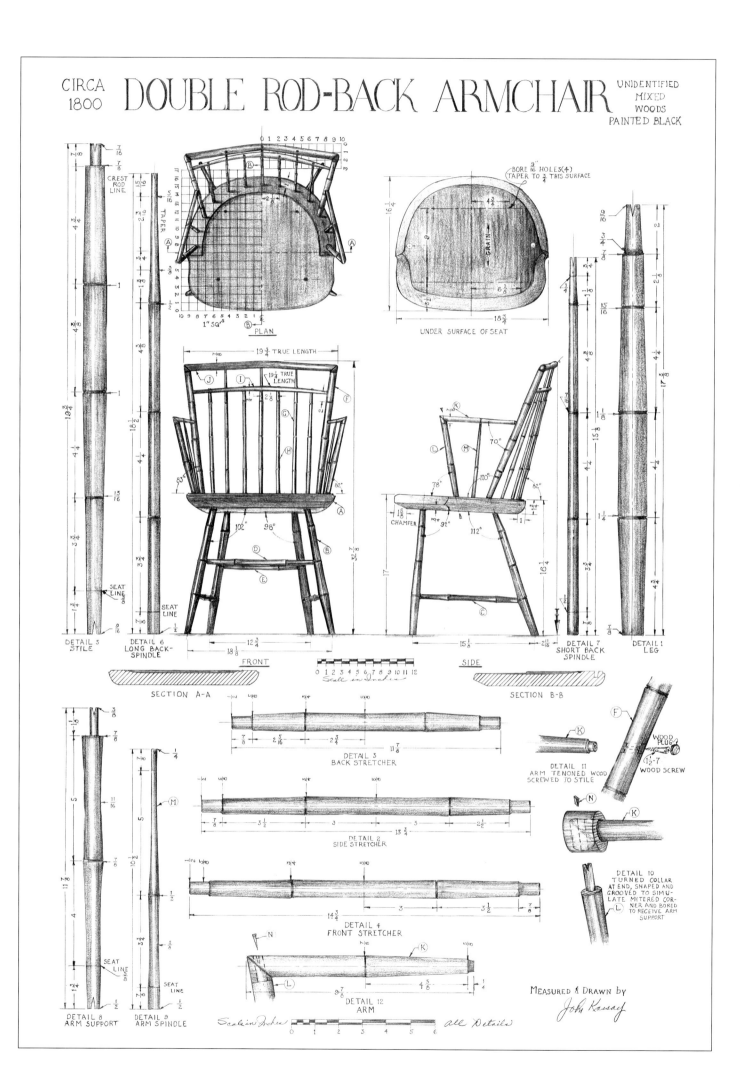

# DOUBLE ROD-BACK ARMCHAIR

CIRCA 1800

UNIDENTIFIED MIXED WOODS PAINTED BLACK

CREST ROD LINE

TAPER

PLAN

1" SQ.

UNDER SURFACE OF SEAT

BORE 9/16" HOLES (4) TAPER TO 3/4 THIS SURFACE

GRAIN

19 3/4 TRUE LENGTH

19 1/4 TRUE LENGTH

FRONT

SIDE

SEAT LINE

SECTION A-A

Scale in Inches

SECTION B-B

DETAIL 5 STILE

DETAIL 6 LONG BACK SPINDLE

DETAIL 7 SHORT BACK SPINDLE

DETAIL 1 LEG

CHAMFER

DETAIL 3 BACK STRETCHER

DETAIL 2 SIDE STRETCHER

DETAIL 4 FRONT STRETCHER

DETAIL 11 ARM TENONED WOOD SCREWED TO STILE

WOOD PLUG

WOOD SCREW

DETAIL 10 TURNED COLLAR AT END, SHAPED AND GROOVED TO SIMULATE MITERED CORNER AND BORED TO RECEIVE ARM SUPPORT

DETAIL 8 ARM SUPPORT

DETAIL 9 ARM SPINDLE

SEAT LINE

DETAIL 12 ARM

Scale in Inches

All Details

MEASURED & DRAWN BY
John Kassay

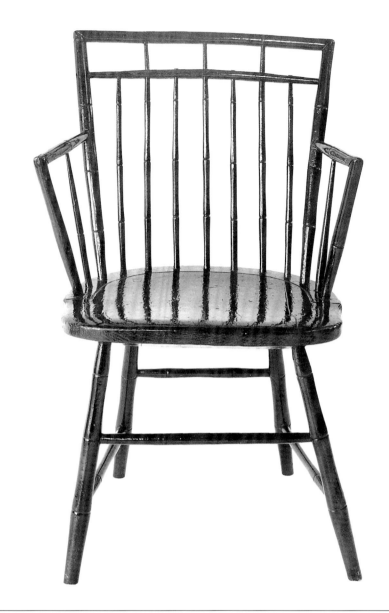

## 121. Double Rod-Back Armchair

Probably New England, 1800

Maker unidentified

Woods unidentified. Recent black paint covers original black paint.

George W. Dodge

H 32⅞, W 21⅞, D 20¼

Though more expensive than side chairs, matching double rod-back armchairs were also marketed in great numbers. This armchair is assembled with forty-two mortise-and-tenon joints, twenty-five of which are the open-wedged variety. The others are blind-socketed and hold the stretchers to the legs and the spindles to the seat. The arm and back corner joints have false miter grooves. The seat is vaguely shield shaped, lightly saddled without a pommel and has squared off edges.

| Letter | No. | Name | Material | T. | W. | L. |
|---|---|---|---|---|---|---|
| A | 1 | seat | unidentified | 1¾ | 18¾ | 16¼ |
| B | 4 | legs | unidentified | 1¼ dia. | | 17⅜ |
| C | 2 | side stretchers | unidentified | ¾ dia. | | 13¾ |
| D | 1 | front stretcher | unidentified | ¾ dia. | | 14¾ |
| E | 1 | back stretcher | unidentified | ¾ dia. | | 11⅞ |
| F | 2 | stiles | unidentified | 1 dia. | | 19¾ |
| G | 3 | long spindles | unidentified | ½ dia. | | 18½ |
| H | 4 | short spindles | unidentified | ½ dia. | | 15⅛ |
| I | 1 | secondary crest rail | unidentified | ¾ dia. | | 19¼ |
| J | 1 | crest rail | unidentified | ⅞ dia. | | 19¾ |
| K | 2 | arms | unidentified | ⅞ dia. | | 9⅞ |
| L | 2 | arm supports | unidentified | ⅞ dia. | | 11⅞ |
| M | 2 | arm spindles | unidentified | ½ dia. | | 10½ |
| N | 35 | wedges | unidentified | | size to suit | |

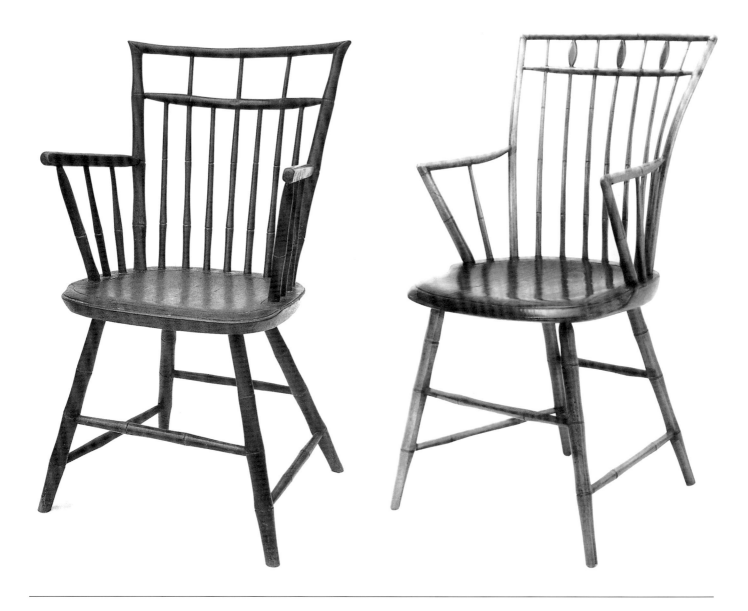

## 122. Double Rod-Back Armchair

Unidentified, about 1815

Maker unidentified

Woods and finish unidentified

The American Museum in Britain, Bath

Size unidentified

Photo: Courtesy, The American Museum in Britain

The flat sides on the rodlike arms of this handsome rod-back chair detract from its otherwise attractive features. The turned arms were probably modified to reduce their bulk and to introduce a variant arm style to the line. Most parts of the chair are standard forms, some, however, are exaggerated and create added interest. One's attention is naturally drawn to the well-aligned bamboo ringing at the bottom of the arms and back, and to the concave undercuts between the ringing. The well-realized duck-bill at the back corners and the great leg splay also contribute interest.

## 123. Double Rod-Back Armchair

New England, about 1820

Maker unidentified

Seat—pine; all other parts—maple. Clear varnish.

Mardie M. Miller

H 35½, W 20, D 20½

This chair and figure 120 have very similar features and it is likely that the two were made in the same shop, probably as a matched set. Each has an attractive airy, light, feminine quality. The backs of both chairs have the same distinctive backward arch and three identical oval medallions. Both have a decorative groove on their stiles, well-shaped rods, and attractive double beading along the front and sides of the seat. Their understructures are also alike. The seats are different in that the side chair is slightly shield-shaped and the armchair is nearly square with rounded sides.

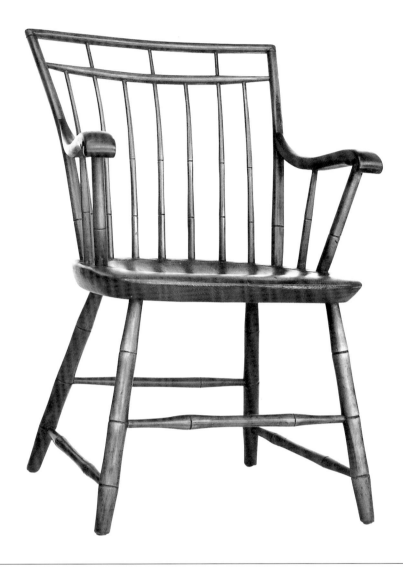

### 124. Double Rod-Back Armchair

Probably New Hampshire, about 1830

Branded N. Cutter

Seat—pine; arms—probably mahogany or cherry; all other parts—maple.

Original black paint.

Montgomery Antiques

H 32¾, W 21½, D 21⅝

The vertical scrolled tapered arms of mahogany and the heavy legs are forms that came into rod back production late in the first quarter of the nineteenth century. The same patterns were used on rocking chairs manufactured during this period (see fig. 152). Construction features of the chair include the rectangular wedged tenon on the arm-to-stile joint and the pinned stop tenon on the arm support to the arm. The exceptionally wide seat is only moderately saddled.

## Introduction

The step-down Windsor chair style first appeared around 1812 in the Boston area of Massachusetts. The name "step-down" comes from the cut-out "steps" on the crest board.

Except for the wide crest board, the design features and construction details of step-down and slat-back Windsor chairs are basically the same as those on rod backs. The raised center of the crest board was adopted from the tablet-style crest on Sheraton formal chairs. The broader crest board afforded greater space for painted decoration than that provided on rod backs. The decoration on an otherwise plain board was considered more attractive and, therefore, better competition with the highly decorated, popular Sheraton fancy chairs that were being marketed at the same time.[1] Step-down and slat-back chairs represent the end of approximately one hundred years of essentially hand-crafted American Windsor chairmaking, and with their introduction the golden age of the Windsor chair was replaced in time with machine-made, mass-produced, so-called kitchen chairs.

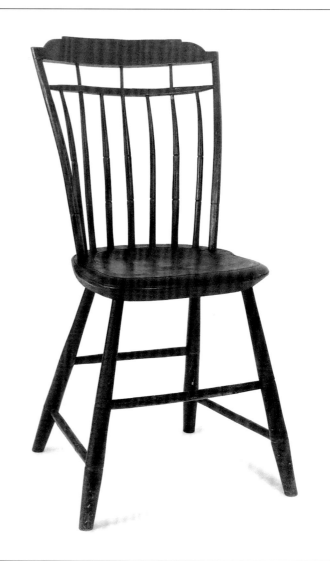

## 125. Step-Down Side Chair

New England, 1820

Maker unidentified

Seat—pine; legs, stretchers, crest rails, spindles—maple; stiles—probably red oak. Original dark maple varnish stain, floral decoration and gold striping.

Private collection

H 34⅜, W 19¼, D 20½

The secondary crest piece on this step-down side chair is singular and makes the chair very attractive. Not as round as is typical on rod backs but square in section, this rail adds greater interest to the piece. Also pleasing but faded and not visible in the photograph are the painted floral decorations on the crest board, the seat edge, and front legs. The shorter back spindles are through-tenoned-wedged to the secondary crest, while the three long one-piece spindles are stop-tenoned and pinned to the crest board. The moderately

| Letter | No. | Name | Material | T. | W. | L. |
|---|---|---|---|---|---|---|
| A | 1 | seat | pine | 2 | 15⁹⁄₁₆ | 15¼ |
| B | 4 | legs | birch | 1½ dia. | | 17¾ |
| C | 2 | side stretchers | birch | ¾ dia. | | 14½ |
| D | 1 | front stretcher | birch | ¾ dia. | | 15¼ |
| E | 1 | back stretcher | birch | ¾ dia. | | 12¾ |
| F | 3 | long spindles | birch | ⅝ dia. | | 18¼ |
| G | 4 | short spindles | birch | ⅝ dia. | | 15⁷⁄₁₆ |
| H | 2 | stiles | red oak | ⅞ dia. | | 19¾ |
| I | 1 | secondary crest rail | maple | ⅝ | 11⁄16 | 19¼ |
| J | 1 | crest rail | maple | 11⁄16 | 2¾ | 20 |
| K | 10 | wedges | maple | | size to suit | |
| L | 2 | wedges | maple | | size to suit | |
| M | 3 | pins | maple | | size to suit | |

scooped, slightly shield-shaped seat is decorated with grooves around the edge and surface. Bamboo grooves on the legs were used to locate stretcher holes. Having only two grooves on the legs allowed space for the painted leafage. The stiles are through-tenoned-wedged to mortises in the crest board, a joint that required careful lay out and cutting.

# STEP-DOWN SIDE CHAIR

MIXED WOODS PAINTED and ORNAMENTED

CIRCA 1820

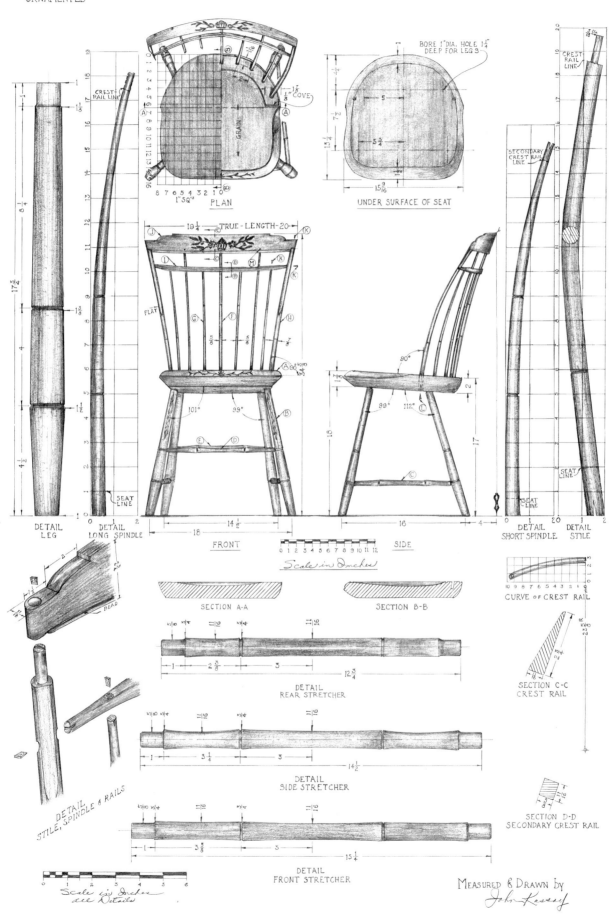

PLAN

UNDER SURFACE OF SEAT

BORE 1" DIA. HOLE 1¼" DEEP FOR LEGS

DETAIL LEG

DETAIL LONG SPINDLE

FRONT

SIDE

Scale in Inches

DETAIL SHORT SPINDLE

DETAIL STILE

CURVE of CREST RAIL

SECTION A-A

SECTION B-B

SECTION C-C CREST RAIL

DETAIL REAR STRETCHER

DETAIL SIDE STRETCHER

SECTION D-D SECONDARY CREST RAIL

DETAIL STILE, SPINDLE & RAILS

DETAIL FRONT STRETCHER

Scale in Inches all Details

MEASURED & DRAWN by
John Kassay

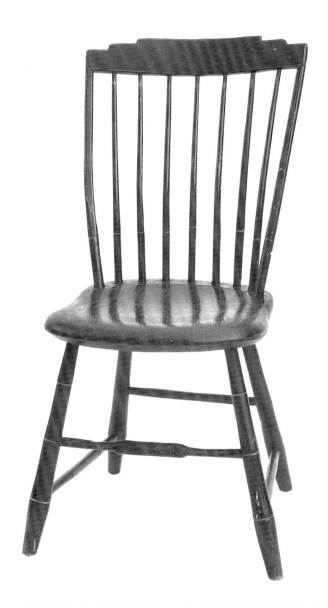
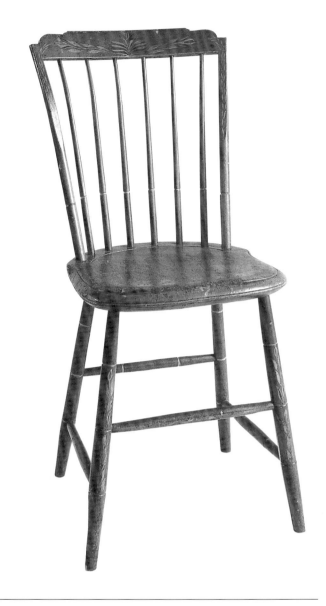

## 126. Step-Down Side Chair

New England, about 1820

Maker unidentified

Seat—pine; all other parts—maple. Original red paint.

Gary and Diane Espinosa

H. 33⅞, W 18¾, D 18¼

This pleasing step-down side chair is one of a matched set of four. Noteworthy details are the footrest on the front stretcher, the very small rounded edge on the middle step of the crest board (a variant typical of large radiuses), and the barely visible painted grasslike decoration on the crest, the footrest, and the legs.

## 127. Step-Down Side Chair

Vermont, about 1838

John White (1803–65)

Seat—pine; other parts—birch and maple. Original salmon-pink paint with white decorations, and green and gold striping.

Private collection

H 35, W 17, D 18⅜

The original salmon-pink paint and leafage decoration in white and dark green have been wonderfully preserved on this handsome step-down side chair. A hand-written paper label pasted on the underside of the seat (probably put there by an early owner) reads: "John White side chair—one of pair—number 2." The chair is remarkably similar to a documented one made by White of Woodstock, Vermont, and is most likely one of his many surviving Windsors.[2]

John's father, Francis White, operated a chair shop beginning in 1790. John learned the chairmaking business from his father under whom he served an apprenticeship, worked as a journeyman, and became a master. This training qualified him to open his own shop, which he did in 1838.

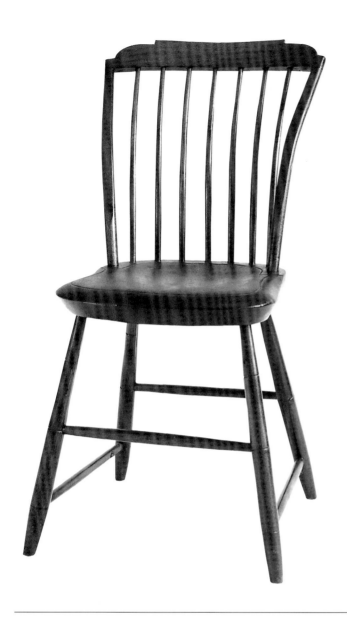
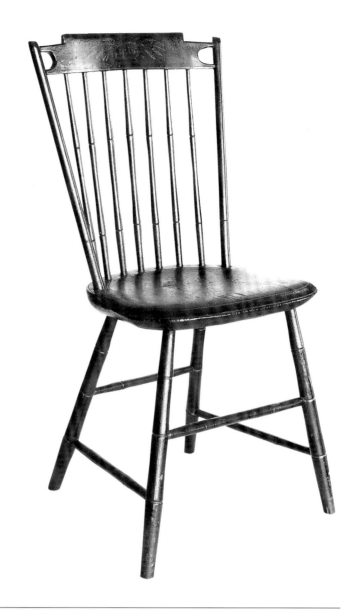

## 128. Step-Down Side Chair

Probably Vermont, about 1830

Possibly John White

Seat—pine; crest rail—oak; other parts—maple. Mahogany stain.

Pocumtuck Valley Memorial Association, Memorial Hall Museum, Deerfield, Massachusetts

H 33¼, W 18⅛, D 18½

Although this chair lacks a stencil decoration, which might help determine when and who made it, it is nevertheless of a style so similar to documented John White step downs that it is safe to assume that it was made by him or at least by someone familiar with his chairs.[3] The stiles have a longer than typical flattened-off front face and an abrupt backward bend midway, which were probably an attempt to introduce greater comfort to the chair. Sharp edges on the front and sides of the exceptionally thick seat divide the rounded upper surface from the heavily chamfered under edge.

## 129. Step-Down Pierced Slat-Back Side Chair

Probably Woodstock, Vermont, about 1820

Attributed to John White

Seat—pine; legs, stretchers, stiles, crest rail—maple; spindles—hickory. Old dark red paint over original paint of same color.

Society for the Preservation of New England Antiquities, Gift of Edgar Rollins

H 35⅜, W 18⅜, D 18⅛

Photo: David Bohl

The crest board on this chair has a single step and elongated semi-circular cut outs at the ends. Chairs with this open crest pattern are rare and are referred to as fish-tail or yoke-slat Windsors. The chair is probably another John White product. This attribution is based on the painted wheat decoration on the crest board, which is identical to one on an identified John White yoke-slat Windsor.[4] Also of interest are the straight rod-shaped stiles and the cushionlike sculpted seat.

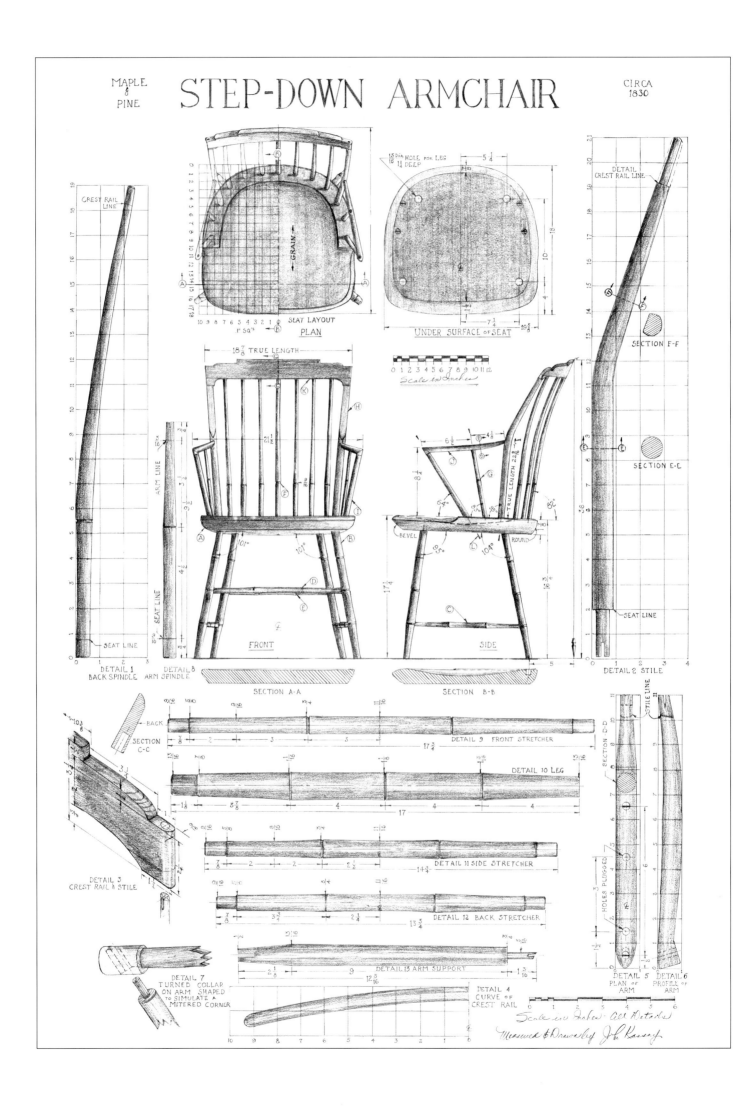

# STEP-DOWN ARMCHAIR

MAPLE & PINE

CIRCA 1830

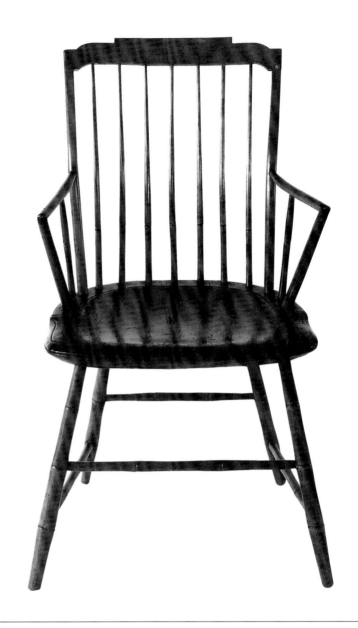

## 130. Step-Down Armchair

New England, about 1830

Maker unidentified

Seat—pine; other parts—maple. Maple stain, varnished.

Greg and Bonnie Randall

H 36, W 21½, D 22½

On this step-down (also called tablet top) armchair, the back spindles are bent gradually for comfort and the stiles have an abrupt bend where the arms are joined. This intersection is a weak assembly, although the arm supports and spindles contribute needed strength. The stiles are cut flat on the face, the seat is slightly saddled, and the bamboo turnings have one, two, or three grooves. The arm supports are tenoned to the arms without a false miter groove. An interesting innovation is the small holes on the top of the arms, one of which is visible on the right

| Letter | No. | Name | Material | T. | W. | L. |
|---|---|---|---|---|---|---|
| A | 1 | seat | pine | 1⅞ | 19⅝ | 18 |
| B | 4 | legs | maple | 1³⁄₁₆ dia. | | 17 |
| C | 2 | side stretchers | maple | ¾ dia. | | 14¾ |
| D | 1 | front stretcher | maple | ¾ dia. | | 17¾ |
| E | 1 | back stretcher | maple | ¾ dia. | | 13¾ |
| F | 7 | back spindles | maple | ⁹⁄₁₆ dia. | | 19 |
| G | 2 | arm spindles | maple | ⁹⁄₁₆ dia. | | 9½ |
| H | 2 | stiles | maple | ⅞ dia. | | 22⁹⁄₁₆ |
| I | 2 | arm supports | maple | 1³⁄₁₆ dia. | | 12⁵⁄₁₆ |
| J | 2 | arms | maple | 1³⁄₁₆ dia. | | 11 |
| K | 1 | crest rail | maple | ⁹⁄₁₆ | 3¼ | 18⅞ |
| L | 12 | wedges | maple | | size to suit | |

(note: date in drawing differs from ms. text.)

arm. On some Windsors these holes functioned as locators for pins fastened to the underside of a separate large thin board. When positioned, the board furnished a temporary writing, eating, and reading surface.

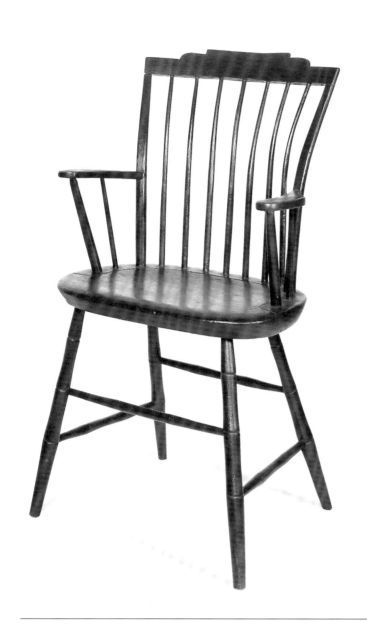

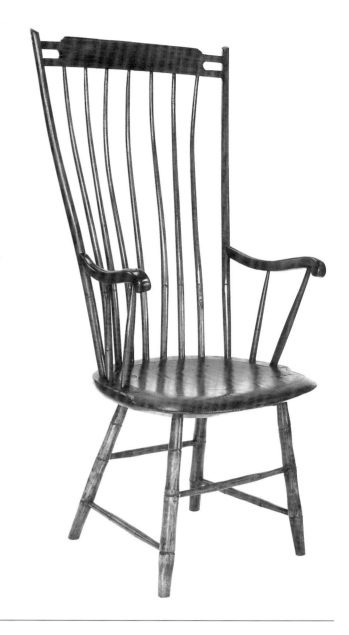

### 131. Step-Down Armchair

Massachusetts, about 1815

Maker unidentified

Seat—pine; crest board, stiles, spindles—probably hickory; other parts—maple. Repainted dark green.

Courtesy, Historic Deerfield, Inc., Deerfield, Massachusetts

H 31½, W 15½, D 15

Photo: Helga Photo Studio

Like the preceding chair, the back on this step down has sharply bent stiles and has survived because of its similar arm supporting components. The compact stepped crest is an attractive variant; the arms are flat boards with ordinary sawn curves. Other details of the chair are typical patterns that were popular and were used on many step downs of the period.

### 132. Step-Down Pierced Slat-Back Armchair

New England, about 1825

Maker unidentified

Seat—pine; arms—mahogany; other parts—maple. Stripped; clear varnish over remnants of red, blue, and original green paint.

Sandra MacKenzie

H 45⅞, W 23, D 21½

The crest rail on this late high-back chair has small steps and semi-rare cut-out fish-tail ends. The thumb-molded stiles and tapered spindles are bent to an S-curve for greater comfort. The arms are tapered in width, sawn in an S-curve, and have scrolled hand holds. They are a common form and are used on several other Windsor chair styles. Other features are the moderately dished round seat with a sharp front edge and incised cove cuts. If they had not been tapered, the typical bamboo-style legs would accept rockers.

### 133. Slat-Back Armchair

Probably Pennsylvania, about 1820

Maker unidentified

Woods unidentified. Original black paint covered with brown, light green, and late nineteenth-century Windsor green paint.

C. K. Wallace Antiques

H 34¼, W 19½, D 18⅞

This plain, no-frills Windsor is an example of the degeneration in the Windsor style that took place in the early nineteenth century, a deterioration brought on by competition among manufacturers, consumer demand for inexpensive chairs, developing mass-production technologies, and a general decline in craftsmanship among chairmakers. The slat-back crest rail is another crest style that came into use on Windsors. The bamboo-grooved double-

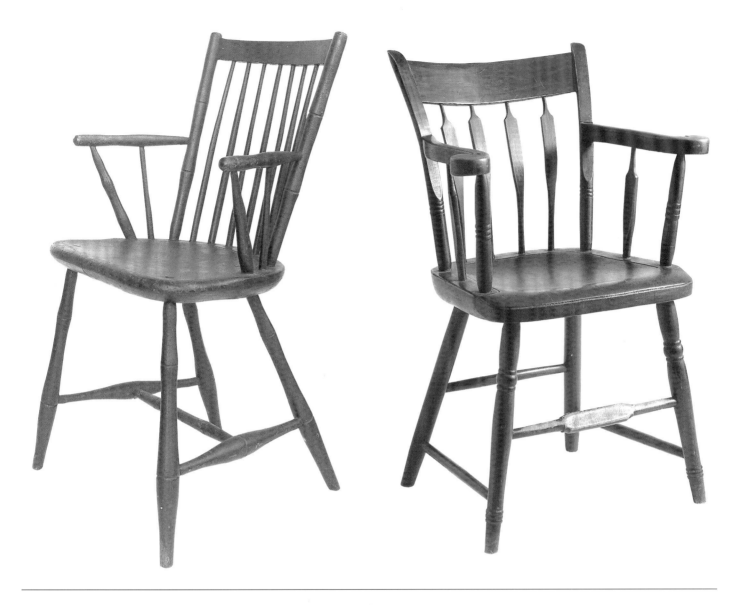

bobbin turnings have rounded shoulders preceding the tenons. The turned caps on the ends of the stiles and arms are hardly decorative. Interestingly, the out-of-favor H-stretcher pattern required one less stretcher, two less holes, and, therefore, probably took less time to assemble than the box arrangement. The seat form is uninspired and virtually without saddling; however, it does hold substantial stiles and arm supports.

## 134. Slat-Back Armchair

West Chester, Pennsylvania, about 1830

Joseph Jones (? –1868)

Seat—poplar; other parts—unidentified. Black over red paint.

Chester County Historical Society, West Chester, Pennsylvania, Gift of Samuel Butler, 1940

H 33¾, W 19, D 16½

Photo: George J. Fistrovich

The chairmaker's label is still intact under the seat of this stoutly built Windsor. Chairs of this style were referred to as arrow backs, a name obviously derived from the arrow-feather-shaped spindles. Arrow-back spindles were introduced during the first quarter of the nineteenth century and were a spindle style popular with New York chairmakers.[5] Components of this chair are uniform in size and shape, which is proof that it was machine-made and mass-produced, mainly for use in public buildings. As to its other features, the front stretcher and arm spindles were first lathe-turned and then slab-sawn to shape. The back spindles were steam-bent to a back-supporting curve and the solid slat-board crest was made in the same manner. The stiles, arm supports, and front legs are decorated with turned beads, while the back legs were left plain for economy's sake.

# 9  Writing-Arm Chairs

## Introduction

The obvious distinguishing features of writing-arm Windsor chairs are their very large wooden paddle-shaped writing arms. The earliest writing-arm Windsors predate the Revolutionary period and continued to be made through the second decade of the nineteenth century. To some extent they followed chronologically the same style changes that took place within the Windsor chairmaking industry as a whole, that is comb backs to rod and board backs,[1] with comb and low backs being the most popular forms. The chairs were built around standard Windsor armchair styles, usually those with U-shaped arm rails, although there are exceptions (see figs. 143, 144, 145). No examples of writing-arm chairs seem to exist in the fan-back form. Possibly chairmakers assumed the side cut outs and the front-to-back grain direction on the shield-shaped seats did not provide enough space for seat extensions needed to support the writing tablet.

The writing-arm Windsor chair form may have originated in Philadelphia, but except for the low-back style made by Anthony Steel, few writing-arm Windsors were made there, in New York, or in most of New England. A considerable number, however, were produced in Connecticut. The best of those were made by the Ebenezer Tracy family and numerous unidentified imitators.

Most writing arms are monumental chairs and they had to be properly designed and engineered to support successfully the large writing arm and other accessories.

They are the most complicated Windsor chairs, especially the comb-backs, with heavy three-piece sawn arms and crested backs. This sawn-arm structure is basically the same as was used on Philadelphia low-back chairs except the writing arm and seat had to be modified. They were expensive chairs then and still are; they are much sought by collectors today.

Writing-arm Windsors can be grouped as either true or adapted from existing chairs. Genuine writing-arm chairs were designed from their inception to include a writing tablet as an integral component of the chair. They have one or two seat projections that are a continuation of the seat. These shelflike extensions hold one to three socketed tablet-supporting spindles. In the adaptations, the tablet was applied to the arm of a Windsor chair, either permanently or temporarily (some swivel and can be demounted) and although the chairs are functional, they usually convey an unattractive, makeshift look. Whether genuine or adapted, their large projecting working surface gives them an awkward, unbalanced appearance.

Most had one or more drawers; the smaller size were suspended under the writing tablet and the larger, under the seat. A few also had a sliding candle shelf and when so equipped the chair became a portable desk that could be moved about the house to take advantage of the best heat and light.[2] Many of the drawers were crudely assembled with joinery that suggests these craftsmen were better chairmakers than cabinetmakers. On some chairs, the drawers were added later. Nevertheless, incorporating writing and storage facilities within a chair was an ingenious expression of Yankee inventiveness.

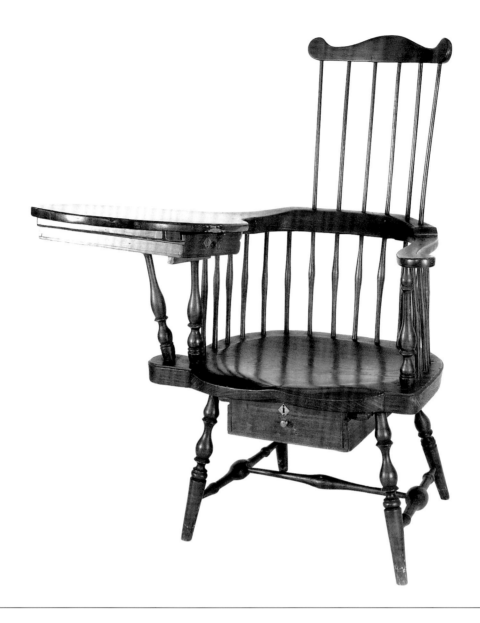

## 135. Comb-Back Writing-Arm Chair

Lisbon, Connecticut, about 1775

Branded E.B: Tracy

Seat—chestnut; legs, arm supports, arms, back—maple; crest rail, spindles—hickory; stretchers—oak? writing tablet, drawers—pine. Originally painted red, now dark brown patina.

Pocumtuck Valley Memorial Association, Memorial Hall Museum, Deerfield, Massachusetts

H 45, W 36, D 33

This comb-back writing-arm chair is one of the finest examples of its type. It was made by Ebenezer Tracy Sr. of Lisbon, Connecticut. The seat is triple branded with his name and numbered underneath with chisel marks. Other examples of his writing-arms are marked in a like manner which suggests he recorded production of writing-arm chairs in this manner. Typical Tracy patterns are evident in the chair: the uncarved round ears on the crest rail, the

abruptly swelled spindles, the bold bulbous well-defined turnings throughout, the socketed legs in the chestnut seat, the single extension on the seat, and the single tablet support. The broad D-shaped seat has a pair of in-line arm supports socketed at the front corners. It is well scooped, has a high pommel, and an unusual cleft at the front edge.

Tracy built his writing-arm chairs on the basic low-back Windsor form, but with several modifications. The left arm and back rail are typical, whereas the tablet arm support is tapered and left unscrolled. This taper with the thicker end at the front gives the tablet an upward tilt and makes the work area more comfortable. The back spindles, which penetrate the arm to form a tall comb, are offset by one to the left, as are the ten arm spindles—six on the right and four on the left. The offset back spindles positions the sitter at a good angle in relation to the writing tablet. A shallow drawer is suspended under the writing

tablet and a larger drawer is under the seat. Both drawers have pulls, stops, and locks. A retractable candle shelf was suspended from the bottom of the tablet drawer. One of the hangers and the shelf are missing.[3]

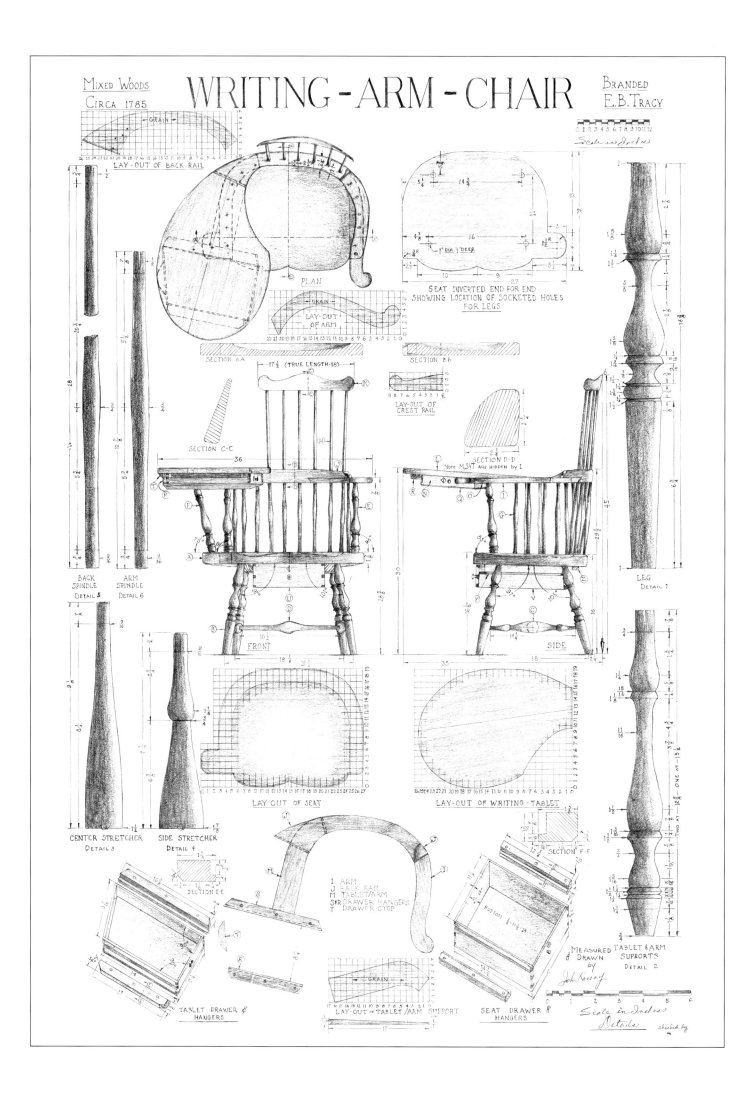

# WRITING-ARM-CHAIR

MIXED WOODS
CIRCA 1785

BRANDED
E.B. TRACY

Scale in Inches

LAY-OUT OF BACK RAIL

PLAN

SEAT INVERTED END FOR END
SHOWING LOCATION OF SOCKETED HOLES
FOR LEGS

1" DIA. ½ DEEP

LAY-OUT OF ARM

SECTION AA

SECTION BB

LAY-OUT OF CREST RAIL

SECTION C-C

17½ (TRUE LENGTH-18)

SECTION D-D
Note M,S,T ARE HIDDEN by I

36

FRONT

SIDE

LEG
Detail 1

BACK SPINDLE
Detail 5

ARM SPINDLE
Detail 6

CENTER STRETCHER
Detail 3

SIDE STRETCHER
Detail 4

LAY-OUT OF SEAT

LAY-OUT OF WRITING-TABLET

SECTION F-F

TABLET & ARM SUPPORTS
Detail 2

SECTION E-E

I   ARM
J   BACK RAIL
M  TABLET/ARM
S&R DRAWER HANGERS
T   DRAWER STOP

TABLET DRAWER &
HANGERS

LAY-OUT of TABLET/ARM SUPPORT

SEAT DRAWER &
HANGERS

BOTTOM

MEASURED &
DRAWN
by
John Kassay

Scale in Inches
Details        checked by

Comb-Back Writing-Arm Chair

| Letter | No. | Name | Material | T. | W. | L. |
|---|---|---|---|---|---|---|
| A | 1 | seat | chestnut | 1⅞ | 19 | 27 |
| B | 4 | legs | maple | 1⅝ dia. | | 16⅜ |
| C | 2 | side stretchers | oak? | 1⅞ dia. | | 15¾ |
| D | 1 | center stretcher | oak? | 1½ dia. | | 18¼ |
| E | 2 | arm supports | maple | 1½ dia. | | 13½ |
| F | 1 | tablet support | maple | 1½ dia. | | 14¼ |
| G | 10 | arm spindles | maple | ¾ dia. | | 12⅞ |
| H | 6 | back spindles | maple | ¾ dia. | | 28 |
| I | 1 | arm | maple | ⅞ | 8 | 21½ |
| J | 1 | back rail | maple | 2¼ | 2¼ | 26 |
| K | 1 | crest rail | hickory | ⅝ | 2⅝ | 18 |
| L | 2 piece | writing inner | pine | ⅞ | 7¾ | 25½ |
| | | tablet outer | pine | ⅞ | 11¼ | 25½ |
| M | 1 | tablet arm/support | pine | ⅞ | 6½ | 17 |

*Tablet Drawer:*

| Letter | No. | Name | Material | T. | W. | L. |
|---|---|---|---|---|---|---|
| N | 1 | front | pine | 5⁄16 | 1¹¹⁄₁₆ | 9¼ |
| O | 2 | sides inner | pine | 5⁄16 | 1¹¹⁄₁₆ | 14 |
| | | outer | pine | 5⁄16 | 1¹¹⁄₁₆ | 16⅜ |
| P | 1 | back | pine | 5⁄16 | 1¹¹⁄₁₆ | 9⁷⁄₁₆ |
| Q | 1 | bottom | pine | 3⁄16 | 9¼ | 17 |
| R | 1 | hanger - outer | pine | ⅞ | 1⅝ | 13 |
| S | 1 | hanger - inner | pine | ⅞ | 1⅝ | 17 |
| T | 1 | stop | pine | ⅞ | 1¼ | 5 |

*Seat Drawer:*

| Letter | No. | Name | Material | T. | W. | L. |
|---|---|---|---|---|---|---|
| U | 1 | front | pine | ½ | 3¾ | 12 |
| V | 2 | sides | pine | ½ | 3¾ | 14½ |
| W | 1 | back | pine | ½ | 3¼ | 11⅞ |
| X | 1 | bottom | pine | ½ | 11½ | 14 |
| Y | 2 | hangers | pine | 1³⁄₁₆ | 1⅝ | 12¾ |
| Z | 1 | drawer stop | pine | 9⁄16 | 1⅛ | 4¼ |
| | 2 | pulls and locks | brass | | | |

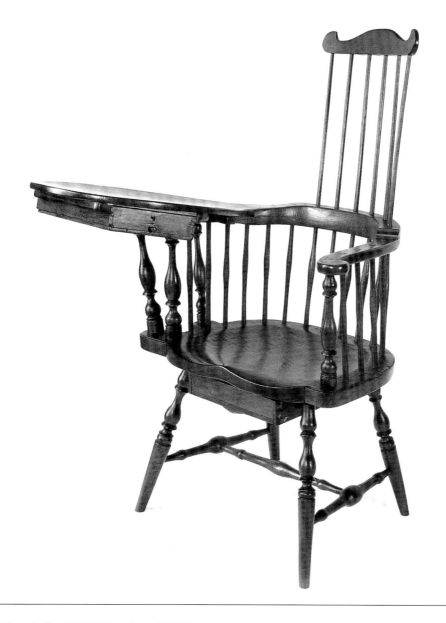

## 136. Comb-Back Writing-Arm Chair

Connecticut, about 1790

Unidentified

Seat—probably oak; legs, back and arms, crest rail, writing tablet—maple; stretchers—ash; spindles—hickory; drawers—pine. Finish unidentified

Slater Memorial Museum, Norwich, Connecticut

H 48½, W 36½, D 40

Many features of this unmarked comb-back writing-arm chair are in the E. B. Tracy style and it was no doubt made by a craftsman strongly influenced by that master's work. The chair is beautifully proportioned with nicely integrated components. The arm crest laps the arms and the elliptical writing tablet is tilted at a convenient angle for writing. The turnings have exceptionally fine features with large onion-shaped balusters and cusps deeply carved with remarkably large sharp edges—a difficult turning to produce. The six comb spindles were installed with one spindle off center to the left. This was purposely done on comb-back writing-arm chairs to give the sitter more arm room. The two somewhat poorly made drawers, possibly later additions, slide on L-shaped hanger runners. The drawer bottoms are simply applied rather than let-in to grooves. The tablet drawer can be locked to secure the contents and to prevent it from sliding forward. The projection on the front of the seat drawer serves as a drawer pull. The seat is well saddled, has a high pommel, and two projections that hold three writing-arm supports.

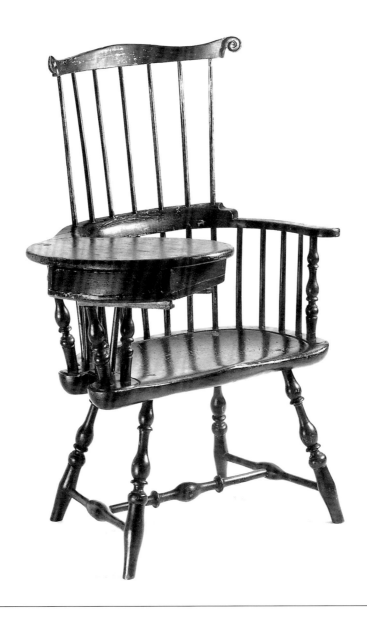

## 137. Comb-Back Writing-Arm Chair

Eastern Connecticut or western Rhode Island, 1775–1805?

Maker unidentified

Woods and finish unidentified

The Henry Francis du Pont Winterthur Museum, Gift of H. Rodney Sharp III

H 45½, W 27¼, D 17¼

Photo: Courtesy, Winterthur Museum

This handsome writing-arm chair has skillfully carved ears on a narrow serpentine crest rail; the curve on the drawer front echoes the curve of the writing tablet and the slightly tilted tablet adds convenience: all point to a master chairmaker, albeit unknown. The comb consists of seven tapered spindles that continue through the arm rail. Holes of different diameters were bored in their related parts; those in the arm rail were tapered from the underside. The arm rail laps the arms in the Philadelphia low-back style whereas the tablet-supporting arm is assembled much like the chairs in figures 135 and 136. The large bead on the legs surmounting the swelled concave tapered foot is a typical Rhode Island turning pattern. Perhaps the chair maker trained in Philadelphia and later moved further north. The two L-shaped hangers under the drawer box are probably later additions and perhaps held a sliding candle shelf or a support for a book or papers. Two seat projections anchor the arm supports. The two exceptionally large turned rings on the center stretcher are unique. Most unusual is the way the drawer opens: from the outside rather than the more convenient front. The drawer originally had a pull, which is now missing, so it is now opened by holes in the back of the drawer box.

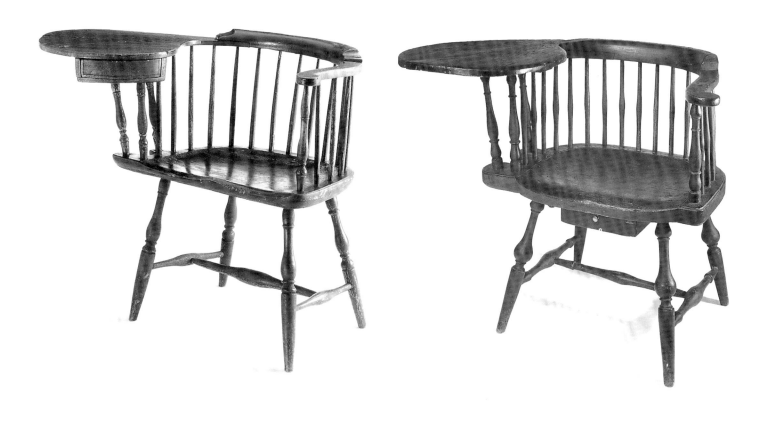

## 138. Low-Back Writing-Arm Chair

Philadelphia, about 1815

Anthony Steel

Woods: Seat—poplar?
Writing tablet, drawer parts—pine?
Arm, back, arm crest—oak?
Spindles—hickory?
Legs, stretchers, writing arm, drawer and arm supports—maple?

Finish: Unidentified

The Henry Francis du Pont Winterthur Museum

H 31⅛, W 38⅞, D 26¾

Photo: Courtesy, Winterthur Museum

The letters A STEEL are burned into the seat of this low-back writing-arm chair. Steel made other Windsor chair forms, but he may have been the only one in Philadelphia producing low-back writing-arm chairs. On this chair the curved edge on the writing tablet and the matching curved drawer front are outstandingly attractive features. The drawer is contained in a box

rather than suspended from hangers. The sides and bottom of the drawer are exposed, that is, not hidden by the drawer front as was traditional. The tablet and scrolled arm butt against shoulders cut into the crested back: this is the joinery used on typical Philadelphia low backs. The tablet is supported by three turned arm supports which are socketed into a pair of seat extensions. The seat is D-shaped, well saddled and holds rather sedate baluster-style turnings.

## 139. Low-Back Writing-Arm Chair

Unknown, about 1790

Maker unidentified

Woods unidentified

Bernard and S. Dean Levy, Inc., New York

H 30, W 35, D 18¾

Photo: Helga Photo Studio

This low-back writing-arm chair has a Pennsylvania provenance but has stylistic details common to chairs made in Connecticut. The large bulbous turnings on the legs, the abrupt swelling on the spindles and arrowlike turnings on the stretchers are Connecticut forms. If the assigned origin is correct, the chairmaker certainly was knowledgeable about Connecticut turning patterns. The single turned ring below the small vase turning on the arm and tablet supports is unusual and may be useful in determining where the chair was made and by whom. The balloon-shaped writing tablet is an integral part of the arm

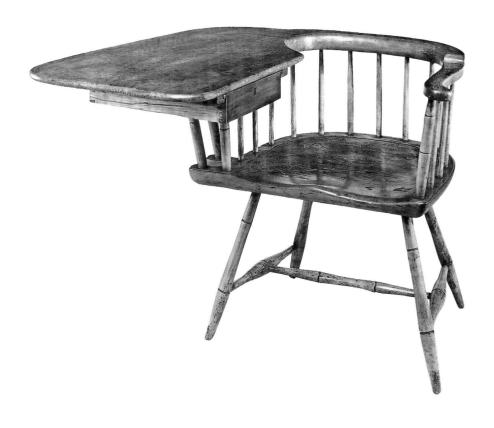

rail and is supported by three baluster-style turned arm segments that are socketed to two seat extensions. The seat is D-shaped and has an interesting extended curved front, another Connecticut feature. The seat is well saddled and holds socketed well-angled legs. The spindle area and the seat profile, including the extensions, are emphasized by a continuous carved groove. The small dovetailed drawer has a brass pull and slides on L-shaped hangers.

## 140. Low-Back Writing-Arm Chair

Probably Connecticut, about 1800
Maker unidentified
Unidentified mixed woods. Finish unidentified.
Bernard and S. Dean Levy, Inc., New York
Unidentified
Photo: Helga Photo Studio

The writing tablet on this chair is somewhat square with three straight sides and a curved end that is cut out to receive the arm rail. The large tablet provides additional working space, although it conveys an off-balance visual and physical condition that is countered by a broad seat and well-splayed legs. All turnings are bamboo-style except the plain tapered spindles. The D-shaped seat is attractively beveled,

saddled, and has an incised edge and two projections that hold three tablet supports. The underslung shallow drawer has dovetailed corners, is fitted with a lock, and is guided by two rabbeted hangers.

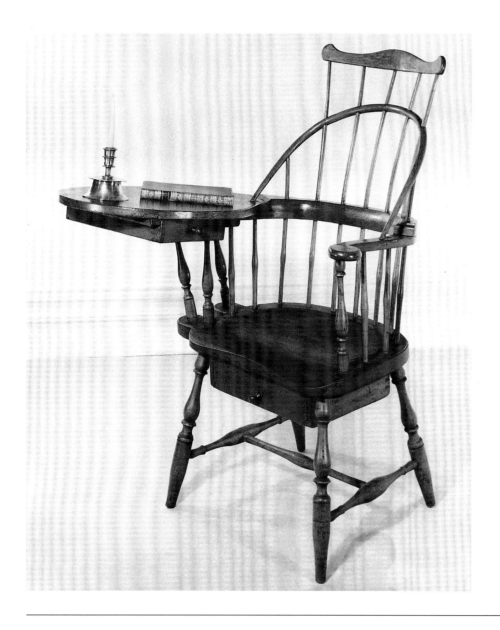

## 141. Sack-Back Writing-Arm Chair with Comb

Probably Rhode Island or eastern Connecticut, about 1800

Maker unidentified

Writing tablet and drawer parts—probably pine; all other parts—hardwood species. Finish unidentified.

Bernard and S. Dean Levy, Inc., New York

Unidentified

Photo: Helga Photo Studio

What is essentially a sack back with a five-spindle comb, through the addition of a writing tablet and two underslung drawers, is transformed into a Windsor masterpiece. The turning pattern on the lower end of the legs suggests the chair was made in Rhode Island; however, the upturned ears on the crest rail, the abruptly swelled spindles, and the arrow-ended turnings on the side stretchers are features found on Connecticut Windsors. The writing tablet butts the end of the back rail on an angle and is supported by a modified arm that is also angle-butted to the back rail. The tablet and underslung drawer are further supported by three angled spindles tenoned into the arm and two seat projections. A second larger drawer, under the seat, is an added convenience and tracks on L-shape hangers. Both drawers have dovetailed corners. The seat is only moderately saddled and pommeled and does not have a cove cut to separate it from the spindles.

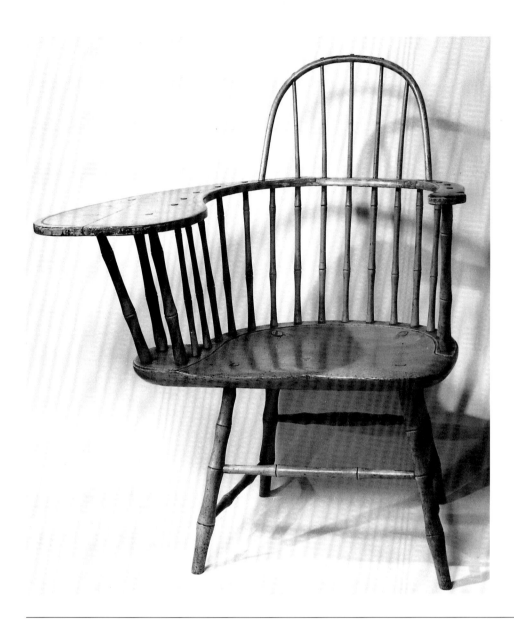

## 142. Sack-Back Writing-Arm Chair

Massachusetts or New Hampshire, pre-1817

Maker unidentified

Seat, writing arm—pine; legs, stretchers, arm supports, arm rail—maple; spindles, sack—hickory. Painted light green.

Robert and Mary Lou Sutter Antiques

H 40¾, W 34¼, D 28

An inscription on the underside of this chair seat reads: "Adam Gordon, Bedford, N. H. 1795-1861. Taken to Dartmouth College Class of 1817."

Writing-arm chairs of the sack-back type are rather rare. This chair with its boldly stated bamboo turnings is one of the finest examples. The large rounded extension, which is part of the seat, and the five long back spindles are an indication that the chairmaker planned from the outset to make a writing-arm chair with a sack back, rather than a low or a comb back which would have required longer spindles. The chair is a wonderful example of how neatly a sack can be assembled to a low-back form. The arm-rail spindles blend well with the writing arm supports, yet given these attractive features, it is surprising how few of these chairs were made. The balloon-shaped writing arm is fabricated from three pieces of wood; two are glued edge-to-edge and the third is an extension at the rear. The curved arm rail is lap-joined to the tablet extension and to the S-shaped arm. All the pieces are the same thickness and on the same plane. Most writing-arm chairs have at least one drawer, although a few were made without drawers as was this charming example. The spindles and sack are assembled to the writing-arm rail with wedged tenons, several of which project above the surrounding surface. This could have been avoided had the tenons been turned with a shoulder. The bamboo-style turnings are triple-scored and have boldly defined thicks and thins. The legs penetrate a moderately saddled seat and are supported by box stretchers. Oddly, the rear stretcher has nonbamboo-style decoratively turned beads at its center.

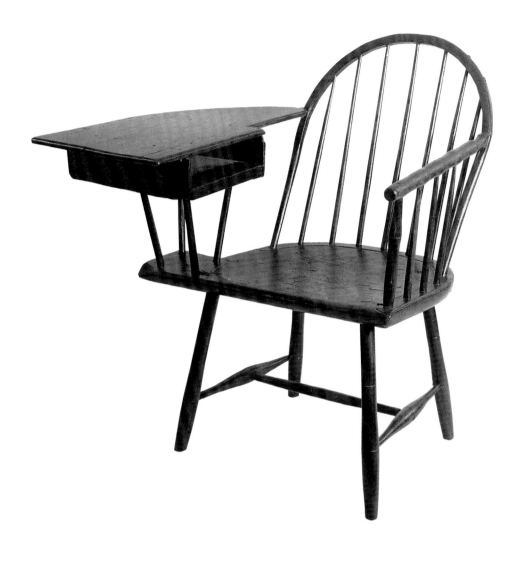

## 143. Bow-back Writing-Arm Chair

Probably Virginia, about 1810

Maker unidentified

Woods and finish unidentified.

Museum of Early Southern Decorative Arts, Winston-Salem, North Carolina

H 36⅛

Photo: Courtesy, Museum of Early Southern Decorative Arts

Design and construction features of this bow-back writing-arm chair are best described as plain and simple. It probably is a one-of-a-kind piece made by a semi-skilled rural craftsman having limited knowledge of writing-arm chair forms. The large projection on the D-shaped seat was formed out of the seat blank for the purpose of accommodating a writing tablet. The straight-sided tablet is anchored directly to the bow and to the three-sided pigeon-hole box, which in turn is supported by four canted spindles socketed to the thick box bottom. Anchoring the writing arm to the bow without additional support from arm spindles indicates the chair was not designed for, or fortunately subjected to, hard usage. Although the bow is wider than those on bow-back armchairs, the shaping is identical. The seat is only slightly saddled and probably held a cushion. Through-tenoned bamboo-style legs, plain bulbous side stretchers, and a very thin center stretcher constitute the undercarriage. These turnings are common Windsor chair patterns of late manufacture.

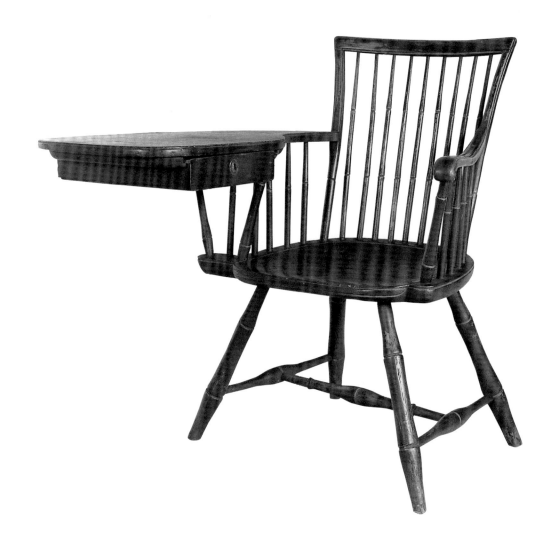

### 144. Rod-Back Writing-Arm Chair

Richmond, Virginia, 1802

Andrew and Robert M'Kim

Woods: Oak, hickory, poplar, maple

Finish: Original black paint, touched up-bamboo nodes and grooves accentuated with yellow paint

Museum of Early Southern Decorative Arts, Winston-Salem, North Carolina

H 37⅞

Photo: Courtesy, Museum Early Southern Decorative Arts

A still intact paper label under the seat of this writing-arm chair reads:
> WINDSOR CHAIRS
> [Made,] Warranted and sold by
> ANDREW & ROB. M'KIM
> At their Shop just below the Capitol
> RICHMOND May 31st 1802

The overall form of the chair is rod back in style. The square back, scrolled mahogany arm, and bamboo turnings are design characteristics of those Windsor forms. The brothers M'Kim and their employees took great care in fabricating and assembling the chair parts. The edge grooving on the flat-bent crest rail is picked up on the intricately shaped stiles which were turned, compound bent, and sculpted. This grooving is carried down the arm. The writing tablet and underslung drawer are supported by three angled supports, which are anchored to a single projection on the seat. Excluding the stretchers, all turnings are well accomplished in the bamboo style and the widely splayed legs are wedged to a nicely carved seat which has an inviting extended front edge decorated with paired highlighted grooves.

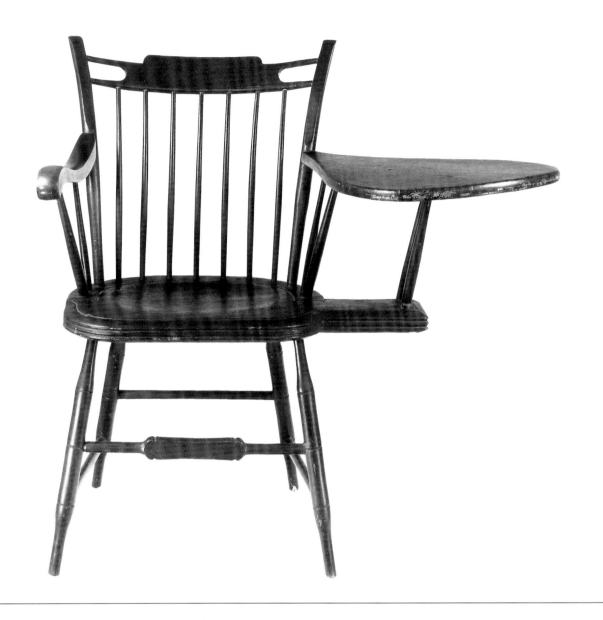

## 145. Step-Down Writing-Arm Chair

New England, about 1825

Maker unidentified

Seat, writing tablet—pine; legs, stretchers, arm supports—maple; stiles, spindles, crest rail—hickory; arm—mahogany, unpainted. Red paint covers original black or green.

Henry Ford Museum and Greenfield Village, Dearborn, Michigan

H 22¾, W 23, D 16¼

Photo: Courtesy, Henry Ford Museum and Greenfield Village

A very rare feature on this writing armchair is the location of the writing tablet on the left side. The chair was obviously designed for a left-handed person. (For another left-hand example, a child-sized writing arm, see figure 175.) Other very interesting features of this unusual chair are the fishtail ends on the stepped crest rail, the long thumb molding on the bent stiles, the extended wide tail piece holding two tablet supports, the balloon-shaped writing tablet, the flat rectangular footrest, and the matching tapers on the legs. Although the chair is a late Windsor, it is another wonderful example of the variety, innovation, and accommodation that could take place in the Windsor family.

# 10 Rocking Chairs

## Introduction

The idea of fitting rockers to chairs may have originated from the earlier use of rockers on cradles and rocking horses. The first rocking chairs were standard chairs whose legs were altered to accept rockers. Early Windsor rocking chairs were also thus modified, and this method continued well into the nineteenth century. Original Windsor rocking chairs, that is, chairs whose rockers were born with the chair, first appeared on the American chairmaking scene during the last decade of the eighteenth century. Production was small until the early 1800s when true rockers became remarkably popular, due to an increase in styles, greater comfort, and painted decoration.

Windsor rockers were produced in all chairmaking areas and in all styles, with the possible exception of low backs, which—if any were made—are rare. Most rocking chairs have arms, but a few side chairs were also made. Bow and comb backs were the first styles, but they were soon displaced by rod backs and step downs.[1]

The earliest rockers were short, unattractive, thick, wide, cradle-shaped boards. Long, thin rockers called "carpet cutters" quickly became the preferred pattern. The ends of these thinner rockers projected an equal distant beyond the legs; later examples had their rockers offset, with the longer end in the rear. Some rockers had decorative cut scrolls sawn along their upper edges and functional scrolled stops at their ends.

Baluster-style leg turnings were the first pattern, but it soon gave way to a variety of extremely popular bamboo forms. Legs either straddled the rockers with a bridle joint or were socketed into them with a tenon. Usually the legs were more widely splayed than those on typical Windsor chairs. The straddled leg had a straight cylinder or an inverted taper, often with a lathe-produced incise mark that indicated the depth of the cutout for the rocker. The socket-type leg was tapered with a dowel end which was let into the rocker and pinned through the side.

Chairs made without side stretchers are true rocking chairs, although many genuine rocking chairs were made with side stretchers. Perhaps some chairmakers continued to install side stretchers out of fear that rockers alone would not give the chair enough strength and stability, or perhaps they did it from tradition. The Boston rocker, which gradually replaced the Windsor rocker, is still made with side stretchers.

Those Windsor rocking chairs that have side stretchers require critical examination to determine if the chair originated with its rockers, or whether the rockers were a later addition. The paint of the rockers must match exactly the paint of the chair, layer for layer, and whatever was done to the legs must have been done while they were still in the lathe (an exception would be socketed legs where the overhang at the sides of the rockers is pared away, as in figure 148). Of course, the design details of the rocker and chair must be of the same period.

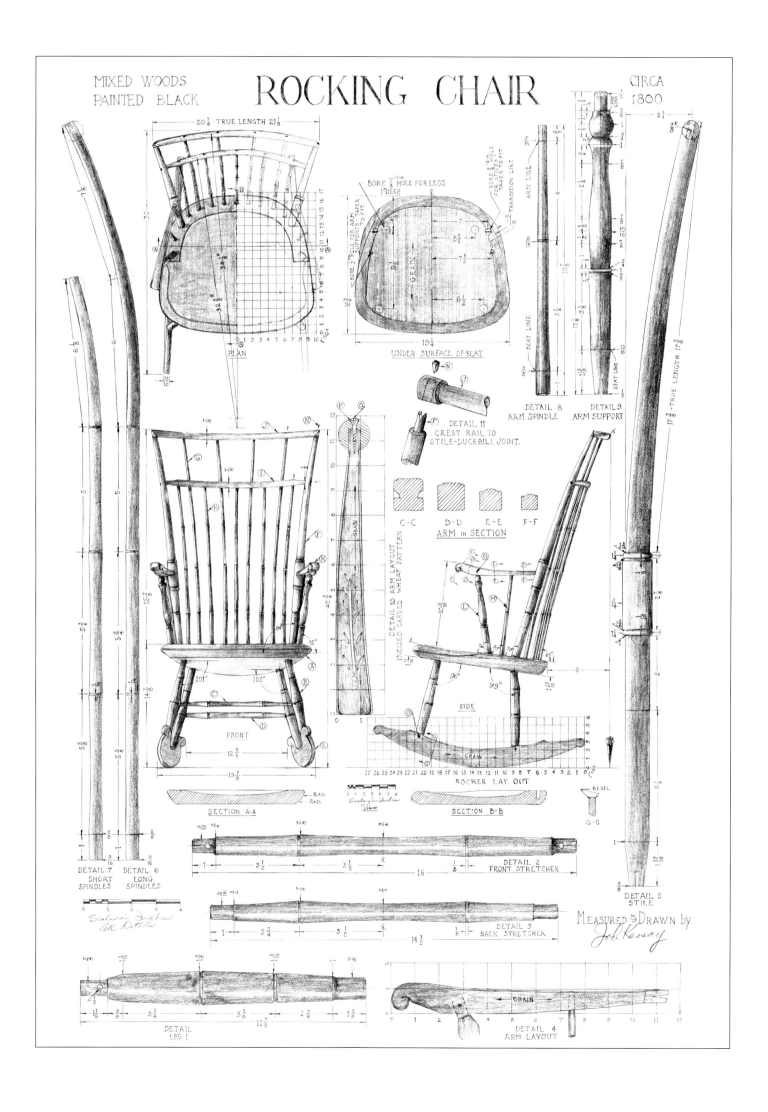

MIXED WOODS
PAINTED BLACK

# ROCKING CHAIR

CIRCA
1800

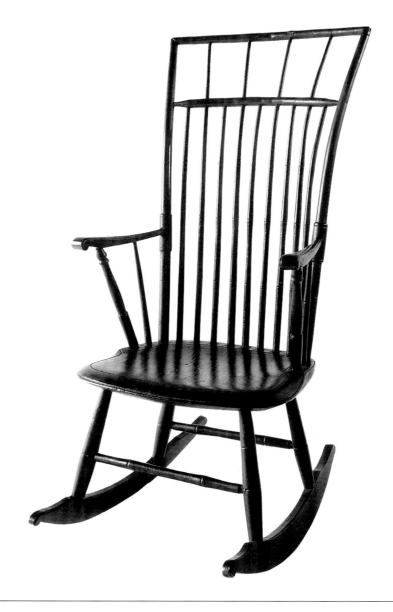

## 146. Double Rod-Back Rocking Chair

New England, about 1800

Maker unidentified

Seat—pine; other parts—probably maple.
Recent black over original black.

Gary and Diane Espinosa

H 40¾, W 21, D 30

Interesting features on this double rod-back rocking chair are the very tall fanned-out back, the collar turnings on the stiles, the bamboo-style turnings throughout, the turning pattern on the arm supports, and the absence of side stretchers. Not visible in the photograph and only faintly evident are attractive incised carved wheat patterns on the upper surface of the sawn and sculpted arms. The stiles and rods were lathe-turned, the spindles were shaved; then all were steam-bent. All tenons are wedged except those on the legs which are pinned to the cradle-shaped rockers. The offset placement of the rockers, the bam-

boo turnings, and the double rod-back date the chair from the early nineteenth century. Unfortunately, the left rocker is a replacement. A matching chair is illustrated by Dyer and Fraser.[2]

| Letter | No. | Name | Material | T. | W. | L. |
|---|---|---|---|---|---|---|
| A | 1 | seat | pine | 1¹³⁄₁₆ | 19¼ | 16¾ |
| B | 4 | legs | maple | 1⅜ dia. | | 11⅞ |
| C | 1 | front stretcher | maple | ⅞ dia. | | 16 |
| D | 1 | back stretcher | maple | ⅞ dia. | | 14½ |
| E | 2 | rockers | maple | ¹³⁄₁₆ | 5⅛ | 26⅜ |
| F | 2 | stiles | maple | 1¼ dia. | | 31¹⁄₁₆* |
| G | 4 | long spindles | maple | ⅝ dia. | | 30½* |
| H | 5 | short spindles | maple | ⅝ dia. | | 23½* |
| I | 1 | secondary crest rail | maple | ⅞ dia. | | 19¼* |
| J | 1 | crest rail | maple | ⅞ dia. | | 21⅛* |
| K | 2 | arms | maple | 1¼ | 1½ | 11½ |
| L | 2 | arm supports | maple | 1 dia. | | 12⅛ |
| M | 2 | arm spindles | maple | ⅝ dia. | | 10⅞ |
| N | 13 | wedges | maple | | size to suit | |
| O | 6 | pins | maple | | size to suit | |
| P | 2 | F. H. wood screws | steel | no. 8 | | ¾ |
| Q | 2 | plugs | | ½ dia. | | ⁵⁄₁₆ |

* total length

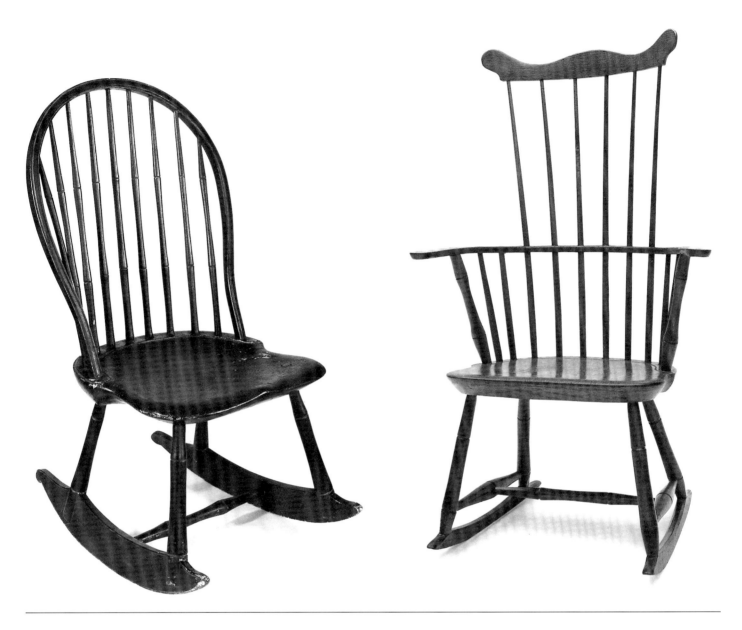

## 147. Bow-Back Rocking Side Chair

Probably New England, about 1790

Maker unidentified

Woods unidentified. Old dark green paint
striped in gold covers white undercoat.

House of Seven Gables

H 33⅜, W 19, D 22½

Most rocking chairs were made with arms,
which provided comfort to the sitter and
strength to the back. Armless rocking
chairs, however, were also made, and in a
variety of Windsor styles. This chair is a
good example of a bow-back form.

The bow is beaded and pinched and has
double-groove bamboo-pattern spindles.
The seat is well shaped, holds four wedged
legs, which are also bamboo-turned. The
legs hold broad carpet-rockers which are
supported by a single stretcher. The lower
bamboo groove on the abruptly tapered
legs determined the depth of cut for the
bridle joint that straddles the rockers. The
back and seat are standard forms found on
ordinary bow-back side chairs.

## 148. Comb-Back Rocking Chair

Connecticut, about 1810

Maker unidentified

Seat—pine; legs, arm supports, side stretchers,
rockers—maple; all other parts—red oak.
Orange shellac.

Private collection

H 38½, W 24¼, D 22½

On the one hand, the side stretchers and
their location and the side cheek cuts on
the legs where they seat into the rockers
suggest that the rockers on this comb back
are a later addition. On the other hand,
the location of the legs in the large seat
and their wide stance and great splay
nullify this suggestion. The rockers are, in
fact, original to the piece.

The uncarved elongated upturned ears
on the crest rail are a typical Connecticut
pattern, one used on many comb and fan
backs of the period (see figs. 12, 36). Six
long, slightly tapered bulbous spindles

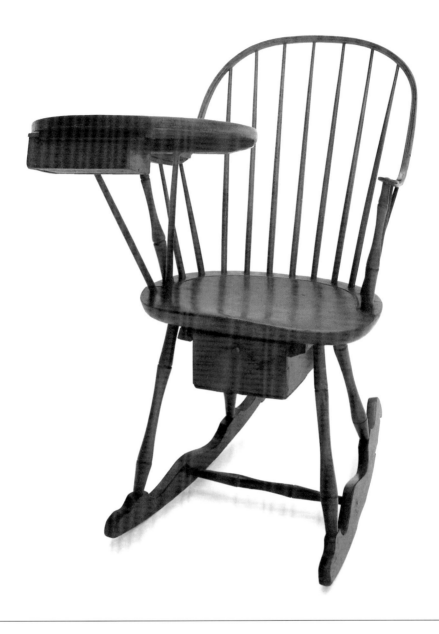

form the back and support the crest rail. The thin arm rail has bevel-edged, side-scrolled hand holds and is supported by arm spindles and bamboo-turned, double-bobbin arm supports carefully turned to match the leg turnings. The slightly shield-shaped seat has beveled edges and scant saddling; a cushion is needed for comfort. Thick but slim short rockers have slightly projecting ends and attractive chamfers on their upper inside edge. All these features make the chair a most attractive Windsor rocker.

## 149. Continuous-Bow Writing-Arm Rocking Chair

New England, probably Connecticut, about 1810

Maker unidentified

Seat, writing tablet, drawers—pine; legs, stretchers, rockers, arm support—maple; bow, spindles—hickory. Natural wood.

Mr. and Mrs. Thomas Harrison

H 39, W 28, D 30

The maker of this chair was remarkably inventive. The chair is fitted with a writing tablet and two drawers and is, most probably, one of a kind. The bow, spindles, arm supports, and seat are patterns found on typical continuous-bow armchairs. The writing tablet, drawer, and two supporting spindles were added, as was the drawer under the seat. The absence of a tablet-supporting seat extension makes one wonder whether the writing-arm components were included in the original design of the chair or added later. The writing tablet is supported by a roughed-out and unscrolled hand hold and two short spindles, which match the chair's other spindles. Because the patina on these parts matches that on the rest of the chair, it seems likely that they were there from its inception and that the chair was designed as a rocking chair. Writing and rocking at the same time must have been quite an achievement for the occupant; possibly, writing was kept to a minimum.[3]

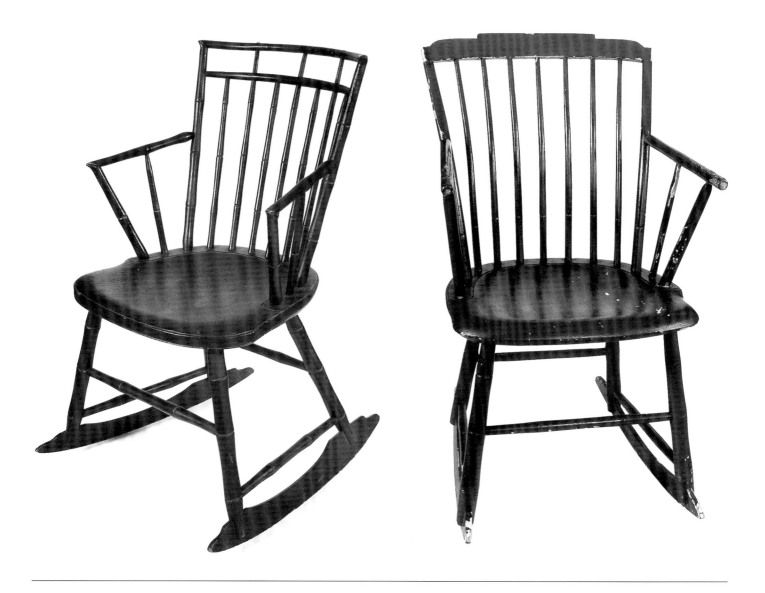

## 150. Double Rod-Back Rocking Chair

New England, about 1810

Maker unidentified

Woods unidentified. Painted black.

House of Seven Gables

H 30¾, W 20¾, D 21¾

On this chair both ends of the short "carpet-cutter" rockers are identical and extend what appears to be an equal distance beyond the legs, although they actually protrude slightly more at the back. In true rocker fashion the greatly splayed legs are bridle-jointed and pinned through the rockers. The seat has an attractive double bead on the sides and across the front and it supports socketed legs. The stretchers join the legs at the bamboo grooves. The corners on the upper back rail and arms are joined with a mortise-and-tenon and are sculptured to form an accentuated false miter joint. The components of this chair—its back, seat, and undercarriage—are standard patterns and were used on many ordinary rod-back chairs of the period.

## 151. Step-Down Rocking Chair

New England, about 1820

Maker unidentified

Woods unidentified. Red paint over white.

House of Seven Gables

H 32¼, W 19½, D 22⅝

Chronologically the stepped crest rail, such as is seen on this chair, followed the rod-back style and preceded the popular Boston rockers. The tapered legs with their large diameter at the rockers are indisputable evidence that the legs were designed to be slotted (bridle-jointed) to accept rockers.

The chair features simplified bamboo-style turnings, bent back spindles, thumb-molded stiles, and plain rod-shaped arms and arm supports. It also has a shield-shaped seat, with sharp chamfered edges (typical of the period), a box stretcher, and thin, narrow rockers. With a different leg taper, components similar to those on this chair were used to make regular step-down Windsors.

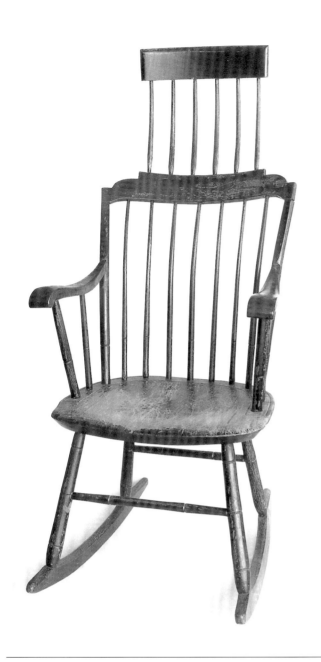

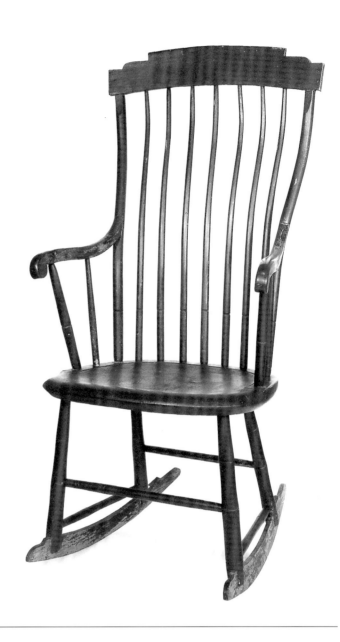

## 152. Step-Down Rocking Chair with Added Comb

New England, about 1810

Maker unidentified

Seat—bass; all other parts—maple. Original black paint.

Society for the Preservation of New England Antiquities

H 45½, W 20½, D 26

Photo: Courtesy, Society for the Preservation of New England Antiquities

The most interesting feature of this step-down rocking chair is the added comb-back head rest. It does not match the stepped crest rail and was obviously an afterthought, added by the original maker at a later date and designed to lend additional comfort. Other features of this and similar chairs of the period are the thumb-molded stiles, the scrolled arms, and the bamboo-style turnings (here merely suggested). The slightly saddled oval seat, the socketed tapered legs, the thick rockers, and the absence of side stretchers indicate the chair was designed as a rocking chair.

## 153. Step-Down Rocking Chair

New England, probably Boston, about 1820

Possibly Samuel Gragg (w 1808–1830)

Woods unidentified, arms probably mahogany. Painted black.

Salem Maritime, NHS

Size undetermined

Rocking chairs became more comfortable when longer reverse bent spindles and stiles were introduced, as in this tall step-down example. The crest rail, back spindles, and stiles were bent in different bending molds. The heavy stiles were lathe-turned, then partially shaped, and steam bent in a very strong form. The final shaping was done when the stiles were dry. The scrolled arms are held with arm supports, spindles, and a wood screw through the stiles. Although unnecessary, the chair has side stretchers.[4]

# 11  Settees

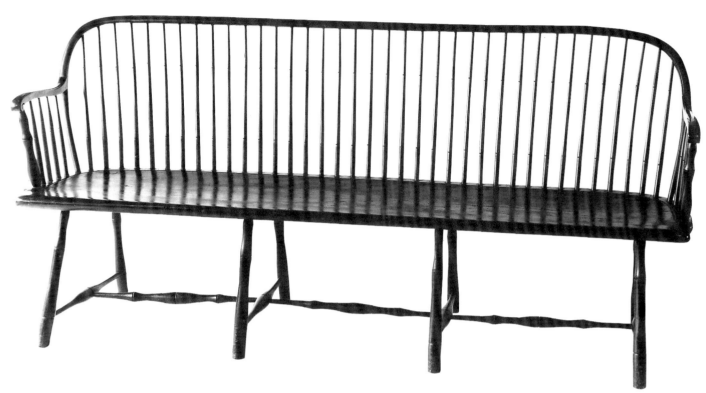

## Introduction

A Windsor settee is a wooden bench with a back and arms and is long enough to accommodate two or more people. The first Windsor settees were made in Philadelphia in the 1750s[1] and were elongated forms of low-back chairs. Jebediah Snowden, a Windsor chair and cabinetmaker, in a bill dated September 14, 1754, charged merchant John Reynell for "2 Double Windsor Chairs with 6 Legs." The six legs indicate the items sold were short settees. Settees were used in gardens, verandas, hallways, rooms of private residences, and in public buildings. Throughout the second half of the nineteenth century they were made in many standard Windsor chair styles and in most Windsor chairmaking centers.

For convenience, settees can be classified as "full sized" or as smaller "double seated" (love seat size). Most full-sized settees are around six feet long, although some are as long as ten feet and can seat as many as seven adults. Full-sized settees were produced earlier than the shorter three- to four-foot pieces. Depending on the seat length, settees have two to six pairs of baluster or bamboo-style leg turnings. The baluster turnings were assembled with H-stretchers, while the later bamboo variants were assembled with box stretchers.

Low- and rod-back styles were the most durable and were produced in the greatest numbers. Other forms such as comb-back, fan-backs, continuous-bow, and armless settees were also made, but they proved to be unsuccessful "experiments," mainly because of their weakly constructed backs. Bracing spindles and rockers were probably not incorporated in settees of the early period.

| Letter | No. | Name | Material | T. | W. | L. |
|---|---|---|---|---|---|---|
| A | 1 | seat | pine | $1\frac{3}{4}$ | $18\frac{1}{2}$ | $77\frac{3}{8}$ |
| B | 8 | legs | maple | $1\frac{9}{16}$ dia. | | $17\frac{1}{2}$ |
| C | 4 | lateral stretchers | maple | $1\frac{3}{8}$ dia. | | $18\frac{1}{2}$ |
| D | 3 | medial stretchers | maple | $1\frac{3}{8}$ dia. | | 22 |
| E | 2 | arm supports | mahogany | $1\frac{1}{2}$ dia. | | 12 |
| F | 8 | arm spindles | mahogany | $\frac{11}{16}$ dia. | | $11\frac{3}{8}$ |
| G | 37 | back spindles | hickory | $\frac{11}{16}$ dia. | | $20\frac{1}{4}$ |
| H | 1 | bow | hickory | 1 | $1\frac{3}{32}$ | 129 |
| I | 2 | arms | mahogany | $1\frac{11}{32}$ | 2 | $15\frac{1}{2}$ |
| J | 35 | wedges | maple? | $\frac{1}{16}$ | $\frac{1}{4}$ | $\frac{1}{4}$ |
| K | 8 | wedges | maple? | $\frac{1}{8}$ | $\frac{7}{8}$ | $\frac{3}{4}$ |
| L | 4 | pins | maple? | $\frac{1}{8}$ dia. | | 1 |

## 154. Bow-Back Settee

Philadelphia, about 1805

Anthony Steel

Seat—pine; legs, stretchers—maple; arms, arm spindles, arm supports—mahogany; bow, back spindles—hickory. Mahogany-color varnish stain.

Mahlon and Isabel Pool

H 36, W $79\frac{1}{8}$, D 23

This bow-back settee, more than six feet long, was designed to accommodate several sitters and was probably used in a public building. The outstanding construction feature of the settee is the one-piece bow—10'9" long—with ends that curve back nicely into the seat. The ends were probably steamed and bent in two sessions (they could have been steamed in a single session but that would have required two

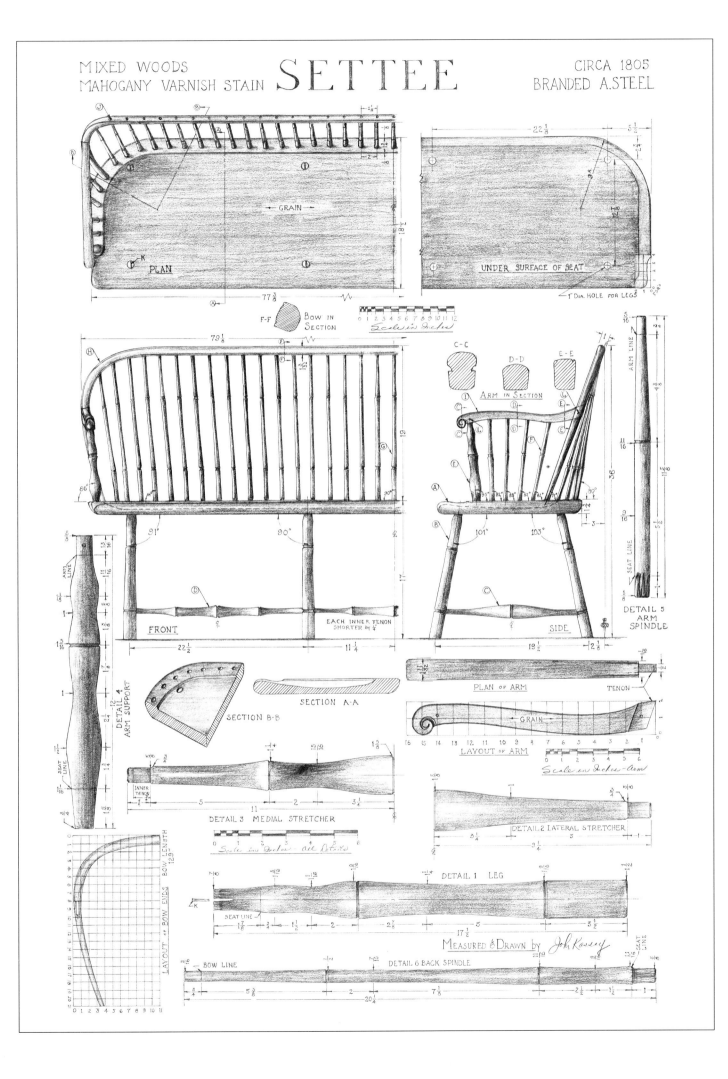

MIXED WOODS
MAHOGANY VARNISH STAIN

# SETTEE

CIRCA 1805
BRANDED A. STEEL

PLAN

GRAIN

UNDER SURFACE OF SEAT

1" DIA. HOLE FOR LEGS

F-F BOW IN SECTION

Scale in Inches

C-C    D-D    E-E

ARM IN SECTION

ARM LINE

DETAIL 5 ARM SPINDLE

FRONT

EACH INNER TENON SHORTER BY ¼"

SIDE

DETAIL 4 ARM SUPPORT

SECTION A-A

SECTION B-B

PLAN OF ARM

TENON

GRAIN

LAYOUT OF ARM

Scale in Inches - Arm

DETAIL 3 MEDIAL STRETCHER

DETAIL 2 LATERAL STRETCHER

DETAIL 1 LEG

Scale in Inches - all Details

LAYOUT OF BOW ENDS BOW LENGTH 129"

MEASURED & DRAWN BY John Kassay

BOW LINE

DETAIL 6 BACK SPINDLE

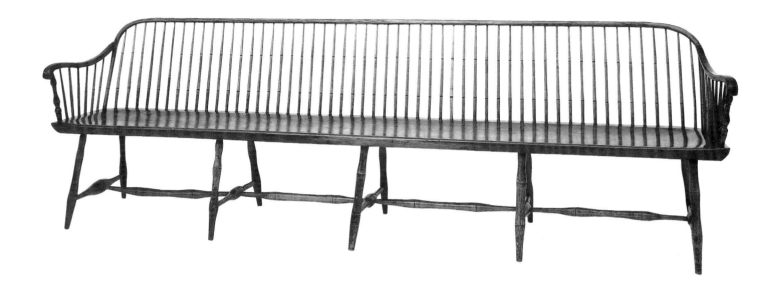

separate steamers or a very large single steaming chamber and a large bending form). Except for the four plain bulbous cross stretchers all turnings were lathe-produced and are in the bamboo pattern. Plane marks on the bottom of the seat show it was surfaced by hand. Considering the size of the seat, this was not easy; neither was scooping out the upper surface, which was also done by hand. The four pairs of legs and the thirty-seven back spindles are physically correct and visually the right number for the length of the settee. The bow ends are tenon-wedged to the seat. The flanking back spindles are stop-tenoned to the bow and the others penetrate the bow and are wedged. The slightly changing angle of the spindles creates an attractive fanned-out pattern. The legs go through the seat and are wedged. The arm supports are tenoned and pinned to the arms and penetrate the seat but are not wedged, a construction oversight on an otherwise well-made Windsor settee.

## 155. Bow-Back Settee

Pennsylvania or Delaware, about 1810

Maker unidentified

Seat—tulip poplar; turnings—maple; bow, spindles—hickory; arms—mahogany. Finish unidentified.

Unknown

H 33⅜, W 109, D 20⅜

Photo: Anonymous

Although unmarked, this exceptionally long bow-back settee has essentially the same physical and construction features of the previous example (see fig. 154) and may have been made in the Philadelphia area. The settee contains eighty-six lathe turnings (an incredible number), each produced individually. Not including its wedges and pins, the chair has ninety separate pieces assembled with 192 joints. It is a remarkable example of Windsor engineering. The bow contains fifty-three bamboo-style spindles; each arm has six

similar turnings and baluster-turned arm supports. Mixing turning patterns on settees was not uncommon.

The back spindles are tenon-wedged to the bow and socketed to the slightly scooped seat. The arm spindles are also socketed to the seat and to the scrolled mahogany arms. The bow and arm supports are tenon-wedged to the seat while the upper end of the arm supports are stop-tenoned and pinned to the arms. Five pairs of legs and four bamboo-turned medial stretchers plus five bulbous-centered lateral stretchers make up the settee's undercarriage. The medial stretchers are stop-tenoned into the cross stretchers, and, for durability, the ends of the tenons do not touch. The ends of the bow are unattractively straight at the bend before they enter the seat, but the tapered foot on the ends of the legs is very pleasing.

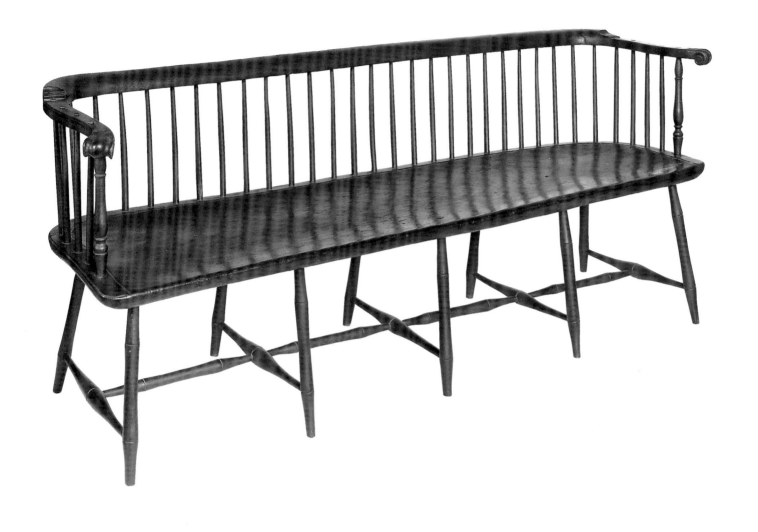

### 156. Low-Back Settee

Philadelphia, 1790

Branded Daniel Carteret (worked 1793–1820)

Seat—pine; turnings—maple; spindles—hickory; arms, arm crest—probably maple. Black paint over original dark green.

Bernard and S. Dean Levy, Inc., New York

H 31½, W 79, D 24

Photo: Helga Photo Studio

This low-back settee was also made in Philadelphia but slightly earlier than the previous example (see fig. 155). It features similar turning patterns and the same number of paired legs but, obviously, has a different back. The back rail laps the arms in the typical Philadelphia manner and the flat S-curved arms terminate in broad carved knuckle hand holds. The arm spindles and supports are wedged to the arms and the leg ends are exposed in the slightly scooped D-shaped seat.

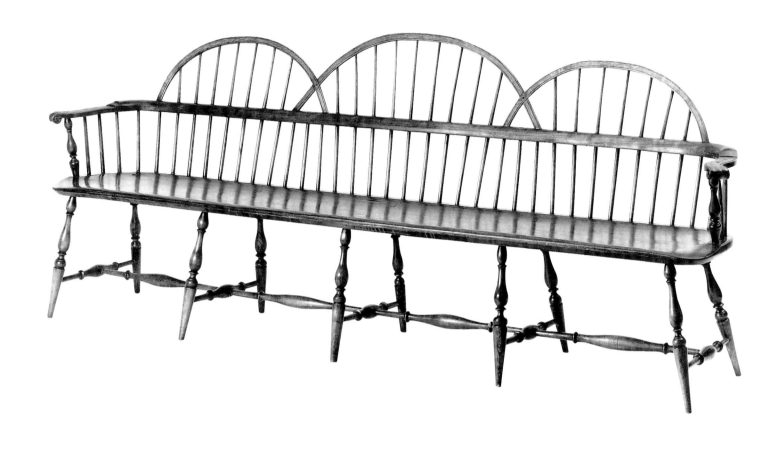

## 157. Triple Sack-Back Settee

Massachusetts or Connecticut, 1775–1800

Maker unidentified

Woods and finish unidentified

The Henry Francis du Pont Winterthur Museum

H 38⅛, W 98½, D 22½

Photo: Courtesy, Winterthur Museum

This triple sack-back settee is a good example of the innovative possibilities within the Windsor form. Except for having fewer arm spindles, it is similar to a published triple sack back that is also part of the Winterthur furniture collection.² On this settee, the three sacks are interlocked with half-lap pinned joints and are anchored to the rail with round shoulder tenons. The center sack is wider and taller than the flanking ones and all have double beading on their front surfaces. The arm rail and arms are contoured and joined and the seat is profiled and saddled in typical Philadelphia low-back style. The baluster-turned arm supports and legs are well matched with good thicks and thins and long tapers. The ring turnings on the nine stretchers draw attention and contribute additionally to the overall attractiveness of the settee.

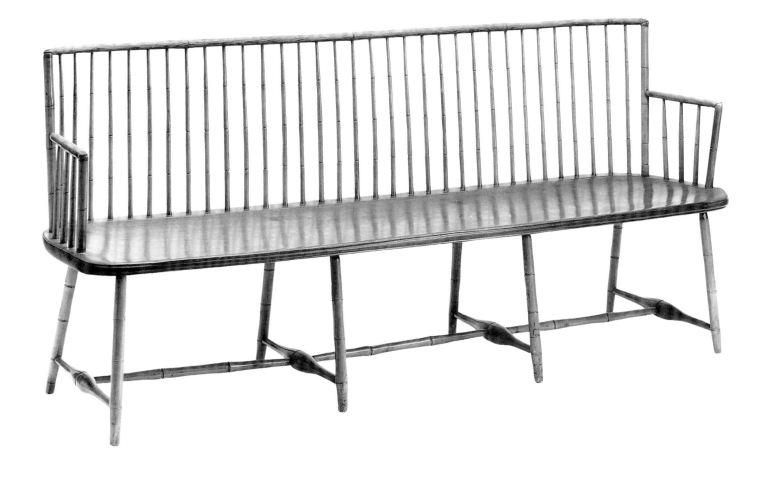

## 158. Single Rod-Back Settee

Philadelphia, about 1806

Marked GILBERT GAW

Woods and finish unidentified

The Henry Francis du Pont Winterthur Museum

H 34⅛, W 76, D 20

Photo: Courtesy, Winterthur Museum

Rod-back settees were developed in Phila-delphia during the first decade of the nineteenth century. Their popularity was soon well established in the New England area where variations of the form included matching sets of side and armchairs. This example has an attractively light look—airy but somewhat fragile; nevertheless it has survived nearly two centuries due, no doubt, to considerate care and use. Except for the cross stretchers, all turnings are in the bamboo style and have one to four bobbins. Three H-stretchers support the four pairs of legs with the two outer pairs raked in opposite directions. Holes for the stiles, arm supports, and legs were bored through the seat and—along with the spindles—glued and wedged in place. Typical false miters (duck-bills) at the corners of the crest rail and stiles and arms and arm supports tend to obscure the mortise-and-tenon joints.

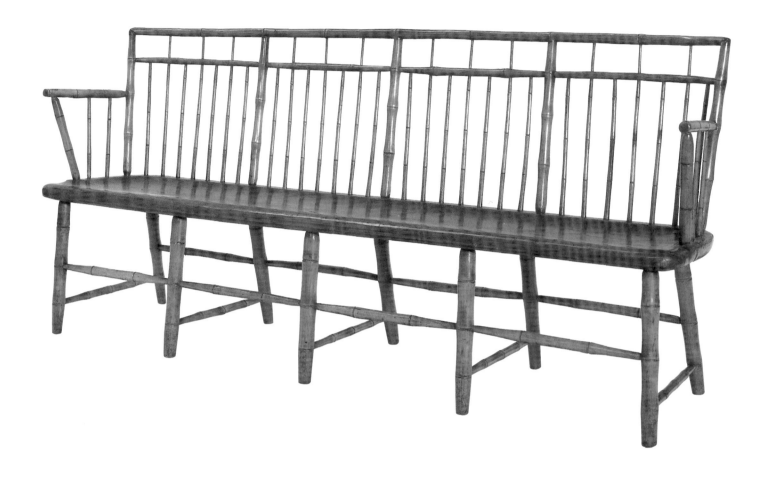

## 159. Double Rod-Back Settee

Philadelphia, about 1815

Joseph Burden

Woods and finish unidentified

The Art Institute of Chicago, Gift of Mrs. George A. Carpenter (1939.546)

Size unidentified

Photo: Courtesy, The Art Institute of Chicago

This settee is a robust, well-built example in the rod-back style, designed no doubt for use in public buildings. The thick, moderately saddled one-board seat holds sixty-eight lathe-turned, bamboo-style parts. The crest rod was probably hand-shaped, including its duck-bill corners. All parts are well executed and five overstated dividing pieces add considerable strength to the back. Box stretchers divide the legs into four sections and five stiles divide the back into four sections. At one time Joseph Burden may have served a partnership with Francis Trumble, a Philadelphia master craftsman. (See figure 22, for more on Trumble.)

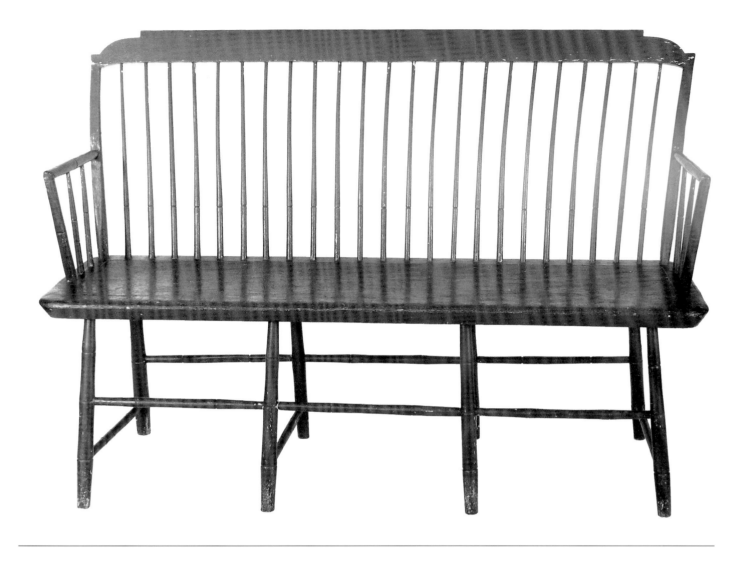

## 160. Step-Down Settee

Probably Vermont, about 1820

Maker unidentified

Woods unidentified. Painted dark green over gray.

Pocumtuck Valley Memorial Association, Memorial Hall Museum, Deerfield, Massachusetts

H 36½, W 54, D (unidentified)

Special features of this settee are stiles with shaved-off fronts, duck-bill joints at the arms and arm supports, a plank seat with angled ends and large beveled edges, and box stretchers that tie inverted tapered legs together. The eight legs have compound angles and the slightly saddled seat has carved grooves separating the spindle area.

# SETTEE

TWO PLACE
LOW-BACK

MIXED
WOODS

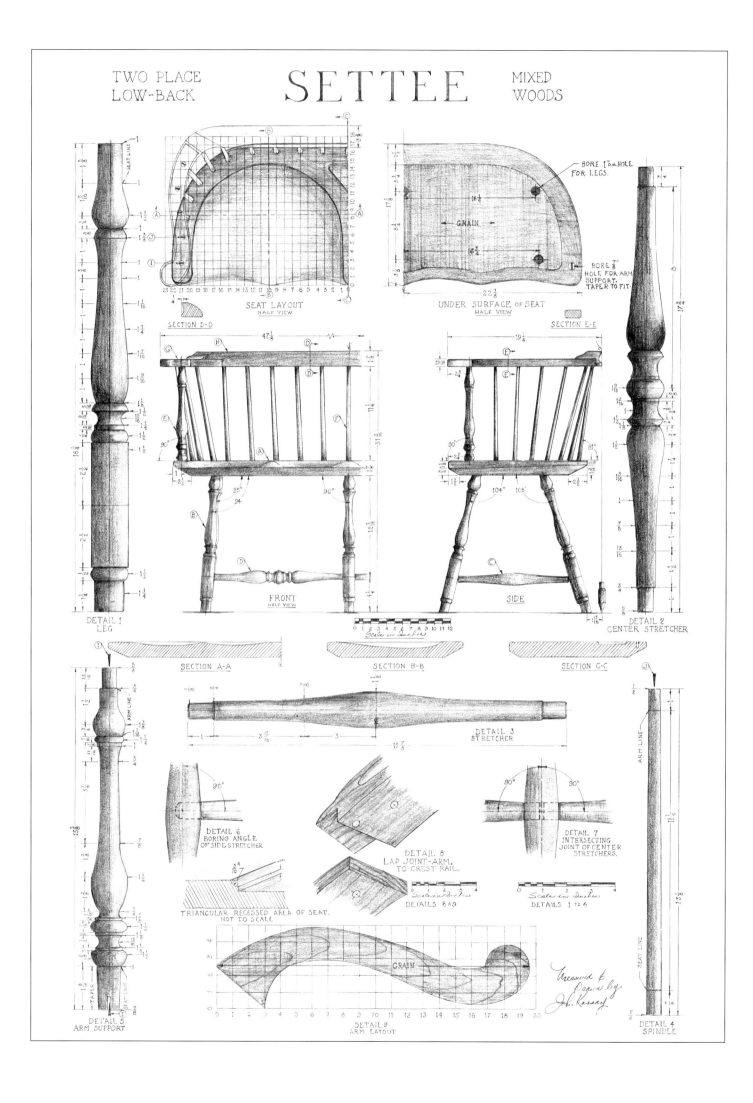

SEAT LAYOUT
HALF VIEW

UNDER SURFACE of SEAT
HALF VIEW

BORE 1" DIA. HOLE
FOR LEGS.

GRAIN

BORE ⅞"
HOLE FOR ARM
SUPPORT.
TAPER TO FIT.

SECTION D-D

SECTION E-E

FRONT
HALF VIEW

SIDE

DETAIL 1
LEG

DETAIL 2
CENTER STRETCHER

SECTION A-A

SECTION B-B

SECTION C-C

DETAIL 3
STRETCHER

DETAIL 6
BORING ANGLE
OF SIDE STRETCHER

DETAIL 8
LAP JOINT-ARM.
TO CREST RAIL.

DETAIL 7
INTERSECTING
JOINT OF CENTER
STRETCHERS.

TRIANGULAR RECESSED AREA OF SEAT.
NOT TO SCALE

DETAILS 8 & 9

DETAILS 1 TO 6

DETAIL 5
ARM SUPPORT

DETAIL 9
ARM LAYOUT

GRAIN

DETAIL 4
SPINDLE

ARM LINE

SEAT LINE

Scale in Inches

Measured &
Drawn by
John Kassay

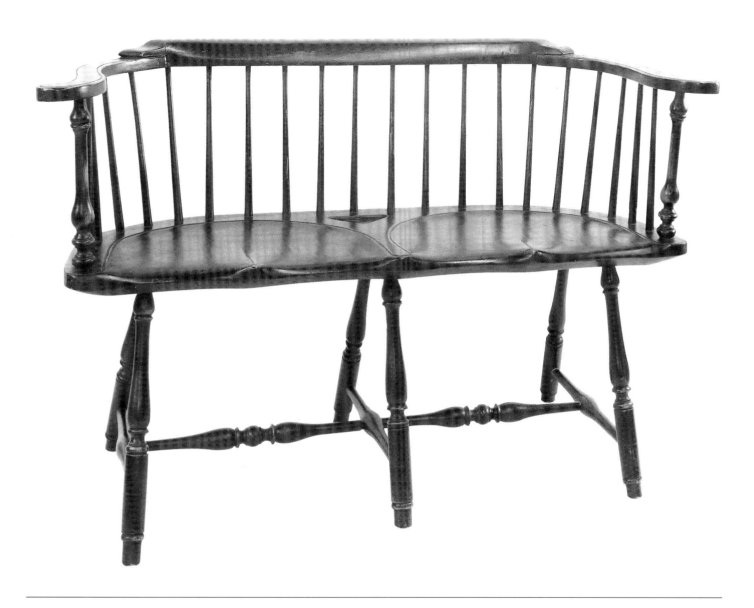

## 161. Two-Place Low-Back Settee

Philadelphia, date unknown

Maker unidentified

Seat—pine; spindles—ash; all other parts—maple. Black paint over white.

I. M. Wiese, Antiquarian

H 31⅝₁₆, W 47⅛, D 20¼

The well-saddled plank seat on this hand-some settee has a carved groove that isolates the spindles and a singular triangular recess at its center rear. This carving detail separates the piece from all ordinary two-place low-back settees. The legs are socketed to the seat and are well raked at the back for greater comfort and stability. The arm spindles and arm supports are through-tenon-wedged to the arms while the back spindles are stop-tenoned to the arm rail.

In his *Blue Book: Philadelphia Furniture*, William Macpherson Honor Jr. describes and illustrates a classic low-back "double-

| Letter | No. | Name | Material | T. | W. | L. |
|--------|-----|------|----------|-----|-----|-----|
| A | 1 | seat | pine | 1⅞ | 17⅛ | 44¼ |
| B | 6 | legs | maple | 1⁹⁄₁₆ dia. | | 18¾ |
| C | 3 | middle & side stretchers | maple | 1½ dia. | | 15⅞ |
| D | 2 | center stretchers | maple | 1⁹⁄₁₆ dia. | | 17¾ |
| E | 2 | arm supports | maple | 1½ dia. | | 13⅜ |
| F | 21 | spindles | ash | ⅝ dia. | | 13⅛ |
| G | 2 | arms | maple | 1³⁄₁₆ | 4⅞ | 19½ |
| H | 1 | crest rail | maple | 1⅞ | 3⅜ | 48¾ |
| I | 4 | arm support wedges | maple | ⅛ | ⅝ | 1 |
| J | 8 | arm spindle wedges | maple | ⅛ | ½ | ½ |

seater" and although it is not identical to this settee, it is somewhat similar. Honor states that "there have been numbers of reproductions of this particular piece during the past fifty years."[3] Could this settee be one of those reproductions? Possibly; however, it is worthy of inclusion because it was skillfully made and has been well cared for.

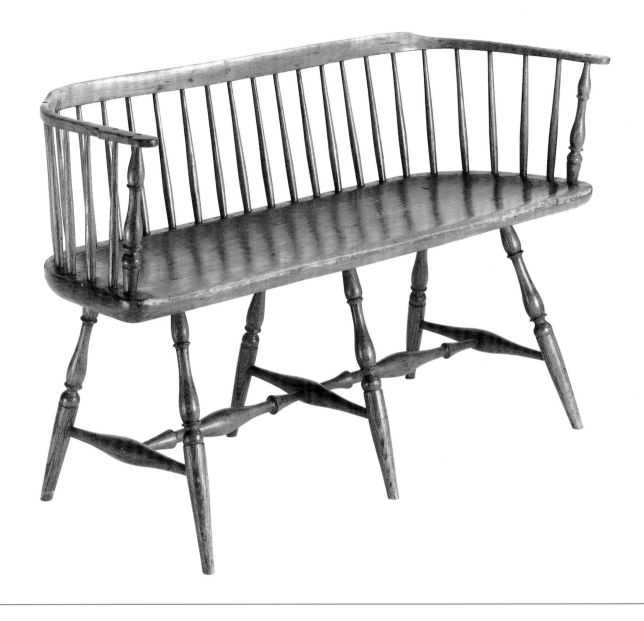

## 162. Low-Back Settee

Southeastern Pennsylvania, about 1780

Maker unidentified

Seat—pine; legs, spindles, arm supports—chestnut; stretchers, arms, arm rail—maple. Natural wood.

The Henry Francis du Pont Winterthur Museum

H 29½, W 52¼, D 17

Photo: Courtesy, Winterthur Museum

The arm rail and arms on this low-back settee were formed from a single piece of wood. The arms were steamed, then bent. They appear twisted, but actually they are not. Other features of this handsome settee are its well-matched baluster-style turnings on the arm supports and legs, its adequately scooped, generously rounded-edge D-shaped seat, and its well-splayed outer legs. The arm supports and legs are tenoned-wedged to the seat. The legs hold plain-turned lateral stretchers and two arrow-ended medial stretchers.

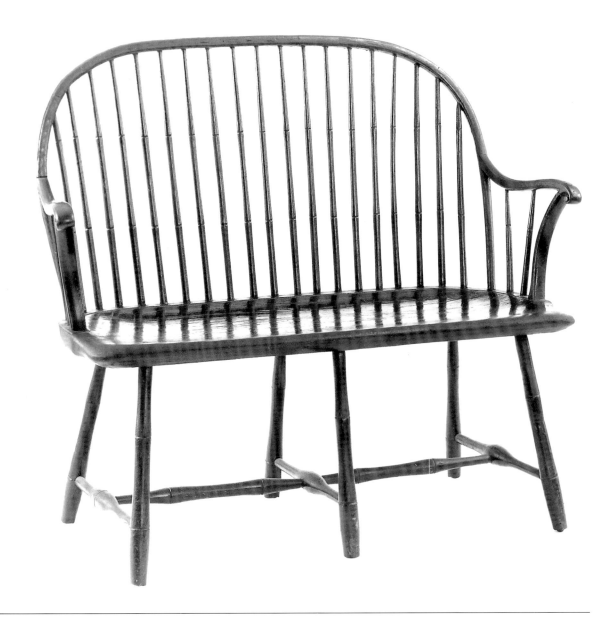

### 163. Bow-Back Settee

Philadelphia, about 1800

John Letchworth (1759–1843)

Seat—poplar; legs, stretchers—maple; bow, spindles—hickory; arms, arm supports—mahogany. Painted black.

Independence National Historical Park, Philadelphia

H 36, W 40⁷⁄₁₆, D 22

Photo: Courtesy, Independence National Historical Park

Though rather plain, this small settee in the bow-back style has attractive features. The bow is semi-circular in cross section and has double beading on the face that continues on the arms and down the front of the arm supports. The cyma-curved arms flow nicely into the bow, as the arm supports do to the arm. The effect is further enhanced with carved volutes. Exposed shouldered tenons lock the arms to the bow and arm supports. The under-carriage has typical bulbous cross stretchers and bamboo-pattern center stretchers and legs. The legs are tapered from small to large at the floor line, which is a common pattern.

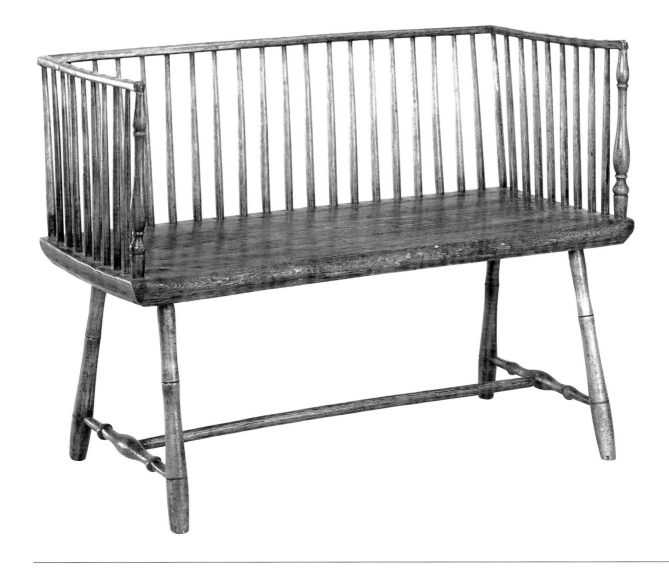

## 164. Rod-Back Settee

Philadelphia, about 1800

John Letchworth (LETCHWORTH branded beneath seat)

Seat—poplar; legs, side stretchers—maple; arm supports, arms, rail, spindles—hickory. Original red paint stripped, now natural wood patina.

Colonial Williamsburg Foundation

H 30, W 42, D 19

Photo: Courtesy, Colonial Williamsburg

This rod-back settee is unusual because the arms and back are the same height. Typically, backs of Windsors of this style extend above the arms. Thirty-seven tapered spindles and two arm supports form the back and sides. All are capped by a crest rail of rods, half-lap joined and pinned at the corners. This fragile but apparently adequate assembly eliminated the need to construct a complicated back. The turnings are mixed with baluster arm supports, bamboo legs, and arrow-ended side stretchers. For increased comfort, the upper surfaces of the arms were flattened, but unfortunately the arm hand holds were broken and are missing. The straight rod-shaped medial stretcher is a noncompatible replacement. The turned rings on the side stretcher show considerable wear, surely caused by children's shoes. Tack holes along the seat edge indicate the seat was once upholstered.

## Introduction

From the earliest years of Windsor chairmaking, chairmakers produced furniture designed especially for children. The early manufacture and sale of a child-sized Windsor chair is documented in the receipt book of Philadelphia merchant Garret Meade. The receipt is dated December 18, 1759, and shows that Meade paid furniture maker Francis Trumble "Eight pound Eighteen shill[ings] in full for 12 Winsor [*sic*] chairs and one for a child."[1] The twelve Windsors were presumably adult-sized chairs.

Children's Windsors were not in great demand and most likely were made in limited numbers, some probably on special order. They were made in all standard Windsor chair styles, with the same woods and finishes and the same level of craftsmanship and attention to detail that was invested in their adult counterparts. Durability and attractiveness were important factors to consider when designing a child's chair. Discerning chairmakers realized all the parts of a chair had a direct visual and physical relationship to each other and therefore, that all had to be reduced accordingly, although not uniformly. Cylindrical parts were shortened appropriately but their diameters were made quite large, otherwise they would look and be weak.[2] Although children's furniture presented different design and technical problems, chairmakers must have enjoyed the challenge of scaling down parts, especially the bends, carvings, and turnings, and gotten pleasure from working directly with caring parents.

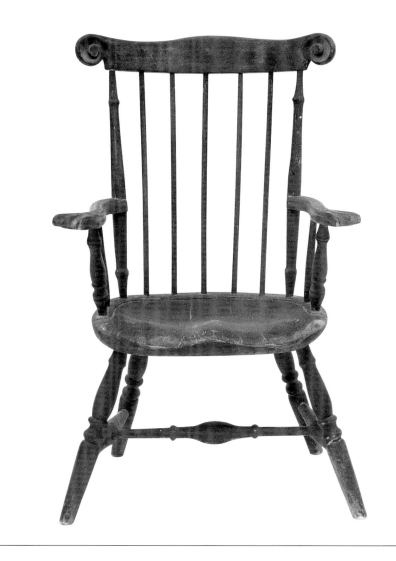

## 165. Child's Fan-Back Armchair

New England, about 1770

Maker unidentified

Seat—pine; legs, stiles, arm spindles—maple; crest rail, arms—beech; back spindles, arm supports—red oak; pins, wedges—maple. Original blue paint over red undercoat.

Donald Flynn

H 27⁵⁄₁₆, W 18⅜, D 13⅞

The back, seat, and undercarriage of this comely fan-back armchair are well proportion and nicely integrated. The crest rail has beautiful, carved voluted ears with exceptionally attractive rolled edges. The oval seat is deeply hollowed and has a very high pommel. These features along with well-splayed legs, may have been incorporated in the chair to discourage the child from getting out or tipping it over. The not-well-defined ring turnings on the stiles, the lack of fullness on the underside of the carved knuckle-shaped hand holds, and the unswelled back spindles are minor design flaws in an otherwise handsome chair. Greater emphasis could have been achieved if there were a shoulder on each side of the ring turnings, applied and carved pieces on the underside of the knuckle hand holds, and a slight swelling two-thirds of the way down on the back spindles.

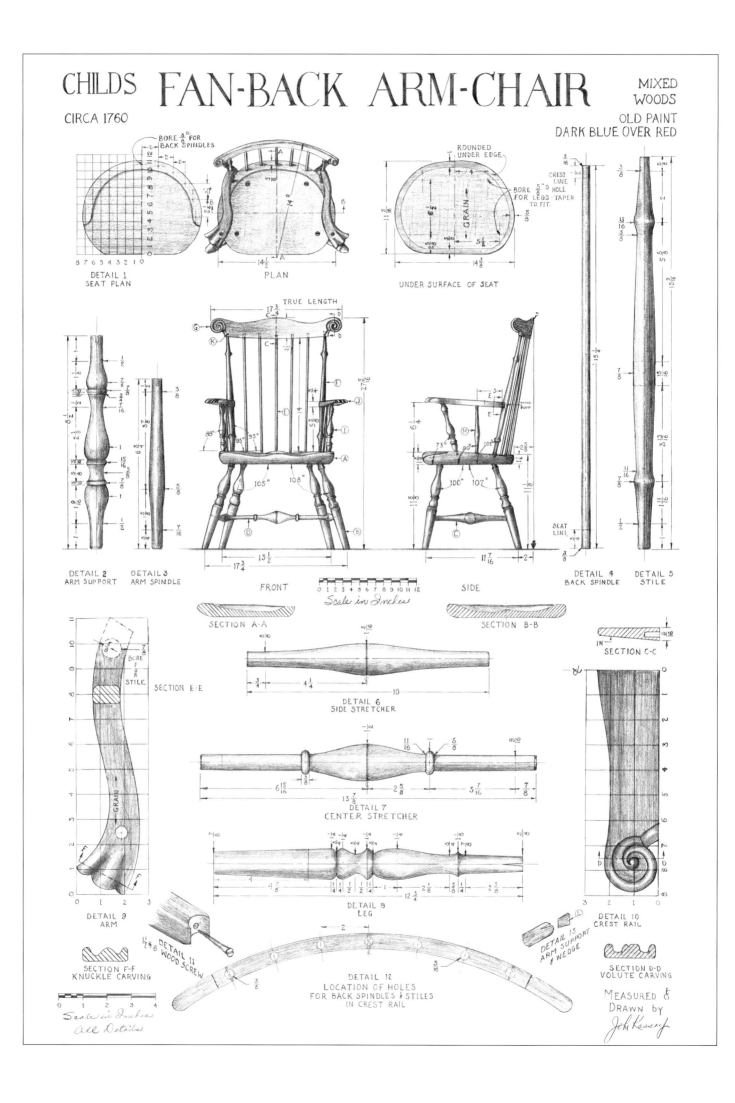

# CHILDS FAN-BACK ARM-CHAIR

CIRCA 1760

MIXED WOODS

OLD PAINT
DARK BLUE OVER RED

DETAIL 1
SEAT PLAN

PLAN

UNDER SURFACE OF SEAT

DETAIL 2
ARM SUPPORT

DETAIL 3
ARM SPINDLE

FRONT

Scale in Inches

SIDE

DETAIL 4
BACK SPINDLE

DETAIL 5
STILE

SECTION A-A

SECTION B-B

SECTION C-C

SECTION E-E

DETAIL 6
SIDE STRETCHER

DETAIL 7
CENTER STRETCHER

DETAIL 8
LEG

DETAIL 9
ARM

SECTION F-F
KNUCKLE CARVING

DETAIL 11
1¾ # 6 WOOD SCREW

DETAIL 13
ARM SUPPORT
& WEDGE

DETAIL 12
LOCATION OF HOLES
FOR BACK SPINDLES & STILES
IN CREST RAIL

DETAIL 10
CREST RAIL

SECTION D-D
VOLUTE CARVING

Scale in Inches
all Details

MEASURED &
DRAWN BY
John Kassay

Child's Fan-Back Armchair

| Letter | No. | Name | Material | T. | W. | L. |
|--------|-----|------|----------|-----|-----|-----|
| A | 1 | seat | pine | 1⅝ | 14⅜ | 11⁵⁄₁₆ |
| B | 4 | legs | maple | 1¼ dia. | | 12¾ |
| C | 2 | side stretchers | red oak | 1⁵⁄₁₆ dia. | | 10 |
| D | 1 | center stretcher | red oak | 1½ dia. | | 13⅞ |
| E | 5 | back spindles | oak | ⅜ dia. | | 15¼ |
| F | 2 | stiles | maple | ⅞ dia. | | 15⁹⁄₁₆ |
| G | 1 | crest rail | beech | ⁹⁄₁₆ | 2½ | 17¾ |
| H | 2 | arm spindles | maple | ⅝ dia. | | 6¾ |
| I | 2 | arm supports | red oak | 1 dia. | | 8½ |
| J | 2 | arms | beech | ¾ | 2⅝ | 11 |
| K | 3 | pins | maple | ⅛ dia. | | ⁹⁄₁₆ |
| L | 6 | wedges | maple | | size to suit | |

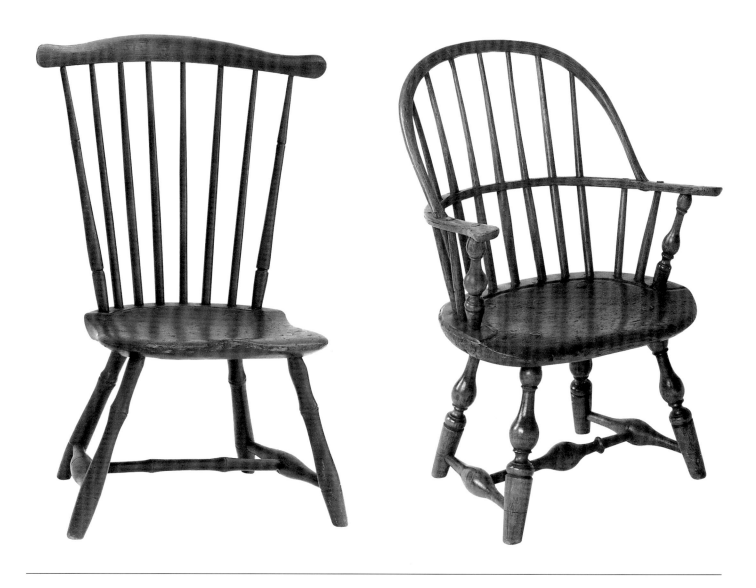

## 166. Child's Fan-Back Side Chair

Probably Pennsylvania, about 1790

Maker unidentified

Seat—pine; legs, stretchers—maple; spindles, crest rail—hickory. Clear varnish over mahogany stain.

Mahlon and Isabel Pool

H 26⅞, W 18³⁄₁₆, D 12¹⁄₁₆

This child's fan-back side chair has six tapered back spindles flanked by double-groove bamboo-turned stiles, all surmounted with a serpentine-shaped crest rail. The shield-shaped seat is handsomely saddled and has well-splayed wedged legs that hold H-pattern stretchers, the center one of which has a double bobbin.

## 167. Child's Sack-Back Side Chair

Probably New York, about 1790

Maker unidentified

Seat—pine; legs, stretchers, arm supports—maple; sack, spindles, arm rail—hickory. Original green paint, stripped, clear varnished wood.

Private collection

H 23⅛, W 16, D 13¼

This robust child's sack-back chair has the same lines and construction details found on adult sack backs. The large diameters of the spindles and turnings add needed strength to the chair. The sack is wedge-tenoned to the arm rail and the mitten-shaped hand holds are attractively beveled. The turner's skill is evident in the well-executed, precisely matched arm supports and legs. The oval seat is well saddled and holds wedged legs which were later shortened to accommodate an even smaller occupant.

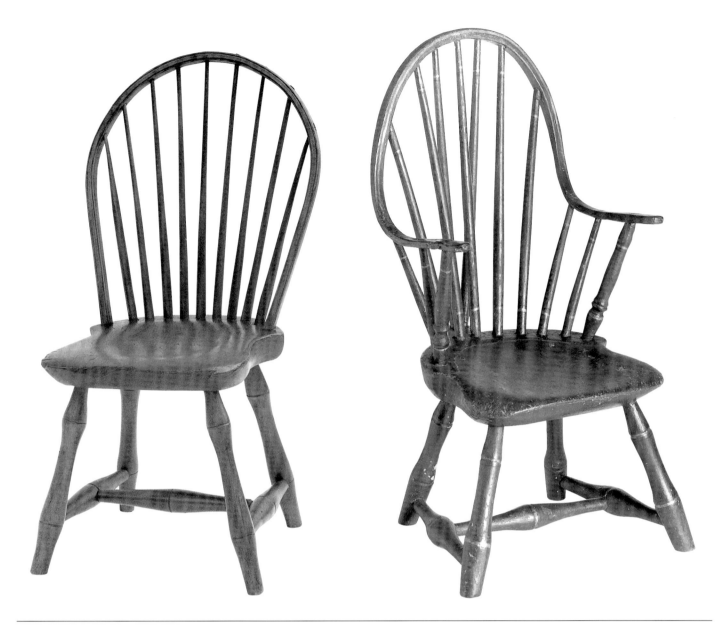

## 168. Child's Bow-Back Side Chair

Probably New England, about 1820

Maker unidentified

Seat—pine; legs, stretchers—maple; bow, spindles—oak. Natural wood patina.

Mahlon and Isabel Pool

H 25, W 13, D 12½

The sides of the bow on this child's bow-back side chair are straight where they enter the seat. The bow front is double-beaded and holds nine attractively tapered spindles, fanning outward from the center. All the spindles penetrate the bow and, like the ends of the bow, are wedged to the seat. The accentuated bamboo-style turned legs are well splayed and hold H-pattern baluster stretchers. Although the rather thick shield-shaped seat has nicely curved edges, the slight pommel and bowl-shaped saddling are rather uninspired.

## 169. Child's Braced Continuous-Bow Armchair

New England, probably Connecticut, about 1790

Maker unidentified

Woods unidentified. Recoated unidentified paint.

The Henry Francis du Pont Winterthur Museum

H 24⅞, W 11, D 13¾

Photo: Courtesy, Winterthur Museum

Child-sized continuous-bow armchairs are rare and of those made, few have survived. This is probably because the compound bend of the back and arms are particularly susceptible to fractures. This chair suffered a most unfortunate accident on its right side. The back at the juncture of the arm, the arm at the juncture of the arm support, and the arm support were seriously broken, but, with the exception of the arm support, they were repaired with the original pieces. The fact that the turning pattern of the arm supports do not match

suggests the original was damaged beyond repair and replaced with a piece salvaged from another child's chair of the period. It is interesting to note that the bracing spindles flank only the center back spindle and that the bamboo nodes on the spindles are simulated with paint whereas those on the stout, cut-down legs are turned grooves. The shield-shaped seat is wonderfully sculpted.

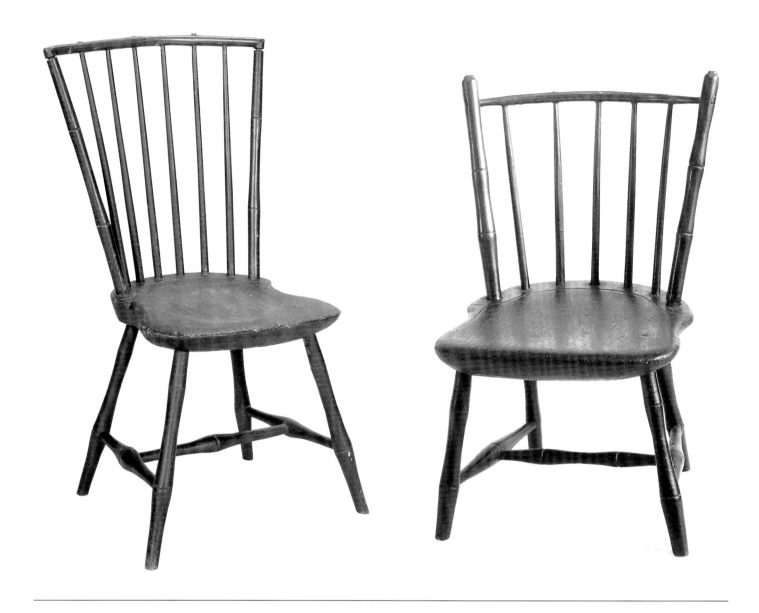

## 170. Child's Rod-Back Side Chair

New England, about 1810

Maker unidentified

Seat—pine; legs, stretchers, stiles, spindles—
birch; crest rod—hickory. Old brown paint
covers original green.

The Art Institute of Chicago, The Robert R.
McCormick Charitable Trust Fund (1980.167)

H 27¾, W 16, D 14½

Photo: Courtesy, The Art Institute of Chicago

The comeliness of this child's rod-back side
chair results from its plain lines and
reserved bamboo-style turnings. All the
turnings have two grooves, although those
on the back spindles are barely discernible.
H-pattern bulbous stretchers support a
slightly saddled, shield-shaped seat. Exter-
nal and internal stresses over the years
caused the false miter joints on the crest
rod and stiles to separate.

## 171. Child's Rod-Back Side Chair

New England, about 1820

Maker unidentified

Woods unidentified. Painted black.

Pocumtuck Valley Memorial Association,
Memorial Hall Museum, Deerfield,
Massachusetts

H 21¾, W 14⅜, D 13¼

The stiles on this child-sized rod-back chair
extend beyond the crest rod. This rod-back
style followed the capped crest-rod pattern
and was also used on adult chairs. Exclud-
ing the side stretchers, all turnings are in
the so-called double-bobbin bamboo-ring
style. The shield-shaped seat is extra thick,
has minimum saddling, rounded upper
edges, and well-splayed socketed legs. All
in all, the chair is a charming example of a
child's Windsor.

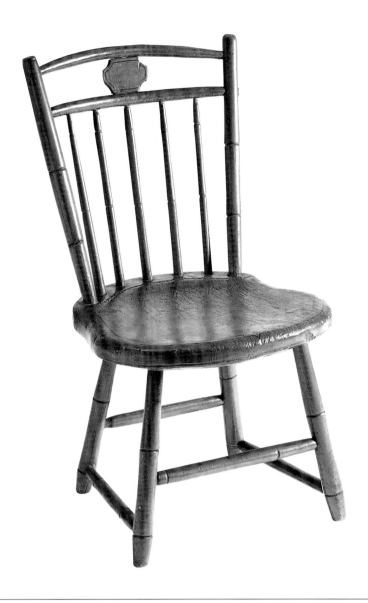

## 172. Child's Double Rod-Back Side Chair

Pennsylvania, about 1820

Maker unidentified

Woods and finish unidentified

Chester County Historical Society, West Chester, Pennsylvania

Unidentified

Photo: George Fistrovich

With the exception of the back stiles and rear stretcher, the turnings on this child's double rod-back side chair are bamboo patterns with double ringing. The back spindles terminate at the secondary crest rod and the space between the rods is partially filled with a so-called butterfly medallion, which originally was decorated with a painted scene.

Additional features of the chair are its ring turnings that cap the ends of the stiles, the saddled but unpommeled seat, the box stretcher, and the shortened but well-splayed wedged legs. The decorative striping (barely evident) on the rounded edges of the seat adds a nice touch to a sturdy child's chair.

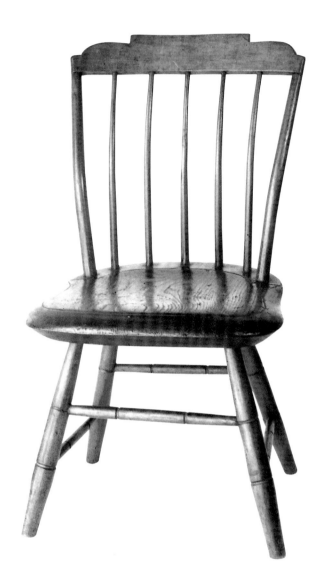
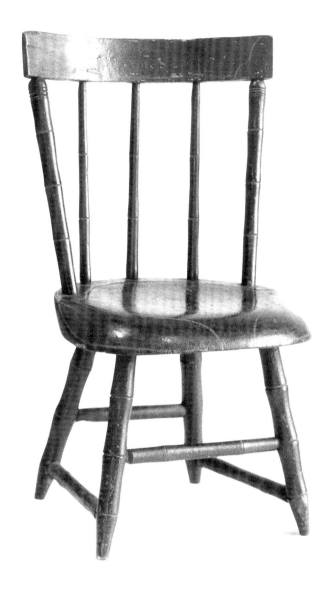

## 173. Child's Step-Down Side Chair

Probably Deerfield area, about 1825

Maker unidentified

Seat—pine; legs, stretchers, stiles, spindles, crest rail—maple. Clear varnish over naturally developed brown patina.

Mr. and Mrs. Benjamin H. Rose

H 32¼, W 13¼, D 14⅝

The attractive features of this charming child's step-down side chair are its two-node bamboo turnings, its suggestion of a shield-shaped seat with decorative cove scoring, its bent back spindles and stiles, and its stepped crest rail. Different bending forms were required to shape and hold the stiles, the spindles, and the crest rail of this important little chair.

## 174. Child's Slat-Back Side Chair

Origin unidentified, about 1830

Maker unidentified

Seat—pine; crest board—oak; all other parts—maple. Original black paint, nodes highlighted with gilt.

Munson-Williams-Proctor Institute, Utica, New York

H 18, W 11¾, D 9⁵⁄₁₆

Photo: Courtesy, Munson-Williams-Proctor Institute

The small size of this comely chair suggests it was made for a toddler, although the parts were made and assembled with the same care invested in Windsors for adults. Notable features of the chair are the steam-bent crest board, the three decoratively turned beads at the upper end of the stiles, and the three bamboo-style back spindles. Also interesting are the well-splayed wedged legs and the box stretchers. The large radius on the front and side edges of the seat and the decorative gilt striping throughout the chair are additional attractive features.

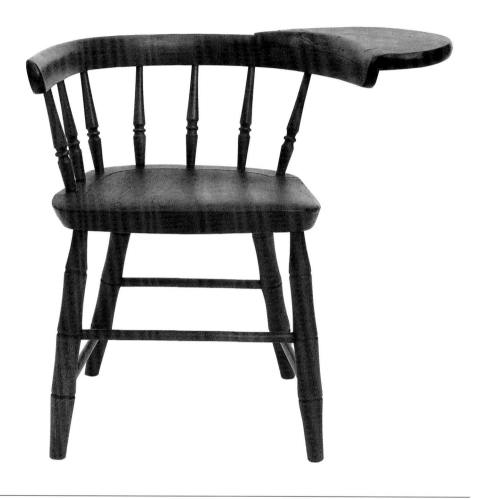

## 175. Child's Writing-Arm Chair

Boston, first quarter nineteenth century

Branded J. [John] C. HUBBARD

Seat—pine; all other parts—maple. Original green paint.

Blue Candlestick Antiques

H 19⅝, W 20½, D 13⅝

The writing tablet and its left-hand location make this child's low-back Windsor a rare example of children's furniture. The chair's design is especially interesting in light of the pressure put on left-handed children of that day (and later) to use their right hand for writing and other tasks. The chair was made by John C. Hubbard, almost assuredly on special order and although it is patterned after adult low-back writing arms, it differs in that the arm rail is one steam-bent piece of wood rather than the typical three-piece sawn assembly.

The tablet was let into the rail and held in place with three countersunk and plugged wood screws. Except for the decorative beading on the tapered spindles, all turnings are plain or three-groove bamboo style. The same bending form could be used to make right-hand writing-arm chairs by simply reversing and tapering the other end of the rail. Of course, in those cases, the seat blank was reversed, shaped, saddled, and the spindle holes bored accordingly. (See figure 145 for an adult left-hand writing-arm chair.)

# 13   High Chairs

## Introduction

Windsor high chairs were a popular form of children's furniture. Early chairs are rare and eagerly sought by collectors and, depending on their condition, can command a high price. The earliest chairs were made in Philadelphia and were styled after adult comb backs. Eventually high chairs were made and patterned after all adult-sized Windsor chair forms, except perhaps the fan-back style. Rod backs were an especially popular form, judging from the number that have survived. The first leg turnings were cylindrical, with blunt-arrow feet, followed first by baluster and later by bamboo-turnings. All high chairs had arms and arm supports and many had a restraining rod and footrest, but none had bracing back spindles. Table chairs (chairs to be drawn up to the table) were designed for older children and were without footrest and restraining rods.

On high chairs, the elevated seat required longer legs than those of regular-sized chairs. Increasing the length of the turnings and keeping them attractive presented a design problem for the chairmaker. The solutions differed depending upon the style: on the Philadelphia-style leg, it was accomplished by stretching out the length of the cylinder and baluster; on the baluster-pattern leg it was done by increasing the number of balusters and the length of the foot taper; on the bamboo-style leg, it was the number of grooves and the spacing between them that were increased. Chairmakers made these adjustments while keeping in mind that the diameters of the turnings had to be retained or even increased proportionally to look right and to provide necessary strength to the chair.[1]

As attractive as these early high chairs are, they are out of compliance with contemporary recommendations from the United States Consumer Product Safety Commission. The Commission requests that manufacturers of high chairs voluntarily install a waist restraint to prevent children from standing up in the chair and, when a tray is used, a crotch strap to prevent the child from slipping out of the front of the chair.

| Letter | No. | Name | Material | T. | W. | L. |
|---|---|---|---|---|---|---|
| A | 1 | seat | pine | 2 | 13⅜ | 12¾ |
| B | 4 | legs | maple | 1¹¹⁄₁₆ dia. | | 23½ |
| C | 1 | bow/arm | hickory | ¹³⁄₁₆ | 1⅜ | 44 |
| D | 2 | side stretchers | maple | 1⁷⁄₁₆ dia. | | 13 |
| E | 1 | center stretcher | maple | 1⁷⁄₁₆ dia. | | 13½ |
| F | 7 | back spindles | hickory | ⁹⁄₁₆ dia. | | 16¼ |
| G | 4 | arm spindles | hickory | ⁹⁄₁₆ dia. | | 7¼ |
| H | 2 | arm supports | maple | 1 dia. | | 8¾ |
| I | 19 | wedges | maple | | various sizes | |
| J | 2 | footrest supports | (missing) | | | |
| K | 1 | footrest | (missing) | | | |

## 176. Continuous-Bow High Chair

New England, about 1775

Maker unidentified

Seat—pine; legs, stretchers, arm supports—maple; spindles, bow, and arm—hickory. Black paint over original black.

Mr. and Mrs. Kenneth D. Brody

H 37½, W 19, D 16¼

Even though its footrest and supports are missing, this continuous-bow high chair merits high marks for its beautiful form and skillfully made parts. Using a continuous bow for the back of a high chair seems risky, especially without bracing spindles. Nevertheless, the chair has survived considerable use. Important features of the chair are the paddle-shaped hand holds, the double-beaded bow, the well-sculptured deeply saddled seat, the great thicks and thins on the legs and matching arm supports, and the ample leg splay. The arm supports have a prominent forward thrust and the slightly bulbous back spindles are attractively fanned, while the plain bulbous H-stretchers are a quiet change of pace.

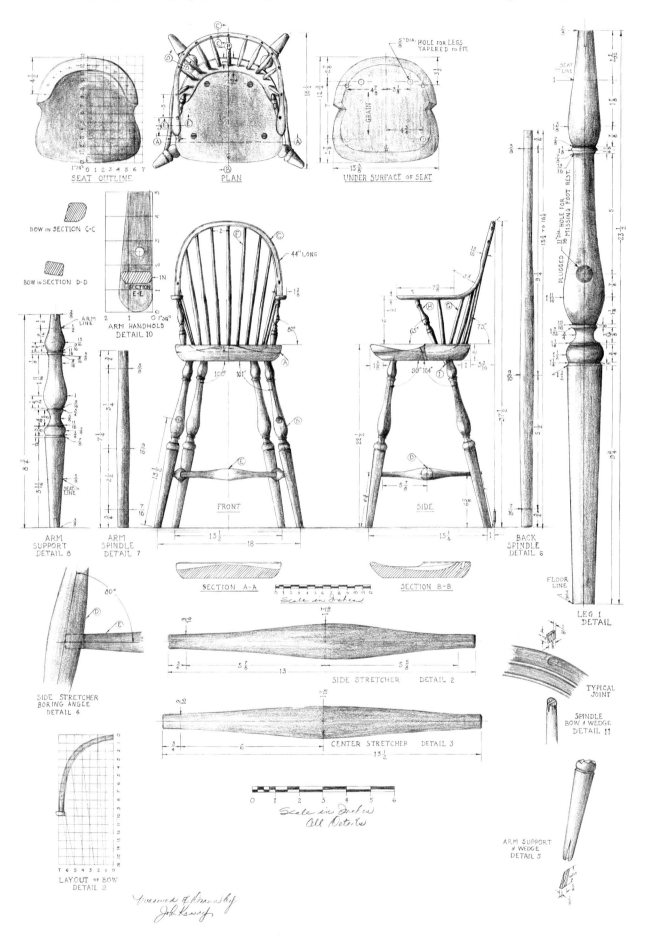

SEAT OUTLINE

PLAN

UNDER SURFACE OF SEAT

BOW IN SECTION C-C

BOW IN SECTION D-D

ARM HANDHOLD
DETAIL 10

ARM SUPPORT
DETAIL 8

ARM SPINDLE
DETAIL 7

FRONT

SIDE

BACK SPINDLE
DETAIL 6

LEG 1 DETAIL

SECTION A-A

SECTION B-B

Scale in Inches

SIDE STRETCHER BORING ANGLE
DETAIL 4

SIDE STRETCHER    DETAIL 2

TYPICAL JOINT

SPINDLE BOW & WEDGE
DETAIL 11

CENTER STRETCHER    DETAIL 3

Scale in Inches
All Details

LAYOUT OF BOW
DETAIL 9

ARM SUPPORT & WEDGE
DETAIL 5

Measured & Drawn by
John Kennedy

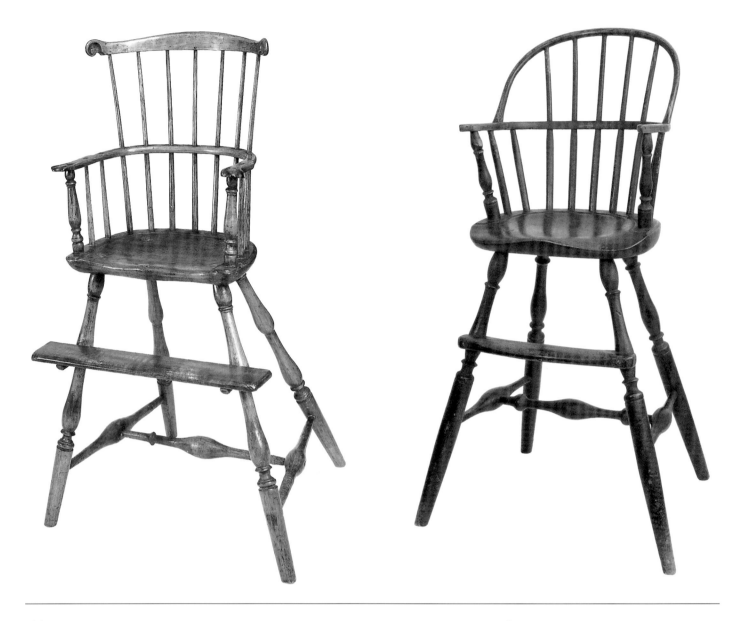

## 177. Comb-Back High Chair

Philadelphia, about 1760

Branded - I. [Joseph] Henzey, Sr. (1743–1796)

Seat—pine; turnings, footrest—maple; spindles, arm and crest rail—hickory. Original green paint, stripped, natural wood finish.

Bernard & S. Dean Levy, Inc., New York

H 37¾, W 17, D 12

Photo: Helga Photo Studio

The attractive details on this chair include carved ears on the long wraparound crest rail, the D-shaped well-saddled seat, the oval footrest supports, and the well-splayed legs. The lack of crispness on the arm-support turnings, the missing fullness on the carved knuckle hand holds, and the overly long footrest, all detract from an otherwise graceful chair.

The curved arm and crest rail required different bending forms and the tapered back spindles made it necessary to bore holes of different diameters in the crest rail, the arm rail, and the seat. Additionally, the holes in the arm rail had to be tapered.

## 178. Sack-Back High Chair

Probably New England, about 1780

Maker unidentified

Sack, arm rail, spindles—hickory; all other parts—maple. Original dark green paint.

Kinnaman and Ramaekers Antiques

H 34⅜, W 20½, D 18

This attractive chair in the sack-back style has good structural integrity and few minor design faults. Tenons on the ends of the sack are shouldered and wedged to the arm rail and give strength to the back and security to the joint. The turning patterns of the arm supports and legs are baluster style with well-coordinated details, although the lower portion of the leg seems overly heavy for the rest of the leg. The angled arm supports and spindles plus the well-sculptured seat give the chair an inviting look and the well-splayed legs contribute visual and physical stability. The legs penetrate the seat and support the

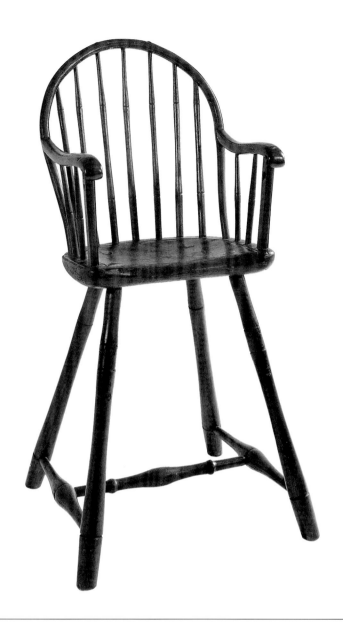

original footrest, the ends of which wrap part way around the legs in an interesting fashion. It is unfortunate that the hand holds are missing the applied pieces that gave them a mitten or scrolled form. Two additional back spindles would have filled in the large open areas in the back, and gradual tapers below the arm rail on all the spindles would have contributed needed grace.

## 179. Bow-Back High Chair

Philadelphia, date unknown

I. [John] Letchworth (1759–1843)

Seat—pine; leg, stretchers—maple; bow, spindles, arm supports—hickory; arms—mahogany. Natural brown patina.

Blue Candlestick Antiques

H 34⅜, W 20½, D 18

Bow-back high chairs with mahogany arms and bamboo turnings are a later high-chair style. This example was made by John Letchworth, one of Philadelphia's most prolific and creative Windsor chairmakers who manufactured no less than eight different Windsor chair styles in adult sizes.

This chair has all the characteristics of a full-sized bow-back. The beaded pinched bow, scrolled arms with voluted hand holds, bamboo turnings, and slightly hollowed seat are reduced from an adult version.

Other interesting features of the chair are the rectangular unturned arm supports, bored to receive a restraining rod, the inverted tapered legs, and the double bamboo grooves on the front legs. The arm supports are through-tenoned to the seat and arms, and the arms are tenon-wedged to the bow. The widely splayed legs are heaviest at the floor line and contribute stability to the piece. The double bamboo nodes were used to locate where holes for the footrest supports were to be bored. Two sets of plugged holes give additional interesting information about the chair. The footrest was originally located at the upper set of holes. As the child grew, a second, lower set was bored. When the child was even older, the footrest was eliminated and the holes were plugged. The chair then became a table chair or youth chair. The restraining rod probably did not survive very long after the child's first meal in the chair. Missing parts are typical of high chairs.

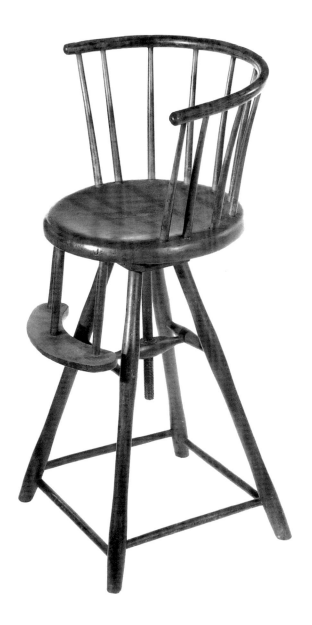

## 180. Low-Back High Chair

Unknown New England Shaker Community, about 1850

Made by unidentified Shaker Brother

Stretchers, legs, spindles—maple; seat—pine; rail—hickory; footrest—maple? Finish unidentified.

Henry Ford Museum and Greenfield Village, Dearborn, Michigan

H 29, W 16½, D 14

Photo: Courtesy, Henry Ford Museum and Greenfield Village

This child's high chair in the low-back Windsor style is a classic example of Shaker ingenuity and was probably one of a kind. Unfortunately, the chair was destroyed by fire and now exist only as a photograph. Nevertheless, careful examination of the photograph and critical analysis of the parts reveal several special features of the chair: the Windsor-pattern spindled back, lathe-turned scooped-out plank seat, and crescent-shaped footrest all revolved and rose as a unit. The footrest was supported by three wooden rods, which were socketed to the underside of the seat. The inside curve of the footrest cleared the canted legs when the seat was rotated.

The moderate bamboo-style lathe-turned legs were stabilized with box and H-pattern stretchers and their upper ends were permanently socketed to a rectangular board—with a cut-out disk at its center. This cut-out piece was firmly fastened to the underside of the seat with wood screws and had an internal threaded metal flange at its center.

The upper end of a threaded metal rod was assembled to this flange and the lower end was threaded into an embedded nut located in the bar of the H-stretcher. The nut can be seen in the photograph.

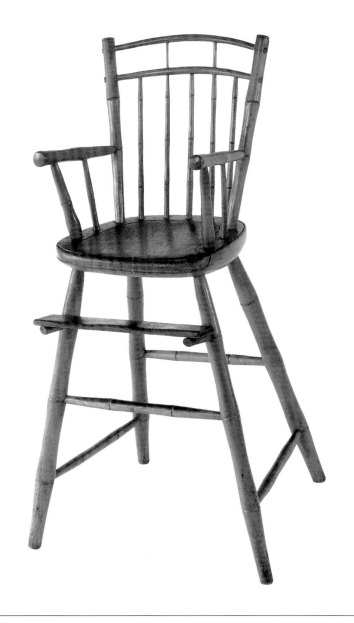

### 181. Double Rod-Back High Chair

New England, about 1820

Maker unidentified

Seat, footrest—poplar; legs, stretchers, arms, arm supports, stiles—maple; rods, spindles—hickory. Original yellow and red paint.

Oveda Maurer Antiques

H 36½, W 20, D 17

A variety of bamboo-style turnings was used in this double rod-back high chair and together they make a unifying design statement. Depending upon their diameter, one, two, and three bamboo ringing was used on the turnings. Other decorative features include button finials on the arms and stiles, red paint that highlights the bamboo ringing, and the nicely contoured D-shaped seat with its paired cove cuts along the front edge and spindle area. Interesting construction features include the back and arm components, which are assembled throughout with wedged tenons, the two back spindles, which pass through the lower rod and form three bird-cage spaces, and the typical box-stretcher configuration.

# CRADLE

MIXED WOODS
PAINTED DARK BROWN

CIRCA 1800
BRANDED I. LETCHWORTH

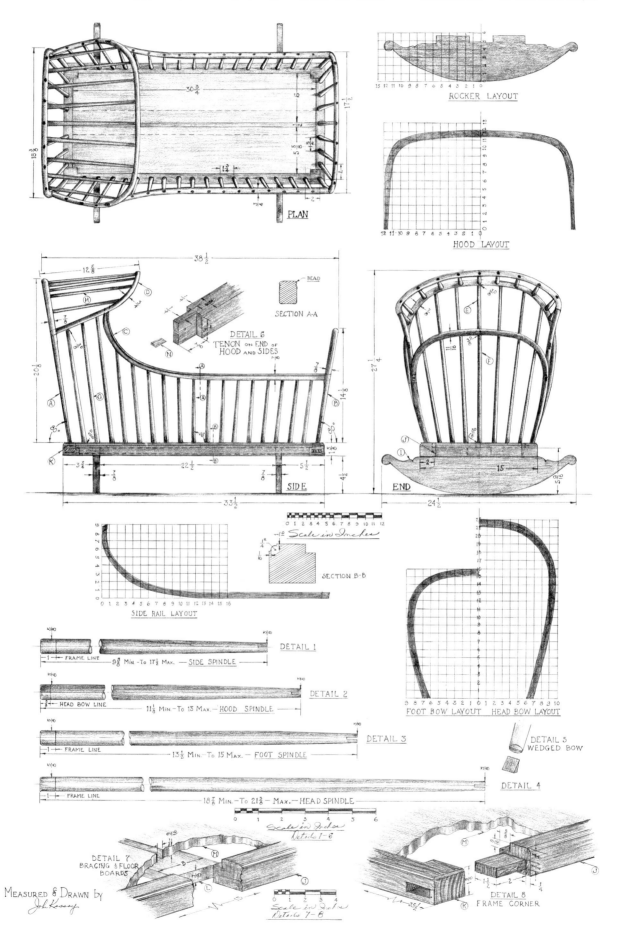

ROCKER LAYOUT

HOOD LAYOUT

PLAN

SECTION A-A

BEAD

DETAIL 6
TENON on END of
HOOD and SIDES

SIDE

END

Scale in Inches

SECTION B-B

SIDE RAIL LAYOUT

DETAIL 1
— SIDE SPINDLE — $9\frac{3}{8}$ Min. -To $17\frac{1}{2}$ Max. FRAME LINE

DETAIL 2
— HOOD SPINDLE — $11\frac{1}{8}$ Min. -To 13 Max. HEAD BOW LINE

DETAIL 3
— FOOT SPINDLE — $13\frac{1}{2}$ Min. -To 15 Max. FRAME LINE

DETAIL 4
— HEAD SPINDLE — $18\frac{7}{8}$ Min. -To $21\frac{3}{8}$ Max. FRAME LINE

FOOT BOW LAYOUT    HEAD BOW LAYOUT

DETAIL 5
WEDGED BOW

Scale in Inches
Details 1-6

DETAIL 7
BRACING & FLOOR
BOARDS

Scale in Inches
Details 7-8

DETAIL 8
FRAME CORNER

Measured & Drawn by
John Kassay

## Introduction

Cradles in the Windsor style date from the late eighteenth century. Their airy, open, spindled ends and sides were a sensible departure from the earlier coffinlike forms. Some Windsor cradles were designed or fitted with hoods, some had raised beds on short legs, and all had rockers. Most were designed with a distinctive head and foot, but some had identical ends. The rockers usually were oriented from side to side, although there are a rare few with rockers running the length of the bed. On these, the cradle rocked head to foot, simulating the motion of a mother rocking a child in her arms. A regulation of the United States Consumer Product Safety Commission specifies that the spacing between spindles on cradles and similar baby furniture must be no greater than 2⅜ inches.[1]

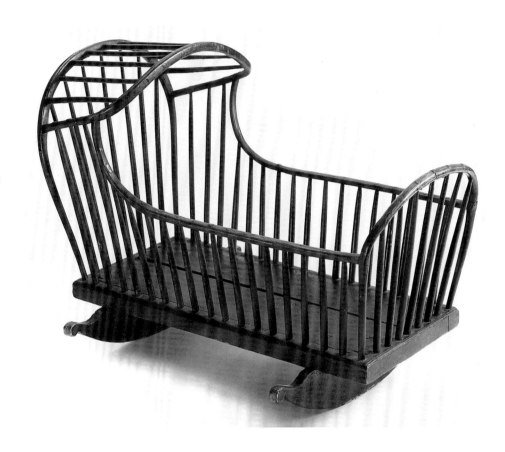

### 182. Cradle

Philadelphia, about 1800

Maker: Branded I [John] Letchworth (1759–1843)

Bent parts—hickory; spindles—maple; floor boards—pine; bracing board—walnut; frame—walnut; rockers—oak (white?). Original dark brown paint.

Chester County Historical Society, West Chester, Pennsylvania

H 27¼, W 24½, L 38½

Photo: Courtesy, Chester County Historical Society

As far as is known, this branded Letchworth cradle is the only one of this style in existence. Considering the complexity of the cradle components and the number of bending forms (three), it is hard to imagine that Letchworth did not make others, but as yet none has come to light. One bending form was used to shape the head and foot bows, and the two side

| Letter | No. | Name | Material | T. | W. | L. |
|---|---|---|---|---|---|---|
| A | 1 | head bow | hickory | ⅞ | ⅞ | 56⅜ |
| B | 1 | foot bow | hickory | ¹¹⁄₁₆ | ⅞ | 43¼ |
| C | 2 | side rails | hickory | ¾ | ⅞ | 33⅜ |
| D | 1 | hood bow | hickory | ¾ | ⅞ | 46½ |
| E | 7 | head spindles | maple | tapered ⅜ to ⅜ dia. | | 18⅞ min., 21⅜ max. |
| F | 7 | foot spindles | maple | tapered ⅜ to ⅜ dia. | | 13½ min., 15 max. |
| G | 34 | side spindles | maple | tapered ⅜ to ⅜ dia. | | 9⅝ min., 17½ max. |
| H | 9 | hood spindles | maple | tapered ⅜ to ⅜ dia. | | 11⅛ min., 13 max. |
| I | 2 | rockers | white oak? | ⅞ | 5⁹⁄₁₆ | 24½ |
| *Bed:* | | | | | | |
| J | 2 | end frames | walnut | 1⅜ | 2 | 15 |
| K | 2 | side frames | walnut | 1⅜ | 2 | 33½ |
| L | 1 | bracing board | walnut | ⅞ | 3 | 29½ |
| M | 2 | floor boards | pine | ⁹⁄₁₆ | 5⅜ & 6 | 30¾ |
| N | 57 | wedges | hickory? | ⅛ | ¼ | size to suit |

rails were bent in a separate form. The hood required a compound bending form. The side rails are through-tenoned-wedged to the foot and hood bow, and the hood bow is assembled to the head bow in the same manner. All spindles appear to be lathe-turned rather then spoke-shaved and

although they vary in length, their major and minor diameters are the same. The spindles are tenoned-wedged to the bent members except for those in the hood, which are stopped-tenoned to the head bow. The bedframe members have molded exposed edges with their corners joined

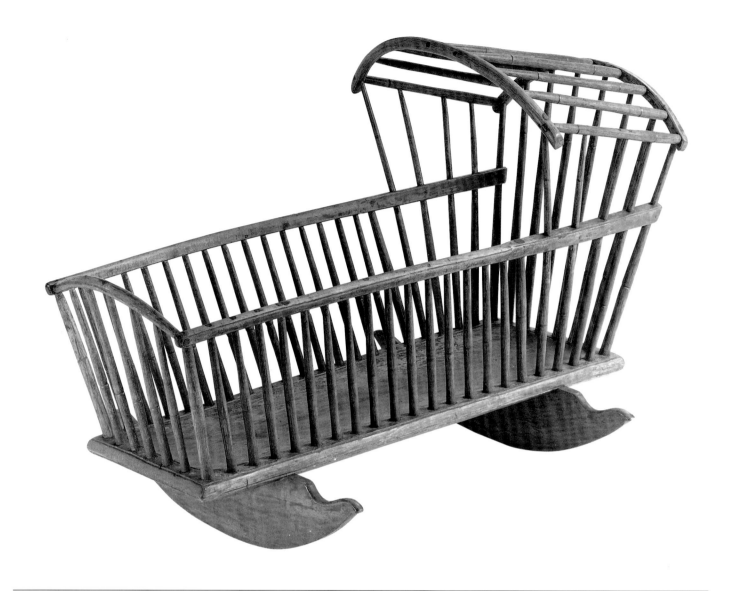

with open tenons. These components have rabbeted inside edges that hold the floor boards, which are nailed to the rockers. The two floor boards have an open space between, due probably to natural shrinkage. The spacing between the spindles is greatest at the upper part of the head and foot bows and is approximately 2¼ inches. The cradle is truly a masterpiece of Windsor furniture.

## 183. Cradle

Origin unknown, about 1800

Maker unidentified

Woods and finish unidentified

The Henry Francis du Pont Winterthur Museum

H 26⅛, W 23¾, L 43

Photo: Courtesy, Winterthur Museum

The hood and the outwardly angled spindles on this cradle give it an attractive Japanese appearance. All the spindles, including those in the hood, are tapered and have double bamboo grooves, which

further contribute to the Japanese feel. The cradle has three bent parts, one at the foot that holds six spindles within the corner posts and two that hold the nine spindles that form the roof of the hood. The center and flanking hood spindles penetrate the bows and are wedged. Eight side spindles, four to a side, pass through the side rails and are tenoned to the flanking hood spindles. All the spindles are socketed to the plank bed, which in turn rests on rockers.

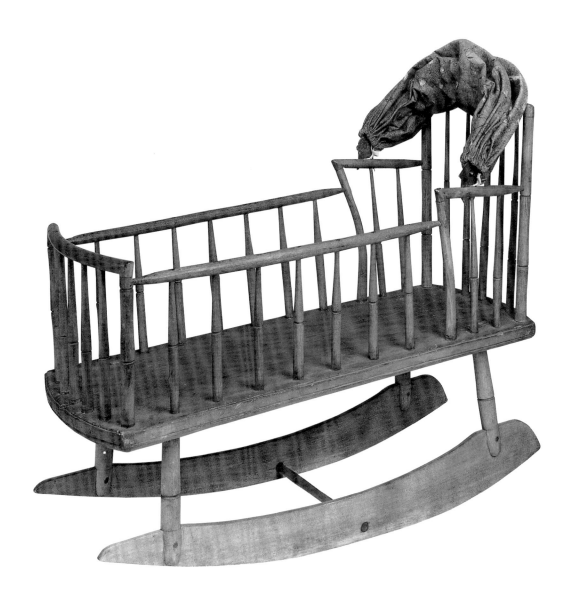

### 184. Cradle

Probably Massachusetts, about 1815

Maker unidentified

Bed—pine; all other parts—maple. Stained red.

Courtesy, Historic Deerfield, Inc., Deerfield, Massachusetts

H 33, W 14, L 36½

Photo: Helga Photo Studio

The collapsible carlike convertible top on this cradle is an afterthought and, although unusual, is not particularly attractive. In fact, it detracts from details of the cradle head—details that are very similar to those found on rod-back armchairs. Perhaps the cradle was made by a craftsman who also made rod-back Windsors. Bamboo turnings, curved crest rods, and duck-bill corners are features of rod backs and are used nicely here. As attractive as the corners are, they present the potential for scratching a child or snagging a child's garment.

The rockers have interesting features. They are "knife-blade" thin, have a wide sleigh-shaped profile with asymmetrical ends, and run parallel with rather than across the bed. They act as side stretchers and are strengthened by a single stretcher. The side rails are tenoned to the corner post. Short heavy turned legs are wedged to the bed board, straddle the rockers, and are pinned for security. The head and foot crest rods echo nicely the curved ends of the bed board.

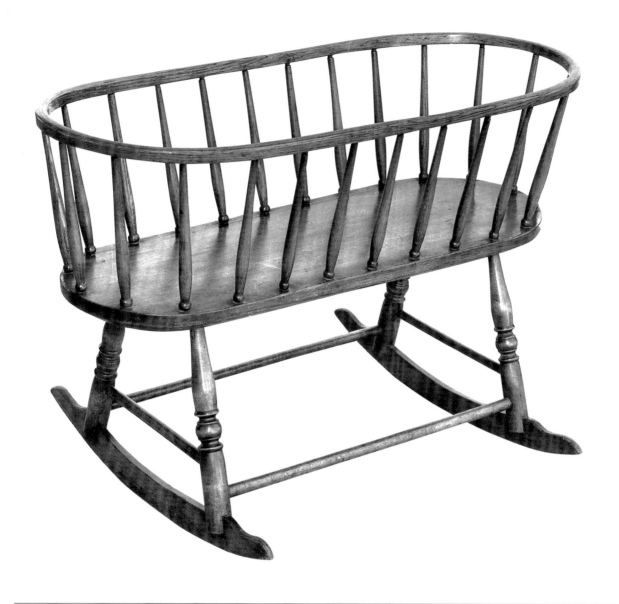

## 185. Cradle

Probably New England, about 1790

Maker unidentified

Bed—pine; legs, spindles—maple; rail, stretchers—hickory; rockers—probably maple. Finish unidentified.

Henry Ford Museum and Greenfield Village, Dearborn, Michigan

H 23³⁄₁₆, W 25½, L 40

Photo: Courtesy, Henry Ford Museum and Greenfield Village

This handsome cradle is one of only two known to exist. Both are unsigned and considered rare. The outstanding feature of the cradle is the continuous rail that is fabricated from two identically bent bows which are scarf-jointed at the sides. The rail, almost square in cross section, has a slightly rounded upper surface. The beaded lower end of the spindles complements the decorative turning on the legs. The one-piece flat bed board holds blind-tenoned legs and has a heavy chamfer around its entire underedge, which is barely visible in the photograph. The legs hold plain-turned box stretchers and straddle thin cyma-ended rockers. The spacing between the turned spindles is greater than the Consumer Product Safety Commission recommendation.

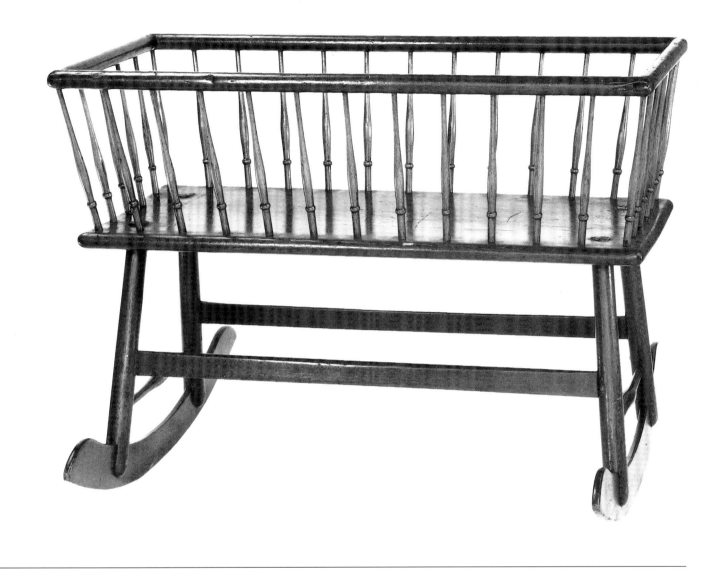

### 186. Cradle

Probably Pennsylvania, about 1830

Maker unidentified

Bed—poplar; legs, side stretchers, rockers—
mahogany; end stretchers, spindles—hickory;
rails—birch. Stained brown, varnished.

Sandra MacKenzie

H 24, W 28⅝, L 33½

This attractive cradle has rod-shaped rails
assembled at the corners with finger joints,
the projecting ends of which are rounded
over to conform with the shape of the rails.
The single ring on the spindles contributes
interest to the otherwise plain turnings,
however, the rectangular board side
stretchers are unbecoming; it would have
been better if they were shaped to echo the
roundness of the rails and the bed board's
edges. The inverted taper-turned legs are
tenoned-wedged to the unscooped bed
board and straddle nicely shaped sleigh-
runner rockers.

# 15   Stools

## Introduction

Stools were made in all areas by craftsmen working in the Windsor style. They were produced from the late eighteenth to the early nineteenth century and can be divided into two categories: low stools designed as footrests and the taller versions used at a desk or workbench. More footstools seem to have been produced than the taller variety, possibly because they were less expensive to make and more versatile, for they could also be used for seating.

Footstools usually have three main parts: a top, legs, and stretchers; however, some stools were designed without stretchers. Four different shaped tops were used: oval, which was probably the most popular; round, also popular; and square and rectangular, less popular. Tops were left flat or scooped and many were upholstered. The four legs (cricket Windsors had three) were turned in either the baluster pattern or in the later bamboo style. Legs were braced with plain turned or bulbous center stretchers.

Tall stools have the same features as low stools. Most were made with a round seat but oval and D-shapes were also popular. Some were saddled, footrest were sometimes included, and many were upholstered. Four baluster- or bamboo-turned legs were often wedged to the seat and usually held H-pattern single or double box stretchers. Three-legged stools were strengthened with three stretchers.

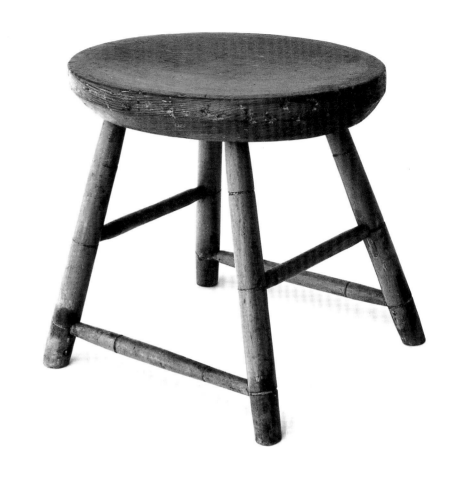

## 187. Upholstered Footstool

Probably New England, about 1820

Maker unidentified

Seat—pine; legs—maple; upholstery—missing. Paint fragments of blue, yellow, and black.

Blue Candlestick Antiques

H 13⅞, W 11⅞₁₆, L 15⅞₁₆

On this low stool the thick, oval top is well dished and has a wide nailing band—evidence that it was designed to be upholstered. A row of tack holes further supports this deduction. The grooves on the turnings simulate bamboo but the spaces between are relatively straight and lack the concavity necessary to accentuate the bamboo pattern. The middle and lower grooves on the legs were used to locate holes for the stretchers. The box-stretcher arrangement suggests an early nineteenth-century date of manufacture.

| Letter | No. | Name | Material | T. | W. | L. |
|---|---|---|---|---|---|---|
| A | 1 | seat | pine | 2 | 11⁷⁄₁₆ | 15⁷⁄₁₆ |
| B | 4 | legs | maple | 1¼ dia. | | 13¾ |
| C | 2 | end stretchers | maple | ¾ dia. | | 8¾ |
| D | 2 | side stretchers | maple | ¾ dia. | | 12¼ |

# UPHOLSTERED FOOTSTOOL
### PINE AND MAPLE
### CIRCA 1820

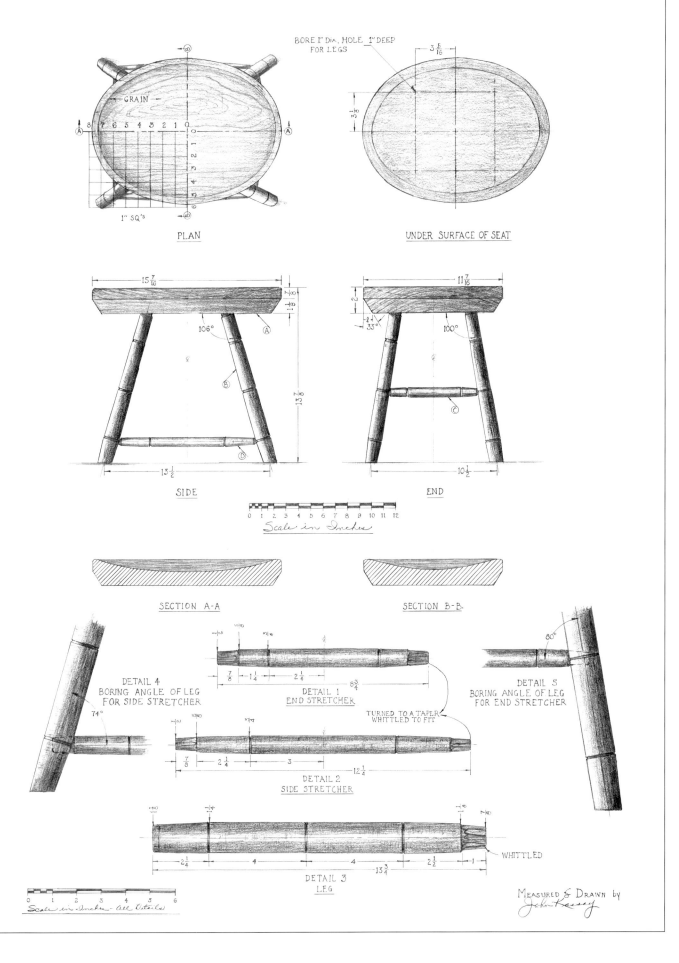

BORE 1" DIA. HOLE 1" DEEP FOR LEGS

GRAIN

1" SQ'S

PLAN

UNDER SURFACE OF SEAT

SIDE

END

0 1 2 3 4 5 6 7 8 9 10 11 12
Scale in Inches

SECTION A-A

SECTION B-B.

DETAIL 4
BORING ANGLE OF LEG
FOR SIDE STRETCHER

DETAIL 1
END STRETCHER

DETAIL 5
BORING ANGLE OF LEG
FOR END STRETCHER

TURNED TO A TAPER
WHITTLED TO FIT

DETAIL 2
SIDE STRETCHER

WHITTLED

DETAIL 3
LEG

0 1 2 3 4 5 6
Scale in Inches - All Details

Measured & Drawn by
John Kassay

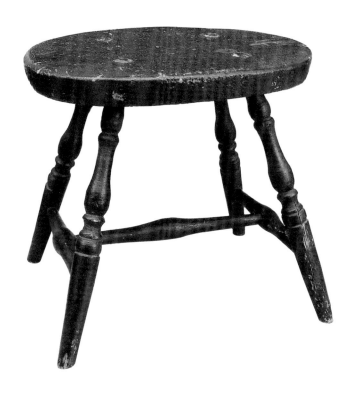

### 188. Footstool

Probably Connecticut Valley, about 1785

Maker unidentified

Woods unidentified, but probably pine seat and maple legs. Finish unidentified.

The Henry Francis du Pont Winterthur Museum, Funds, gift of Charles K. Davis, 1955

H 11¼, W 13¼, D 10¼

Photo: Courtesy, Winterthur Museum

The unscooped and rather thick top on this stool has a large undercut beveled edge and a slightly rounded-over upperedge. It holds baluster-turned, wedged legs that are strengthened by plain bulbous stretchers. The turning details on the legs are adequately achieved; the ring (cusp), however, is vaguely stated.

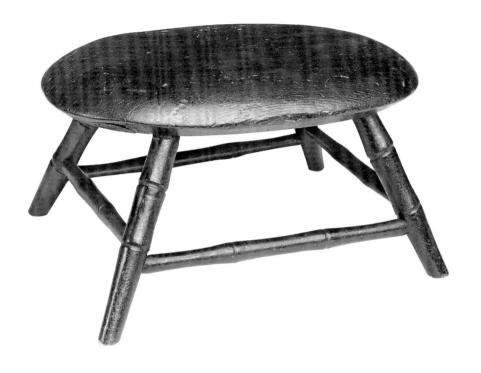

### 189. Footstool

New England, about 1810

Maker unidentified

Seat—pine; other parts—maple. Repainted black.

Courtesy, Historic Deerfield, Inc., Deerfield, Massachusetts

H 6½, W 15⅛, D 13¾

Photo: Helga Photo Studio

The large radius and chamfered edge on the top of this stool give the hint of a cushion and suggest it was never meant to be upholstered. This attractive piece has well-splayed, very short legs, which are probably their original length. The box stretcher and leg turnings are in the popular bamboo style.

# TALL STOOL

MIXED WOODS

CIRCA. 1780

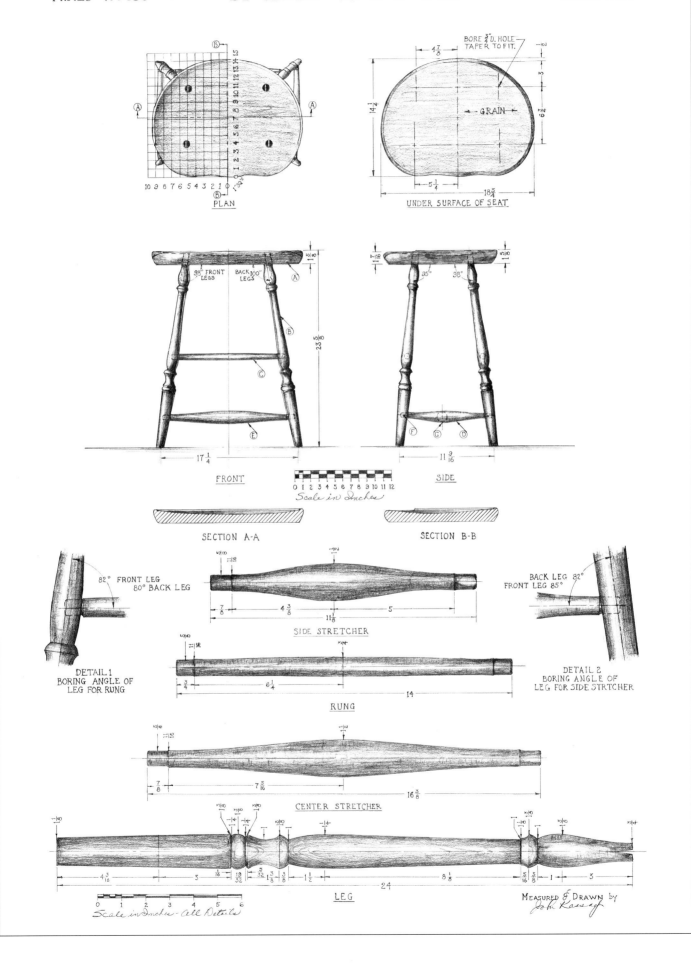

PLAN

UNDER SURFACE OF SEAT

FRONT

SIDE

Scale in Inches

SECTION A-A

SECTION B-B

DETAIL 1
BORING ANGLE OF
LEG FOR RUNG

SIDE STRETCHER

DETAIL 2
BORING ANGLE OF
LEG FOR SIDE STRTCHER

RUNG

CENTER STRETCHER

LEG

Scale in Inches - All Details

Measured & Drawn by
John Kassay

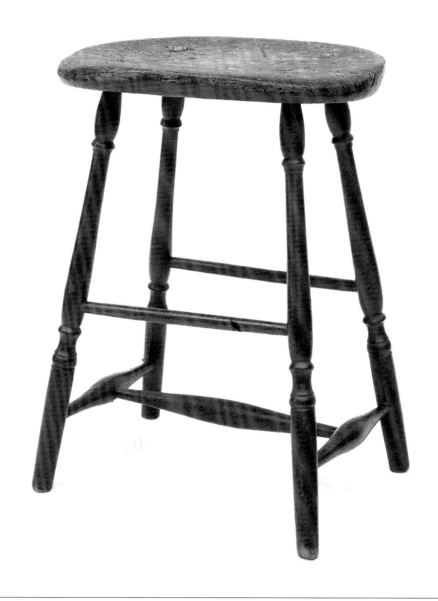

| Letter | No. | Name | Material | T. | W. | L. |
|--------|-----|------|----------|-----|-----|-----|
| A | 1 | seat | pine | 1⅜ | 14¼ | 18¾ |
| B | 4 | legs | maple | 1⅜ dia. | | 24 |
| C | 2 | rungs | hickory | ¾ dia. | | 14 |
| D | 2 | side stretchers | maple? | 1½ dia. | | 11⅛ |
| E | 2 | center stretchers | chestnut | 1½ dia. | | 11⅛ |
| F | 4 | pins | maple | ⅛ dia. | | ¾ |
| G | 2 | pins | maple | ⅛ sq. | | 1 |
| H | 1 | upholstery | leather | | size to suit | |
| I | ? | furniture nails | bronze finish | | | ½ |

## 190. Tall Stool

Probably New England, about 1790

Maker unidentified

Seat—pine; center stretcher—chestnut; other parts—maple. Green paint over original red.

Mr. and Mrs. Jerome W. Blum

H 23⅝, W 18¾, D 14¼

On this tall stool the straight portion of the D-shaped seat designates the front. Numerous tack holes along the edges are evidence that the piece was upholstered many times. The long taper and stretched-out baluster on well-splayed tenoned legs give the stool height and stability. The plain bulbous centered H-stretchers are tenoned to the legs and contribute major strength to the piece. The two plain but interesting, rod-shaped upper stretchers add very little strength, and might have complicated the assembly process. The legs may have lost some of their original length through normal wear.

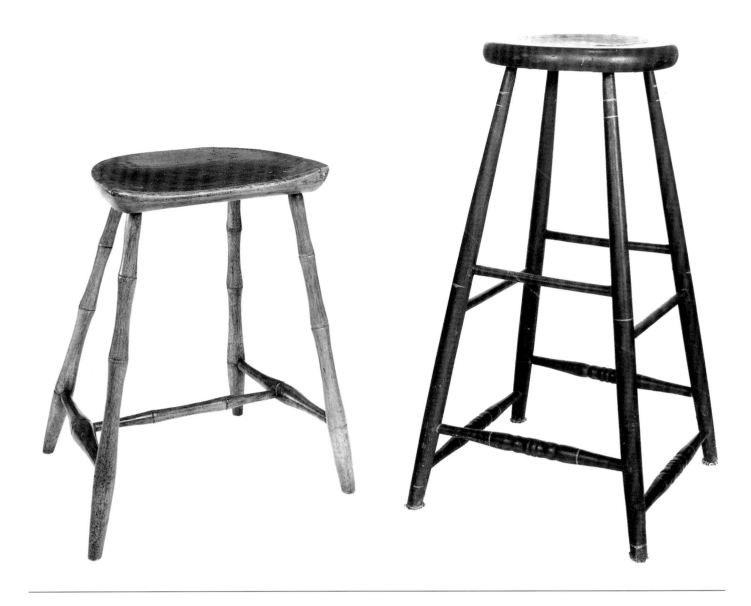

## 191. Tall Stool

Probably New Jersey, about 1810

Maker unidentified

Seat—pine; legs and stretchers—unidentified. Originally painted reddish brown.

Courtesy, Historic Deerfield, Inc., Deerfield, Massachusetts

H 22⅝, W 16, D 10½

Photo: Helga Photo Studio

The seat on this charming tall stool is also D-shaped. The deep saddling and boldly beveled edges indicate the piece was not designed to be upholstered. The tenon-wedged bamboo-style legs have three grooves with good undercut graduated spacing between. The legs hold baluster-tapered side stretchers and bamboo-style center stretchers in an H-pattern.

## 192. Tall Stool

Probably Salem, Massachusetts, about 1810

Maker unidentified

Woods unidentified. Painted black with white line decoration.

Courtesy, Salem Maritime Museum NHS, Salem, Massachusetts

H 31¾, dia. of seat 13¾

On this tall stool, four long, well-splayed legs complement a small lathe-turned seat. The seat is slightly dished, has a pleasing rounded edge, and holds exposed tenon-wedged legs. The plain tapered legs are decorated with painted striping to simulate bamboo turnings. The mushroom ends at the floor line are genuine evidence of extensive use. Removing this unattractive (but interesting) bit of history must have been tempting, but fortunately it was never done. The craftsman who designed the stool judged the extra long legs needed two sets of box stretchers for strength. The secondary (upper) set is plain turned and rodlike, while the lower set has weakly defined decorative beading. The eight stretchers required that the sixteen tenon holes in the legs be located precisely and correctly angled.

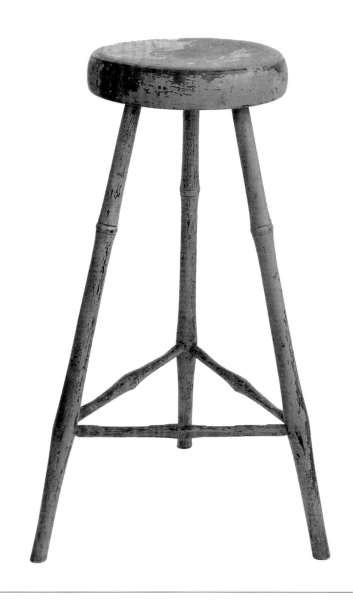

### 193. Three-Legged Tall Stool

Probably New England, about 1820

Maker unidentified

Maple. Light green paint over original black.

Kinnaman and Ramaekers Antiques

H 28, Seat T 2⅛, dia. 11, W (at floor line) 18

The very small seat on this three-legged
tall stool suggests it was designed for
occasional rather than sustained seating.
The well-splayed legs are stop-tenoned to
an exceptionally thick seat and hold three
not offset, equally spaced, slightly bulbous
stretchers. The bamboo-turned legs have
an interesting bead incorporated in the
upper node grooves.

# CANDLESTAND

TIGER GRAIN
MAPLE
STAINED MED. BROWN
CLEAR SHELLAC

CIRCA 1820

120°

GLUE LINE

PLAN

12 3/16

BORE 3 HOLES 9/16" DIA. FOR LEGS. TAPER TO FIT.

DETAIL 5
TOP IN SECTION

DETAIL 6
WEDGE, TOP & TENON LEG

DETAIL 7
ENLARGED DETAIL OF
MOLDED EDGE OF TOP
NOT TO SCALE

TOP LINE

6 1/4

13/16

27 1/8

7 1/2

1 3/16

2 7/8

7

DETAIL 1
LEG

DETAIL 2
STRETCHER

12 3/4

5 1/2

7/8

15/16

7/16

95°

11" DIA.

19 5/8

27 3/8

7

7

13 1/4

FRONT

DETAIL 3
MORTISE LOCATION
FOR LEGS A & B

DETAIL 4
MORTISE LOCATION
FOR LEG C

60°

60°

A & B

C

SCALE IN INCHES
DETAILS

SCALE IN INCHES
VIEWS

MEASURED & DRAWN by
John Kassay

## Introduction

Candlestands in the Windsor style are rare. Those that exist are tall and slender, have a small round top, which is usually dished, and stands on three legs, strengthened by three stretchers. They were usually made from one wood species but candlestands in mixed woods also exist. All parts were lathe-produced and the legs were usually turned in the baluster pattern.

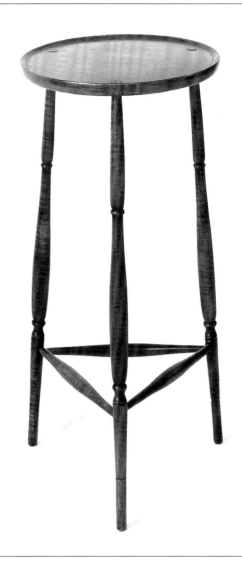

### 194. Candlestand

Probably Chester County, Pennsylvania, about 1820

Maker unidentified

Tiger grain maple. Clear shellac over medium brown stain.

Mahlon and Isabel Pool

H 27⅜, Dia. of top 12³⁄₁₆, Dia. at floor line 13⅞

The lathe-turned dished top with a raised edge is an especially attractive detail on this beautiful candlestand. The beaded edge contributes both interest and security to the candle holder and the attenuated double baluster of the long tapered legs further add to its charm.

A glue line in the two-piece top tends to assign a front and back to the candlestand. Why a two-piece top? Perhaps wide material was unavailable; however the maker knew that two pieces of wood, edge-glued, would minimize dimensional change.

Perhaps the maker wanted a more attractive book-match grain pattern. Visible wedges secure the legs to the top. The pinned stretcher ends by-pass, a construction feature that facilitated

assembly and avoided weakening the legs. Although the stand is a rare piece, another quite similar one with greater leg splay exists and was probably made by the same craftsman.[1]

| Letter | No. | Name | Material | T. | W. | L. |
|--------|-----|------|----------|-----|------|------|
| A | 1 | leg | maple | 1³⁄₁₆ dia. | | 27⅛ |
| B | 1 | leg | maple | 1³⁄₁₆ dia. | | 27⅛ |
| C | 1 | leg | maple | 1³⁄₁₆ dia. | | 27⅛ |
| D | 3 | stretcher | maple | ¹⁵⁄₁₆ dia. | | 12¾ |
| E | 1 | top | maple | ¾ | 12³⁄₁₆ dia. | |
| F | 3 | wedges | maple | ⅟₁₆ | ⁷⁄₁₆ | ½ |
| G | 6 | pins | maple | ⅛ dia. | | ⅝ |

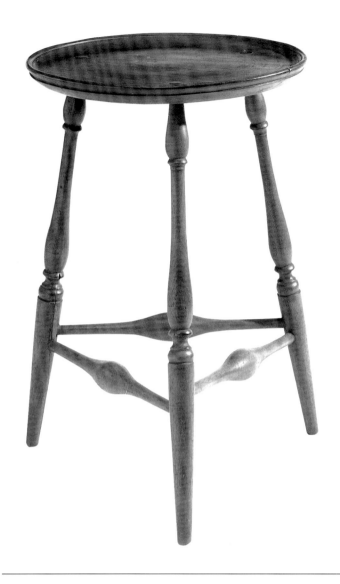

## 195. Candlestand

Chester County, Pennsylvania, about 1790

Maker: Attributed to Nathan Jefferes (1773–1823), East Bradford Township

Butternut. Finish unidentified.

Chester County Historical Society, West Chester, Pennsylvania

H 25, Dia. of top 17½

Photo: George J. Fistrovich

Although this handsome piece of furniture has been classified as a candlestand it has features of both candlestand and table. Its short height and large top are that of a table. One expects candlestands to be taller and have smaller tops. Perhaps this piece is best designated simply as a Windsor stand. The lathe-turned dished top is accentuated with a beautiful beaded edge. The well-splayed legs have a graceful baluster pattern and are secured to the top with wedged-through, exposed tenons.

The bulbous center on the stretchers are effectively exaggerated by the small diameter of their ends. Tenon holes in the legs are offset and pinned for security. The stand is a fine example of superb craftsmanship and a synthesis of parts.

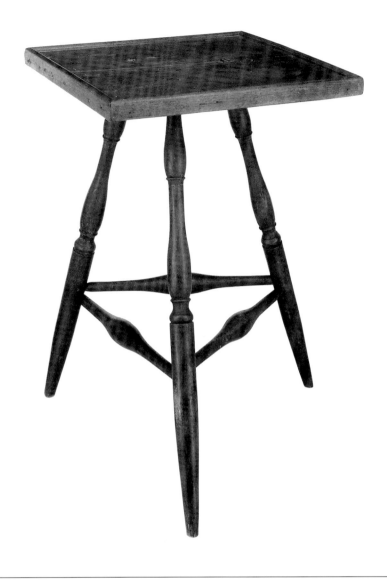

### 196. Candlestand

New England, about 1790

Maker unidentified

Top—walnut; legs, stretchers—maple. Finish unidentified.

The Henry Francis du Pont Winterthur Museum

H 25⅝, top 16⅜ x D 17

Photo: Courtesy, Winterthur Museum

Although the rectangular top on this candlestand is incongruous with the triangular base, it appears to be original to the piece. The top has a nail-applied rim and baluster-turned, double-wedged legs. The lower ends of the legs where the stretchers join are a straight cylinder. This straight portion facilitated clamping and boring the legs' tenon holes. The lower end of the legs are tapered and end in small feet.

# 17  Tables

## Introduction

Tables are another rare form of Windsor furniture. They never achieved the popularity of Windsor chairs, probably because they did not offer anything new in furniture; after all, tables with turned legs have been around for many years. Those Windsor tables that survive vary greatly in size and shape. Tops were left plain and were rarely dished; they are round, oval, square, and even rectangular, suggesting experimentation and customizing among the Windsor furniture makers.

The tops were supported by three or four baluster- or bamboo-style turned legs, strengthened with three, four, or more tenoned stretchers.

Legs were fastened to tops in one of three ways. The simplest and most direct was to have the legs penetrate the top and then glue and wedge them in place. A second method used a subtop or batten to hold the tenoned legs, which was in turn nailed or wood-screwed to the top. The third and most complicated way used aprons that were tenoned in to the sides of the legs, which in turn were fastened, again with nails or screws, to the top, much as in typical table construction.

Those few tables whose basic components—top, legs, and stretchers—harmonize are attractive, functional items of furniture.

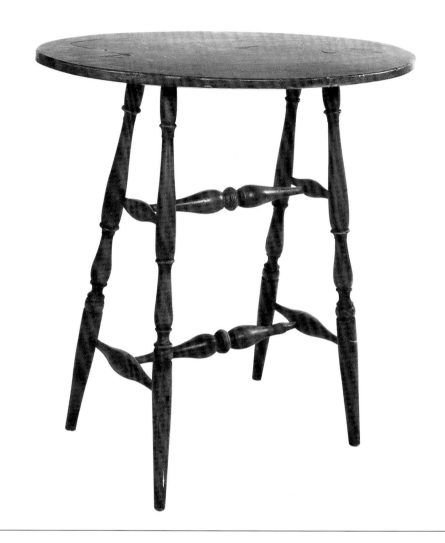

## 197. Table

Probably New England, about 1810

Maker unidentified

Top—pine; legs, stretchers—maple. Brown stain over original red paint.

David Pool

H 33½, W 22 x 35

The height of this table and the size of its top suggest it was designed as a stand-at work piece.

Its exceptionally large oval top is one-board wide, has a very large chamfer on its undersurface, and holds four tenon-wedged legs. The extra long legs have a long tapering foot below a ball-and-ring turning, all topped by three different sized balusters. Two sets of H-pattern stretchers tie the legs together. The side stretchers have plain bulbous centers and the medial stretchers have detailed turned centers similar to those found on Philadelphia bow-back chairs.

| Letter | No. | Name | Material | T. | W. | L. |
|--------|-----|------|----------|-----|-----|-----|
| A | 1 | top | pine | 1⅜ | 22 | 35 |
| B | 4 | legs | maple | 1¾ dia. | | 34⁵⁄₁₆ |
| C | 2 | upper end stretchers | maple | 1⁹⁄₁₆ dia. | | 8⅛ |
| D | 2 | lower end stretchers | maple | 1¾ dia. | | 12 |
| E | 2 | upper center stretchers | maple | 2 dia. | | 18 |
| F | 2 | lower center stretchers | maple | 2 dia. | | 19 |
| G | 4 | wedges | maple | ⅛ | | size to suit |

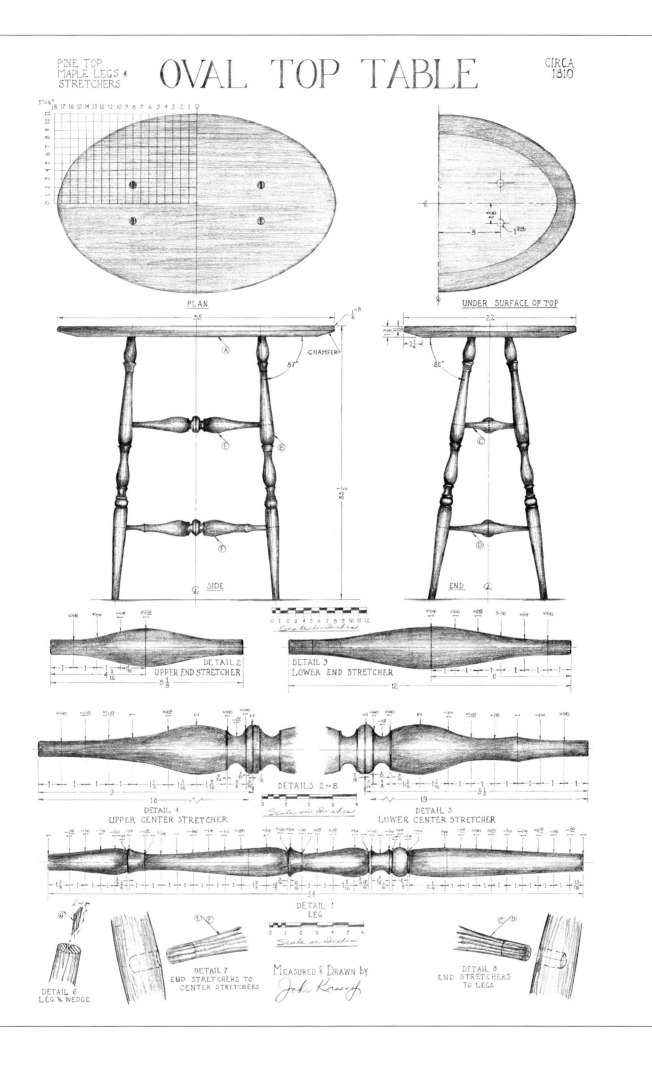

PINE TOP
MAPLE LEGS &
STRETCHERS

# OVAL TOP TABLE

CIRCA
1810

PLAN

UNDER SURFACE OF TOP

CHAMFER

SIDE

END

DETAIL 2
UPPER END STRETCHER

DETAIL 3
LOWER END STRETCHER

DETAILS 2 & 8
Scale in Inches

DETAIL 4
UPPER CENTER STRETCHER

DETAIL 5
LOWER CENTER STRETCHER

DETAIL 1
LEG

Scale in Inches

DETAIL 6
LEG & WEDGE

DETAIL 7
END STRETCHERS TO
CENTER STRETCHERS

MEASURED & DRAWN BY
John Kassey

DETAIL 8
END STRETCHERS
TO LEGS

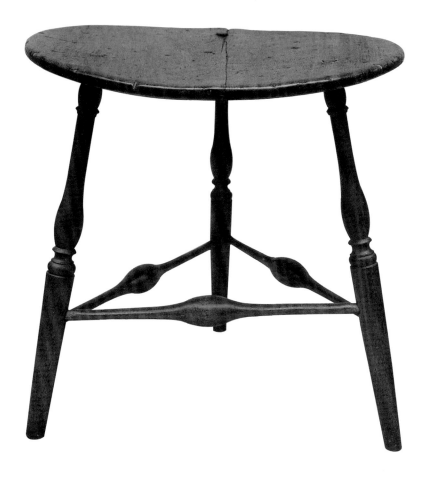

## 198. Table

New England, about 1780

Maker unidentified

Top—poplar; legs, stretcher—maple. finish unidentified.

The Metropolitan Museum of Art, Gift of Mrs. J. Insley Blair, 1947 (47.103.5)

H 24, Dia. of top 24½

Photo: Courtesy, The Metropolitan Museum of Art

The legs on this handsome table are tenon-wedged directly to the top. The top is one-board wide and has warped badly and cracked. This misfortune could have been avoided or at least minimized if intermediate cleats been used, provided they were properly located in relation to the direction of the grain on the top and fastened with wood screws in oversized shank holes. This construction would have allowed unrestricted cross-grain expansion and contraction.

Stretcher holes in the well-splayed, expertly turned, baluster-style legs are offset. Offsetting the holes avoided weakening the legs and permitted greater depth for the bypassing stretcher tenons. The stretchers have interesting compact bulbous centers and very long nontapering ends.

# Notes

## Introduction

1. Hollis S. Baker, *Furniture in the Ancient World* (New York: Macmillan Co., 1966), p. 119, fig. 159.

2. Jack Hill, *Country Chair Making* (Newton Abbot, Devon, England: David and Charles Book, 1993), p. 56.

3. Baker, *Furniture in the Ancient World*, p. 303.

4. John A. Kassay, "Historical Development of the Lathe" (master's thesis, Kansas State Teachers College, 1950), p. 12.

5. J. Geraint Jenkins, *Traditional Country Craftsmen* (New York: Frederick A. Praeger, 1965), p. 17.

6. Nancy Goyne Evans, "A History and Background of English Windsor Furniture," *Furniture History* 15 (1979): 27.

7. Thomas Crispin, *English Windsor Chair* (Dover, N.H.: Alan Sutton, 1992), p. 5.

8. Simon Jervis, "The First Century of the English Windsor Chair, 1720–1820," *The Magazine Antiques* (February 1979): 363.

9. Jenkins, *Traditional Country Craftsmen*, p. 114.

10. Crispin, *English Windsor Chair*, p. 10.

11. Evans, "History and Background," p. 34.

12. Nancy Goyne Evans, "Design Sources for Windsor Furniture: Part I: The Eighteenth Century," *The Magazine Antiques* (January 1988): 283.

13. Ibid.

14. William N. Hosley Jr., "Timothy Loomis and the Economy of Joinery in Windsor, Connecticut, 1740–1786," in *Perspectives on American Furniture*, ed. Gerald W. R. Ward, A Winterthur Book (New York: W. W. Norton, 1988), p. 129.

15. J. Stogdell Stokes, "American Windsor Chair," *Antiques* (April 1926): 222.

16. Nancy Goyne Evans, "American Painted Seated Furniture: Marketing the Product, 1750–1840," in *Perspectives on American Furniture*, ed. Gerald W. R. Ward (New York: W. W. Norton, 1988), 153–68.

## Chapter 1. Comb-Back Chairs

1. Nancy Goyne Evans, "Design Sources for Windsor Furniture, Part I: The Eighteenth Century," *The Magazine Antiques* (January 1988): 283.

2. Carl H. Drepperd, *Handbook of Antique Chairs* (Garden City, N.Y.: Doubleday, 1948), p. 51.

3. Charles Santore, *The Windsor Style in America*, vol. 2 (Philadelphia: Running Press, 1987), p. 42.

4. David Schorsch, "American Catalogue No. 1: Windsor Chairs 1760–1830" (Greenwich, Conn.: David and Marjorie Schorsch, 1982), p. 33.

5. Ibid.; J. B. Kerfoot, "American Windsor Chairs," *New Country Life* (October 1917): 69, fig. 47; and Charles Santore, *The Windsor Style in America, 1730–1830* (Philadelphia: Running Press, 1981), p. 59, fig. 23–23a.

6. Evans, "Design Sources, Part I," p. 282, fig. 1.

7. Nancy A. Goyne, "American Windsor Chairs: A Style Survey," *The Magazine Antiques* (April 1969): 538, fig. 7.

8. Nancy Goyne Evans, "The Aberrant Windsor," *Maine Antique Digest* (February 1990): 1c.

9. Thomas H. Ormsbee, *The Windsor Chair* (New York: Deerfield Books, 1962), pp. 194–97, figs. 75–78.

10. Evans, "Design Sources, Part I," p. 288, fig. 9.

11. Gordon F. Roe, *Windsor Chairs* (New York: Pitman, 1953), p. 33.

12. Alfred Coxe Prime, "The Arts and Crafts in Philadelphia, Maryland and South Carolina, 1721–1785," *Gleanings from Newspapers* (Philadelphia: Walpole Society, 1929), pp. 188–89; and Milo M. Naeve, "An Aristocratic Windsor in Eighteenth-Century Philadelphia," *American Art Journal* (July 1979): 67.

13. Nancy Goyne Evans, "Striking Accents: Ornamental Hardwoods in American Windsors," *Maine Antique Digest* (December 1988): 8c.

14. Naeve, "An Aristocratic Windsor," p. 73.

15. William Macpherson Hornor Jr., *Blue Book: Philadelphia Furniture, William Penn to George Washington* (Washington, D.C.: Highland House, 1977), pp. 309, 300.

## Chapter 2. Low-Back Chairs

1. Nancy Goyne Evans, "Design Sources for Windsor Furniture, Part I: The Eighteenth Century," *The Magazine Antiques* (January 1988): 283.

2. Harold Sack and Deanne Levison, "American Roundabout Chairs," *The Magazine Antiques* (May 1991): 234–35, 937.

3. Ivan G. Sparkes, *American Windsor Chair* (Bourne End, Buckinghamshire: Spurbooks, 1975), p. 78.

## Chapter 3. Fan-Back Chairs

1. Nancy Goyne Evans, "The Tracy Chairmakers Identified," *Connecticut Antiquarian* [The Bulletin of the Antiquarian and Landmarks Society, Inc., Hartford, Connecticut] 33, no. 2 (December 1981): 14–21.

2. Nancy Goyne Evans, "Francis Trumble of Philadelphia: Windsor Chair and Cabinetmaker," *Winterthur Portfolio*, vol. 1, ed. Milo M. Naeve (Winterthur, Del.: Winterthur Museum, 1964), p. 222.

3. Ibid., p. 239.

4. Ibid.

5. William Macpherson Hornor Jr., *Blue Book: Philadelphia Furniture, William Penn to George Washington* (Washington, D.C.: Highland House, 1977), p. 237.

6. Charles Santore, *The Windsor Style in America, 1730–1830* (Philadelphia: Running Press, 1981), p. 87, fig. 75; Wallace Nutting, *Furniture Treasury*, 3 vols. (New York: Macmillan Co., 1948), vol. 2, fig. 2578.

7. Nutting, *Furniture Treasury*, fig. 2578.

8. Ibid., figs. 2606, 2676, 2677.

## Chapter 4. Sack-Back Chairs

1. William Macpherson Hornor Jr., *Blue Book: Philadelphia Furniture, William Penn to George Washington* (Washington, D.C.: Highland House, 1977), pp. 297, 302, pl. 479.

2. Nancy Goyne Evans, "Francis Trumble of Philadelphia: Windsor Chair and Cabinetmaker," *Winterthur Portfolio*, vol. 1, ed. Milo M. Naeve (Winterthur, Del.: Winterthur Museum, 1964), p. 232, fig. 7.

3. Ethel Hale Bjerkoe, *The Cabinetmakers of America* (New York: Bonanza Books, 1957), p. 90.

4. Thomas H. Ormsbee, *The Windsor Chair* (New York: Deerfield Books, 1962), p. 176, fig. 65.

5. Nancy Goyne Evans, "The Tracy Chairmakers Identified," *Connecticut Antiquarian* [The Bulletin of the Antiquarian and Landmarks Society, Inc., Hartford, Connecticut] 33, no. 2 (December 1981): 18.

6. Donna Keith Baron, "Furniture Makers and Retailers in Worcester County, Massachusetts, Working to 1850," *The Magazine Antiques* (May 1993): 793, pl. 13.

7. Santore, *The Windsor Style in America, 1730–1830* (Philadelphia: Running Press, 1981), 107, fig. 113.

## Chapter 5. Bow-Back Chairs

1. Charles Santore, *The Windsor Style in America*, vol. 2 (Philadelphia: Running Press, 1987), p. 118.

2. Nancy Goyne Evans, "Design Sources

for Windsor Furniture: Part I: The Eighteenth Century," *The Magazine Antiques* (January 1988): 288.

3. William Macpherson Hornor Jr., *Blue Book: Philadelphia Furniture, William Penn to George Washington* (Washington, D.C.: Highland House, 1977), p. 326.

4. Santore, *The Windsor Style,* vol. 2, p. 269.

5. Hornor, *Blue Book,* p. 309.

6. Thomas H. Ormsbee, *The Windsor Chair* (New York: Deerfield Books, 1962), p. 178.

7. Margaret Berwind Schiffer, *Furniture and Its Makers of Chester County, Pennsylvania* (Philadelphia: University of Pennsylvania Press, 1966), fig. 70.

8. *Maine Antique Digest* (May 1989): 25b.

9. Evans, "Design Sources, Part I," p. 292, fig. 15; p. 296, fig. 22.

10. Hornor, *Blue Book,* p. 310.

11. Santore, *The Windsor Style,* vol. 2, p. 164, fig. 207.

12. Ibid., p. 124, fig. 142.

13. Ibid., p. 127, fig. 147.

14. Wallace Nutting, *Furniture Treasury,* 3 vols. (New York: Macmillan Co., 1948), vol. 2, no. 2520.

15. Santore, *The Windsor Style,* vol. 2, p. 129, fig. 129.

## Chapter 6. Continuous-Bow Armchairs

1. Nancy Goyne Evans, "Design Sources for Windsor Furniture: Part I: The Eighteenth Century," *The Magazine Antiques* (January 1988): 292.

2. Thomas H. Ormsbee, *The Windsor Chair* (New York: Deerfield Books, 1962), p. 72.

3. F. Gordon Roe, *Windsor Chairs* (New York: Pitman, 1953), pl. 47.

4. Evans, "Design Sources, Part I," p. 292.

5. Charles Santore, *The Windsor Style in America,* vol. 2 (Philadelphia: Running Press, 1987), p. 120, fig. 115.

6. Evans, "Design Sources, Part I," p. 292.

7. Joe Kindig III, "Upholstered Windsors," *The Magazine Antiques* (July 1952): 52–53.

8. Nancy Goyne Evans, "The Tracy Chairmakers Identified," *Connecticut Antiquarian* [The Bulletin of the Antiquarian and Landmarks Society, Inc., Hartford, Connecticut] 33, no. 2 (December 1981): 17, fig. 4.

9. Ibid., p. 19.

10. Charles Santore, *The Windsor Style in America, 1730–1830* (Philadelphia: Running Press, 1981), p. 113, fig. 121.

11. Evans, "Tracy Chairmakers," pp. 19, 17.

## Chapter 7. Rod-Back Chairs

1. Nancy Coyne Evans, "Design Sources for Windsor Furniture: Part II: The Early Nineteenth Century," *The Magazine Antiques* (May 1988): 1128.

2. Ivan G. Sparkes, *American Windsor Chair* (Bourne End: Spurbooks, 1975), p. 75.

3. Evans, "Design Sources, Part II," p. 1132, fig. 4.

## Chapter 8. Step-Down and Slat-Back Chairs

1. Zille Rider Lea, *The Ornamented Chair: Its Development in America, 1700–1890* (Rutland, Vt.: Charles E. Tuttle, 1960), p. 61.

2. Ibid., p. 72.

3. Ibid., p. 61, pl. 3.

4. Ibid., p. 71, fig. 31-31a.

5. Evans, "Design Sources, for Windsor Furniture: Part II: The Early Nineteenth Century," *The Magazine Antiques* (May 1988): 1130.

## Chapter 9. Writing-Arm Chairs

1. Christopher P. Monkhouse and Thomas S. Michie, *American Furniture in Pendleton House* (Providence, R.I.: Museum of Art, Rhode Island School of Design, 1987), p. 159.

2. Ibid., p. 153.

3. Patricia E. Kane, *300 Years of American Seating Furniture* (Boston: New York Graphic Society, 1976), shows a Tracy writing-arm chair with a complete candle slide (see page 195, fig. 173).

## Chapter 10. Rocking Chairs

1. Nancy Goyne Evans, "The Genesis of the Boston Rocking Chair," *The Magazine Antiques* (January 1983): 246.

2. Walter A. Dyer and Esther Stevens Fraser, *The Rocking-Chair, an American Institution* (New York: Century, 1928), pl. 11a.

3. Thomas H. Ormsbee, *The Windsor Chair* (New York: Deerfield Books, 1962), pp. 116–17.

4. Evans, "The Genesis of the Boston Rocking Chair," p. 250, fig. 8.

## Chapter 11. Settees

1. Nancy Goyne Evans, "Francis Trumble of Philadelphia: Windsor Chair and Cabinetmaker," *Winterthur Portfolio,* vol. 1, ed.

Milo M. Naeve (Winterthur, Del.: Winterthur Museum, 1964), p. 222.

2. Robert Bishop, *Centuries and Styles of the American Chair, 1640-1970* (New York: E. P. Dutton & Co., 1972), p. 197, fig. 270.

3. William Macpherson Hornor Jr., *Blue Book: Philadelphia Furniture, William Penn to George Washington* (Washington, D.C.: Highland House, 1977), p. 311, pl. 483.

## Chapter 12. Children's Chairs

1. Nancy Goyne Evans, "Francis Trumble of Philadelphia: Windsor Chair and Cabinetmaker," *Winterthur Portfolio,* vol. 1, ed. Milo M. Naeve (Winterthur, Del.: Winterthur Museum, 1964), p. 228

2. Charles Santore, *The Windsor Style in America,* vol. 2 (Philadelphia: Running Press, 1987), p. 208.

## Chapter 13. High Chairs

1. Charles Santore, *The Windsor Style in America,* vol. 2 (Philadelphia: Running Press, 1987), p. 208.

## Chapter 14. Cradles

1. Federal Hazardous Substances Act, Consumer Product Safety Commission, Code of Federal Regulations, #16, part 1500–1512 (revised January 1, 1991): 438–49.

## Chapter 16. Candlestands

1. Wallace Nutting, *Furniture Treasury,* 3 vols. (New York: Macmillan Co., 1948), vol. 2, p. 1304.

# Bibliography

Baker, Hollis S. *Furniture in the Ancient World.* New York: Macmillan Co., 1966.

Baron, Donna Keith. "Furniture Makers and Retailers in Worcester County, Massachusetts, Working to 1850." *The Magazine Antiques* (May 1993).

Bishop, Robert. *Centuries and Styles of the American Chair, 1640-1970.* New York: E. P. Dutton & Co., 1972.

Bjerkoe, Ethel Hale. *The Cabinetmakers of America.* New York: Bonanza Books, 1957.

*Classic American Furniture.* Introduction by John Kassay. The Art of Woodworking Series. Alexandria, Va.: Time-Life Books, 1995.

Crispin, Thomas. *English Windsor Chair.* Dover, N.H.: Alan Sutton, 1992.

Drepperd, Carl H. *Handbook of Antique Chairs.* Garden City, N.Y.: Doubleday, 1948.

Dunbar, Michael. *Windsor Chairmaking.* New York: Hastings House, 1976.

Dyer, Walter A., and Esther Stevens Fraser. *The Rocking-Chair, an American Institution.* New York: Century, 1928.

Evans, Nancy Goyne. "The Aberrant Windsor." *Maine Antique Digest* (February 1990).

————. "American Painted Seated Furniture: Marketing the Product, 1750-1840." In *Perspectives on American Furniture,* edited by Gerald W. R. Ward. A Winterthur Book. New York: W.W. Norton, 1988.

————. *American Windsor Chairs.* New York: Hudson Hills Press, 1996.

————. "Design Sources for Windsor Furniture: Part I: The Eighteenth Century." *The Magazine Antiques* (January 1988).

————. "Design Sources for Windsor Furniture: Part II: The Early Nineteenth Century." *The Magazine Antiques* (May 1988).

————. "Francis Trumble of Philadelphia: Windsor Chair and Cabinetmaker." In *Winterthur Portfolio,* vol. 1, edited by Milo M. Naeve. Winterthur, Del.: Winterthur Museum, 1964.

————. "The Genesis of the Boston Rocking Chair." *The Magazine Antiques* (January 1983).

————. "A History and Background of English Windsor Furniture." *Furniture History* 15 (1979).

————. "Striking Accents: Ornamental Hardwoods in American Windsors." *Maine Antique Digest* (December 1988).

————. "The Tracy Chairmakers Identified." *Connecticut Antiquarian* [The Bulletin of the Antiquarian and Land-marks Society, Inc., Hartford, Connecticut] 33, no. 2 (December 1981).

Federal Hazardous Substances Act, Consumer Product Safety Commission, Code of Federal Regulations, #16, part 1500-1512 (revised January 1, 1991): 438-49.

Goyne, Nancy A. "American Windsor Chairs: A Style Survey." *The Magazine Antiques* (April 1969).

Hill, Jack. *Country Chair Making.* Newton Abbot, Devon, England: David and Charles Book, 1993.

Hornor, William MacPherson, Jr. *Blue Book: Philadelphia Furniture, William Penn to George Washington.* Washington, D.C.: Highland House, 1977.

Hosley, Willliam N., Jr. "Timothy Loomis and the Economy of Joinery in Windsor, Connecticut, 1740-1786." In *Perspectives on American Furniture,* edited by Gerald W. R. Ward. A Winterthur Book. New York: W. W. Norton, 1988.

Jenkins, J. Geraint. *Traditional Country Craftsmen.* New York: Frederick A. Praeger, 1965.

Jervis, Simon. "The First Century of the English Windsor Chair, 1720-1820." *The Magazine Antiques* (February 1979).

Kane, Patricia E. *300 Years of American Seating Furniture.* Boston: New York Graphic Society, 1976.

Kassay, John. "Historical Development of the Lathe." Master's thesis, Kansas State Teachers College, 1950.

Kerfoot, J. B. "American Windsor Chairs." *New Country Life* (October 1917).

Kindig, Joe, III. "Upholstered Windsors." *The Magazine Antiques* (July 1952).

Lea, Zille Rider. *The Ornamented Chair: Its Development in America, 1700–1890.* Rutland, Vt.: Charles E. Tuttle, 1960.

Monkhouse, Christopher P., and Thomas S. Michie. *American Furniture in Pendleton House.* Providence, R.I.: Museum of Art, Rhode Island School of Design, 1987.

Moser, Thomas. *Windsor Chairmaking.* New York: Sterling Publishing, 1982.

Naeve, Milo M. "An Aristocratic Windsor in Eighteenth-Century Philadelphia." *American Art Journal* (July 1979).

Nutting, Wallace. *Furniture Treasury.* 3 vols. New York: Macmillan Co., 1948.

————. *A Windsor Handbook.* Rutland, Vt.: Charles Tuttle, 1978.

Ormsbee, Thomas H. *The Windsor Chair.* New York: Deerfield Books, 1962.

Prime, Alfred Coxe. "The Arts and Crafts in Philadelphia, Maryland and South Carolina, 1721-1785." *Gleanings from Newspapers.* Philadelphia: Walpole Society, 1929.

Roe, Gordon F. *Windsor Chairs.* New York: Pitman, 1953.

Sack, Harold, and Deanne Levison. "American Roundabout Chairs." *The Magazine Antiques* (May 1991).

Santore, Charles. *The Windsor Style in America, 1730–1830.* Philadelphia: Running Press, 1981.

————. *The Windsor Style in America,* vol. 2. Philadelphia: Running Press, 1987.

Schiffer, Margaret Berwind. *Furniture and Its Makers of Chester County, Pennsylvania.* Philadelphia: University of Pennsylvania Press, 1966.

Schorsch, David. "American Catalogue No. 1: Windsor Chairs 1760-1830." Greenwich, Conn.: David and Marjorie Schorsch, 1982.

Sparkes, Ivan G. *American Windsor Chair.* Bourne End, Buckinghamshire: Spurbooks, 1975.

Stokes, J. Stogdell. "American Windsor Chair." *Antiques* (April 1926).

Watson, Aldren A. *Country Furniture.* New York: Thomas Y. Crowell, 1974.